THE GOLDEN AGE OF IVORY

GOTHIC

CARVINGS IN

NORTH AMERICAN

COLLECTIONS

Richard H. Randall, Jr.

HUDSON HILLS PRESS

NEW YORK

FIRST EDITION

© 1993 by Richard H. Randall, Jr.

Published in the United States by Hudson Hills Press, Inc., Suite 1308, 230 Fifth Avenue, New York, NY 10001-7704.

Distributed in the United States, its territories and possessions, Canada, Mexico, and Central and South America by National Book Network, Inc.

Distributed in the United Kingdom and Eire by Shaunagh Heneage Distribution.

Distributed in Japan by Yohan (Western Publications Distribution Agency).

Editor and Publisher: Paul Anbinder

Copy Editor: Judy Spear

Proofreader: Lydia Edwards

Indexer: Karla J. Knight

Composition: U.S. Lithograph, typographers

Manufactured in Japan by Toppan Printing Company

Library of Congress Cataloguing-in-Publication Data

Randall, Richard H.
 The golden age of ivory : Gothic carvings in North American collections / Richard H. Randall, Jr.—1st ed.
 p. cm.
 Companion volume to: Masterpieces of ivory from the Walters Art Gallery.
 Includes bibliographical references and index.
 ISBN 1-55595-076-0 :
 1. Ivories, Gothic—Catalogues. 2. Ivories—Collectors and collecting—United States—Catalogues. 3. Ivories—Collectors and collecting—Canada—Catalogues. I. Walters Art Gallery (Baltimore, Md.). Masterpieces of ivory from the Walters Art Gallery. II. Title.
NK5875.R35 1993
730'.094'07473—dc20 93-19466
 CIP

Contents

Preface

The wealth of Gothic ivories in American museums became apparent during work on a catalogue of the ivories at the Walters Art Gallery in Baltimore, published in 1985. That museum owns 109 Gothic ivories, the Metropolitan Museum of Art in New York 182, and there are 224 in the sixty-one American and Canadian museums described here. Included also are twenty-one works of great interest in private collections, bringing the total in this volume to 245.

The scope of the book encompasses only ivories of the Gothic period from the thirteenth to the fifteenth century. Works displaying Renaissance characteristics are excluded, as are those rare and exceptional works in the Gothic style that were made in Spain and other countries as late as the seventeenth century. Likewise left for another study are Romantic ivories of the nineteenth century in the Gothic manner (for example, the superb Saint George and the Dragon in the Toledo Museum of Art; inv. 69.296), as it is not yet clear in many instances whether these are Gothic Revival pieces or were made as commercial forgeries at the end of the century.

The collection of the Metropolitan Museum, whose catalogue is in progress under the direction of Charles Little, is not included in the present volume (except for two panels that form part of a polyptych [cat. no. 45]). Neither do the published Walters Art Gallery ivories appear here; however, two unpublished examples from that collection are added to this book. One (cat. no. 95)—a diptych—is a recent gift; and the other (cat. no. 212)—a rare Italian plaque—was overlooked, having been bound into the nineteenth-century cover of a manuscript in the Walters Rare Book Library.

The undertaking has been aided by two factors. One is the generous wisdom of the Samuel H. Kress Foundation in funding the travel and study necessary for the research, and the other is a team of colleagues who have been working together for nearly two decades. This group, created in 1974 (when the Walters catalogue was in progress) to help solve the multifarious problems of attributing Gothic ivories, includes Danielle Gaborit-Chopin, Curator of *Objets d'Art* at the Musée du Louvre in Paris, Charles Little, Associate Curator of Medieval Art at the Metropolitan Museum, Neil Stratford, Keeper of Medieval Antiquities at the British Museum in London, and Paul Williamson, Keeper of Sculpture at the Victoria and Albert Museum in London. Peter Barnet, Associate Curator of Decorative Arts at the Detroit Institute of Arts, joined the group in 1987, when that museum (whose collection of ivories is the third largest in the country) consented to sponsor the present project. Norbert Jopek of Kons, Germany, was present at three of our annual meetings, bringing his knowledge of German work and of forgeries.

The continual correspondence and exchange of photographs and information among members of the group has led to a far greater body of knowledge than any one person could have assembled. For the past four years we met annually to survey the latest thoughts, additions, and changes, examining original material at the same time. We did not always agree with each other—indeed some of the disagreements were the most valuable part of the process—and I must point out that my colleagues bear no responsibility for the opinions in the present volume that may be incorrect; the final product is that of the author, who may not see the medieval world through London, Paris, or New York eyes.

The Gothic ivories spread liberally throughout American museums—varying widely in their quality and in their places of origin—cover the entire history of the subject. The beautiful Virgin of Saint-Denis in the Taft Museum (cat. no. 3) surely stands at the top of the list for workmanship and royal provenance, and she is joined in this volume by many other important examples. Interesting also are the levels of quality, which, when studied closely, yield considerable information about ivory ateliers. Works from the Embriachi atelier in Venice (cat. nos. 217–245 passim), for instance, illustrate three different levels of workmanship: the finest in ivory, a second quality in bone with elaborate intarsia borders, and lesser works with poor carving and intarsia replaced by plain strips of cow horn. A similar range can be seen in works from other centers, as in a Paris group of second quality related to plaques on a book cover from the Treasury of Saint-Denis (see cat. no. 120).

Readers will find the present work heavily laced with question marks, as there are many problems that cannot be resolved. An attempt has been made, however, to find logical homelands for the ivories of non-French character, even including some that are based directly on known French prototypes. The clay models found in the Scheldt River and at Liège, for instance, show that the French style was being imported into the workshops of Belgium, yet there is a group of works from the same region that has local characteristics and follows the sculptural style of the Cathedral of Huy. With a growing community of scholars working on these problems, more definitive answers may be forthcoming in the next decade.

Were I to list the names of all those who have been of help in this project, it would equal the staff rosters of sixty-one museums; not only the curators but the directors, registrars, photographers, and others have made access easy and the work pleasurable. Since medievalists are not commonplace staff members in American museums, it was often the registrars who provided the information essential to the study, and I salute their profession.

I owe great thanks to Sam Sachs and the Detroit Institute of Arts for agreeing to sponsor the project in 1987 and for dealing with the multifarious problems of travel for six scholars. My colleagues and I express profound appreciation to the Samuel H. Kress Foundation, without whose support the research would have taken twenty years instead of four. Publication has been made possible by gifts from three individuals as well as an additional grant toward the illustrations from the Samuel H. Kress Foundation. For the final form of the book, Hudson Hills Press is to be highly commended.

Various scholars outside the field of ivories have been generous with their time, especially Claude Blair, former Keeper of Metalwork at the Victoria and Albert Museum, in the area of arms and armor; Leonie von Wilckens, former Curator of Costume at the Germanisches Nationalmuseum in Nuremberg, on costume details; and James Marrow, Professor of Art History at Princeton University, for interpreting a puzzling inscription in Flemish. Paul Williamson has been of great service in reviewing the text.

I have also to thank my wife, Lilian, whose sharp eye for manuscript comparisons has been very challenging, and my daughter, Julia, who helped to unravel the myriad problems of the largest uncatalogued collection I ever encountered.

R.R.

The Collecting of Gothic Ivories in America

T he number of Gothic ivories in American and Canadian collections—which now totals 536—needs some historical explanation. The earliest gift of an ivory to a museum took place in Boston in 1893, showing that Americans understood the collecting passion of their European contemporaries for ivories. Always considered a semiprecious material, ivory had been coveted by European collectors from the middle of the seventeenth century. As part of the Romantic movement's interest in history, ivories were collected in London as early as 1685 by John Tradescant, whose massive accumulations eventually formed the nucleus of the Ashmolean Museum at Oxford. Tradescant was followed by Francis Douce, Samuel Rush Meyrick, William Beckford, and many others. By the middle of the nineteenth century, ivory was often given primary place in collection catalogues like the great six-volume work of the holdings of Frédéric Spitzer, published in 1896. Hardly a major collector was without an interest in the subject, and the new generation of museums, like the Victoria and Albert in London, became eager competitors. In France in particular, ivory was prime material for numerous medieval collectors, who in the nineteenth century were centered mainly in Paris and Lyons. Major English and German collections were formed as well, by both industrial barons and princely houses, in the second half of the century.

The two figures who emerge as the foremost collectors of ivory in America—J. Pierpont Morgan and Henry Walters—could not have been more different. Morgan was a collector of collections, while Walters bought objects one at a time. The leading financier of his day, Morgan acquired, for instance (in 1906), the collection of Georges Hoentschel, which included thirty-seven ivories of all periods. Adding to that large assortments from the collections of Oscar Hainauer, Albert Oppenheim, and others, he projected a major wing on the Metropolitan Museum for his assembled decorative arts. Morgan died suddenly in 1913, and his collection of 5,500 objects was officially accessioned in 1917.

During the same years Henry Walters, a New York resident, chairman of the Atlantic Coastline Railroad, and a trustee of the Metropolitan Museum, was assembling a collection in his hometown of Baltimore. Unknown to the world, he was forming a museum, not just a private collection, and he was doing it sagaciously. In each area—pottery, bronze, jewelry, sculpture, painting, and ivory—Walters was putting together its entire history, from Babylon to his own day. His ivories extended in unbroken splendor from predynastic Egypt to the oeuvre of René Lalique. When Walters died in 1931, he surprised both the Metropolitan Museum and the city of Baltimore by leaving his collection to his native city. There were 403 ivories in the bequest, 108 of them Gothic.

During his lifetime Walters had witnessed a great change in the art world. After World War I, as collections in Europe were dispersed in the 1920s and 1930s, the chief pieces were acquired and brought to New York. The dealers involved were those who understood the taste of the European collectors and whose contacts were with the European sources. Jacques Seligmann from Paris, Dikran Kelekian from Constantinople and Paris, Paul Drey from Munich, and Joseph Brummer from Paris began to move to New York, helping many younger collectors and new museums to become interested in Gothic art and Gothic ivories.

The names of several preeminent art collectors of the late nineteenth and early twentieth centuries are included in this catalogue. Isabella Stewart Gardner heads the list, having acquired two works in ivory, one a rare Scandinavian

Virgin and Child, in 1897. Archer Huntington, the railroad magnate and founder of New York's Hispanic Society, purchased a great seated Virgin from Duveen in 1907, and Dr. Albert C. Barnes, inventor of Argyrol and famed for his Impressionist and Post-Impressionist paintings, bought two ivories before 1922. The Virgin of Saint-Denis, the only ivory belonging to Mr. and Mrs. Charles Phelps Taft, was acquired in 1924.

One of the most interesting of the ivory enthusiasts was John Gellatly, a pioneering spirit in the appreciation of American painting, whose collection forms the heart of the National Museum of American Art in Washington, D.C. Gellatly not only assembled some of the finest works of James McNeill Whistler, John Singer Sargent, Abbott Thayer, John Henry Twachtman, and others, but his interests included Renaissance jewelry, porcelains, and a variety of Gothic works of art. In 1929 he gave twenty-seven ivories, along with over one hundred paintings and other objects, to the (then) National Collection of Fine Arts. Ten of the ivories are Gothic and include a rare English Trinity and a superb Parisian Ascension Plaque.

An outstanding collector was Robert H. Tannahill, who as the honorary curator of American art at the Detroit Institute of Arts mounted one of the first major exhibitions of Gothic art in America in 1928. He himself lent nine ivories and borrowed from many collectors and dealers. Included in the exhibition, for instance, was the great English "Brown" Virgin now at the Cloisters of the Metropolitan Museum of Art but then in the possession of the dealer G. J. Demotte. Tannahill, who became a trustee of the Institute in 1931 and left it a superb collection of Impressionist paintings in 1970, gave many ivories to that museum over the years.

While J. P. Morgan's name looms large in the cases of the Metropolitan Museum, there were many other astute collectors whose ivories are now housed there as well. One of the earliest was Theodore M. Davis, who is remembered in the art world for his important contributions to Egyptian archaeology. In addition to 1,100 Egyptian objects willed to the Metropolitan in 1915, his collection included sculpture, ceramics, Italian furniture, Islamic textiles, Chinese jade, and Gothic ivories. His four ivories include a superb large-scale Virgin and Child of the second quarter of the fourteenth century and one of the finest of the folding Virgin shrines.

Another contributor was the noted paintings collector Michael Friedsam, whose early Flemish and Italian panels are world famous. He left 480 objects to the Metropolitan Museum in 1932, including an ivory standing angel that is one of the treasures of the medieval collection. Friedsam was followed by George Blumenthal, president of the Metropolitan for two decades, whose bequest of 1941 included marble courtyards and hundreds of works of art. Among his ivories was a great mirror case with hunters from the Spitzer collection and a fine folding Virgin shrine. The names of Robert Lehman, Jack and Belle Linsky, and Harry Friedman add distinction to the list of ivory donors to the medieval department, and superb ivory dagger hilts, crossbows, saddles, and sword mounts are to be found in the armor department as gifts from Bashford Dean and his fellow collectors.

While the Boston Museum of Fine Arts was in the vanguard of collecting in 1893 with its lone ivory, it was the impact of the Morgan gift to the Metropolitan Museum in 1917 that sparked a greater interest in medieval art in general and in ivories in particular. The Worcester Art Museum was early to seek ivories for its collections in 1919, followed by the Rhode Island School of Design in 1922. The Detroit Institute and the Cleveland Museum of Art made their first purchases in 1923, and both continued to collect steadily over the following decades. The World Heritage Museum in Urbana, Illinois, was the first academic museum to procure an ivory in 1926, followed in 1929 by Princeton University. A fine Gothic ivory came to be endemic in teaching collections, and virtually every college and university museum added a specimen or two between the 1940s and the 1970s.

Ivory collecting was not restricted to any particular area, however. While Friedsam was gathering early panels and ivories in New York, Mr. and Mrs. Martin A. Ryerson were collecting equivalent works in Chicago. The Ryersons'

ivory triptych by the Berlin Master is one of the great treasures left to the Art Institute in 1937. Ralph C. and Violette M. Lee formed a collection in the 1930s of over one hundred examples, seven of them Gothic, which are now in the keeping of the Crocker Art Museum in Sacramento; the ivories John Davis Hatch acquired in the 1930s and 1940s are at the Williams College Museum of Art. Hatch bought in 1941 a remarkable box lid with Saint Margaret that had been sold by Mrs. Henry Walters and whose history takes it back to the Douce collection in England, published by Samuel Rush Meyrick in 1838.

Mr. and Mrs. Percy S. Straus of New York formed a small, elegant collection on the classic New York model in the 1920s and 1930s, and seeing the great wealth of the Metropolitan, willed it to the Houston Museum of Fine Arts, in 1944. It is to Houston that we must travel to see the great standing Burgundian Trinity in the manner of Claus Sluter. William Randolph Hearst, who owned many ivories, is represented in American museums by only one, the extraordinary Embriachi casket in the Los Angeles County Museum.

William Valentiner, director of the Detroit Institute of Arts from 1924 to 1945, exercised much influence on the collectors of Detroit. He undoubtedly encouraged and abetted the collecting of Robert Tannahill as well as that of Mr. and Mrs. Edsel Ford. The finest Virgin-and-Child ivory of the Ford collection was given to the North Carolina Museum of Art in Valentiner's memory, and two panels—one of which is Gothic—are in the collection of the Edsel & Eleanor Ford House at Grosse Point Shores.

The ivories of Thomas Flannery are among several fine private collections recently dispersed. Mr. & Mrs. James Aldsdorf have made gifts to the Snite Museum of Art at the University of Notre Dame, Judge Irwin Untermeyer to the Godwin-Ternbach Museum at Queens College, and Dr. Lillian Malcove to the University of Toronto. In 1960 the Royal Ontario Museum, which had collected quietly over the years, received the holdings of Lord Lee of Fareham, including a most interesting diptych which is probably English.

Raphael Stora, a New York dealer, bought one of the finest of the Lyons ivory collections, that of Emile Baboin, in the 1940s and dispersed it in the following decade. Except for half a dozen pieces that went back to Europe, the Baboin ivories are to be found spread across the museums of the United States and Canada.

In the mid-1930s there was a new influx of dealers from Germany and Austria, including Rosenberg and Stiebel, Leopold Blumka, and Fritz Glueckselig, all of whom understood ivories and encouraged collectors and museums to collect them. The sale of the Joseph Brummer collection in 1949 brought thirty-one more Gothic ivories on the New York market at ridiculously low prices. In the 1940s a Hungarian dealer, Mathias Komor, arrived from China and began dealing in European material. Both he and Blumka became prominent purveyors of Gothic ivories in the 1940s and were joined in the 1950s by J. J. Klejman and Edward R. Lubin.

The patterns have changed since World War II, when Europeans began to collect again. The outflow of material to America has been vastly reduced, and many of the dealers with European connections have left the scene. Compelled again to go abroad to find treasurers, American buyers acquired choice ivories at the sale of the Lucerne collectors E. and M. Kofler-Truniger in 1965 and the auction of the contents of Hever Castle in Kent (England) in 1983. Fewer important examples now reach the United States through the traditional channels, and there are increasing numbers of enthusiastic European collectors of ivories competing for the important pieces.

Attributing Gothic Ivories

As the collecting craze for Gothic ivories in the late nineteenth and early twentieth centuries was coming to a close, Raymond Koechlin published his masterwork, *Les ivoires gothiques français,* in 1924. Koechlin had studied the subject for many years, and in his book he was able to illustrate that Paris was the seminal center of the ivory industry in the thirteenth and fourteenth centuries. He had discovered the records of the ivory workers in Paris, the bylaws of their corporation, and bills and accounts of their widespread mercantile activities. His thesis was reinforced by the position of Paris as the cradle of the Gothic style in architecture and book illumination. France was the dominant center for all of Gothic art, and as its hegemony spread across Europe, so its artisans, like William of Sens at Canterbury, carried the style directly to other countries; likewise the ivories of Paris were to be found in churches and collections throughout Europe. Koechlin's book had such influence that medieval scholars began to assume all their ivories came from France. Instead of raising appropriate questions the English, Belgians, Germans, Dutch, Scandinavians, and Italians were satisfied to label the ivories in their museums "French." The result was ultimately a cessation of work in the field for over fifty years.

Several flaws in Koechlin's book, which are now simple to see, have been overlooked in the intervening years. He was writing about a new and potent style and its dissemination but was not looking for examples of its imitation. Just as the English and Germans flocked to Limoges to learn the enamel industry in the thirteenth century, so they must have gone to Paris in the fourteenth century to learn the techniques of ivory shops. Since the style they took home to the Rhineland, North Italy, and England was the style of Paris, the production of centers away from Paris is extremely difficult, and sometimes impossible, to recognize.

The work of Jehan Aubert is a case in point: Koechlin himself published an account of this Parisian carver who returned home to Tournai when he inherited his uncle's workshop.[1] Otherwise little work has been done in European archives outside France to discover ivory carvers. The concept that ivories were portable works of art and "could have been imported" ruled the day, and the world has continued to call all Gothic ivories "French."

Style was the only major consideration of Koechlin's book, to the exclusion of all other elements concerning an ivory—design source, find site, iconography, provenance, and inscription—factors that constitute essential evidence in any field. The fundamental point to be made about the first of the omissions—design source—is that ivory carving is a form of sculpture, both in the round and in relief. Many scholars have attempted to illustrate a relationship to manuscript illumination or other arts, only to conclude that ivory carving is an art unto itself. This is quite clearly not the case. As sculpture it followed the traditions and alternations of Gothic sculpture for two centuries until the evolution of the print, at which point (in the mid-fifteenth century) its source of design changed to that medium.

A number of clear cases have been published and illustrated, most important being a group of Paris ivories that follow the fashionable model of the Virgin and Child in the 1240 trumeau of the north portal of Notre Dame in Paris. More than half a dozen surviving examples are known from this popular statue (most of the finest published in 1972 by Max Seidel in an article on the Virgin made for Pisa Cathedral in 1299[2]), and later examples of Paris ivory carving can be

Figure 1 *Portail de la Calende, Rouen Cathedral, limestone, French, 1330–1340.*

related similarly to major cathedral sculpture. A group of diptychs attributed to the Passion atelier, dating from the middle of the fourteenth century to 1380 or 1390, follow both the style and the composition of the tympanum at the Cathedral of Mantes of about 1330–1340.[3] The sculptural style and format appear again in the Portail de la Calende at Rouen Cathedral (figure 1), and one particular scene, that of the Arrest of Christ, is repeated detail for detail in the ivories of the Passion Master (cat. nos. 102 and 147).

The same tradition of inspiration from major works of sculpture can be seen in Germany—for instance, in a Virgin from a Pietà (cat. no. 9) that is based on a large group of wood and leather statues from the Rhineland and Franconia[4] (see figure 2). This important relationship was first pointed out by Paul Williamson. The style of the Master of Kremsmunster has been traced by Danielle Gaborit-Chopin to the Middle Rhine and related to the Commemoration Portal of the Cathedral of Mainz.[5] A remarkable master who stands apart from others in his control of the medium of ivory, his chiaroscuro effects in relief carving, and his personal interpretation of the biblical characters, this carver, who appears to have understood all of the formats and possibilities, must have been trained in Paris in his youth (see cat. nos. 149 and 150).

In the Meuse Valley, where the inventories of church treasuries indicate that bishops and abbotts were not to be without the stylish ivory products enjoyed

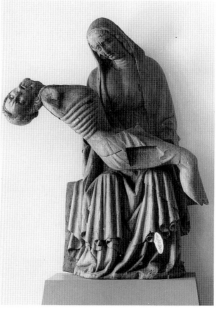

Figure 2 *Pietà, Veste Coburg, linden, German (Franconia), about 1320.*

11

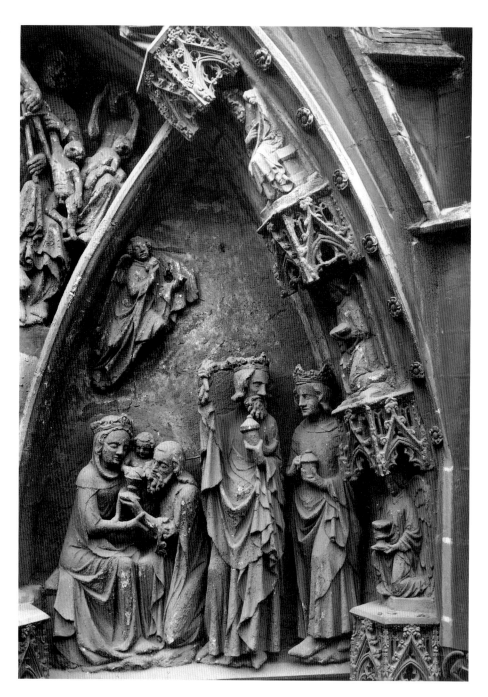

by their peers in other areas, there is a late group of works that follow the sculptural style not of Paris but of Huy (see figure 3). The casual approach of these Meuse ateliers in rendering the Gothic frames of the scenes is a feature almost inconceivable in Paris (see cat. nos. 86, 153, and 154).

Italian interest in French ivories can be illustrated with the importation of a Virgin and Child for the altar in the Cathedral of Assisi,[6] and it is even more apparent in French models for various sculptures by the Pisani.[7] The clearest case is the use of a French ivory (after the Virgin of the trumeau of Notre Dame) as a model for a Virgin and Child by Giovanni Pisano (1240?–1320?).[8] Cat. no. 204, a crozier, is a fine example of an Italian copy of a French model.

A separate sculptural tradition in Italy—that of profile figures—clearly divides Italian copies of French ivories from a true Italian usage. The format derives from classical antiquity, probably from coins, and caused Italian carvers, unlike those of northern Europe, to show their figures and genre scenes in pure profile (see cat. nos. 213–216). Established by Italian marriage certificates of the fourteenth century, the convention was carried on in the fifteenth in painted portraits.[9]

Of the ivories that have been excavated from archaeological sites over the past several centuries, many can be disputed—for instance, the great set of

chessmen in walrus ivory found on the Isle of Lewis.[10] But some of the finds are now beginning to be considered evidence for attribution to the country where they were discovered. One such example is a writing tablet of indifferent workmanship (now in the Southhampton City Museums) excavated at Saint Michael's House in Southhampton in 1972.[11] To this can be added others, such as a plaque with the Adoration found in the wall of the parsonage of Broadoats, Cornwall, in 1764 and one with the Crucifixion dug up in Thomas Street, Dublin (both now in the National Museum of Ireland), and a relief figure of a reclining soldier recently unearthed in London.[12]

While there is no positive proof that these pieces are not imported from elsewhere, their findspots must be considered as evidence, as they have not been in the past. It is known, for instance, that ivories were carved in England from early times, and there are ample works in walrus ivory from the Romanesque period. London was known for producing chessmen in the late twelfth century, as attested by Chrétien de Troyes in *Romance of Perceval le Gallois*.[13] Edward I kept his treasures in ivory boxes (whether carved or plain is not known), and that he imported them all is unlikely. There seems every reason to believe in an existing ivory industry in England, as there was in France and Germany.

Recent scholarship has shown that the "Brown" Virgin of the Cloisters is indisputably English,[14] her attribution based on both style and the existence of a number of other "deep-fold" Virgin statuettes that had been identified as English by Edward Prior and Arthur Gardner early in this century.[15] Such comparative evidence does not always withstand scrutiny, however; a related Virgin (cat. no. 9) whose deep folds resemble those of English ivories[16] now turns out to be German. So the problems of attribution remain difficult and may never be entirely resolved, yet an attempt must be made to interpret the available information.

A few late groups of ivories do not derive from Paris but are creations of their own cultures—for example, a remarkable series of paxes and plaques produced in Utrecht in the fifteenth century (cat. nos. 167–169—one a diptych published by Robert Koch in 1958). Another group, long mislabeled Italian, comprises Flemish Virgin shrines of ivory and bone, along with a large series of bone caskets (see cat. nos. 163 and 164), based on Flemish print sources such as the *Biblia Pauperum*. The reasons for the Italian attributions are obvious, since many examples were discovered in Italy, the country with which Flanders carried on extensive trade in the fifteenth century. But a major piece of evidence

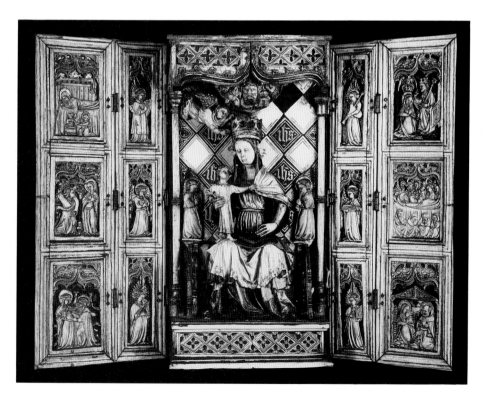

Figure 4 Virgin shrine, from Saint-Jean, Bruges, ivory and bone, Flemish, 1430–1460.

was ignored: the finest of the folding Virgin shrines (figure 4), which has always stood in the Church of Saint-Jean in Bruges, is patently Flemish in every detail.

There are many areas of difficulty in attributing Gothic ivories, not the least of which is that carvers outside France were not trying to produce local works but works that imitated those of Paris. That they often succeeded makes it extremely difficult to recognize their skillful craftsmanship. It is only when local characteristics invade the copy that the real origin becomes apparent. For instance, the carving of eyeballs separated from the corners of the eye sockets—unknown in French work—was a technique used by the Master of Kremsmunster in the Middle Rhine. It appears also in several other groups of statues and plaques, some of which, like a Virgin at Langenhorst, are in their original Rhenish church treasuries, while others are in German collections.[17]

To recognize the ivory production of Cologne in the Gothic period is not a simple matter because Cologne, like London, was already famous in the twelfth and thirteenth centuries for its ivory carving, from walrus tusks. There are chessmen, enamel-and-ivory cupola shrines, and an extensive series of bone reliquaries with standing saints that date from the late Romanesque period. Suddenly in the fourteenth century, the greatest moment in the history of ivory production, the style of Cologne becomes difficult to distinguish. The reason is the same again: that the works look very much like those of Paris. In recent years Danielle Gaborit-Chopin has attributed a mirror case called French to Cologne, as its nearest relative is a secular casket in the very same German city: from the treasury of the Church of Saint Ursula.[18]

That iconography has been cited rather vaguely in ivory studies is a consequence of motifs traveling quickly from one location to another. For some years almost all the diptych plaques bearing as subject the murder of Thomas Becket were attributed to the Rhine without question because in the adjoining Crucifixion scene a sword or issue of blood from the figure of Christ pierces the Virgin's breast. This iconography was considered to originate in the religious mysticism of the Rhineland and the teachings of Johannes Tauler and Heinrich Suso. It now appears, from analysis of a plaque with the Entry into Jerusalem (cat. no. 120), that the closest stylistic relation is to a diptych, probably of Paris origin, given to the Abbey of Saint-Denis in 1405.[19] The sword, as it turns out, was not limited to Germany but was the dominant iconography of the Dominican Order. (The royal priests at the French court in the fourteenth century were Dominican, and their influence can be seen in the Hours of Jeanne d'Evreux of 1324.) Sword iconography had been used in France also in the Hours of Marguerite de Beaujeu (1318), in the Psalter of Yolande de Soissons (about 1275), and in a Jacobin missal from Toulouse (thirteenth century).[20] The Entry plaque is probably from the same workshop as several of the Becket ivories (see cat. no. 121), whose attributions must now be changed from the Rhineland to Paris.

Provenance is difficult to interpret for many ivories. Considering the casket from Saint Ursula in Cologne and the Virgin shrine from Saint-Jean in Bruges, it is clear that the original location of a piece can be important in determining the origin of others. There are, however, the aforementioned French ivory on the altar of Assisi Cathedral and many other similar examples of export. In the case of a diptych that once belonged to Lord Lee of Fareham (cat. no. 61), the finding that all related material is from ancestral English collections has strong implications. The same can be said of two Trinity diptychs (cat. nos. 62 and 63); many missing wings and related pieces are to be found in England (see figures 10 and 11).

It appears that Gothic ivories were sometimes imported into France from other countries—for example, a diptych once said to have come from the Cathedral of Laon (cat. no. 209) and another from the Treasury of Saint-Denis,[21] both published as Italian by Donald Egbert in 1929. Since most of the treasures of cathedrals came from elsewhere as gifts of the faithful—Islamic crystals, Byzantine cups, Roman cameos—it would not be surprising if some ivories were also of foreign origin. Could the two diptychs not be gifts brought to France from

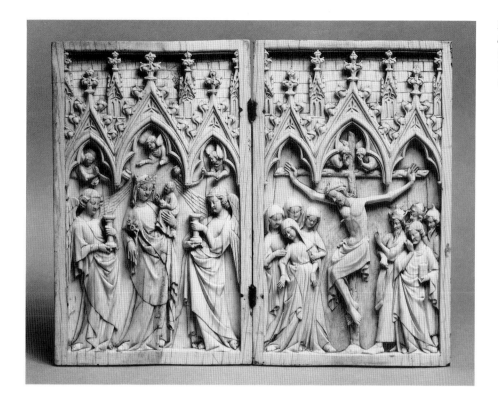

Figure 5 *The Virgin, and Child with Angels and the Crucifixion, ivory diptych, German (Cologne?), second quarter 14th century, Walters Art Gallery, Baltimore, 71.276 (Randall, no. 297).*

the sacred city of Rome or some other Italian location? It is another question difficult to resolve, but one must consider the coarseness of the carving and the misunderstanding of Gothic moldings and postulate if they could have possibly been made in Laon or Paris.

We know from documents that there were Gothic ivories in virtually every royal treasury in Europe and also in every sacristy, but in none of the inventories is the origin of the example recorded. On rare occasions a coat of arms appears on an ivory, the most famous being four made for John Grandisson, bishop of Exeter in the mid-fourteenth century.[22] As for inscriptions, original or added, there are so few of them in the study of ivories that it constitutes only a very small point. Of major import, however, is an ink inscription on a diptych (figure 5) that has always been called French; the annotation relates the work to the diocese of Lescar, near Pau in the Pyrenees. It now turns out to be a German example and probably from Cologne. The leaf of the Virgin with angels is close indeed to Parisian models, but the Crucifixion leaf, which has the issue of blood, among other details, shows an entirely different physical type; the thin, pointed faces relate to other works from Cologne—a statue of Saint Nicholas in the Diocesan Museum and an ivory diptych (see cat. no. 88). Both the sculptural style and the architectural format of the diptych—a tiled roof with pinnacles between the arches—were much favored in Cologne (see also cat. no. 87).

Figure 6 *The Annunciation, engraving, Master E. S., German, c. 1450–1460 (Lehrs 184).*

A box in a pure North Italian "profile" style that is difficult to localize (cat. no. 214) is inscribed with mottoes in French. The inscription suggests an origin in Savoy, where French was the court language. Yet another example is an inscription, in medieval Flemish, that records a personal presentation of a quatrefoil diptych (cat. no. 118) then over a century old. This expensive annotation gives further credence to the attribution of ivories with studded borders to Flemish and Mosan ateliers.

In the study of ivories of the fifteenth century, the printed source becomes a new and important factor. Religious boxes produced in Flanders (cat. nos. 163 and 164) have been shown to derive from the woodcuts of the *Biblia Pauperum* of 1430–1460, and prints—as yet unidentified—would have inspired scenes from the Virgin's life on the wings of several folding shrines (see cat. nos. 35, 162, and 163). In Germany the Master E. S. was the major producer of printed subjects, not only for ivories but for objects in stone, wood, mother-of-pearl, and pipe

clay. One Annunciation roundel (cat. no. 170) is interesting for what it omits of the print by E. S. (figure 6), while another (cat. no. 171) follows what was undoubtedly the master's most popular composition.[23]

To the foundation laid by Koechlin has been added much new material from several countries, along with a new generation of scholars around the world. Roland Koekkoek has published and exhibited the ivories of Holland, Niels Liebgott those of Denmark, and Paola Giusti and Pierluigi Leone de Castris those of Naples.[24] Moreover, archival exploration is being undertaken in many countries, so that gradually a fuller picture of the widespread production of ivories in the thirteenth and fourteenth centuries will emerge.

The ivories in this volume illustrate the great diversity of national origins, while at the same time illustrating the glory of the finest Parisian work.

NOTES

1. Koechlin, vol. 1, p. 535.

2. See Seidel.

3. H. Krohm, "Die Skulptur des Querhausfassaden an der Kathedrale von Rouen," *Aachener Kunstblätter* 40 (1971), fig. 81.

4. W. Krönig, "Rheinische Vesperbilder aus Leder und ihr Umkreis," *Wallraf-Richartz Jahrbuch* 24 (1962), pp. 97–192.

5. Gaborit-Chopin, p. 170.

6. Gaborit-Chopin, figs. 229 and 230.

7. Seidel, pp. 24–40.

8. Seidel, pp. 1–50. The sculpture is in Pisa Cathedral.

9. Randall, no. 348.

10. M. Taylor, *The Lewis Chessmen* (British Museum, London, 1978).

11. *Age of Chivalry*, no. 428.

12. Neither of the Dublin examples has been published; the London find is in *Age of Chivalry*, fig. 75, p. 111.

13. M. Longhurst, *English Ivories* (London, 1926), p. 39.

14. Wixom 1987.

15. Prior and Gardner, fig. 11, pp. 10 and 364.

16. Longhurst, vol. 2, no. 202–1867 (as English); see also nos. 201–1867 and 204–1867 (as French).

17. Jászai, figs. 9 and 10.

18. D. Gaborit-Chopin, *Avori Medievali* (Florence, 1988), no. 17. The mirror case is at the Bargello in Florence; for another example of the same group, at the Victoria and Albert Museum, see Longhurst, vol. 2, no. 222–1867.

19. *Trésor de Saint-Denis*, no. 49.

20. The Jeanne d'Evreux manuscript is at the Cloisters of the Metropolitan Museum of Art (inv. 54. 1.2). See also T. Belin, *Les Heures de Marguerite de Beaujeu* (Paris, 1925), f. 104v; K. Gould, *The Psalter and Hours of Yolande de Soissons* (Cambridge, 1978), f. 345v, pl. 37; *Les trésors des bibliothèques de France*, vol. 5 (Paris, 1933), pl. XIX.

21. Egbert, nos. 40 and 41.

22. *Age of Chivalry*, nos. 593–596.

23. H. Huth, "Ein verlorener Stich des Meisters E. S.," *Festschrift Adolph Goldschmidt, zu seinen Siebenzigsten Geburtstag* (Berlin, 1935), pp. 74–79.

24. Koekkoek II; Liebgott; and Giusti and de Castris.

OPPOSITE

COLORPLATE 1 (cat. no. 1) *The Virgin and Child, ivory statuette, North French, 1240–1250, The Art Institute of Chicago, Kate S. Buckingham Fund, photographed by Robert Hashimoto, height 8⅞ in.*

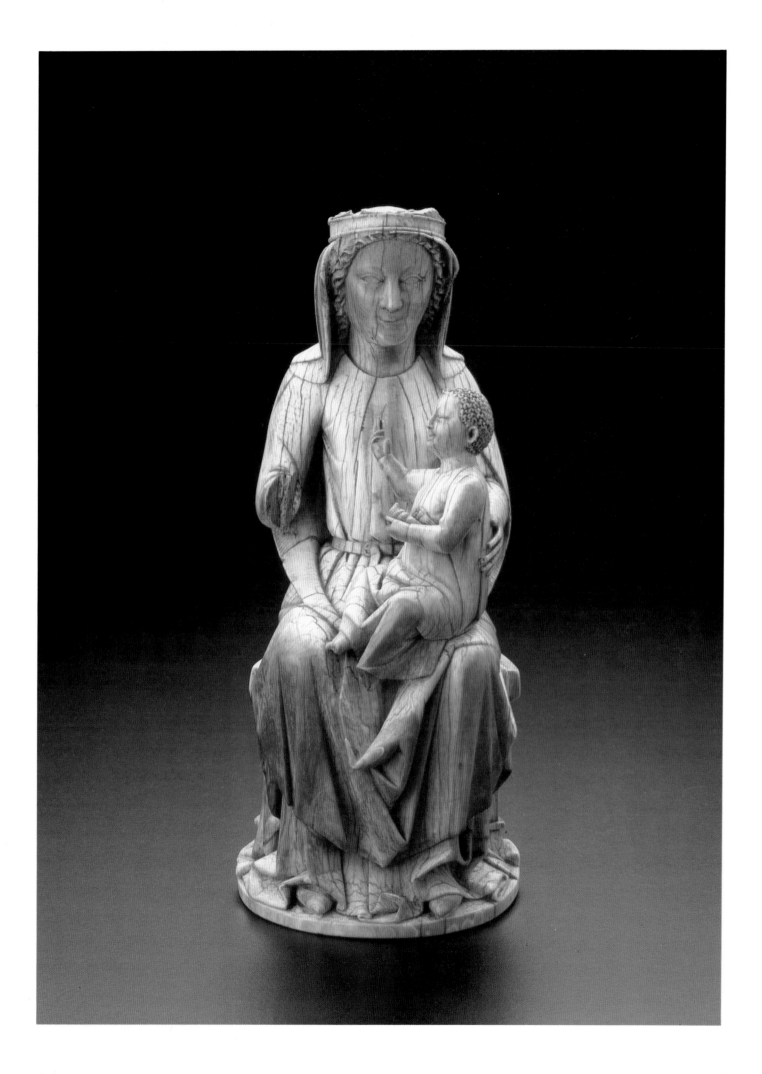

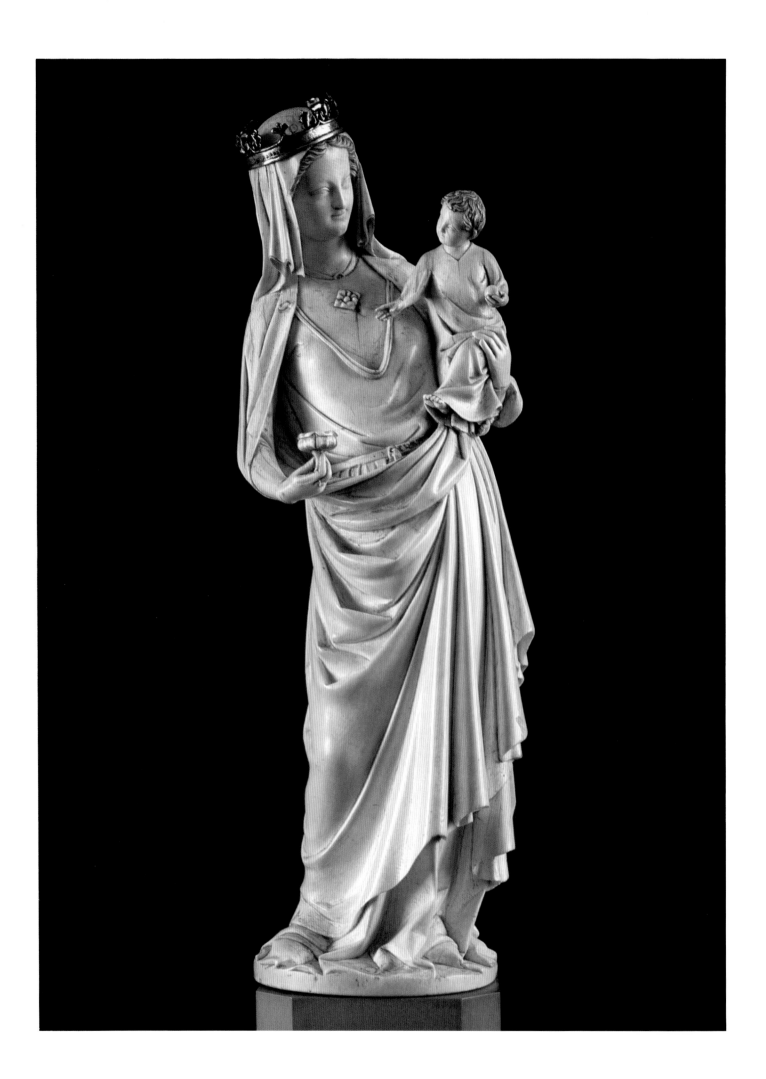

OPPOSITE

COLORPLATE 2 (cat. no. 3) *The Virgin and Child from the Abbey Church of Saint-Denis, ivory statuette, French (Paris), 1260–1280, The Taft Museum, Cincinnati, Bequest of Mr. and Mrs. Charles Phelps Taft,* height 13¹¹⁄₁₆ in.

COLORPLATE 3 (cat. no. 24) *The Virgin and Child, ivory statuette, said to be from the church of Lagny-sur-Marne, French (Lorraine), 1380–1400, Worcester Art Museum, Worcester, Massachusetts, height* 8¼ in.

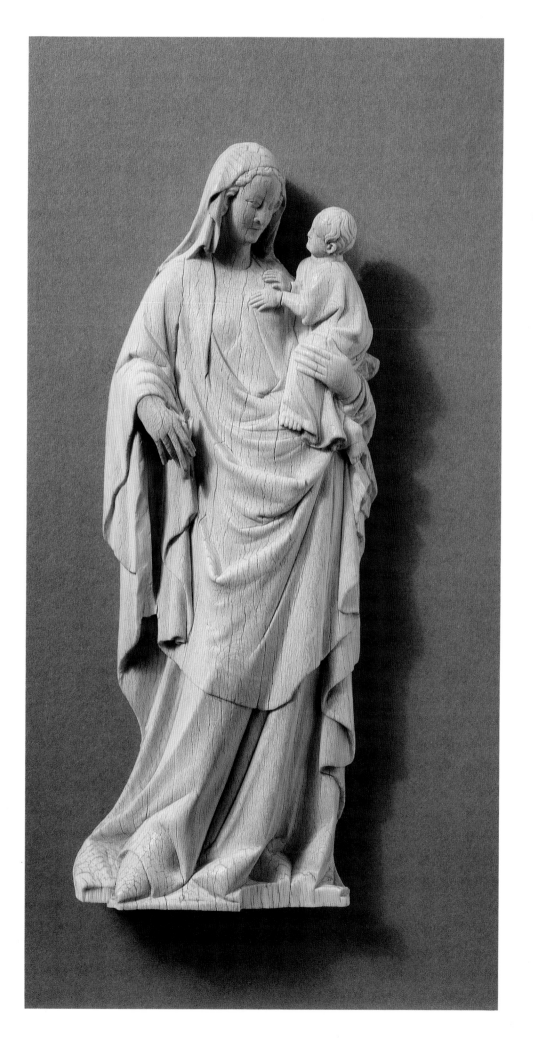

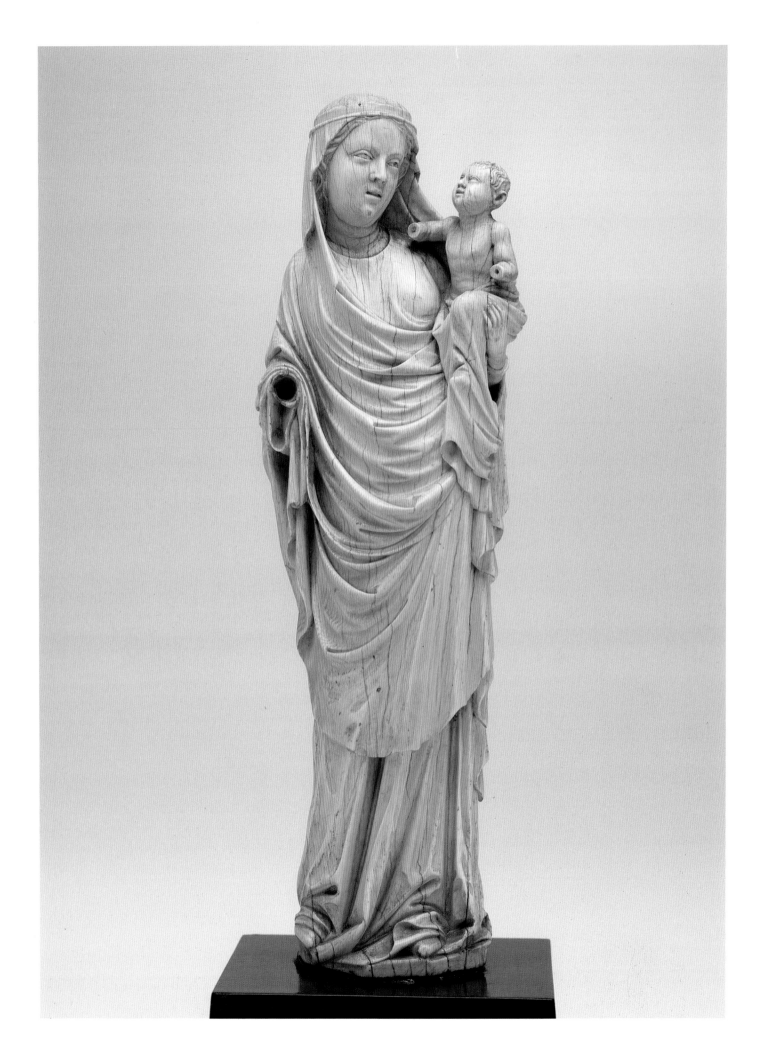

OPPOSITE

COLORPLATE 4 (cat. no. 25) *The Virgin and Child, ivory statuette, Mosan, fourth quarter of 14th century, The Nelson-Atkins Museum of Art, Kansas City, Nelson Fund, height 12⅞ in.*

COLORPLATE 5 (cat. no. 26) *God the Father from a Trinity, ivory statuette, French (Dijon), 1380–1400, The Museum of Fine Arts, Houston, Edith A. and Percy S. Straus Collection, height 9¹³⁄₁₆ in.*

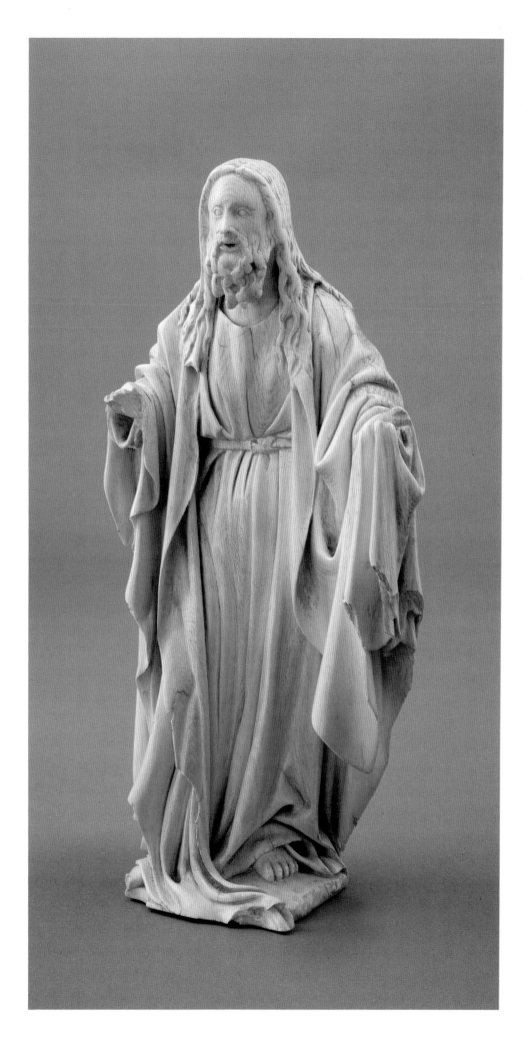

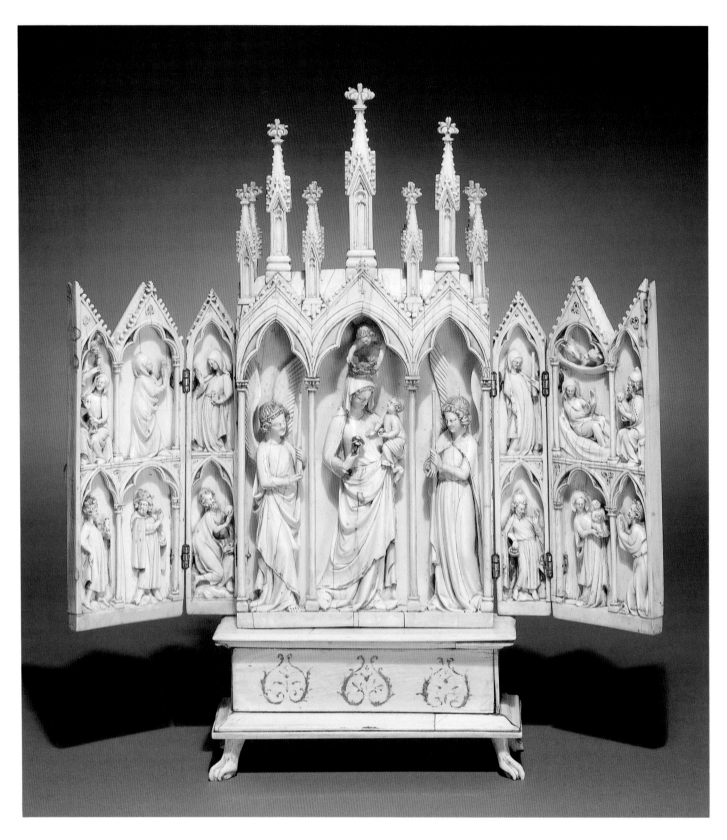

COLORPLATE 6 (cat. no. 32) *The Life of the Virgin, ivory polyptych, French (Paris), 1280–1290, The Toledo Museum of Art, gift of Edward Drummond Libbey, height 11½ in.*

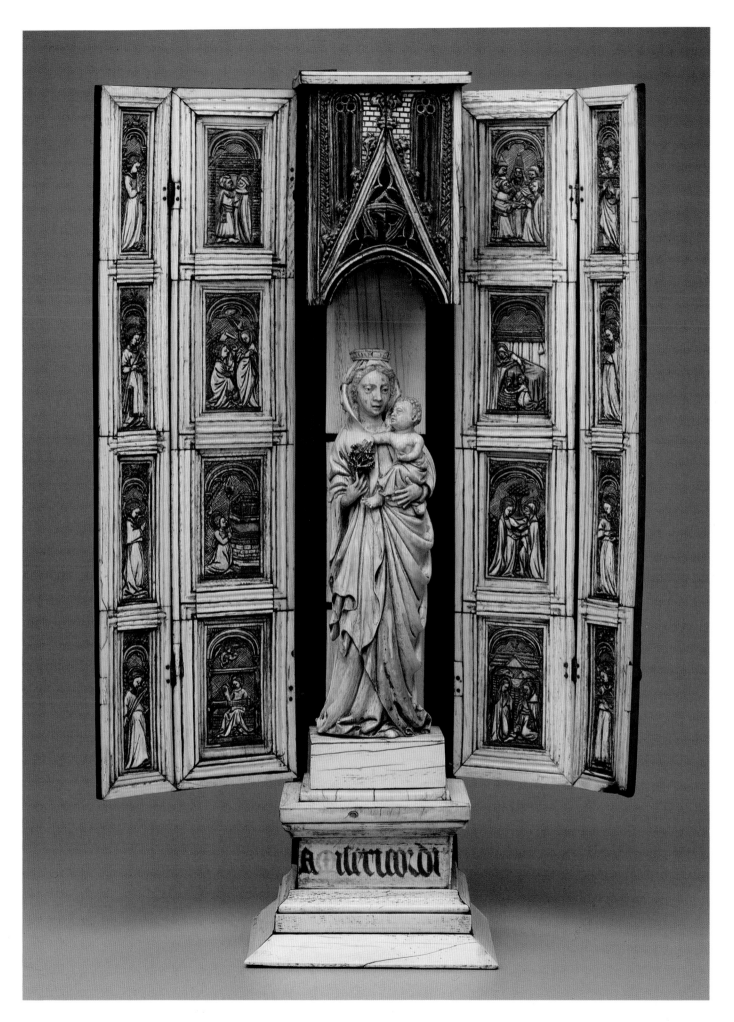

COLORPLATE 7 (cat. no. 35) *The Virgin and Child, ivory and bone polyptych, Flemish, 1430–1460, Detroit Institute of Arts, Founders Society purchase, height 19 in.*

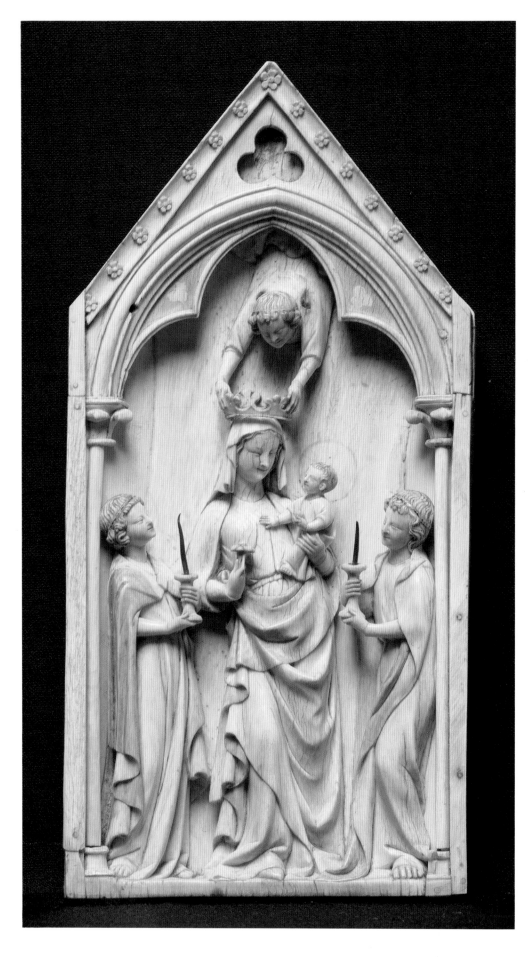

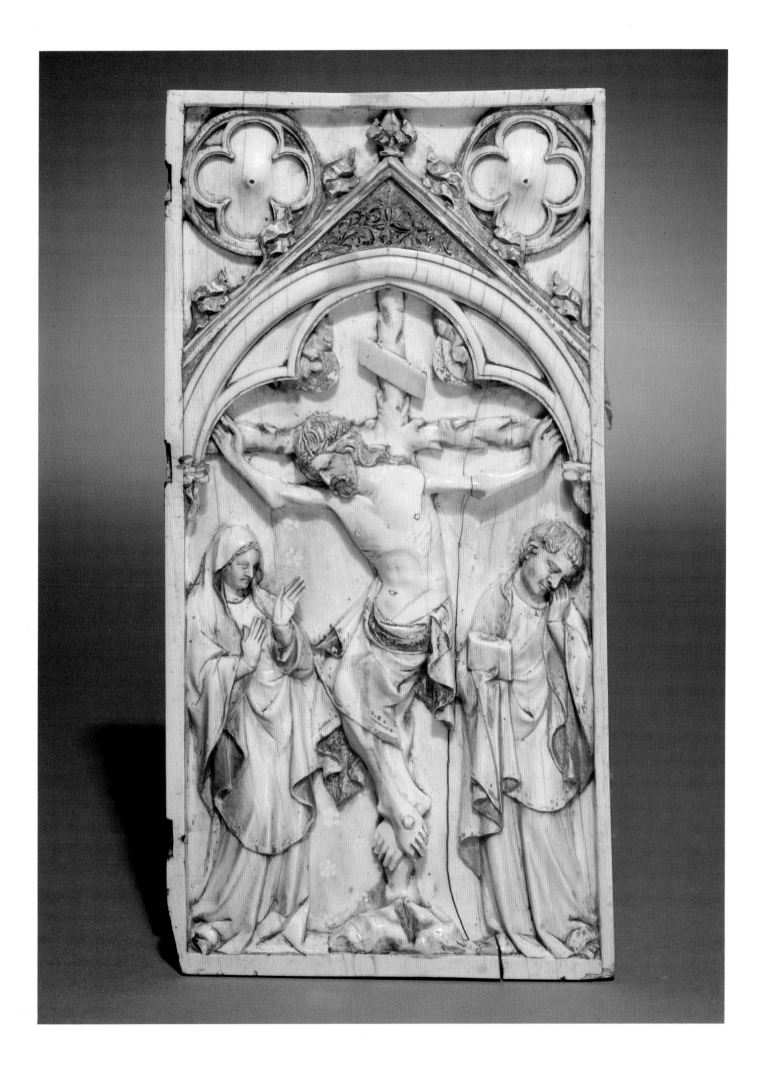

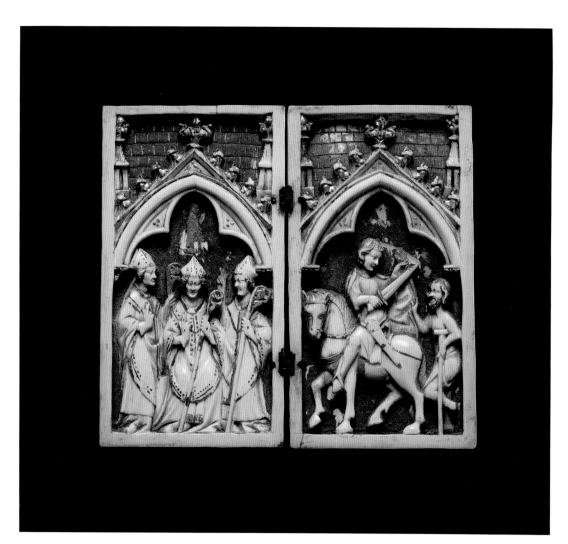

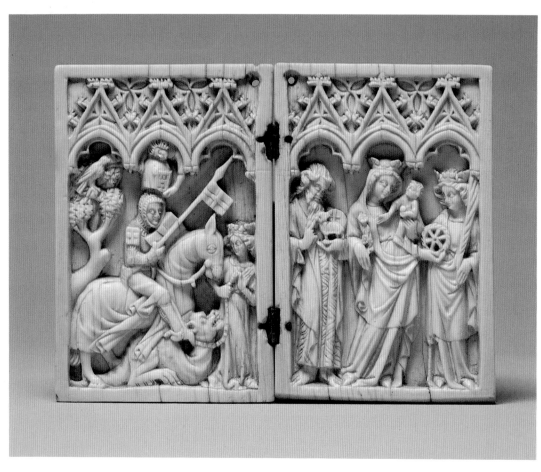

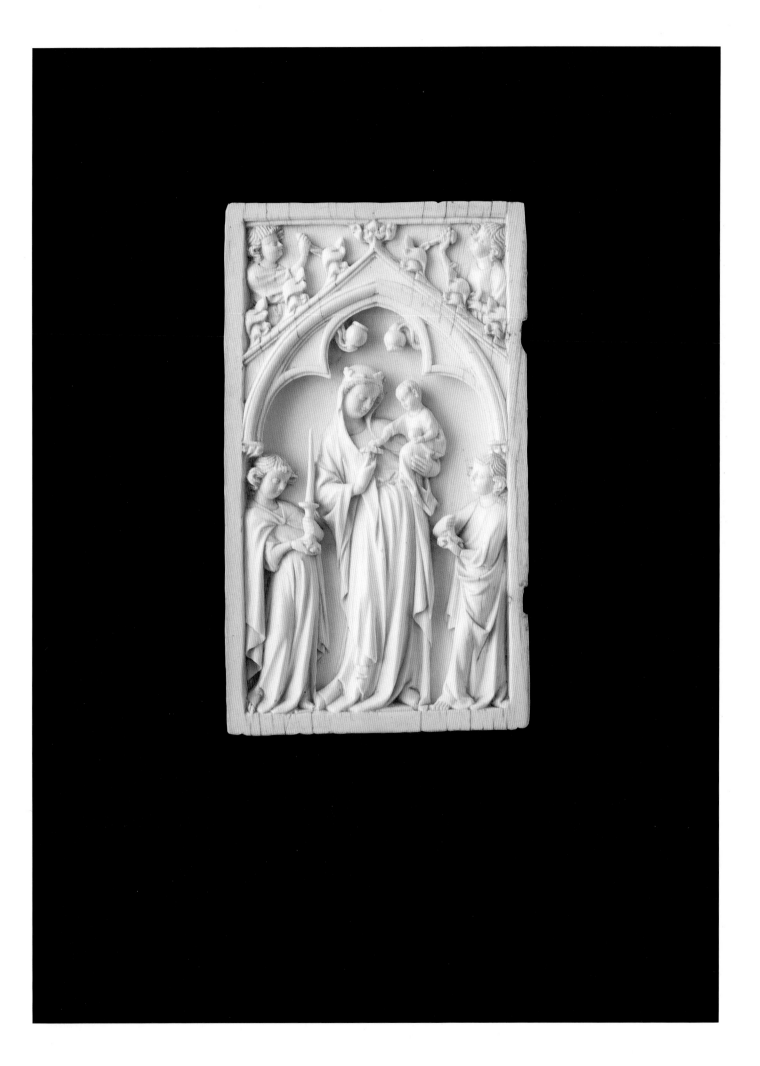

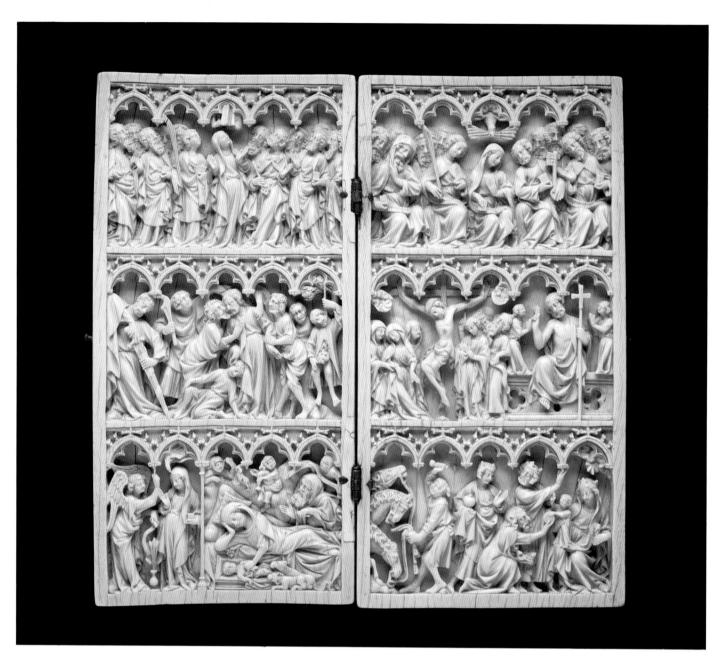

COLORPLATE 13 (cat. no. 147) *The Life and Passion of Christ, ivory diptych, French (Paris), 1375–1390, The Minneapolis Institute of Arts, gift of Mr. and Mrs. John E. Andrus III, Atherton and Winifred Bean, and The Centennial Fund, height 8³⁄₁₆ in.*

COLORPLATE 14 (cat. no. 160) *The Life of Saint Margaret of Antioch, lid of an ivory casket, Flemish, 1380–1410, Williams College Museum of Art, Williamstown, Massachusetts, gift of John Davis Hatch, Jr., length 4³⁄₁₆ in.*

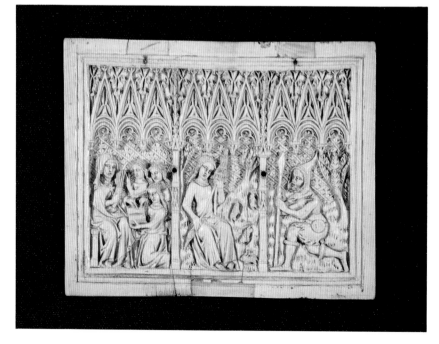

COLORPLATE 15 (cat. no. 167) *The Virgin and Child with Saints, ivory pax, Dutch (Utrecht), 1440–1470, Detroit Institute of Arts, gift of Mrs. Lillian Henkel Haass, height 4¾ in.*

COLORPLATE 16 (cat. no. 188) *Jousting, ivory mirror case, French (Paris), 1330–1350, Virginia Museum of Fine Arts, Adolph D. and Wilkins C. Williams Fund, diameter 4¾ in.*

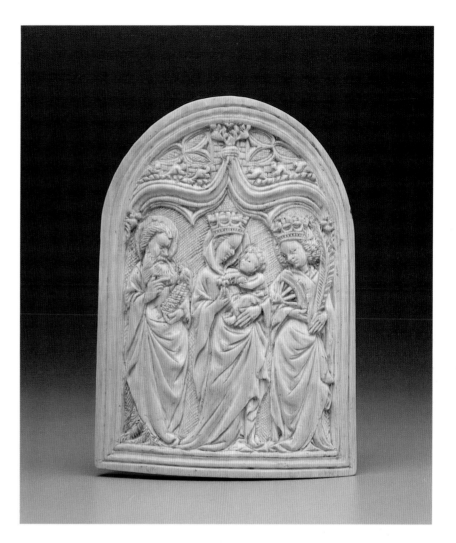

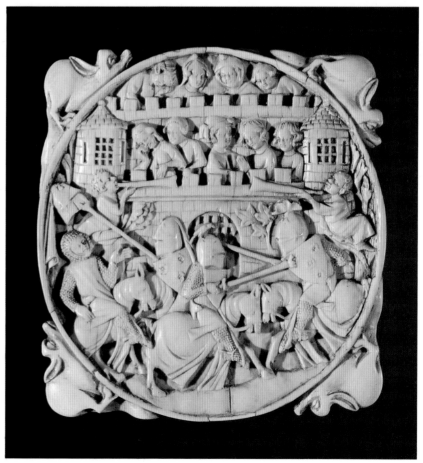

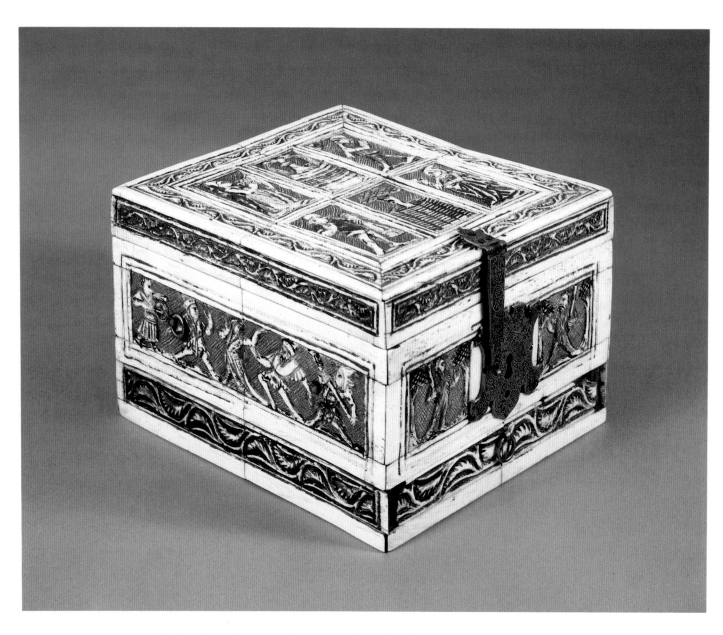

COLORPLATE 17 (cat. no. 195) *Secular Scenes, bone game box on a wood core, French (Alsace) or German (Black Forest), 1440–1470, The Art Museum, Princeton University, museum purchase, gift of the National Forge Foundation, length 6³⁄₁₆ in.*

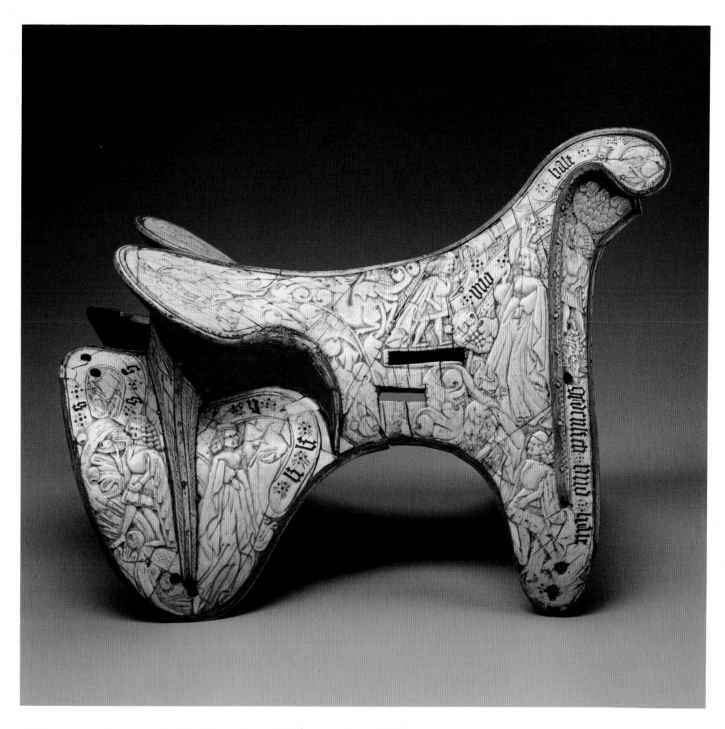

COLORPLATE 18 (cat. no. 199) *Secular Figures, bone saddle on a wood core, Tyrolean, second quarter of 15th century, Museum of Fine Arts, Boston, Centennial Acquisition Fund, height 16 in.*

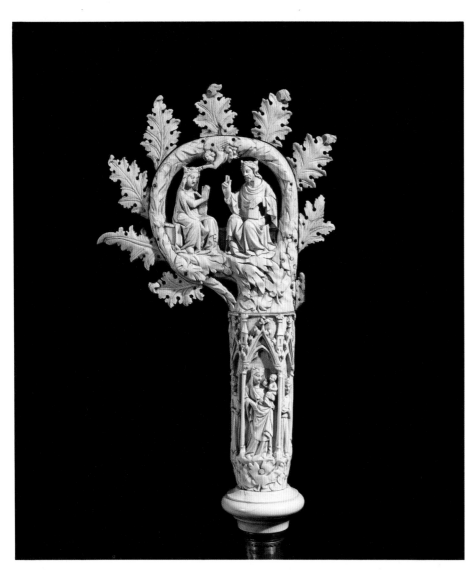

COLORPLATE 19 (cat. no. 204) *The Coronation of the Virgin, ivory crozier, Tuscan or Lombard (?), third quarter of 14th century, Private Collection, New York, height 12¼ in.*

COLORPLATE 20 (cat. no. 231) *The Story of Jason, bone, intarsia, and wood marriage casket, Venetian (Embriachi workshop), about 1390, The Minneapolis Institute of Arts, John R. Van Derlip Fund, length 14 in.*

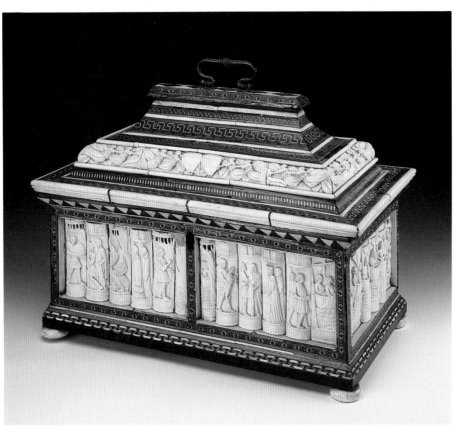

RELIGIOUS IVORIES

SCULPTURE

1

The Virgin and Child

Ivory statuette, North French, 1240–1250

The Virgin of this massive group sits in a frontal position with the Child sideways across her lap; he holds a bird in his left hand and makes a gesture of blessing with his right. The drapery is in simple, broad geometric planes and folds, varied in the overlapping upper V-fold in the skirt. Under an integral crown and headcloth the Virgin's hair is treated as a series of crisp curves. The Child's shift is simply handled, with three folds in the lap, and his large head is tightly covered with short curls. Both figures have wide, blank, staring eyes and a stylized smile. A series of delicate arches painted on the throne are now seen in silhouette on its left side.

The Virgin's right arm is broken off at the elbow, and the ornaments of her crown are lacking. The head of the bird is missing, and both of the Child's feet are damaged. There is an original hole for attachment in the back of a large hole for the nerve in the center of the base. Minor damage (gnawed?) has occurred to the Virgin's veil on the proper left.

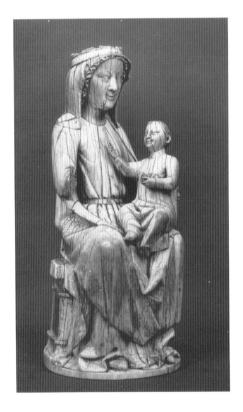

Notes: The piece has long been known and discussed, most thoroughly by William Monroe. It is closely related to sculpture of the late 1230s at Villeneuve-l'Archevêque and at Amiens Cathedral, where a geometric approach to drapery is evident in the archivolts (Monroe [Bib.], figs. 4–7). Other French ivory Virgin statues with similar broad, planar drapery include a standing figure of about the same date as the Chicago example and a seated one of perhaps a few years earlier (Randall, nos. 261 and 262). The Christ Child with the standing Virgin is close in posture and modeling to the Chicago Child, which suggests that the two may come from the same atelier.

H: 8⅞ in. (22.4 cm); W: 3¾ in. (9.6 cm); D: 3⁵⁄₁₆ in. (8.4 cm)

The Art Institute of Chicago (1971.786), Kate S. Buckingham Fund

History: Collections of Octave Homberg, Paris; anonymous owner, Paris; and E. and M. Kofler-Truniger, Lucerne. (Purchased from Leopold Blumka, New York, 1971.)

Bibliography: Koechlin, no. 11; Homberg sale, Petit, Paris, 4–5 June 1931, lot 128; Grodecki, p. 82, pl. 21; Schnitzler, Kofler cat. , no. S–31; Seidel, pp. 29, 50, fig. 31; W. H. Monroe, "An Early Gothic French Ivory of the Virgin and Child," *Museum Studies* 9 (Art Institute of Chicago, 1978), pp. 6–29.

See also colorplate 1.

2

The Virgin and Child

Ivory statuette, French (Paris), 1250–1270

The tall figure of the Virgin has a flattish face, framed in curls beneath an undulating veil and a metal crown. Her drapery, pulled tight across the right elbow, is caught by the left arm and falls in a fan of folds, ending in deep Vs on the right side. The Christ Child holds a globe in his left hand while blessing with his right. The Virgin holds a flower in her right hand.

The Child's head, right arm, and left arm from the wrist are restored, as are the Virgin's right arm and crown. There are a number of small breaks on the edges and

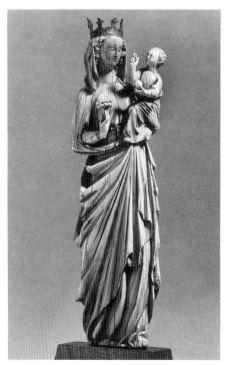

bottom of the Virgin's skirt. Of the four holes in the base, two are old. Traces of blue paint remain in the folds of the Virgin's skirt and under the Child.

Notes: The statuette is among a number that follow closely the trumeau of the north porch of Notre Dame in Paris, completed about 1240. One figure from the trumeau was used as a model by Giovanni Pisano in creating an ivory Madonna for Pisa Cathedral (for others see Seidel, fig. 7; and Randall, no. 264). The North Carolina work is related also to a marble Virgin and Child by Nicola Pisano on the pulpit in Siena Cathedral, even to the exaggerated length of the lower torso of the Virgin. (Seidel, figs. 25 and 26).

H: 11¾ in. (29.8 cm)

North Carolina Museum of Art, Raleigh (G.59.6.1), gift of Mrs. Edsel B. Ford in memory of W. R. Valentiner

History: Collections of Eugène Giraud, Paris (before 1886); Emile Baboin, Lyons; and Mr. and Mrs. Edsel Ford, Grosse Point, Mich. (Purchased from Raphael Stora, New York.)

Bibliography: Koechlin, Baboin cat., no. 23; Seidel, fig. 26 (shown without crown).

3

The Virgin and Child from the Abbey Church of Saint-Denis

Ivory statuette, French (Paris), 1260–1280

The Virgin stands with her weight on the right leg, smiling serenely at the Child she holds on her left arm and offering him a wide, flat flower. She wears a simple robe caught at the waist by a belt; on her breast is a jewel carved of ivory. Her mantle, with its cords on her chest, is carved in a series of descending folds over the right hip and in simple pleats from the left; the back is handled with one long fold to the ground. A long veil falling down her back is held in place with a silver crown. The Child, who reaches tentatively toward his mother, wears a simple shift that is agitated by the kick of his left foot. He has a head of short, curly hair.

The condition is almost without blemish. Once broken, the Child's right arm was repaired in the seventeenth century with the original piece. The flower in the Virgin's hand was originally covered with gold foil, and the carved jewel on her breast is a nineteenth-century substitution for the medieval jewel that ornamented the figure.

The hair is gilt, and the belt is decorated with a pattern in black and gilt, now somewhat rubbed. A silver crown replaces the gold and jeweled one of the thirteenth century.

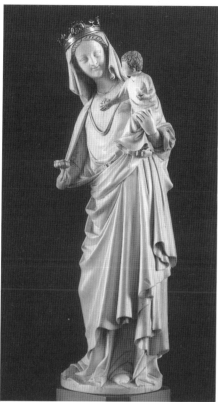

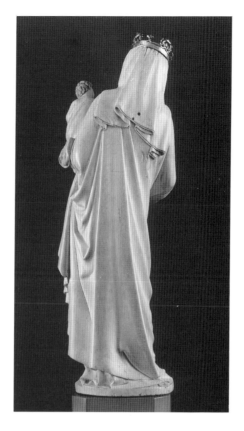

Notes: Although it passed through two important collections in the nineteenth century and was published by both Emile Molinier and Raymond Koechlin (see Bib.), the statue was not recognized between 1811, when it was sold as a confiscated treasure of the church, and 1973, when Blaise Montesquiou-Fezensac identified it as the lost Virgin from the royal Abbey of Saint-Denis. Engraved by Father Michel Félibien in 1706, the statue appears in numerous inventories of the abbey. The earliest (dated 1505) reveals that the Virgin was part of a group that included two standing angels and a small flying one. The small angel, which has disappeared, was undoubtedly crowning the Virgin statue, suggesting that the figures were placed on a base with some type of support, either a column or the background of a small shrine, to sustain the flying angel. The two surviving angels were separated from the Virgin after 1642, to be incorporated into a reliquary of Saint Placide and Saint Flavie. At the time of the Revolution, the piece was sent to Rouen Cathedral, where it was transformed into a reliquary for the local patron saint, Romain, and the lost wings of the angels were restored in ivory. (See Randall [Bib.] for a suggested reconstruction of the group, and Gaborit-Chopin, *Revue du Louvre* [Bib.], for a photograph showing the two Rouen angels with the Virgin statue.)

H: 13¹¹⁄₁₆ in. (34.8 cm)

The Taft Museum, Cincinnati (1931.319), bequest of Mr. and Mrs. Charles Phelps Taft

History: Presented to the royal Abbey Church of Saint-Denis in the thirteenth century, the ivory is first mentioned in an in-

ventory of 1505. The many succeeding inventories are quoted in full by Montesquiou-Fezensac (see Bib.). Sequestered at the time of the Revolution with the entire treasure of Saint-Denis, the statue was despoiled of its gold and jewels in 1802 and sold after 1811. It was shown at the *Exposition rétrospective* at the Trocadéro in Paris in 1889 as in the possession of Edouard Delacour and passed into the collection of Gaston Lebreton before being sold in 1921. The ivory was purchased by Mr. and Mrs. Charles Phelps Taft in 1924 from Duveen, New York.

Bibliography: Father Michel Félibien, *Histoire de l'abbaye royale de Saint-Denys en France* (Paris, 1706); *Exposition rétrospective de l'art français au Trocadéro* (Paris, 1889), no. 111; E. Molinier, *Histoire générale des arts appliqué à l'industrie* (Paris, 1896), vol. 1, p. 88; Lebreton sale, George Petit, Paris, 6 December 1921, lot 196; Koechlin, no, 97; B. Montesquiou-Fezensac, "Le reliquaire de St. Romain," *Les monuments historiques de France*, no. 2 (April–June 1956), pp. 137–141; Seidel, fig. 53; B. Montesquiou-Fezensac and D. Gaborit-Chopin, *Le Trésor de Saint-Denis* (Paris, 1973–1976), 3 vols.; Gaborit-Chopin, fig. 199; C. Little, "Ivoires et art gothique," *Revue de l'art* 46 (1979), p. 62, fig. 9; R. Randall, "The Ivory Virgin of St. Denis," *Apollo* 128 no. 322 (December 1988), pp. 394–398; D. Gaborit-Chopin, "La Vierge à l'Enfant et les anges d'ivoire du Trésor de Saint-Denis," *Revue du Louvre* 4 (1991), pp. 26–27.

See also colorplate 2.

4

The Virgin and Child

Ivory statuette, French (Seine Inférieure or Normandy), last quarter of 13th century

The Virgin, seated sideways, offers a flower to the Child, who stands in her lap and extends his hand with a globe. Swathed in deep, complex drapery, she wears a crown and a double-folded veil; a long pendant falls from her belt into her lap. The Virgin's face is large and flat with large eyes and a small mouth. Her left foot rests on a monster in the form of a dolphin

The crown is a restoration, as is the head of the Child and his right arm. There are many traces of pigmentation, including a Kufic inscription on the Virgin's collar, a gilt brooch on her breast, borders on her gown, and details on the dolphin. The left forearm of the Child is missing.

Notes: As illustrated in the Schevitch sale catalogue (see History), the crown of the Virgin and the head and hands of the Child are missing. There was more polychromy, and the brooch on the chest was completely painted at that time.

Both the large, bland face and the form of this figure relate it to other seated Virgins (see, for example, Randall, no. 267; and Dalton, no. 334). The face occurs in many examples from the Seine Inférieure and Normandy—for instance, a Virgin from Montaigu-les-Bois (Manche; see *Fastes du gothique*, no. 50).

H: 10 in. (25.4 cm); W: 4 in. (10.2 cm); D: 1½ in. (3.8 cm)

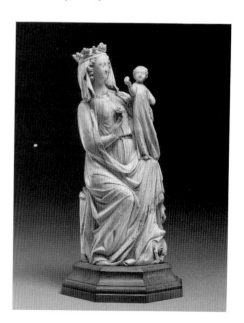

Detroit Institute of Arts (64.71), Founders Society purchase, General Membership Fund

History: Collections of M. D. Schevitch, Paris (until 1906); and Baron Robert Rothschild, Paris.

Bibliography: Schevitch sale, Georges Petit, Paris, 4–7 April 1906, lot 150; *BDIA* 61, no. 4 (1984), p. 42, fig. 13.

The Virgin and Child

Ivory statuette, French (Paris), last quarter of 13th century

The Virgin is seated frontally with her face lowered toward the Child, who sits on her left leg, feet in her lap, looking up at her. A veil with a wavy edge covers her head and reaches to the middle of her back. The drapery falls simply from the shoulders, turning into a series of square-edged folds in the lap. Cords of the Virgin's mantle are exposed on her chest, and at her neck is a necklace with a medallion. The Child holds an apple in his left hand and reaches for his mother's veil with his right.

There are traces of polychromy, including a floral pattern on the rear moldings of the throne, painted flowers on the Virgin's skirt, and gilding on the back of the veil. The statuette was carved from a block that was not rectangular but faceted, so that the throne had to be completed with additional ivory. The diagonal faces of the throne were crosshatched to hold glue for the corners, which are now missing. Moldings on the ends of the throne, similarly attached, are lacking as well.

Tiny cuts at each side of the veil in back were probably intended for a later halo. A tiny hole is drilled in the front just above the base, and there is a chip behind the right foot of the Virgin.

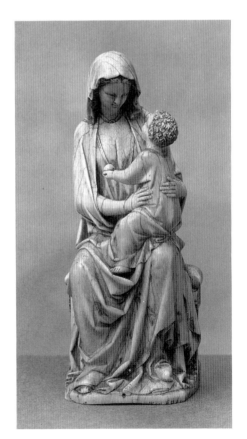

Notes: The finesse of the details, the tenderness of the pose, and the square-fold drapery suggest that this is a precocious work of the end of the thirteenth century. The drapery is a stage between the rectangular treatment of Amiens Cathedral and a seated Virgin (cat. no. 1) of 1240–1250 and the smoother, more curvilinear drapery of the early years of the fourteenth century.

A standing Virgin at the Church of Saint Michel in Courtrai (Brussels, A. C. L. negative 145912; unpublished) exhibits nearly identical treatment of details in veil, mantle cords, drapery folds, facial expressions, and relationship of the Virgin and the Child. The Courtrai statuette is related in turn to three others with square-fold drapery (Koechlin, nos. 73, 74, and 75)— all of them following a slightly variant model and with the Child touching the Virgin's chin.

The present work has nothing to do with the custodia with which it was bought (see History) but was probably placed in it by Duveen to fill the vacant space. An exact duplicate of this statuette (Molinier, Spitzer cat., vol. 1, p. 46, no. 55, pl. XVII) has a complete throne with carved arches on the ends. It is now at the Museum für Kunst und Gewerbe in Hamburg.

H: 7⅝ in. (18.5 cm); W: 3 in. (7.6 cm)

The Hispanic Society of America, New York (D 754)

History: Purchased in 1907 by Archer M. Huntington from Duveen Brothers in London as the central ornament of a custodia by Cristobal Becerril from the Church of San Juan in Alarcon (the custodia made for Gaspar de Quiroga, Bishop of Cuenca, in 1585).

Bibliography: B. I. Gilman, *Catalogue of Sculpture* (Hispanic Society of America, New York, 1932), p. 7; HSA *Handbook* (New York, 1938), p. 65.

6

The Virgin and Child

Ivory statuette, French or English (?), about 1300

The seated Virgin holds the Child lightly, while he reaches for the pectoral on her chest. Her drapery is boldly rendered with deep folds between the knees and a riffle of folds along each side. The Child, whose feet are notably large, wears a heavily folded shift.

The Virgin's head is missing, as is that of the Child and his left arm. There is a restoration of the Virgin's right arm between elbow and wrist, and the left foot is broken off. That the heads were at one time restored is indicated by an ivory pin in the neck of the Virgin and a hole for insertion of a new head on the Child.

Notes: The power and originality of the conception are noteworthy. While the mantle cords of the Virgin's robe make the strong-

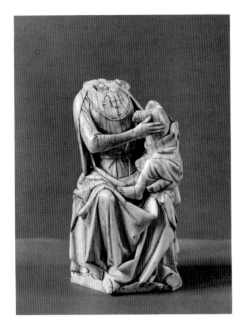

est argument for dating the work to about 1300, allowance might be made, on sculptural grounds, for its being later. The statuette can be compared with another Virgin (*Age of Chivalry*, p. 112, fig. 77), also lacking its head, which is attributed to England.

H: 6³⁄₁₆ in. (15.7 cm)

The Art Museum, Princeton University (47-320), Caroline G. Mather Fund

History: Purchased from Leopold Blumka, New York, 1947.

Bibliography: E. T. DeWald, "An Ivory Madonna and Child," *Record of the Art Museum*, Princeton University, 8, no. 2 (1949), pp. 4–5; *Carver's Art*, no. 75.

7

The Virgin and Child

Ivory statuette, French (Paris), first quarter of 14th century

The seated Virgin looks straight ahead, while the Child looks up at her, reaching for the morse on her gown. An object she held in her right hand is now missing. Her drapery is complex, the ends carefully handled with recurved folds and turnovers, and she wears a veil of double cloth held by a crown with foliate decorations. At four points on the crown are leaves, trees, and branches of oak. The Virgin crushes with both feet a serpent with human head, claws, and a long tail.

Under the figures is a throne, decorated on the back with ten trefoil arches, which have been regilded. The head of the Child and the right hand of the Virgin are restorations, as is the Child's left hand, carefully inset. The end of the Virgin's right foot is missing. Inside the base (octagonal, with unequal segments) is an iron pin, seven-eighths of an inch long, possibly original.

There are no traces of paint except the re-gilding. The statuette is a stark white, probably from a thorough cleaning in the nineteenth century.

Notes: Among the few other Virgin statues that tread on a serpent are one of 1220–1240 (*Age of Chivalry*, no. 248) and an

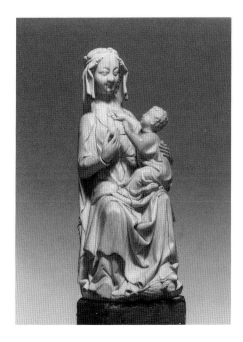

Amiens-style Virgin of the second quarter of the thirteenth century (Koechlin, no. 12). In the present work the serpent is emphasized and has a Rheimsian angelic face. The small details of the refolding of the pleats and the treatment of the crown are exceptional.

H: 6⅞ in. (17.5 cm)

Private collection

History: Collection of Lord Astor of Hever Castle, Kent, England.

Bibliography: Hever Castle sale, Sotheby's, London, 6 May 1983, lot 237.

8

The Virgin and Child

Ivory statuette fragment, French (probably Paris), 1320–1340

The standing Virgin holds the Child in her right arm and extends her left with an object—a flower or bird—for which he is reaching. Her drapery is arranged in folds across the entire figure with pendant reversed folds at the sides.

The statuette, which has been cut off below the Virgin's knees, has two holes drilled in her chest. Both heads, the left hand of the Virgin, and the Christ Child's hands are lacking; the Child's right hand was originally inserted. Uncarved on its flat back side, which was not meant to be seen, the figure was probably for use in a shrine.

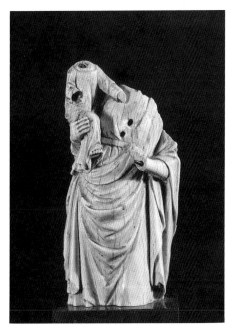

Notes: The drapery is typical of a group of Ile-de-France statues in stone and ivory. Rarely seen, however, is the placement of the Child on the right arm (see Koechlin, nos. 633 and 657, for this arrangement and for the more usual type).

H: 5¾ in. (14.7 cm)

Fogg Art Museum, Harvard University, Cambridge (1959.137), gift of Stuart Cary Welch, Jr., in memory of his father, Stuart Cary Welch, A.B. '17, M. Arch. '22

9

A Virgin of a Pietà

Ivory statuette, German (Rhineland or Franconia), 1320–1340

The Virgin is seated in a contemplative pose, looking downward, her arms extended before her. She wears a veil on her head and a mantle that falls in a series of folds across her chest; the double-layered skirt has one deep fold between the knees. The eyes are both drilled and inlaid. The throne is unornamented.

Both arms have been severed, and the right one was drilled for reattachment of the missing part. The entire head was broken off at one time and repaired; the nose remains disfigured. The right knee has been recarved, apparently a long time ago, to remove traces of the corpus of Christ, which rested there. Several holes are drilled in the statue—three in the back of the head for a halo, one in the top of the head, one in the center of the base, and a large opening in the back for attachment. Traces of red-brown stain are visible on the back, and the entire surface has been solidified with a coat of thin varnish. The surface is cracked and checked, and there are a number of chips, including a large break at the right foot.

Notes: While the ivory has been attributed to England, it is undoubtedly German, relating closely to a group of wood and leather sculptures from the Rhine Valley

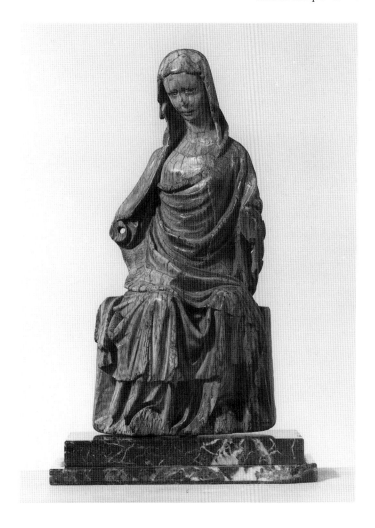

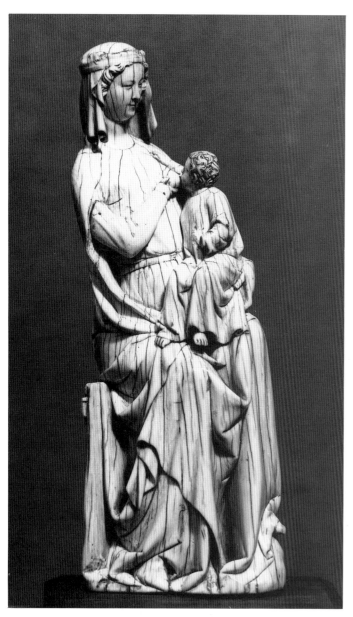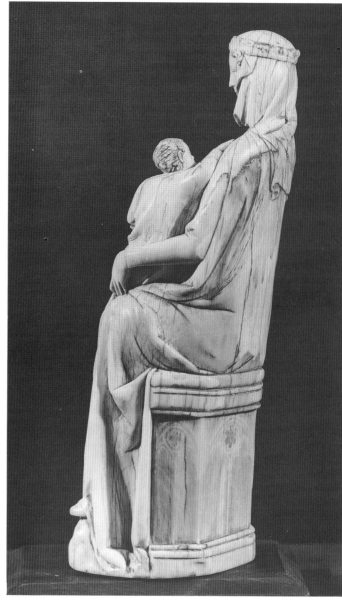

and other areas (described by W. Krönig in "Rheinische Vesperbilder aus Leder und ihr Umkreis," *Wallraf-Richartz Jahrbuch* 24 [1962], pp. 97–192). The drapery of the skirt is paralleled by a wood Pietà from Coburg (Krönig, fig. 44), and the treatment of the folds over the chest is seen in an example from Erfurt (Krönig, fig. 46), both of which are Franconian. It is apparent that the corpus of the Coburg piece rested on one leg and was held by the two hands.

Numerous features, including the downward glance of the Virgin, make it doubtful that the statuette represented a Virgin and Child, as some scholars have believed (see *Court Style* and Wixom 1987).

H: 7¼ in. (18.6 cm); W: 3½ in. (8.9 cm)

Yale University Art Gallery, New Haven (1956.17.5)

History: Purchased from Mathias Komor, New York, 1956.

Bibliography: Art of the Courts, no. 69, pl. 94; *Court Style*, no. 21; W. Wixom, 1987, no. 2 A,B,C.

10

The Virgin and Child

Ivory statuette, French (Paris), second quarter of 14th century

The Virgin sits in a sideways posture offering her breast to the Child, who sits in her lap and is lightly held with her left hand. Below an undulating headcloth, retained with an integral crown, the drapery falls simply from the shoulders and develops into a complex series of V-folds at both sides and in the lap. The Virgin's left foot is raised on a boulder.

Areas of polished bark on the back of the figure indicate that the statue is made from an outside cut of ivory. The throne is unevenly faceted, each face retaining a silhouette of painted or gilded double arches, the smaller ones at the sides with a quatrefoil at the top and the wider central one with a hexafoil. There are traces of gilded borders of leaves and scrolls on the Virgin's robe. Her right arm is restored from the upper arm to the wrist, and the

Child's left hand is missing. A later hole is drilled in the top of the Virgin's head, and a large oval hole in the base (probably not original) has been plugged.

Notes: The Virgin seated sideways, popular in several sizes—and of varying levels of quality—in the second quarter of the fourteenth century, is characteristically Parisian. Most of the figures, while carved in the round, are of flattened section, and a few, like a great group from Villeneuve-les-Avignon (Koechlin, no. 103), are fully three-dimensional. The Yale Virgin is related to the finest and largest specimens (for example, Randall, "Monumental Ivory," figs. 1, 7, and 8; and Williamson, no. 22), but the present figure is the only one of the group shown suckling the Child. There are a number of other statues of the suckling Virgin in the round datable to the second quarter of the fourteenth century (Koechlin, nos. 635, 637, and 638) and one

(*L'Europe gothique*, no. 354) that is possibly from the late thirteenth century. (Cat. no. 18 shows a continuation of the tradition.)
H: 10⅛ in. (25.9 cm)
Yale University Art Gallery, New Haven (1949.100), Maitland F. Griggs Fund
History: Collections of D. Ricardo Blanco, Santiago de Compostela, Spain; and Spanish Art Gallery, London. (Purchased at the Joseph Brummer sale, New York, 1949.)
Bibliography: Brummer sale, Parke-Bernet, New York, 14 May 1949, lot 696.

11

The Virgin and Child

Ivory statuette, French (Paris), second quarter of 14th century

The Virgin is seated sideways, looking to the right but turned slightly toward the viewer. The Child stands in her lap and looks at something in her right hand while he fondles the globe in her left hand. Carved with a deep fold between the knees, the Virgin's drapery is finely treated

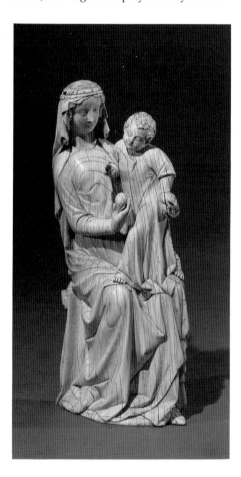

with a progression of folds on her right side. Her headcloth falls in recurved folds. The eyes are strongly emphasized in both figures, and the Child has thick, curly hair.

There are traces of red paint in various folds of the Virgin's dress. The crown of her head is restored, as is her right arm below the elbow. The Child's right arm is

restored, and there is an old break and repair in his neck. A repair on the base includes a restoration of the Virgin's left foot.
Notes: The statue had a crown when in the Spitzer and Nodet collections (see History). Christ's gesture of stroking the globe in the Virgin's hand—a rare motif—is seen in slightly different form in a Virgin of the Sainte-Chapelle (Koechlin, no. 95). The unusual fold at the neck of the Child's shift is found also in the Sainte-Chapelle statue and in a triptych at the Hôtel Pincé, in Angers (Koechlin, no. 117).
H: 8⅜ in. (21.4 cm); W: 3¾ in. (9.6 cm)
The Toledo Museum of Art (49.38), gift of Edward Drummond Libbey
History: Collections of Frédéric Spitzer, Paris (until 1893); Charles Nodet, Paris (until 1908); and Jules Porges, Paris (until 1924). (Purchased at the Joseph Brummer sale [New York, 1949] by Raphael Stora.)
Bibliography: Molinier, Spitzer cat., vol. 1, no. 44; *Catalogue des objets d'art et de haute curiosité: Antiques du moyen-age et de la renaissance de la collection Spitzer*, sale, Chevallier et Mannheim, Paris, 17 April 1893, lot 79; *Exhibition rétrospectif* (Paris, 1900), no. 64; Nodet sale, Hôtel des Commissaires, Marseilles, 10 March 1908; Porges sale, Georges Petit, Paris, 17–18 June 1924, lot 150; Brummer sale, Parke-Bernet, New York, 20–23 April 1949, lot 657.

12

Saint Anne with the Virgin and Child

Ivory statuette, French, second quarter of 14th century

Holding the Virgin nursing the Christ Child, in her lap, Saint Anne wears a wimple and cape over a belted robe. The nursing Virgin has a simple gown, and the Child wears a shift. The throne is plain with moldings at top and bottom.

Saint Anne lacks her right forearm and hand, and the Virgin is missing her head, both of which were restored at one time. Remains of Mary's flowing hair can be seen on her back. There is minor damage to the Virgin's right knee, and the end of Saint Anne's right foot is broken off.
Notes: The subject of Saint Anne and the Virgin is rare in ivory although common in other media of the mid-fourteenth century. One ivory example (Koechlin, no. 710) has a costume like that of the present statue, and the use of the wimple for Saint Anne can be observed, for instance, in a painting of Saint Anne teaching the Virgin of about 1335 (*Age of Chivalry*, p. 448, fig. 132).
H: 4½ in. (11.4 cm); W: 2¹⁄₁₆ in. (5.3 cm)
Private collection
History: Purchased from Mathias Komor, New York, 1961.
Bibliography: *Private Collections*, no. 81.

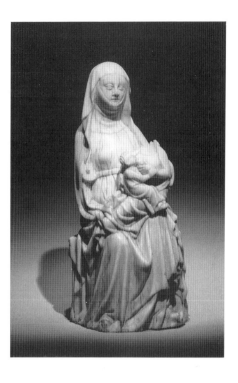

13

The Virgin and Child

Ivory statuette, French (Lorraine?), second quarter of 14th century

The Virgin is seated with her body slightly twisted, as she holds the Child, who is half-kneeling in her lap. She wears a veil without a crown, and her heavy drapery falls in a deep fold between her legs.

Both the Child's head and the Virgin's right forearm and hand have been broken off. There are several age cracks, including

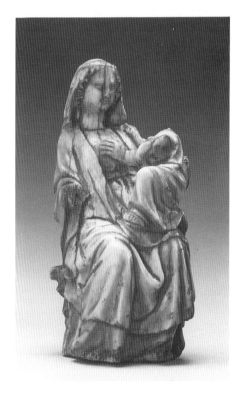

one through the face of the Virgin. The base is uneven, and the Virgin's left foot (previously restored) is missing. Traces of blue paint are visible on the Virgin's skirt.

Notes: Characteristic of a number of other small Virgin-and-Child statues (for example, cat. no. 14), the heavy proportions suggest the work of Lorraine rather than Ile-de-France.

H: 3⅞ in. (9.8 cm); W: 2 in. (5.1 cm)

Detroit Institute of Arts (70.397), bequest of Robert H. Tannahill

14
The Virgin and Child

Ivory statuette, French (Lorraine?), second quarter of 14th century

The seated Virgin suckles the Child, who sits in her lap. Her drapery is well conceived, with a variety of folds on her right side and a deep fold descending from her knees. She wears a crown, which is carved integrally with her veil.

The ivory has been gnawed by a rodent in several places on the back, and the tip of the left foot is entirely missing.

Notes: This is a rather refined member of the small Virgin-and-Child statuettes (see

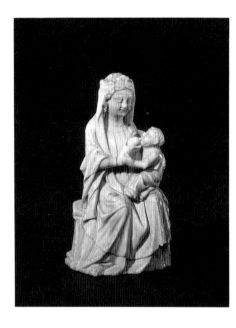

cat. no. 13). A second work by the same sculptor (J. J. Klejman sale, Sotheby's, New York, 1 November 1974, lot 17) is slightly taller and thinner in proportion while actually smaller in size (3⅛ inches high).

H: 3¹³⁄₁₆ in. (9.5 cm); W: 2¹⁄₁₆ in. (5.1 cm)

Museum of Fine Arts, Boston (64. 1588), gift of Mrs. Albert Hale

History: Collection of Mrs. Albert Hale, Dedham, Mass. (Purchased from Mathias Komor, New York.)

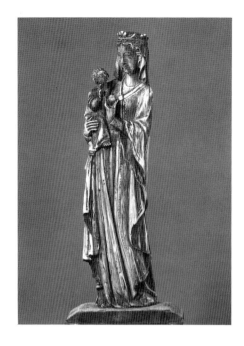

15
The Virgin and Child

Ivory statuette, French, second quarter of 14th century

Carved from a flat billet of ivory, the statue is unfinished on the back and was undoubtedly intended to be the centerpiece of a shrine. The Virgin is tall and has a contained silhouette, with simple falling drapery enlivened by broad turnovers at each side. She holds the Child in her right arm and offers him an apple. Her crown is integral.

There are remains of dotted borders on the Virgin's robe, which now appear in reverse impression on the much-darkened ivory. The hole in the base is probably original.

Notes: No other shrine Virgin and Child with simple drapery and a contained silhouette is known in ivory, although there are two comparable standing Virgins in the round, dating to the second quarter of the century (Koechlin, nos. 624 and 626). The concept occurs in wood sculpture—for instance, a polychromed statuette in the Oratoire at Gy (Haute Saône).

H: 8¹¹⁄₁₆ in. (22 cm)

The Art Museum, Princeton University (63-37), gift of Alexander P. Morgan, class of 1922, and nieces and nephew (Sarah Gardner Tiers, Mary Josephine Fenton, and Alfred Gardner, class of 1952)

Bibliography: Record of the Art Museum, Princeton University, 23, no. 2 (1964), p. 45; *Carver's Art,* no. 76.

16
The Virgin and Child

Ivory statuette, Mosan, second quarter of 14th century

The stocky standing Virgin holds the Child with her left hand. Under her veil is a frame of hair around a large, oval face in which the eyes are emphasized by protuberant lower lids. Her robe and cape fall simply from the shoulders, the edge of the cape caught up under her right arm. Christ has a turned-up nose and a head of curly hair.

The Virgin wears a silver crown of the Baroque period. Her right forearm and hand are lacking, and the statue has been gnawed by a rodent in the center of the base. The Child's left hand and two fingers of the right are missing, as is part of the first finger of the Virgin's left hand.

Notes: The general attitude and the simple drapery are seen in an ivory Virgin at the Musée Diocésain in Liège (J. de Borchgrave d'Altena, *Sculptures conservées aux pays mosan* [Verviers, 1926], fig. 37). The Child's position and head are paralleled in a stone Virgin and Child of Notre-Dame in Huy (Devigne, fig. 48). A seventeenth-century crown, typical of the Meuse Valley, has been added to the Liège ivory as well as to life-size Virgins at Hamont; Notre-Dame, Maastricht; and Saint-Saveur, Maastricht (Devigne, figs. 36, 51, and 52).

The habit of holding the folds of the robe under the arms was fashionable in the second quarter of the fourteenth century, as seen in the stone tomb of a lady at Paulerspury, Northamptonshire, and a Virgin Annunciate in stone at Stamford, Lincolnshire (*Age of Chivalry,* nos. 224 and 506).

H: 7⅝ in. (19.5 cm); W: 2¾ in. (7.1 cm)

The Fine Arts Museums of San Francisco (45.33.3), gift of Mrs. Herbert Fleischhacker

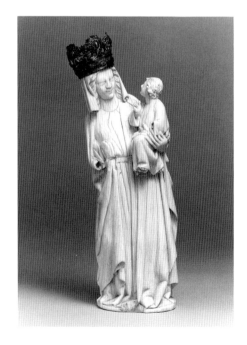

17

Saint John the Evangelist

*Ivory statuette, Moravian (?), second
quarter of 14th century*

The figure follows closely the rectangular
shape of the block. John's hair is tightly
curled at the edges, and his slit eyes are
both drilled and painted. He holds a book
in his right hand and rests his left on his
chest. The drapery folds are sharp and
angular in character.

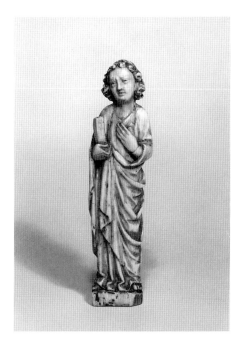

There is much remaining polychromy:
gold in the hair, blue and gold on the gar-
ments, and black in the pupils of the eyes.
The squared base has a black border and a
vertical hole inside for a pin. The statue is
unfinished on the back, which is cross-
hatched to receive glue for attachment.
Notes: The cross-hatching on the back indi-
cates that the figure must have formed
part of a Crucifixion within a shrine (see
Koechlin, no. 176, which is German; com-
pare nos. 740 and 746 for French and
English [?] examples of the type). The co-
lumnar stance of Saint John and the rigid
drapery folds can be seen on a group of
Moravian wood sculptures from the region
of Brno (*L'Europe gothique*, nos. 153 and
154).
H: 6³⁄₁₆ in. (15.7 cm); W: 1¼ in. (3.3 cm)
The Cleveland Museum of Art (30.660),
gift of M. and R. Stora
Bibliography: BCMA 50 (September 1963),
no. 26, p. 204.

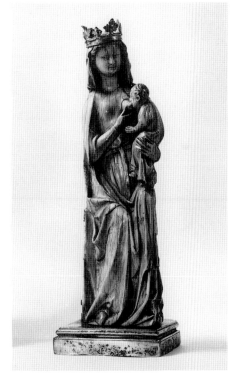

18

The Virgin and Child

Ivory statuette, French, 1340–1360

The carver of this statue made no attempt
to break the outline of the tall, rectangular
block with which he was working. Seated
sideways, the Virgin offers her breast to
the Christ Child, held in her left arm. The
drapery falls in deep, dryly rendered V-
folds, and Mary's hair is carved in flattish
curls.

The back of the statue, although flat, is
finished. Modern additions include the gilt-
copper surround for the throne, the crown,
and the base. The Virgin's left foot has
been broken off, and there are several
chips in the base.

Notes: The dryness of the carving and the
lack of plasticity suggest a date later than
that of the figure's large group of Paris pre-
cedents (such as cat. no. 10). That the
figure was displayed in a shrine is
confirmed by the lack of a fully carved
throne and by the hole for attachment.
H: 11 in. (28.1 cm); W: 3¾ in. (9.6 cm)
Royal Ontario Museum, Toronto (953.170)
History: Collection of Emile Baboin, Lyons.
(Purchased from Raphael Stora, New York,
1953.)
Bibliography: Koechlin, Baboin cat., no. 25.

19

The Virgin and Child

*Whale-tooth-ivory statuette, Scandinavian,
mid-14th century*

The Virgin sits in a frontal position with
the Child nursing in her lap, his legs
stretched straight across her knees. She
wears a crown over her veil and has wavy
hair framing a serious, round face with
staring, drilled eyes. Her square-necked,
belted gown descends in pleated folds in
front and a rich series of overlaps at each
side. On the Virgin's right side is a scarf
falling from her arm. The Child has sinu-
ous, thin arms and a mop of curly hair.
The two are seated on a throne with five
turned ball finials across the back.

Carved in a rectilinear format, follow-
ing closely the shape of the block, the
ivory shows variations at the lower corners
of the back. There is wear, particularly
on the Virgin's head and crown, from
handling.
Notes: The statue is closely related to three
chessmen long preserved in London
(Victoria and Albert Museum; Longhurst,
vol. 2, no. 213–1867, plate LI) and Berlin

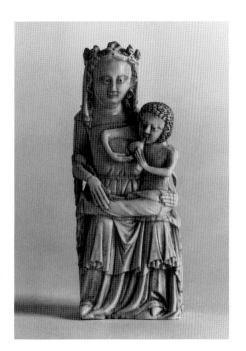

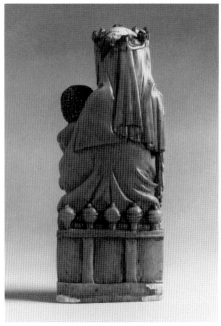

(Volbach, figs. 666 and 667). The latter two, one destroyed and the other damaged in World War II, were in the Kunstkammer in 1828; that in the Victoria and Albert was accessioned in 1867. All have the same treatment of the face and drilled eyes, and while called German, all are made of walrus ivory and are probably Scandinavian.

There is ample reason to believe that the Gardner Museum Virgin was the product of a chess atelier, both for its correspondence to the figures mentioned and for the special emphasis given the throne and back view—a feature common to chessmen. Their conservative style is demonstrated by numerous Scandinavian Gothic pieces (see Randall, no. 259). Another Virgin and Child that seems to have been the product of a chess-carving atelier (Philippovitch, p. 117, fig. 87) was excavated in Iceland. Carved in walrus ivory and measuring ten centimeters in height, it is also of the fourteenth century.

The throne is typical of Scandinavian furniture (from the Romanesque period onward) in which the turned members have ball finials. Examples include a thirteenth-century chair from Baldishoel (A. Feulner, *Kunstgeschichte des Möbels* [Frankfurt, 1980], fig. 38b) and a desk, bench, and chair of about 1200 from Vallstena Church in Gotland (H. Hayward, *World Furniture* [London, 1971], fig. 43).

A slightly earlier wood Virgin and Child from West-Skrukeby Church in East Gotland is comparable with the present statue in two aspects: the face type and the Christ Child with his legs crossing the Virgin's lap (M. Blindheim, "Scandinavian Art and Its Relation to European Art around 1200," in *The Year 1200: A Symposium* [New York, 1970], fig. 39, p. 465). The posture of the Child has another close parallel in a twelfth-century Romanesque capital in Chur Cathedral (K. Escher, *Die Münster von Schaffhausen, Chur, und St. Gallen* [Frauenfeld, 1932], p. 43).

H: 3¼ in. (8.4 cm)

Isabella Stewart Gardner Museum, Boston (S27 W28)

History: Collection of Emile Peyre, Paris. (Purchased 15 December 1897 by Isabella Stewart Gardner.)

20

The Virgin and Child

Ivory statuette, Mosan, third quarter of 14th century

The Virgin stands holding the Christ Child on her right arm and a fold of drapery in her left hand. Sweeping down from the scarf on the back of the head and across the body, the drapery descends in vertical folds from the right hip. There are multiple changes of direction in the several layers

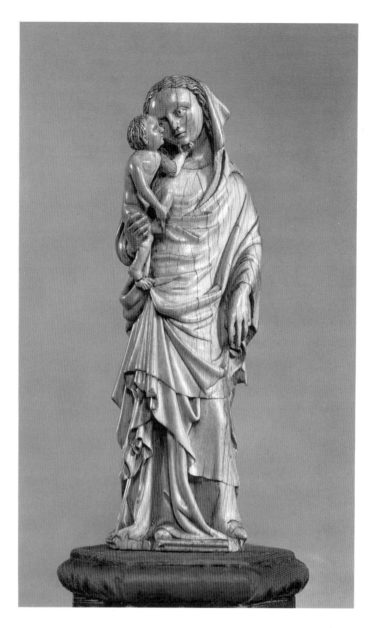

of the garments. The Christ Child touches the Virgin's chin with his left hand, while holding his own left leg with his right. The hair of both figures is rendered as flattened curls.

The figure of the Child, deeply undercut, was broken off at some time and has been reattached with a new section in the left arm and a fill in the Virgin's right wrist. Christ is missing three fingers of the right hand, and his mother lacks the little finger of her left. Folds of drapery are broken at the base and at knee level on the proper left back. The base is finished with a double molding.

Notes: While long attributed to North France, the Virgin shares many features with a group of marble sculptures from the Meuse Valley that have related patterns of complex drapery and details varying from French prototypes (see W. Forsyth, "A Group of Fourteenth-Century Mosan Sculptures," *JMMA* 1 [1968], pp. 41–59, figs. 1, 17, and 20). In all the statues drapery is composed of several overlapping garments, with a horizontal emphasis on folds

above the waist and vertical folds descending through several layers below. A Virgin from Diest (see W. Forsyth, fig. 1), the earliest of the series, can be dated 1345 by documents. Another ivory related to the group (Randall, no. 281) has drilled eye pupils like the Chicago figures.

Also comparable is a wood Virgin from La Gleize (*Art mosan et arts anciens au pays de Liège*, pl. LX) and a silver statue of Saint Blaise from Namur (Devigne, fig. 47).

H: 6⁹⁄₁₆ in. (16.7 cm)

The Art Institute of Chicago (1943.62), Kate S. Buckingham Fund

History: Collection of Mayer-Fuld, New York (until 1943).

Bibliography: Mayer-Fuld sale, New York, 1943; M. Rogers and O. Goetz, *Handbook to the Lucy Maud Buckingham Medieval Collection* (Art Institute of Chicago, 1945), no. 49, pl. 22; *Waning Middle Ages*, no. 83, pl. 8.

21

The Virgin and Child

Ivory statuette, French (?), third quarter of 14th century

The standing Virgin supports with her left hand the Christ Child who holds a globe in his left hand and reaches with his right toward a bird that was once in his mother's right hand. The low crown of the Virgin is integral with her veil, and her overmantle falls from the right shoulder in descending folds to a level below her knees. Her robe gathers on the ground, and the toes do not protrude. The Virgin's hair is treated with S-shaped curls around the face, and the Child has large ears and curly hair. The eye sockets are rendered with bulges below the eyes.

Half of the bird is missing, as is the Virgin's right hand and that of the Child. Several of the ornaments of the crown are broken, and there is chipping of the drapery at the base.

Notes: The drapery and the tall, lean figure of the Virgin suggest a date in the third quarter of the century.

H: 9⅛ in. (23.4 cm)

Indianapolis Museum of Art (57.97), gift of Mrs. Booth Tarkington, in memory of Booth Tarkington

History: Collections of Graf Wilzek, Burg Kreutzenstein; and Booth Tarkington, Indianapolis. (Purchased through Silberman Galleries, New York, 1934.)

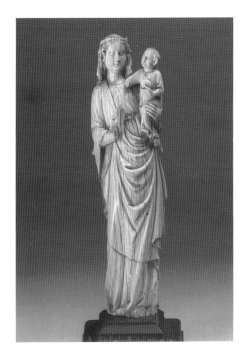

22

The Virgin and Child

Ivory statuette, Lower Rhenish (?), third quarter of 14th century

The statuette is carved from a triangular block of ivory, the throne being the width of the back of the block. The frontal Virgin holds the Child with both hands, as he stands in her lap facing her and grasping her cape on both sides. Falling in a deep fold from Mary's lap, the drapery is arranged in a series of folds below the edges of the throne on each side. Her head was carved for a crown of metal, and her hair is rendered in undulating curls. The face is bland, with a small mouth and deep pouches beneath the eyes.

Christ's head and his mother's crown are missing. There is some minor damage to the Virgin's skirt on the proper right side, and a small pattern of dots indents her forehead.

Notes: The placement of the Child looking into the Virgin's face is rare. His posture corresponds to a composition used for a nursing infant in another Virgin-and-Child statue (Koechlin, no. 635), where the two figures' hands are identically placed. The latter work, while probably French, reveals a similar approach to the rendering of eyes, hair, and drapery.

Comparable with this ivory are two small Virgin-and-Child statues also carved from a triangular block. One (Brussels, A. C. L. negative A12419), somewhat different in detail, repeats features such as the sharp, pointed face, the head carved for the crown, and the drapery folds falling on the sides from the throne. The other (Schnütgen Museum, Cologne; inv. B-113) shows the Virgin with a broad face, offering her breast to the Child sitting in her lap. (The piece was transferred recently from the Cologne Kunstgewerbe Museum.)

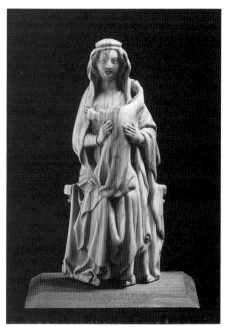

The concept of carving a three-dimensional group from a triangular block has not been noted elsewhere. Although the three works are certainly not by the same carver, it is possible that they are from the same locale.

H: 4³⁄₁₆ in. (10.4 cm); W: 1¹³⁄₁₆ in. (4.4 cm); D: 1¼ in. (3 cm)

Museum of Fine Arts, Boston (49.468), William Francis Warden Fund

History: Collection of Joseph Brummer, New York (until 1949).

Bibliography: Brummer sale, Parke-Bernet, New York, 23 April 1949, lot 648.

23

The Virgin and Child

Ivory statuette, Middle Rhenish, 1365–1380

The tall and slim figure of the Virgin is carved from a relatively thin billet of ivory. Her crowned head is small in relation to her body. The drapery falls in sweeping folds across the figure, and there is an elaboration of the vertical folds as they turn to the back on Mary's left side. She holds a flower in her right hand, while the Child's hands are extended, either in wonder or to hold a missing object. He has full cheeks, a pointed nose, and a head of markedly curly hair.

Traces of red paint remain on the hem and in the interstices of the Virgin's gown. There are chips at the feet and on the back of the base. The silver crown and the right hand of the Virgin with the flower are restored.

Notes: The Toledo Virgin and Child is part of an extensive group of Middle Rhenish statuettes of the second half of the fourteenth century. Notable features are faces with small pointed noses, distinctive rendering of the eyes, the exaggeratedly curly hair of the Child, and a simple elegance in the drapery. (See Jászai, figs. 8 and 9, for statues that are closely related but not by the same master, the latter still in a Middle Rhenish church at Langenhorst.). The head of the Child is paralleled in a standing Virgin in Glasgow (Burrell Collection, inv. 21⁄13), related to an appliqué in the Walters Art Gallery (Randall, no. 282), and the seated group in Budapest *(Eastern European Objects and Ivories from the Years 1100–1900 in the Collection of the State Museum, the Hermitage in Leningrad* [Narodowe Museum, Warsaw, 1981], no. 24). The group has grown to include ivories related for various details such as eye treatment,

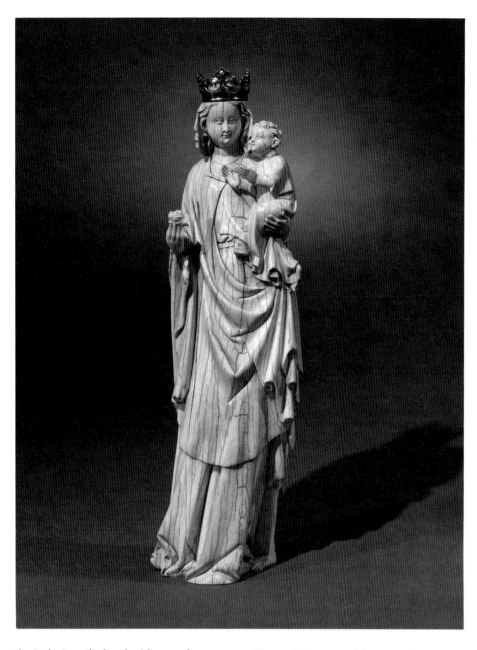

Sweeping across the body in broad arcs, the mantle falls in reverse folds from the wide sleeves. On the Virgin's head is a veil with no sign of a crown. The Christ Child rests both hands on his mother's chest and returns her gaze.

Traces of a gilt border of circles and lozenges remain on the lowest transverse fold of drapery, and blue paint can be seen on the robe and under the veil. There is a break in the drapery falling from the sleeve at the left, and a section of the base is broken. An original hole in the back was for attachment to a shrine or other background.

Notes: The ivory is related to a group of stone sculptures from Lorraine; it parallels closely the drapery of a limestone figure in the Musée de Cluny in Paris (*Fastes du gothique*, no. 6).

H: 8¼ in. (21.1 cm); W: 3³⁄₁₆ in (8.2 cm); D: ¹⁵⁄₁₆ in. (2.4 cm)

Worcester Art Museum, Worcester, Massachusetts (1940.27)

History: Said to have been found in the church of Lagny-sur-Marne about 1860; private collection, Nancy. (Purchased from Louis Carré, New York, 1940.)

Bibliography: Art through Fifty Centuries (Worcester, 1948), p. 38, fig. 51; Worcester Art Museum, *News Bulletin* 6, no. 3 (December 1950); S. L. Faison, *The Art Museums of New England* (Boston, 1982), p. 347, fig. 294; *Handbook* (Worcester Art Museum, 1973), p. 47.

See also colorplate 3.

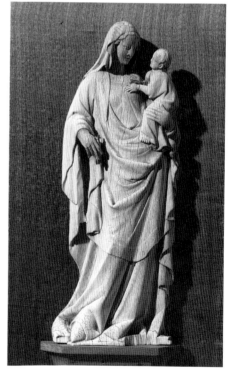

the inclusion of a hand with spread fingers, similar drapery, and the treatment of the Christ Child's head and hands (see Gaborit-Chopin [no. 263] and Jászai [figs. 6–10]). While most of the works date from the fourth quarter of the fourteenth century, certain examples (see Hegemann, fig. 18) are from the third quarter, and the center, wherever it was located, may have been productive for several generations. The group's attribution to Mainz (see Gaborit-Chopin, p. 170) is possible but not certain, and its relation to plaques by the Master of Kremsmunster (see cat. nos. 149 and 150) is one of contemporary feeling rather than detail.

H: 10¾ in. (27.4 cm)

The Toledo Museum of Art (50.305), gift of Edward Drummond Libbey

History: Collections of Sigismond Bardac, Paris; and Emile Baboin, Lyons. (Purchased from Raphael Stora, New York.) (The Toledo ivory does not appear in the Bardac sale catalogue [Georges Petit, Paris, 10 May 1920].)

Bibliography: Koechlin, Baboin cat., no. 24; Koechlin, no. 632 bis; R. Riefstahl, "Medieval Art," *Toledo Museum News*, n.s. 7, no. 1 (1964), p. 17; "Medieval Art at Toledo: A Selection," *Apollo* 86, no. 70 (December 1967), fig. 9.

24

The Virgin and Child

Ivory statuette, French (Lorraine), 1380–1400

The broad figure of the Virgin is carved in deep relief and was intended for placement against a background. She supports the Christ Child with her left hand and holds the stem of a flower in her right.

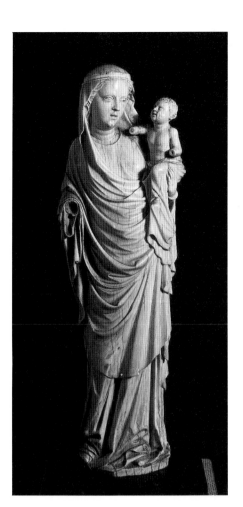

25

The Virgin and Child

Ivory statuette, Mosan, fourth quarter of 14th century

The Virgin faces forward with the Child on her left arm. Both are shown with mouths slightly open. The Virgin's head is carved for a metal crown that would have been placed over her veil, which falls in a sweeping fold from the right side. Her overmantle is crisscrossed with a wealth of folds, giving a strong play of light and shade. The bare-chested Child has an unusually long drapery that falls below his mother's waist.

There are traces of polychromy, including a gray-blue on the garments and black remaining on the pupil of the Virgin's left eye. She lacks her right hand, which appears to have been originally inset. Both the Child's hands are missing, as is the metal crown.

Notes: This large, imposing figure was undoubtedly the work of a sculptor, as seems to have been the tradition at the end of the fourteenth century, rather than the production of an ivory workshop. It is closely related to a smaller Virgin statue (Brussels, A. C. L. negative M154976), which has the same busy drapery, painted eyes, and arrangement of crown and veil. In posture and drapery tradition the type is reminiscent of a stone Virgin of Saint Servatius in Liège (J. de Borchgrave d'Altena, *La sculpture gothique à l'exposition d'art religieux* [Liège, 1930], fig. 3), which dates from the second quarter of the century.

H: 12⅞ in. (32.4 cm); W: [of base] 3 in. (7.6 cm)

The Nelson-Atkins Museum of Art, Kansas City (34.139), Nelson Fund

History: Purchased from Brummer Gallery, New York, 1934.

Bibliography: The William Rockhill Nelson Collection (Kansas City, 1949), p. 110.

See also colorplate 4.

26

God the Father from a Trinity

Ivory statuette, French (Dijon), 1380–1400

The imposing figure stands with arms raised to hold the crucifix. He has long hair and a beard formed of individual curls. Over a simple, belted shift the large cape is caught by both arms and descends in a series of generous folds at each side, touching the ground on the proper right.

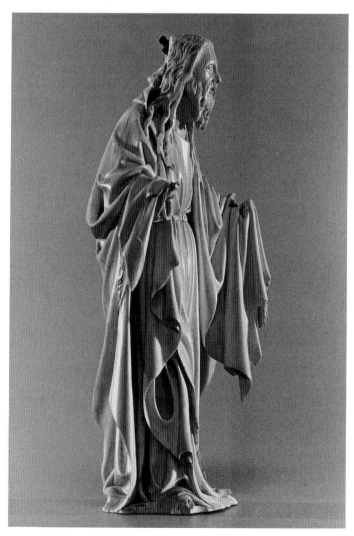

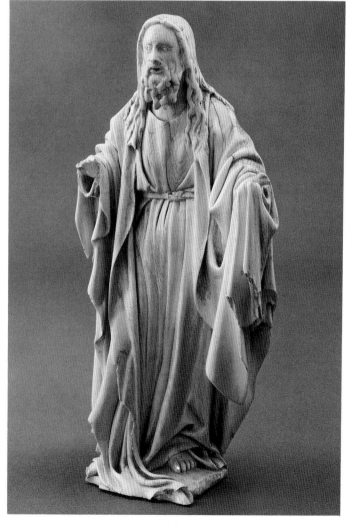

The back is finished with sweeps of transverse folds. As is customary in the Trinity configuration, with the dove flying toward the crucifix, the Father's mouth is shown slightly open.

The crucifix and dove are lacking, the right hand is broken, and a segment of the base is broken at the right foot. The left hand is open to hold the Cross arm and has a hole for attachment. A heavy bolt, possibly to hold a halo, has been inserted in the back of the head, which is partially cut away.

Notes: The ivory employs the rare form of the standing Trinity, an iconography particularly chosen by the dukes of Burgundy for the Chartreuse de Champmol in Dijon in place of the more usual seated Trinity. The origins of this concept and comparisons with stone examples of the Trinity are discussed by Verdier (see Bib.). Gaborit-Chopin (see Bib.) makes the cogent observation that the ivory figure is pre-Sluterian and more in keeping with the work of Jean de Marville (d. 1389), though probably carved later. In developing this thesis, Mosneron Dupin (see Bib.) illustrates the use of models in the Burgundian workshops and makes telling comparisons between the Houston ivory and mourner no. 78 from the tomb of Jean sans Peur, carved by Juan de la Huerta (active 1443–1462). It has long been known that Jean de Marville purchased ivory for the use of his atelier, a fact that reinforces the attribution of other major ivories of the late fourteenth and early fifteenth century to sculptors, rather than to ivory ateliers. It seems entirely likely, therefore, that the ivory is the work of de Marville or his workshop and so falls in date into the late fourteenth rather than the early fifteenth century.

H: 9¹³/₁₆ in. (24.3 cm)

The Museum of Fine Arts, Houston (44.581), Edith A. and Percy S. Straus Collection

History: Collection of Henry Garnier, Lyons. (Purchased from Joseph Brummer, New York, January 1935.)

Bibliography: Catalogue of the Edith A. and Percy S. Straus Collection (Museum of Fine Arts, Houston, 1945), no. 57; P. Verdier, "La Trinité debout de Champmol," *Etudes d'art français offertes à Charles Sterling* (Paris, 1975), pp. 65–90; Gaborit-Chopin, p. 171, fig. 267; A. Erlande-Brandenburg, *L'art gothique* (Paris, 1983), no. 634; I. Mosneron Dupin, "La Trinité debout en ivoire de Houston et Les Trinités bourguignonnes de Jean de Marville à Jean de la Huerta," *Wiener Jahrbuch* 43 (1990), pp. 35–65, figs. 1–20. *See also colorplate 5.*

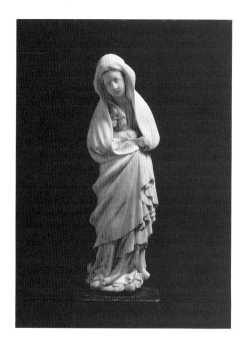

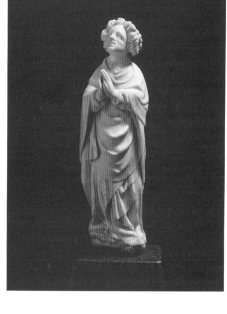

27

The Virgin and Saint John from a Crucifix

Ivory statuette, Flemish (?), early 15th century

The Virgin, standing on a branch and leaves, looks away from the Cross. She is enveloped in a heavy mantle that covers her head. The bold but soft folds are carved with rounded forms as well as smaller, busy pleats on the left hip and the scarf end. Saint John, portrayed with a mop of curly hair, looks upward, his hands folded in prayer. The heavy rounded folds of his robe contrast with a number of crossovers and returns. He stands likewise on leaves and a branch.

Each statue is drilled centrally in the base for a vertical pin to attach it to a crucifix; for stabilization each has a hole in one side. The Virgin's hands are lacking.

Notes: The same soft folds of drapery are found in a Burgundian Virgin and Child in limestone (*International Style*, no. 80), dated in the first quarter of the fifteenth century.

Virgin—H: 4 in. (10.2 cm); W: 1¼ in. (3.4 cm)

John—H: 3⅞ in. (9.9 cm); W: 2⅛ in. (2.9 cm)

Museum of Fine Arts, Boston (49.486 and 487), William Francis Warden Fund

History: Collection of Gabriel Dereppe, Paris. (Purchased at the Joseph Brummer sale, New York, 1949.)

Bibliography: Brummer sale, Parke-Bernet, New York, 14 May 1949, lot 683; *Medieval Treasury*, p. 163, no. 90.

28

The Virgin and Child

Ivory statuette, Flemish, second quarter of 15th century

The Virgin is seated on a wide throne with sides and back. She holds the nursing Christ Child on her lap with her left hand and displays a scroll with her right. Below a modest cape and veil is a skirt carved with folds like those of the painter Rogier van der Weyden, the drapery falling in complex patterns over the throne and on the ground. The figures are placed on an integral openwork base that includes stepped moldings and a center pierced with late-Gothic tracery.

The heads of the figures are somewhat worn. There are traces of polychromy.

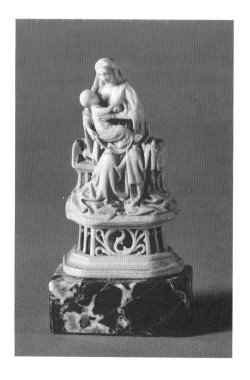

Notes: While certain questions have been raised regarding small statuettes on pierced bases, this ivory appears to be a typically Flemish work of the second quarter of the fifteenth century or possibly slightly later. Comparable examples include a standing Virgin with a Flemish crown and drapery of similar style (Volbach, no. 705), which entered the Kunstkammer in Berlin in 1856 from the royal collections, and a seated Virgin (Lehmann sale, Georges Petit, Paris, 4–5 June 1925, lot 321).

H: 3 in. (7.6 cm)

The Art Museum, Princeton University (68-7), gift of J. Lionberger Davis

History: Purchased from Mathias Komor, New York, 1968.

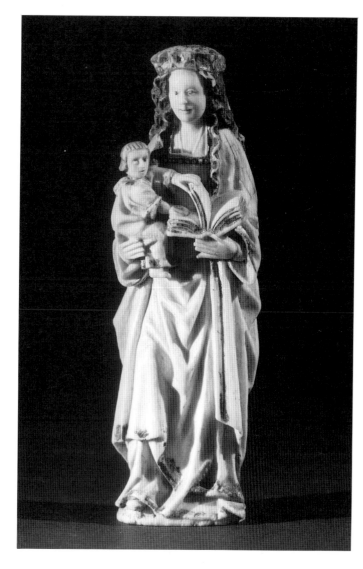

29

The Virgin and Child

Ivory statuette, Dutch, 1455–1475

The Virgin supports with her right hand the Christ Child, who turns the pages of the book she holds with her left. Dressed in a square-necked gown covered by a cape, Mary wears a necklace and a cap and crown over long, wavy hair.

There is much remaining polychromy. Gilding ornaments the crown, the edges of the book, the Child's hair, and the wide borders of the dress and gown. The Virgin's hair is painted black, as are details of the borders and the eyes of both figures. In the base are several holes, one deep and four shallow.

Notes: The treatment of the crown and cap is typically Dutch, and the face and hair are close to that of the Saint Agnes by the Master of the Utrecht Saint Martin and the Four Saints (*Middeleeuwse Kunst der Noordelijke Nederlanden* [exh. cat., Rijksmuseum, Amsterdam, 1958], no. 293d). The drapery is related in type to Dutch wood sculpture of 1470–1475 (*Middeleeuwse Kunst*, nos. 330 and 331).

H: 4½ in. (11.5 cm); W: 1⅝ in. (4.2 cm); D: 1⅛ in. (2.9 cm)

Williams College Museum of Art, Williamstown, Massachusetts (78.2.4), gift of John Davis Hatch, Jr.

History: Collection of John Davis Hatch, Jr., Lenox, Mass.

30

Mary Jacobi

Ivory statuette, French, early 16th century

The veiled figure of Mary Jacobi stands with a hand raised against her bosom in a gesture of mourning. She wears a dress with a gathered neck and a cape retained by a braided mantle cord. The cape, gathered under her right hand, falls in deep,

squarish folds. Carved in relief at the hem is the inscription [MA]RIA IA[CO]BI EMIT.

The right hand is missing, and various projecting surfaces on the front of the statue are severely rubbed.

Notes: Mary Jacobi is rarely represented in medieval art except as one of the women at the Crucifixion and Entombment. Also called Mary Cleophas, she was thought to be a sister of the Virgin, although there is considerable historical confusion on the subject. She was the mother of Saint James the Less. A statue showing her with three children decorates the south portal of Saint-Vulfran in Abbeville (H. Zanettacci, "Statuaire de la façade à Saint-Vulfran d'Abbeville," *Bull. mon.* 95 [1936], p. 348), and she appears again as mother in the Hours of Etienne Chevalier by Jean Fouquet (Sterling, fig. 44). Mary Jacobi's association with the anointing of Jesus' body suggests that her right hand might have held an ointment jar.

H: 7 in. (17.7 cm); W: 2¼ in. (5.8 cm)

Virginia Museum of Fine Arts, Richmond (68-60), Adolph D. and Wilkins C. Williams Fund

History: Collection of John Hunt, Dublin.

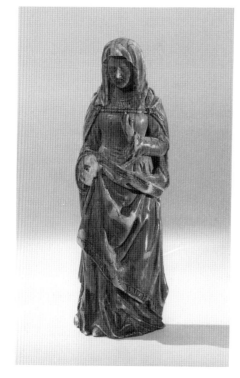

RELIGIOUS IVORIES

TRIPTYCHS AND POLYPTYCHS

31

The Virgin and Child

Center of an ivory polyptych, Spanish, 1270–1290

The crowned Virgin is seated on a bench within a niche formed of a tall trefoil arch supported on two colonnettes. Her left arm supports the Christ Child, whose head had been turned halfway toward her. The Child once held a book in his left hand; his right is placed against his mother's chest.

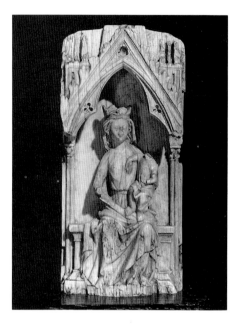

The interstices of the arch are pierced with trefoils, as is the tympanum above, and the roof line is treated with flat, leaf-shaped crockets of unusual design. Above the roof line are two well-articulated Gothic towers. The piece was the center of a tabernacle with four hinged wings and is fitted for three hinges on each side.

Considerable abrasion and damage has occurred on the front at the base of the ivory and on the drapery over the right knee. The Virgin's right hand and the Child's left are missing, as are his head and Mary's nose. The towers and crockets are severely abraded.

Notes: The ivory exhibits a refined architectural conception, its drapery closely paralleled by a Spanish seated Virgin in ivory from the Convent of San Marcos in León (Koechlin, no. 66). Also from the period is a large French seated Virgin and Child (Koechlin, no. 22). In both the Child is frontal and blessing in the Romanesque fashion.

The León ivory is related to a large group of Spanish wood Virgin-and-Child statues of the early fourteenth century, which in turn descend from a stone prototype, also beneath a trefoil canopy: the Virgin at Villalcázar de Sirga, dating from the third quarter of the thirteenth century (R. Randall, "A Spanish Virgin and Child," *BMMA* 13, no. 4 [December 1954], p. 139).

That statue is shown a number of times in the Cantigas da Santa Maria of 1284 under a tall trefoil arch decorated with trefoil piercings.

There is one difference between the Hartford panel and the Virgin of Villalcázar and her descendants, and that is the awkward position of the Child's right hand, which in the ivory does not make the blessing gesture as in all other Spanish parallels. Unlike French examples, however, the Child once held a book. (Compare a Spanish ivory with the book and blessing gesture in the collection of Martin Le Roy, Paris [Koechlin, no. 4]). Also following the Spanish precedent is the rendering of the Virgin's eyes in the ivory, with strong emphasis on the upper and lower planes of the eye sockets, giving a wide-eyed expression.

H: 3⅝ in. (9.4 cm); W: 1¾ in. (4.5 cm); D: ⅝ in. (0.4 cm)

Wadsworth Atheneum, Hartford (1949.183), Hartford Foundation for Public Giving

History: Purchased at the Joseph Brummer sale, New York, 1949.

Bibliography: Brummer sale, Parke-Bernet, New York, 12 May 1949, lot 685.

32

The Life of the Virgin

Ivory polyptych, French (Paris), 1280–1290

The central block of the shrine shows the Virgin being crowned between candle-bearing angels, while she offers a flower to the Christ Child. He places his right hand against Mary's chest and holds a globe in his left. The figures are in three-quarter relief, undercut so as to appear in the round.

The center of the tabernacle is formed of three niches with trefoil arches, supported on four freestanding colonnettes. There are gables with floral borders and a transverse roof with eleven pinnacles. The base of the central block, with wide projecting upper and lower plinths, is supported on four claw-and-ball feet. The front face of the base is painted with three pairs of addorsed floral scrolls.

The wings are formed of four hinged sections of ivory that enclose the shrine completely when folded. Reading from the left are, at the top, scenes of the Annunciation, the Visitation, and the Nativity (with the unusual figure of a woman holding a candle); and, at the bottom, the Three Kings in Adoration and the Presentation in the Temple. The figures of the central block are carved from a solid piece of ivory, from which the colonnettes, arches, and roof are also made. The lower edges of the outer panels are separate but original pieces. As the block is not absolutely rectangular, the sculptor added a large wedge of ivory that supports the entire section and is joined at the bases of the columns.

Except for the pinnacles, which are restored, the work is nearly perfectly preserved. There are traces of paint—red and blue on the garments of the central figures—as well as gilt traces on hair, crown, and garment borders. Decorating the gables are trefoils painted with blue dots on a red ground. The trefoil arches show remains of red and blue paint.

Notes: Probably from the same workshop but by different hands are two polyptychs that show similar details of carving, although the character of the figures varies. One is a large example with a Last Judgment placed above the Virgin and angels (Koechlin, no. 172). The treatment of

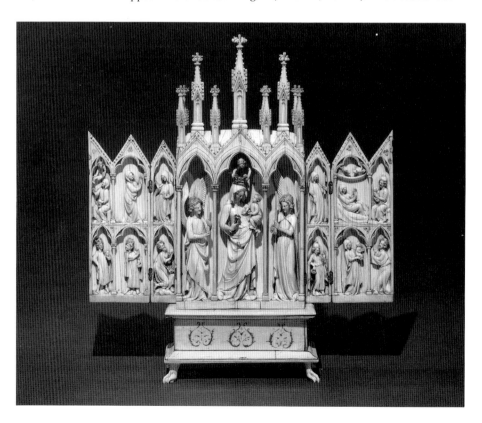

the architectural elements, particularly the freestanding colonnettes, is handled in an identical manner, and the wings of the angels are closely related. The woman attendant in the Nativity likewise holds a candle.

The second related example (Little [Bib.], fig. 12) is the central block of a polyptych showing the Virgin being crowned between candle-bearing angels. While the character of the faces is different, the similar details of niches, bases of roof finials, and angels' wings, as well as the treatment of the crowning angel and the Christ Child, suggest the same Parisian workshop.

The use of claw-and-ball feet has been questioned, but they appear to be original. A precedent can be found in Abbot Suger's eagle vase in the Treasury of Saint-Denis of the mid-twelfth century (B. Montesquiou-Fezensac and D. Gaborit-Chopin, *Le Trésor de Saint-Denis*, vol. 3 [Paris, 1976], pl. 23).

H: 11½ in. (29.4 cm); W: [open] 10½ in. (28 cm); [closed] 4⅜ in. (11.2 cm)

The Toledo Museum of Art (50.304), gift of Edward Drummond Libbey

History: Collections of Frédéric Spitzer, Paris; Oscar Hainauer, Berlin; and Emile Baboin, Lyons. (Purchased from Raphael Stora, New York, 1950.)

Bibliography: Molinier, Spitzer cat., vol. 1, no. 84; W. Bode, *Die Sammlung O. Hainauer* (Berlin, 1897), no. 138; K. Koechlin, "Quelques ateliers d'ivoiriers," *GBA* 2 (1905), p. 467; Koechlin, Baboin cat., no. 21; "Medieval Art at Toledo," *Apollo* 86 (December 1967), p. 440; C. Little, "Ivoires et art gothique," *Revue de l'art*, no. 46 (1979), p. 61.

See also colorplate 6.

33

The Virgin and Child

Ivory polyptych, English, second quarter of 14th century

The seated Virgin is enthroned under a baldachin with five pierced spires. Her right hand is pierced to hold a flower, and the Christ Child, holding a globe or fruit, stands in her lap. On the left wings are relief scenes of the Annunciation and the Nativity above those of the Birth of John the Baptist and the Annunciation to the Shepherds. On the right are the Three Kings and the Coronation of the Virgin above the Flight into Egypt and the Presentation in the Temple.

The wings are decorated with trefoil arches beneath gables painted with trefoils and ornamented with floral crockets and finials. Rising from the Virgin's baldachin, which is supported on two columns with carved capitals, is a trefoil arch and a gable with piercings, including a central trefoil. The roof is bordered by crockets and finials and has five pierced openwork spires, each carved separately; the four corner ones were inset, and the central one was glued

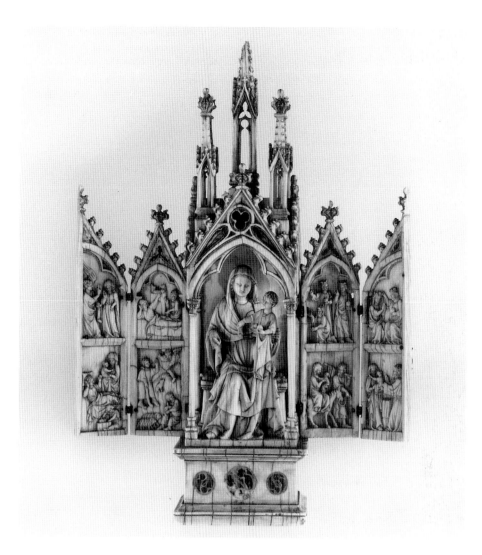

to the crest. Made of a single block of ivory, hollowed out in back for the insertion of a relic and closed with a rectangular panel, the oblong base has moldings at top and bottom and is painted with tracery in green on a gold ground.

There are numerous traces of polychromy on the gables, crockets, and finials, as well as gilding on the hair of the Virgin and Child and on the outer sides of the wings and back. The polychromy is modern (see illustration in Molinier, Spitzer cat. [1890])—restoration done before 1900—and the central spire was broken after 1920. All but two of the hinges have been repaired with new ivory insets. Part of the Virgin's right hand (including a flower) is missing.

Notes: The Virgin, a type of which several English examples exist, stands between the monumental "Brown" Virgin of the Cloisters at the Metropolitan Museum of Art (*Age of Chivalry*, no. 518) of the early fourteenth century and two examples dating from the second quarter—one in the Victoria and Albert Museum (Longhurst, vol. 2, pl. XXII, no. 201–1867) and the other once in the collection of Claudius Cote (*Les arts*, November 1906, p. 31). Three scenes in the wings—the Flight into Egypt, the Coronation of the Virgin, and the rare Birth of John the Baptist—differentiate this shrine from French examples (see cat. no. 45).

H: 8⅜ in. (21.3 cm); W: [open] 6¼ in. (15.9 cm); [closed] 2½ in. (6.4 cm)

The Carnegie Museum of Art, Pittsburgh (56.3.1), gift of Jeannine Byers

History: Collections of Frédéric Spitzer, Paris (before 1896); Michel Boy, Paris (1900–1920); and Mr. and Mrs. J. Frederic Byers, Sewickley, Pa. (Purchased from French and Company, New York.)

Bibliography: Molinier, Spitzer cat., vol. 1, no. 47, pl. XXII; *Exposition Universelle* (Paris, 1900), no. 111, ill. p. 16 (as loan from Michel Boy); Koechlin, no. 160.

34

The Virgin and Child

Center panel of an ivory polyptych, French (Paris), 1330–1350

The seated Virgin holds the Child, who takes a step across her lap. She offers him a bird, which he touches with his right hand, while holding a globe in his left. The drapery details, with a deep fold between the Virgin's knees, are well conceived.

Both the figures and their niche are carved from a single block of ivory; the roof is a separate piece. Abutting the throne on which the Virgin sits are colonnettes that support a pierced trefoil arch,

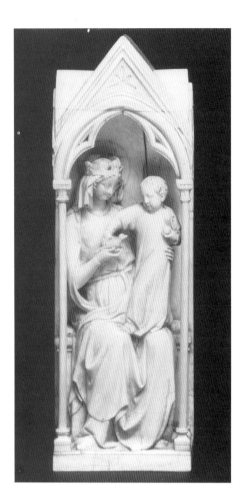

which is in turn surmounted by a gable and a transverse roof.

There are traces of blue color on the Virgin's robe, and the bole of a halo remains on the background of the niche. The round holes for wire hinges are plugged with ivory. The gable, decorated with an incised five-armed motif, is a restoration.

Notes: Seated central figures in polyptychs are less common than standing figures. An example in the Metropolitan Museum, complete with wings on either side (Koechlin, no. 142), is of approximately the same date, whereas a triptych by the Berlin Master (Koechlin, no. 120), also showing the striding figure of the Child, is slightly later. A number of French freestanding Virgin-and-Child statues (including Koechlin, no. 678 and Randall, no. 272) are close in date and drapery arrangement.

H: 7⅞ in. (17.5 cm); W: 2⁷⁄₁₆ in. (6.3 cm)

Martin D'Arcy Gallery of Art, Loyola University, Chicago (1-88)

History: Collection of Lord Astor, Hever Castle, Kent, England.

Bibliography: Hever Castle sale, Sotheby's, London, 6 May 1983, lot 231.

35

The Virgin and Child

Bone and ivory polyptych, on a wood core, Flemish, 1430–1460

The ivory Virgin holds the Child in her left hand and a branch of flowers in her right. She wears a veil on the back of her head beneath a low crown, probably intended as the base for a silver crown. The heavy mantle falls in a cascade of V-folds on the proper left and a simple, long fold on the right. Placed beneath a Gothic canopy, the figures stand on a stepped and molded base inscribed DME REGINA MISERICORDI [?]ITA DULCED.

The wings, each with four bone plaques, contain scenes carved in relief on a hatched ground. Those on the outside have music-making angels under round arches, while the inner wings have the story of the Virgin's life. On the left are Joachim and Anna, the Annunciation, the Virgin Praying in the Temple, and the Virgin Weaving; on the right are the Marriage of the Virgin, the Birth of the Virgin, the Visitation, and the Nativity. The scenes are set within molded frames composed of bone strips.

There is much remaining polychromy and gilding. The Virgin has blue on her mantle, gilt hair, and green on the branch. The relief scenes are basically reserved against gilding but with touches of green, brown, and red. The canopy is painted brown and gilt.

Diamonds of bone alternating with diamonds of wood-and-bone intarsia are inlaid in a floral pattern on the back of the shrine. An hourglass in bone is inset in the base. The ivory block on which the Virgin stands and the plain ivory background strip are replacements. There are four intarsia panels missing, and five are damaged.

Notes: The shrine is one of a group made in a workshop that produced large caskets

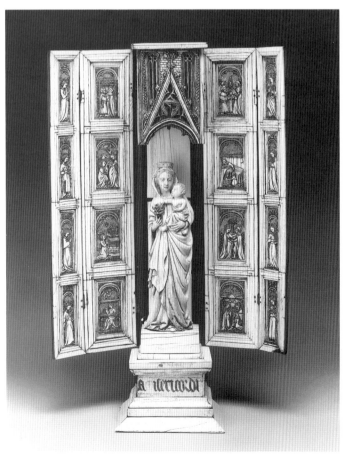

with scenes of the lives of the Virgin or of Christ, some of which are based on prints from the *Biblia Pauperum* (Randall, no. 359). The unidentified prints used to portray the life of the Virgin on a casket in the Victoria and Albert Museum (Longhurst, vol. 2, no. 176–1866) are the same, in many cases, as those used for the six that are known of these folding shrines, all of which have central Virgin statues. (In several instances, such as scenes of the Virgin praying, the same source has been used in all six shrines.) The shrine at L'Hôpital de Saint-Jean in Bruges (Koechlin, no. 946) is the finest and largest of the group, with a seated Virgin and the scenes placed beneath ogee arches, as on the caskets. It is the only other example with a flat top to the canopy. The other four shrines, all with standing Virgins (see Philippovitch, no. 60, p. 78; Zastrow, nos. 44 and 45; and Egbert, fig. 46), have figures or patterns ornamenting the background for the Madonna.

The Detroit polyptych, wherein several of the episodes of the Virgin's life are out of order, is based on the same print source as the Victoria and Albert casket for the Birth of the Virgin, the Virgin Praying, the Virgin Weaving (reversed), the Marriage of the Virgin, and the Annunciation. The other scenes come from different prints or are slight variants of the Victoria and Albert scenes.

Technical notes: The material of the Virgin statue was tested by accelerator mass spectrometry in November 1990 at the University of Toronto Department of Physics. Examination of a 35-milligram sample of carbon extracted from an ivory core taken from inside the base shows the figure to be datable plus or minus 1480. The stylistic date of 1460 occurs on the graph at the eighty-fifth percentile marking.

Of five other samples taken and sent to the laboratory, four failed to produce enough carbon for a positive test, and one test was wildly inaccurate. While the scientific community is confident that accurate results can be obtained, their estimate of the amount of material needed in a sample seems generally to be inadequate yet large enough to make curators wary of taking larger samples, especially from diptych plaques. Using sizable ivory cores, the Oxford University laboratory achieved successful carbon testing in 1987, dating a Spanish Romanesque ivory and other medieval pieces for the British Museum.

Statuette—H: 8½ in. (21.6 cm)

Shrine—H: [with base] 19 in. (48.3 cm)

Detroit Institute of Arts (23.149), Founders Society purchase

See also colorplate 7.

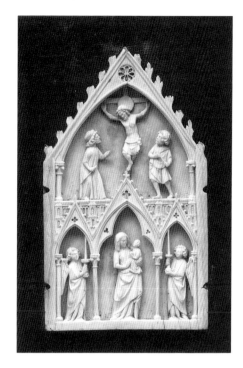

36

The Crucifixion and the Virgin and Child

Center panel of an ivory triptych, French (North France or Paris), 1250–1270

The plaque is divided into two tiers, with the Crucifixion scene at the top under a broad, pointed arch. Emphasized by the open space of the composition are the figures of a dignified Longinus, in cap and long robe, and Stephaton, in a short skirt. The crucifix is placed between them, Christ's head against a carved nimbus. Beneath her wide arch in the lower tier, the Virgin stands holding the Child, while the angels fill the spaces of the side arches.

Columns with simple foliate capitals support the arches, while the tympana are pierced with quatrefoils in the lower section and with an octafoil in the upper portion. A band of architectural decoration of blind arcades and towers fills the spandrels behind the lower arches. Flat trilobate leaves decorate the cornice.

The panel is drilled for two wire hinges on each side, and the lower edge is cross-hatched, indicating that the triptych once stood on a base. A small incised circle is placed in the center of the back of the panel. The lances of Longinus and Stephaton are broken, and many of the leaves of the cornice are damaged.

Notes: The panel is part of the so-called Soissons Group of ivories of the mid- to late thirteenth century, named for the famous diptych that came from Saint-Jean-des-Vignes in Soissons (Longhurst, vol. 2, no. 211–1865). It relates (particularly in the Crucifixion scene) to earlier members of the group (for example, Koechlin, nos. 37 and 43) and to the center of a triptych now in the Metropolitan Museum

(Koechlin, no. 47). Architectural decoration of the four works is treated in a similar fashion. The flat leaves of the cornice appear on only one other ivory of the group, a complete triptych (Koechlin, no. 52), which differs in other details.

H: 5 in. (12.8 cm); W: 3 in. (7.7 cm); D: ½ in. (1.4 cm)

The Cleveland Museum of Art (29.437), J. H. Wade Fund

History: Purchased from Durlacher Brothers, London, 1929.

Bibliography: BCMA 16 (July 1929).

37

The Passion of Christ

Bone triptych, French, 1260–1280

Reading up from the bottom left, down the center, and up on the right, the scenes include the Flagellation, the Carrying of the Cross, the Crucifixion, the Deposition, the Entombment, and the Harrowing of Hell. Several details are unusual, as in the Carrying of the Cross, which shows a soldier with a sword, rather than a hammer, and a man in the background bearing a ladder; the Entombment includes the three Marys with ointment jars and censing angels; and in the Harrowing there are two mouths of Hell. Except for details such as the Cross in the Harrowing scene, the figures are mostly completed. Architectural elements, only roughed in, include arches, crockets, and the wide borders of the central panel, where bone has been left for colonnettes on each side.

The triptych was badly abraded during burial, and the left wing has areas of disintegration. Made separately and pinned on, the top of the center panel is now missing. The modern hinges are incorrectly placed so that the wings are too high. There are two holes in the base of the central panel for mounting.

Notes: This small, unfinished work is interesting for the light it throws on the process of carving an ivory, indicating that the architectural elements were left until after the figures were completed. As the piece is in bone, it is also possible that it was a workshop model, with only the important parts finished, and that it was later discarded.

The triptych forms part of the Soissons Group in style and iconography, although it varies from the other ivories in both the simplicity of the enframement and the details of certain scenes. While the Flagellation is similar to that of the Soissons diptych itself (Koechlin, no. 38), the remaining scenes, particularly those of the central panel, are given more space

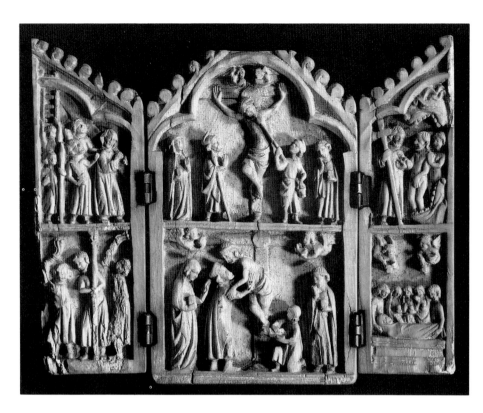

than in the other ivories of the group. The center of an ivory triptych (cat. no. 36), the nearest in scale and format, has architecture that is more developed. Another Soissons triptych (Koechlin, no. 198) provides the closest parallel to the architectural disposition and suggests the date of the present example.

H: 3½ in. (8.9 cm); W: [open] 4⁷⁄₁₆ in. (11.3 cm)
Williams College Museum of Art, Williamstown, Massachusetts (78.2.3), gift of John Davis Hatch, Jr.
History: Collection of John Davis Hatch, Jr., Lenox, Mass.

38

The Virgin and Child

Center of an ivory triptych, French (Paris), last quarter of 13th century

The Virgin is posed in an exaggerated hipshot stance, supporting the Child on her left side, a branch of flowers in her right hand. The Child holds a globe and makes the gesture of blessing. Over the Virgin's dress a prominent cord holds her open mantle, its drapery falling in well-articulated folds below her belted waist. The niche, supported on two corbels, has a trefoil arch with openwork ribs; the gable, ornamented with small, globular crockets, is broken at the top, and only the bases of the pinnacles remain.

Because the plaque is damaged at both sides, large portions of the background are missing. The figure of the Virgin is broken off at the foot, and the lower folds of her

robe and those on the right side of the panel are lost, as is the front fleuron on her crown. The one remaining round hinge hole shows that the hinges were of wire.

Notes: The figure of the Virgin is an early type, closely related to a freestanding ivory Virgin of the Sainte-Chapelle in Paris that is datable to 1265–1279 (Koechlin, no. 95; Gaborit-Chopin, ill. on pp. 198–199). Other indications that this piece is earlier than most Virgin triptychs are the pinnacles and

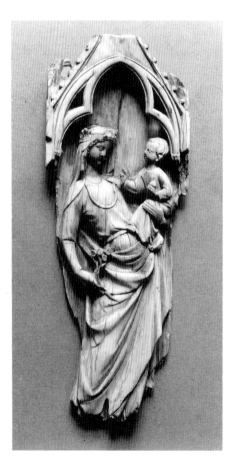

wire hinges, which suggest a date in the last quarter of the thirteenth century.
H: 6³⁄₁₆ in. (15.7 cm); W: 2⁵⁄₁₆ in. (6 cm)
The Art Museum, Princeton University (53-57), John Maclean Magie and Gertrude Magie Fund
History: Collection of Comte Max de Germigny, Paris.
Bibliography: Koechlin, no. 126; *Record of The Art Museum,* Princeton University, 13, no. 2 (1954), p. 63; *Carver's Art,* no. 12.

39

The Virgin and Child with Angels

Center panel of an ivory triptych, French (Paris), 1320–1330

Standing between candle-bearing angels, the hipshot Virgin is crowned by a third angel. She holds the Child in her left hand and a flower in her right; the Child places one hand against his mother and holds a globe in the other. The skirt is arranged so that an upper fold is caught at the proper right side, forming a small apronlike turnover at the top and descending in pleats to the ground. The drapery of each angel differs, that on the left falling straight and that on the right in a reversed curve. Whereas the angels at the sides are not winged, the crowning angel once had doweled wings, which are missing. The prongs of the candlesticks are of iron.

The upper gathering of the Virgin's skirt and the robes of the angels are stained red, as are the interstices of the arches, which have reserved trefoil patterns. All the angels' heads are bound with fillets painted blue and gold, and the halo of the Christ Child on the background shows traces of a red ground.

A tympanum pierced with a trefoil surmounts the trefoil arch, and the gable is decorated with rosettes. The original crest of the tabernacle was made of separate pieces (now missing), as indicated by cross-hatching for glue and a hole for attachment. Additional strips of ivory at the sides of the plaque are replacements, as are the two columns.

Notes: The unusual drapery of the Virgin is repeated in almost all details in the freestanding Virgin of a tabernacle that has the same red staining of the upper fold of the skirt as well as of the arches (Wixom 1987, fig. 5). It also has painted halos for the figures. The two works are certainly from the same Parisian workshop and perhaps by the same carver.
H: 9 in. (23 cm); W: 4½ in. (11.6 cm)
The Cleveland Museum of Art (23.719), gift of J. H. Wade and Mr. and Mrs. John L. Severance
History: Collections of Francis Douce, London (until 1824); Sir Samuel Rush Meyrick, Goodrich Court, Hertfordshire

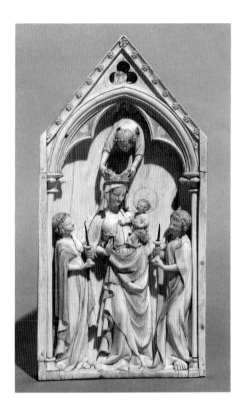

and bases of the colonnettes—all repainting of the nineteenth century. The crest and finial of the central section are nineteenth-century replacements, as is the entire base. The new hinges are attached with screws.

Notes: As part of a thorough cleaning and restoration in the nineteenth century, the central gable was cut transversely near the top. It was originally constructed with the glued border strips and finial of the central block in the same manner as an example at the Kunsthistorisches Museum in Vienna that was also restored and repainted (Koechlin, no. 125). There the gable is similarly cut, and the two are nearly identical in size, ignoring the tall finial on the Cleveland triptych. The scenes are the same and carved in the same flat manner, although the Virgin of the Vienna example is more typically Parisian in style, whereas the massive quality of the Cleveland Virgin is closely related to works from Lorraine. It seems possible that they come from the same workshop, however, perhaps of a Paris-trained carver working in Austria.

There are striking similarities between this ivory Virgin and an Austrian wood statue of a Virgin in Frankfurt (A. Legner, *Gotische Bildwerke aus dem Liebieghaus* [Frankfurt, 1966], fig. 36). The joining of the mantle without a clasp, for instance, is seen in both figures.

H: [without base] $10^{3}/_{16}$ in. (25.9 cm);
W: [open] $8^{3}/_{8}$ in. (21.4 cm)
The Cleveland Museum of Art (51.450), J. H. Wade Fund
History: Collections of Boehm, Vienna; and princes of Liechtenstein, Vaduz. (Purchased from Rosenberg and Stiebel, New York, 1951.)
Bibliography: J. von Hefner-Alteneck, *Trachten* (Frankfurt, 1879), vol. 3 pl. 169; H. Semper, "Ueber eine besondere Gruppe elfenbeinerner Klappaltärchen des XIV Jahrhunderts," *Zeitschrift für Christliche Kunst* 11 (1898), pp. 117–118; CMA *Handbook* (1958), no. 137; *BCMA* 50 (September 1963), no. 24, p. 174.

(until 1848); John Malcolm of Poltalloch, County Argyll, Scotland; and Col. Edward Donald Malcolm (until 1913). (Purchased from Durlacher Brothers, London, 1923.)
Bibliography: S. R. Meyrick, "The Doucean Museum," *Gentlemen's Magasine* (June 1836), no. 39, p. 586; *Catalogue of Bronzes and Ivories* (Burlington Fine Arts Club, London, 1879), no. 275; Malcolm sale, Christie's, London, 1 May 1913, lot 19; Koechlin, no. 169 bis; CMA *Annual Report*, 1923; CMA *Handbook* (1925), p. 15 (1928 ed., no. 139; 1969 ed., p. 52); *Treasures from Medieval France*, p. 194, V.13.
See also colorplate 8.

40

The Life of the Virgin

Ivory triptych, French (Lorraine?) or Austrian (?), second quarter of 14th century

The broad figure of the Virgin, crowned by an angel and holding the Christ Child on her left arm, stands in the central section of the triptych. She held a flower, now missing, in her right hand, and the Christ Child holds an apple. They are placed beneath a trefoil arch supported by two colonnettes. On the wings are depicted the Annunciation, the Visitation, the Three Kings, and the Presentation in the Temple. The figures are broad and flatly carved. The lower scenes are beneath a trefoil arch, and the upper ones occupy half a wider arch.

Gilt and black paint decorate the hair and crowns, the vase in the Annunciation,

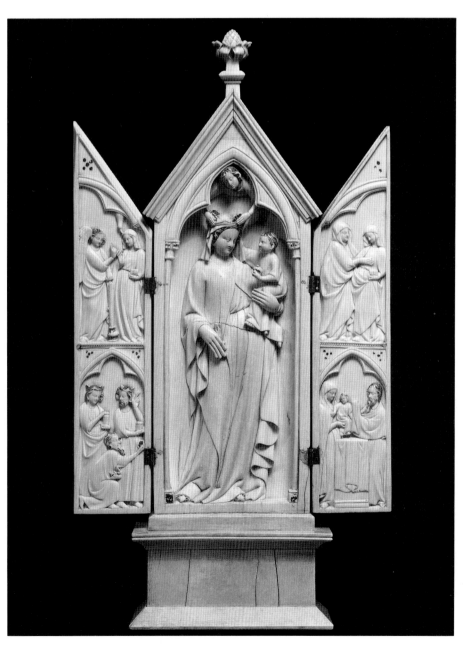

41

The Virgin and Child

Center panel of an ivory triptych, French (Paris), second quarter of 14th century

The large figures of the Virgin and Child fill the space of a columnar niche. An angel has just crowned Mary, as she stands gazing at the Child, who holds a globe or fruit in his left hand. In an unusual gesture the Virgin grasps a fold of her mantle— rather than a flower or bird—in her right hand. The drapery is treated in a broad sweep, with accented, recurving folds at each side.

The niche, supported by two colonnettes with floral capitals, consists of a trefoil arch with a plain gable above. Crosshatching on the edges of the gable enabled it to receive glued borders of crockets made from separate pieces, a feature to be seen in other triptychs (see, for example,

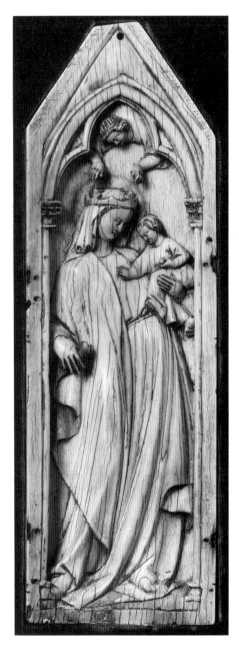

Koechlin, no. 125). The top of the gable has been drilled with a later hole and trimmed of its point.

There is a brown ground for a halo behind the Virgin's head, and the recurved edges of the drapery show traces of dark stain. Besides the original four slots for hinges, there are four modern diagonal holes for mounting, and plastic wood fills in the bottom edge. The wings, which would have shown scenes of the Virgin's life or candle-bearing angels, are missing.

Notes: A group of Virgin triptychs (see Dalton, no. 266; and cat. no. 40 in this book) share a common size, all being just over ten inches in height. They also share numerous stylistic features of the second quarter of the fourteenth century, including the detail of glued moldings on their gables. Yet they come from different shops.

A smaller triptych with angels on its wings (Longhurst, vol. 2, no. 236–1867) is so similar in many aspects that it may be from the same shop as the Fogg example. It is less fine in carving, but the sweep of drapery and several of its accents parallel those seen here: the position of the Virgin's head and her serious gaze, as well as the way she holds the edge of the robe in her right hand.

H: 10⅛ in. (25.2 cm); W: 3¼ in. (8.2 cm)

Fogg Art Museum, Harvard University, Cambridge (1931.33)

History: Collection of Mrs. Louis Stern, Paris. (Purchased from Arnold Seligmann, Rey and Co., New York, April 1931.)

Bibliography: Koechlin, no. 116; *American Magazine of Art* 23, no. 2 (August 1931), p. 145.

42

The Adoration of the Kings; and Saints

Wings of an ivory triptych, English, 1325–1350

The left wing shows Saint Christopher, the Murder of Thomas Becket, and Saint Ethelbert holding his crowned head. On the right wing the Adoration of the Kings is the uppermost scene, above Saint John the Evangelist standing on his eagle symbol; in the final panel are Saints Margaret and Catherine. The scenes are framed in simple rectangles, with chamfering on the undersides of the crossbars. The borders of the plaques, cut to accommodate modern hinges, are uneven in width.

The original hinges, replaced by the present ones in silver, were small and inset diagonally. A silver nail in the right-hand plaque once served as a catch.

Notes: Misidentification of the bottom saint in the left wing as Saint Denis has led scholars to consider these panels as French. Since the head of the martyr wears a crown and not a miter, however, it must be identified as Saint Ethelbert of England,

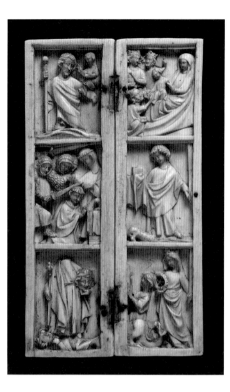

making the wings certainly English. Inclusion of the Adoration among the saints implies that the central scene was a rectangular plaque showing the Virgin and Child.

Saint Catherine's drapery is early fourteenth century in style, but other details indicate a later date. The unusual placement of Saint John standing on his eagle and Saint Ethelbert on his executioner suggests that the workshop was inventing details rather than using standard models.

H: 5¼ in. (13.1 cm); W: 1½ in. (3.6 cm) each

Museum of Fine Arts, Boston (51.5–6), Helen and Alice Colburn Fund

History: Collection of Emile Baboin, Lyons. (Purchased from Raphael Stora, New York, 1951.)

43

The Life and the Passion of Christ

Ivory triptych, German (Cologne), third quarter of 14th century

Shown in the lower tiers are the Annunciation, the Adoration of the Kings, and the Presentation in the Temple. In the upper tiers the Carrying of the Cross is followed by the central Crucifixion and Noli Me Tangere. The figures of the central panel are delicately carved and well spaced. Those of the wings are thin and elongated, particularly in the Annunciation and in the Presentation, where the head of Simeon is exaggerated.

The upper scenes are placed beneath rounded trefoil arches, the central one having a crisply cut trefoil in the tympanum

above. The lower scenes are under pairs of narrow trefoil arches (at the sides) and three wider arches (in the center). There are traces of color on the garments, and the gilding of the crowns is well preserved.

The upper edges of the triptych, now broken or trimmed, may have resembled originally the treatment of the well-known triptych by the so-called Berlin Master (Koechlin, no. 120). Both wings have applied modern moldings on their upper edges, while the center panel has a replaced molding on the right, a missing section on the left, and new edges. The triptych has been broken at the hinges and is repaired at all four hinge miters. In the base are modern mounting holes plugged with ivory. The discoloration on the chest of Christ is from the silver pin used for a hook in the right wing.

Notes: The triptych can be assigned to the hand of the Berlin Master. Its finely carved central section, compared to the distortions of the wings, suggests that the wings were completed by lesser hands within the atelier. The Crucifixion scene is comparable

with one in a diptych that is taken from the same model, with changes in the drapery of Saint John (Randall, no. 301). Another feature common to the two works and to several others (see Koechlin, nos. 120 and 533) is the crisp cutting of the trefoil in the tympanum. (For a different treatment above the arch, see cat. no. 122; and Schnitzler, Kofler cat., no. S-66.)

H: 10 in. (25.1 cm); W: [open] 7 in. (18 cm)

The Art Institute of Chicago (1937.827), the Mr. and Mrs. Martin A. Ryerson Collection

History: Collection of Frédéric Spitzer, Paris (until 1893).

Bibliography: Molinier, Spitzer cat., vol. 1, p. 47, no. 60; *Catalogue des objets d'art et de haute curiosité: Antiques du moyen-age et de la renaissance de la collection Spitzer*, sale, Chevallier et Mannheim, Paris, 17 April 1893, lot 95; Koechlin, no. 208; H. Parker, *The Christmas Story* (Chicago, 1949), unnumbered ill.

The Life of Christ

Left wing of an ivory polyptych, Spanish or French (?), about 1300

The wing is unconventional in iconography as well as in format, with four levels of scenes instead of the usual three. In the

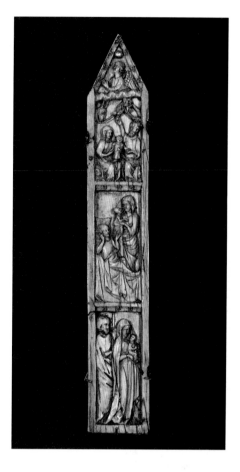

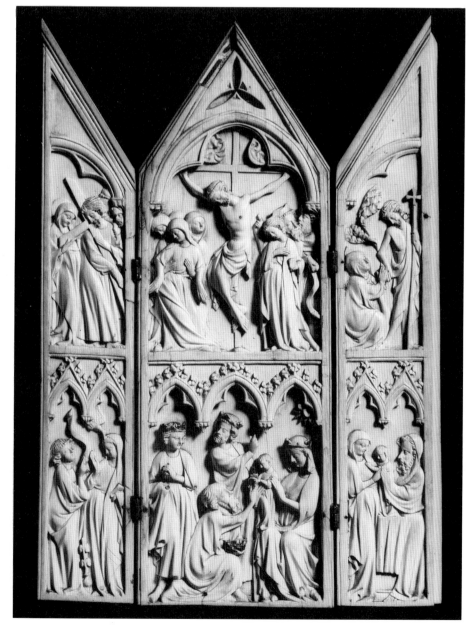

upper compartment is an angel; the second presents Joseph reaching to pick fruit from a tree above his head, while the Virgin holds the Christ Child, and animals hover around her. Unlike the standard Nativity scene with characters facing each other, the two figures face the viewer, as in a Coronation of the Virgin. The third scene, also rare, shows the Virgin in bed, attended by a woman who holds the Christ Child— a format used for the Birth of John the Baptist. At the bottom is a portion of the Presentation in the Temple: the Virgin and Child accompanied by a bearded figure with a candle. There are rosettes decorating the gable and two of the transverse moldings. The upper molding is a wavy-cloud motif.

The gable has been trimmed of its external decoration (crockets?), and only fragments remain of two silver hinges on the right side. The figures are considerably rubbed.

Notes: Details of the Barnes Foundation plaque suggest that it is the outer left wing of a Virgin shrine with four wings. The Presentation, for instance, which is almost invariably at the lower right in Virgin shrines, must have had the figure of

Simeon on the next wing. Another unusual feature is the format of the upper Nativity, and the inclusion of two Nativity scenes is otherwise unknown. A figure of a woman attendant occasionally occurs in a Nativity scene (see, for example, Koechlin, no. 171).

In summary, the attenuated figures in the Presentation, the weak quality of the carving, and the unusual iconography imply that this wing was made in a provincial center, perhaps in Spain or rural France.

H: approx. 8¼ in. (21.2 cm); W: approx. 1¼ in. (3.3 cm)

The Barnes Foundation, Merion, Pennsylvania

History: Acquired by Dr. Albert Barnes before 1922.

45

The Life of Christ

Fragments of ivory polyptych wings, English, second quarter of 14th century

Of these seven scenes that survive from the wings of an ivory polyptych, dismembered before 1910, six are in American collections. The Annunciation (a) shows a long-faced angel, his left wing spread across the composition, holding a scroll inscribed AV.. (for *Ave Maria*) in his left hand. The Virgin, holding her book, makes a gesture of surprise.

In the Annunciation to the Shepherds (b) an angel stands on top of a tall hillock, pointing down at two shepherds accompanied by grazing sheep.

The Massacre of the Innocents (c) includes a soldier in chain mail stabbing an infant, while a seated mother mourns over her child. This panel would have followed Herod (g) holding a sword and giving orders to two soldiers.

The Presentation (d) is portrayed with the common iconography, including a long-faced Simeon, as are the Visitation (e) and the Flight into Egypt (f). The donkey in the Flight is rendered with remarkable realism.

All the figures are placed beneath single trefoil arches set on corbels, and the scenes are divided by moldings decorated with roses, which appear also on the pinnacles of the upper scenes. There are many traces of polychromy, the backgrounds in all cases being covered with circles of six or seven dots, originally gilt. In the Annunciation to the Shepherds the hillock is painted with grass and foliage, and the first shepherd's boots are black.

The complete composition of the four wings can be reconstructed both from the iconography and from the fact that the panels are of two different sizes, the inner wings having been narrower than the outer ones. The central motif of the tabernacle would have been a statue of the Virgin and Child (see figure 7).

Notes: The evidence suggests an English origin for these panels, as the scenes are not

those usually depicted on the wings of French polyptychs. The Herod scene appears on only one other ivory, probably German (in the collection of Prince Wallerstein-Oettingen; Koechlin, no. 181 bis), which also shows the rare Flight into Egypt. The Flight is to be found in French work only in two of the Soissons Group diptychs of the thirteenth century (Koechlin, nos. 37 and 44) and on a pyx of the mid-fourteenth century (Koechlin, no. 241). Another pyx with the Flight (Metropolitan Museum of Art; inv. 17.190.168) might well be English, and the Flight that appears in cat. no. 33 is also attributed to England.

The Annunciation to the Shepherds as a separate scene is rare at this time (see Koechlin, nos. 447 and 448); the present example is close in conception to that in a quadriptych with the angel standing on a hillock (Longhurst, vol. 2, p. 23, fig. 2).

It has been pointed out (by Claude Blair, former keeper of metalwork at the Victoria and Albert Museum) that the sword in the hand of Herod is blunted and may be the Curtana, or English sword of Mercy—a usage that is not known to have occurred outside Britain. The soldiers' headgear, with reinforcing bands and bulging sides, resembles the Spangenhelm type, but it is in fact (according to Blair) a German hat used by knights in the fourteenth century, as seen in the Manessa Codex and the tomb of Premislaus of Steinau (M. Norris, *Monumental Brasses, The Craft* [London, 1978], fig. 113). This fact and the similarity of the iconography with the Wallerstein ivory suggest that a German workman or a German model was employed in the English workshop from which the polyptych came.

Figure 7 *Projected restoration of polyptych (cat. no. 45).*

The angel of the Annunciation, whose wing spreads across the composition, also an English feature, is found occasionally on the Continent in French and Flemish manuscripts. (In French ivories the angel is usually flying down to the Virgin, but if standing his wings are behind him [Koechlin, nos. 250 and 819; and cat. no. 57 in this book]). The English fondness for this spreading wing is best illustrated in manuscripts—for instance, four of about 1300–1310 (Sandler, figs. 77–80).

(a) *Annunciation* H: 2¹⁵⁄₁₆ in. (7.6 cm); W: 1¾ in. (4.4 cm)

(b) *Shepherds* H: 2¹¹⁄₁₆ in. (6.9 cm); W: 1³⁄₁₆ in. (3.1 cm)

(c) *Massacre* H: 2¹⁵⁄₁₆ in. (7.6 cm); W: 1¼ in. (3.3 cm)

(d) *Presentation* H: 2⅞ in. (7.3 cm); W: 1¾ in. (4.4 cm)

(e) *Visitation* H: 2¹¹⁄₁₆ in. (6.9 cm); W: 1³⁄₁₆ in. (3.1 cm)

(f) *Flight* H: 2⅞ in. (7.3 cm); W: 1¹¹⁄₁₆ in. (4.3 cm)

(g) *Herod* H: 2⅞ in. (7.3 cm); W: 1¹¹⁄₁₆ in. (4.3 cm)

(a,b,c) Crocker Art Museum, Sacramento (1960.3.54, 78, and 79), gift of Ralph C. and Violette M. Lee; (d) National Museum of American Art, Smithsonian Institution, Washington, D.C. (1929.8.240.14), gift of John Gellatly; (e,f) The Metropolitan Museum of Art, New York (64.27.19 and 20), bequest of Charles F. Iklé; (g) Musée des Beaux Arts, Niort (314 A 137)

History: The Herod scene was published while in the collection of M. Piet-Lataudrie, by which time the wings must have been dismembered.

Bibliography: E. Molinier, "La collection de M. Piet-Lataudrie," *Les Arts,* August 1909, p. 6; Koechlin, no. 182.

a

e

b

g

c

d

f

59

46

The Arrest of Christ

Ivory relief, Flemish (?), 1340–1370

Christ, holding a book, is embraced by Judas, while a soldier grasps him by the shoulder. In the background is a second soldier making a grimace. The figures are tall, the drapery simple in the mode of the second quarter of the century, and the edges of the plaque are notably straight.

The ivory has no signs of attachment. There is some rubbing of heads of the figures.

Notes: Of the altars made of many scenes with applied ivory figures, few remain intact. There is one, for example, in Trani Cathedral with a central Virgin and Child that appears to be French (or an accurate copy of a French ivory) of the late thirteenth century, while the framework and other figures are clearly Italian (Giusti and de Castris, p.46). A triptych of the same period (*Aachener Kunstblätter* 51 [1982], p. 40, no. 43), with Italian ivories and frame, has had a Rhenish ivory angel added and the exterior painted, probably in Cologne. Precedents exist in the North as well, such as the large groups from a Passion altar (*Fastes du gothique*, nos. 133–136). A three-figure plaque from an Arrest (Koechlin, no. 27) can be dated in the late thirteenth century.

The present relief is most closely related to a scene of the Washing of the Feet (Koechlin, no. 734), which is approximately the same size, has similar elongated faces, and may come from the same ensemble. The grimacing soldier is northern in character, like the tormentor in a Carrying of the Cross (cat. no. 174) and a similar figure in

a marked Antwerp wood relief (sale, Sotheby's, London, 10 April 1967, lot 111). H: 4 in. (10.2 cm); W: 1⅞ in. (4.9 cm) Collection of Max Falk, New York *History:* Collections of Fernandez, Paris; Charles Bollas Rogers, New York; and Thomas Flannery, Winnetka, Ill. (until 1983).

Bibliography: World as Symbol, no. 57; Flannery sale, Sotheby's, London, 1 December 1983, lot 59.

47

Seated Scholar

Ivory relief, Middle Rhenish, fourth quarter of 14th century

The bearded man is seated with one hand raised and the other grasping his left knee. He wears a scholar's hat (a type that is sometimes a Hebrew cap) and sits on a bench with incised brick patterns. The eyes are carved to show the pupils.

The back is crosshatched to hold glue for attachment. The right hand is lacking, as are the toes of both feet.

Notes: The teaching gesture of the figure suggests that he is a doctor disputing with the Christ Child. Such a seated figure is seen in a diptych (formerly in the Dormeuil collection; Koechlin, no. 351), and the subject appears in other ivories of the fourteenth and fifteenth centuries (Koechlin, nos. 821 and 956).

The rendering of the eyes and the crisp handling of the drapery relate to late-fourteenth-century works from the Kremsmunster atelier and other middle-Rhenish productions.
H: 3½ in. (8.2 cm)
Private collection

48

Arm Reliquary

Ivory, French (?), last quarter of 14th century

The reliquary is a left lower arm, curving slightly and wearing a long sleeve with the cuff overlapping the back of the hand. There are six laces to secure the cuff on the underside. A rectangular opening with a recessed border, with six holes for a frame, once retained a crystal or glass window. The base is ornamented with a double molding and was originally closed with an oval inset, which is lacking. The thumb is rather fat, and the fingers are carefully delineated with joints and nails.

Notes: The cuff overlapping the wrist was used throughout western Europe in the last part of the fourteenth century (according to Leonie von Wilckens, a textiles specialist in Nuremberg). It was worn by both

men and women. A fine representation of it can be seen on the tomb of an unknown lady in the cathedral at Hallesaale (H. Kunze, *Die gotische Sculptur in Mitteldeutschland* [Bonn, 1925], fig. 43).
H: 11³⁄₁₆ in. (27.8 cm); W: 2⅛ in. (5.1 cm)
Museum of Fine Arts, Boston (49.488), William Francis Warden Fund
History: Purchased at the Joseph Brummer sale, New York, 1949.

Bibliography: Brummer sale, Parke-Bernet, New York, 14 May 1949, lot 692; *Boston Museum Bulletin* 60, nos. 301–302 (1957), p. 97, fig. 58.

RELIGIOUS IVORIES

DIPTYCHS AND PLAQUES

49

The Passion of Christ

Ivory diptych, French (North France or Paris), 1250–1270

The ivory belongs to the Soissons Group of diptychs (see cat. no. 36). Its eighteen scenes read from the bottom left to right, back and forth in three tiers, as follows: the Temptation of Judas, the Payment of Silver, the Arrest of Christ, Judas Hanged, Christ Led before Pilate, Pilate Washing His Hands, the Flagellation, Christ Carrying the Cross, the Crucifixion, the Deposition, the Entombment, the Three Marys at the Tomb, the Pentecost, the Harrowing of Hell, Noli Me Tangere, Christ Appearing to His Mother, Doubting Thomas, and the Ascension.

The scenes are placed beneath tall trefoil arches with openwork hexafoils in the central spandrels, while in the two lower tiers large leaves fill the outside spandrels (flanking the hexafoils). The upper tier has pointed gables with crockets and pinnacles, the center of each plaque being emphasized by a larger pinnacle.

Except for rubbing and loss of paint, the only damage is a broken finial on one of the larger pinnacles.

Notes: While there is much variation in ivories of the Soissons Group, the model for the scene of the Temptation of Judas appears almost identically in two works that differ in all other particulars from the present diptych (Longhurst, vol. 2, no. A546–1910; and Koechlin, no. 34). The use of large leaves in the spandrels, also with openwork hexafoils, occurs in only one other ivory, a triptych portraying the Infancy of Christ (Koechlin, no. 44).

H: 8 in. (20.4 cm); W: [open] 6¾ in. (17.3 cm)

The Saint Louis Art Museum (183:1928)

History: Collection of Frédéric Spitzer, Paris (until 1893). (Purchased from Arnold Seligmann, Rey and Co., New York, 1928.)

Bibliography: Molinier, Spitzer cat., vol. 1, p. 58, no. 96; *Catalogue des objects d'art et de haute curiosité: Antiques du moyen-age et de la renaissance de la collection Spitzer*, sale, Chevallier et Mannheim, Paris, 17 April 1893, lot 131; *The Life of Christ* (exh. cat., Wadsworth Atheneum, Hartford, 1948), fig. 12.

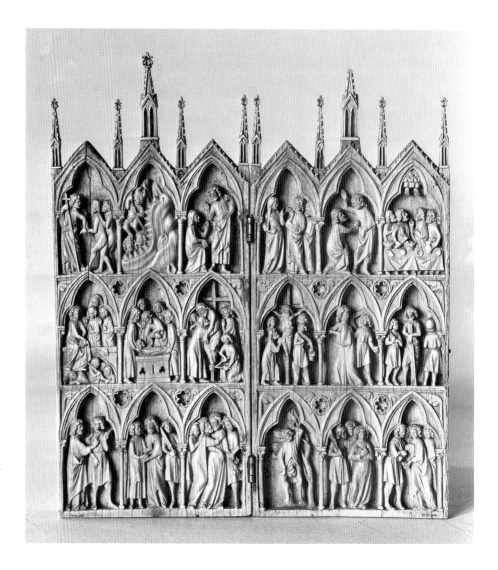

50

The Crucifixion

Fragment of an ivory diptych, French (Paris?), 1290–1320

The figure of Christ is placed between Longinus, who is holding his lance and touching his forehead, and the missing sponge bearer, whose sponge can be seen on the right. The Virgin, wringing her hands, stands behind Longinus.

A fragment of a colonnette remains on the left edge, which has been broken away. Also missing are the upper part of the plaque, including Christ's arms, and the entire right side, which would have shown the sponge bearer and Saint John. There is a hinge miter on the left side.

Notes: This fragment is from the right wing of a diptych. The figures, with large heads and small features, are related to a number of other works in many collections. A gabled diptych wing with the Annunciation (Musée du Louvre; inv. OA 2761) has carving that seems to be by the same master. The position and large feet of Longinus in the Crucifixion are comparable to those of the angel in the Annunciation; similar also is a feature of the Virgin's garment in the Cleveland fragment and that of the angel in the Annunciation (below the belt in each

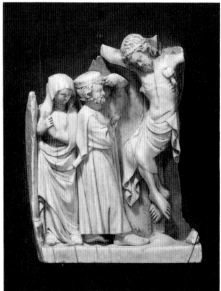

case, the drapery falls in vertical folds). The mate to the Louvre wing, a Nativity in the Victoria and Albert Museum with the annunciate angels standing on a hillock (Longhurst, vol. 2, no. 242–1867), has the same composition as an Annunciation to the Shepherds in a gabled diptych in the Louvre (Gaborit-Chopin, nos. 215–216).

Two aspects common to English work occur in these ivories: the gable form (as pointed out by Alfred Maskell, who once owned the Victoria and Albert wing; see Longhurst, vol. 2, no. A545–1910) and the feature of the annunciate angel or angels standing on a hillock (see Warner, *Queen Mary's Psalter*, f. 162).

H: 3⁵⁄₁₆ in. (8.4 cm); W: 2½ in. (6.4 cm); D: ⁷⁄₁₆ in. (1.1 cm)

The Cleveland Museum of Art (78.55), gift of Dr. Norman Zaworski

History: Collection of Countess M. Benckendorff.

Bibliography: Medieval Works of Art, sale, Sotheby's, London, 2 December 1969, lot 15A; Wixom 1979, p. 114.

51

The Crucifixion

Right leaf of an ivory diptych, French, first quarter of 14th century

The arms of the Christ are nearly parallel to the arms of the Cross. His figure is flanked on the left by the Virgin and Longinus and on the right by Stephaton with bucket and sponge and Saint John with a book. Framing the scene is an unusually heavy trefoil arch with bud crockets on its upper edge. The plaque is not rectangular, the upper border being sloped from the center, and appears to have been trimmed.

The hinge miters are filled, and the back is crosshatched. A small section is missing from the shaft of Stephaton's sponge.

Notes: The placement of Christ with arms parallel to the Cross is found in a few ivories of the early part of the fourteenth century—for example, a French triptych (Koechlin, no. 194) and an English example (Longhurst, vol. 2, no. 243–1867). The combination of features suggests that the Kansas City ivory is French from a center other than Paris.

H: 3¹³⁄₁₆ in. (9.6 cm); W: 3⅛ in. (8 cm)

The Nelson-Atkins Museum of Art, Kansas City (51.8), Nelson Fund

Figure 8 Virgin and Child, ivory, Musée du Louvre, Paris.

History: Collection of Emile Baboin, Lyons. (Purchased from Raphael Stora, New York, 1951.)

Bibliography: Koechlin, Baboin cat., no. 1; Koechlin, no. 434.

52

The Crucifixion

Right leaf of an ivory diptych, French (Paris), early 14th century

The figures are carved to unusually massive scale in this large diptych. Christ is shown in an S-posture with arms, of different lengths, at slightly different angles. His

loincloth is detailed. Wearing apron drapery, the Virgin, at the left, raises her hands expressively, while, at the right, Saint John looks away, one hand to his cheek and one holding a book. On either side of the *titulus* posted on the rugged Cross, the sun and the sickle moon emerge from behind clouds.

The scene is set beneath a single wide trefoil arch surmounted by a gable and large floral crockets and finial. In the spandrels are two large quatrefoils with raised conical centers.

There is considerable remaining polychromy: red, silver, and gold on Christ's drapery; gold dotted borders and red turnovers with silver dots on Mary and John; gilding in the hair; green on the Cross; gold, white, and red on the leafage; and blue on the clouds. The gable is painted with a floral pattern in green and red on a white ground. Traces of gilt dots remain on the background, and it is evident that the cones in the quatrefoils were originally gilt. When the ivory was cleaned in 1989, much new gilding was removed, especially on the dotted background, the crockets, and the hair. The paint on the gable appears to be old, but the patterns and treatment are Baroque rather than Gothic.

Large hinges (now missing) were inset diagonally; there are chips at the upper hinge miter and the lower right corner. A small diagonal cut truncates the lower left corner, and bark shows on the back.

Notes: The other leaf of this diptych shows the Virgin standing on a dragon between candle-bearing angels (see figure 8; formerly in the Leopold Goldschmidt collection in Paris, it is now in the Louvre). The dragon is a rare and early feature, and the angels are of Rheimsian type with thirteenth-century drapery. Hovering angels touching the Virgin and kissing the hand of the Christ Child are unknown in other examples. Cut from the same section of tusk, the two plaques have the same flaw at their lower corners.

The early features of the Virgin plaque contrast with the apron drapery of the Crucifixion, which must date the two in the early fourteenth century.

H: 9¼ in. (23.5 cm); W: 5 in. (12.8 cm)

The Toledo Museum of Art (50.301), gift of Edward Drummond Libbey

History: Collection of John Malcolm of Poltalloch, County Argyll, Scotland; exhibited Leeds, 1868 (according to label); collections of Baron Malcolm of Poltalloch; and Col. Edward Donald Malcolm (until 1913). (Purchased from Raphael Stora, New York, 1950.)

Bibliography: Catalogue of Bronzes and Ivories (Burlington Fine Arts Club, London, 1879); Malcolm sale, Christie's, London, 1 May 1913, lot 19; R. Riefstahl, "Medieval Art," *Toledo Museum News*, n.s. 7, no. 1 (Spring 1964), p. 15; "Medieval Art at Toledo: A Selection," *Apollo* 86, no. 70 (December 1967), p. 441, fig. 11; D. Gaborit-Chopin, *Nouvelles acquisitions du département des objets d'art, 1985–1989* (Musée du Louvre, Paris, 1990), no. 20, pp. 52–55.

See also colorplate 9.

53

The Life and the Passion of Christ

Ivory diptych, possibly Spanish, first quarter of 14th century

Reading from the lower left upward, then downward in the right leaf, the six scenes include the Entry into Jerusalem, the Flagellation, the Crucifixion, the Deposition, the Entombment, and the Harrowing of Hell. As part of the consistent exaggeration and distortion that occurs in the figures, there is unusual violation of the frames of scenes with drapery, accoutrements, feet, and, in the case of the nail puller in the Deposition, legs braced against the spandrels of the segment below. In the Harrowing of Hell, John the Baptist appears behind Christ.

The framing of the scenes includes fluted pilasters at the sides, from which spring a series of five uneven trefoil arches with nascent crockets, set against a striated architrave. The ground plane is canted toward the viewer in the two lower scenes and the Deposition.

There are considerable remains of polychromy: gold on hair, beards, halos, and Crosses; green on the tree; brown on the lance, whips, and designs on the sarcophagus; and blue on a number of garments.

The diptych leaves were joined by four sets of hinges, now missing, and some of the miters are filled with added blocks of ivory.

Notes: The origin of this ivory is complex, as it comes from an atelier from which four other works are known, all with unusual features. Two diptychs with related

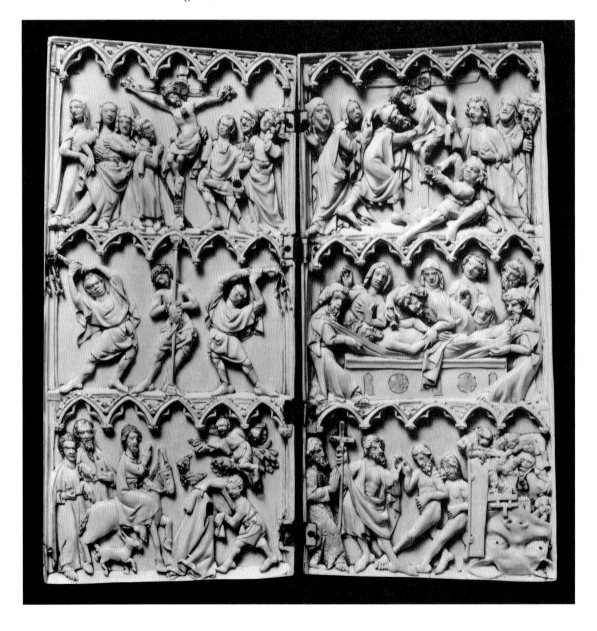

Passion scenes, both beginning with the Arrest of Christ rather than the Entry, are in London at the Wallace Collection (inv. 431) and the British Museum (Dalton, no. 283). They include John the Baptist in the Harrowing and similar groups of figures in similar costumes in the other settings. Both scenes of the Arrest give a prominent role to Hedroit, the smith's wife, who made the nails for the Crucifixion. The architectural enframements of the two ivories, which have wide, flattened arches with trefoil piercings, are quite different from those of the Montreal example.

A diptych with a similar arcade of five arches, once in Germany (Neuhaus advertisement, *Kunst und Antiquitäten* 3 [1986]), contains scenes of the Dormition and the Coronation of the Virgin. This ivory relates in turn to a leaf with the Dormition of the Virgin in the Louvre (Koechlin, no. 215), which has the architectural framework of the British Museum and Wallace Collection diptychs. All the works seem to be by different hands in a workshop that understood Gothic architecture only vaguely and was experimenting with several schemes.

The Montreal diptych is replete with expressive gestures and experiments. The Flagellation, for instance, is given an entire tier of the ivory, while the same scene is reduced to a small space in the other examples. The Mouth of Hell, combined with the Gates of Hell, is introduced into the Harrowing, and the treatment of the nude Adam and Eve is daringly innovative— far in advance of the interpretation in the other works. The continual overlapping of borders and violation of the frame is a feature found at this time only in English art—manuscripts, sculpture, and architecture—for instance, the Ramsey Psalter of 1300–1310, where every border is violated and two figures even lean out of a miniature into the margin (*Age of Chivalry*, fig. 566). It can only be concluded that the carver of the Montreal ivory, no matter where he may have been working, was an Englishman.

The closest models for the present subjects are two Rose Group diptychs in the Gulbenkian Foundation collection in Lisbon (Koechlin, no. 256) and the Escorial (Koechlin, no. 258), which are possibly Spanish. The introduction of Hedroit into the Arrest was known both in England (Queen Mary's Psalter; see Warner, pl. 256) and France (Hours of Etienne Chevalier;

see Sterling; fig. 16), and the Virgin carried to Heaven in a napkin by angels occurs in English alabasters. The appearance of John the Baptist in Hell, Byzantine in origin, can be found in Italy at Torcello, in Greece at Daphne, in England at the British Library (Arundel MS. 83, f. 132v), in France at the Louvre (the *Parement de Narbonne*), and in Spain in a door panel of the Cathedral of Burgos (A. Masseron, *St. Jean Baptiste dans l'art* [Paris, 1957], figs. 127–131).

The place of origin for the present work and related ivories must have been located where good models were known and Byzantine influence was current in the early fourteenth century but where Gothic architecture was not fully understood. It seems unlikely that the workshop was in France, England, or Germany, unless it was in a backwater; therefore, it was probably in Spain, where there were workmen of differing sculptural backgrounds.

H: 8½ in. (21.6 cm); W: 4 in. (10.2 cm) each

The Montreal Museum of Fine Arts (950.51.Dv.6), gift of Miss Olive Hosmer

History: Collection of Emile Baboin, Lyons; and Miss Olive Hosmer, Montreal. (Purchased from Raphael Stora, New York, 1950.)

Bibliography: Exposition retrospective (Dresden, 1906), no. 1429; Koechlin, Baboin cat., no. 20; Koechlin, no. 823; *The Montreal Museum of Fine Arts: Painting, Sculpture, and Decorative Arts* (Montreal, 1960), p. 31; L. de Moura Sobral, "La crucifixion vue à travers les ages," *M* 6 (Spring 1975), p. 17, fig. 7.

54

The Life of the Virgin

Ivory diptych, English, first quarter of 14th century

With their figures occupying all the available space, the four scenes read from left to right, beginning at the bottom: the Annunciation and the Visitation, the Adoration of the Kings, the Coronation of the Virgin, and the Death of the Virgin. In the upper register a wavy band of clouds fills the sky.

There is much polychromy on the ivory. Behind the Coronation is a cloth of honor, painted green with gilt designs; the throne is treated with black verticals; and the garments, as in all the scenes, have gilt borders with an accompanying row of dots. The Virgin's book in the Annunciation is red with gold clasps; and in the Adoration red is used for the cross in Christ's halo, for the collar of one king, and for the turnovers of the kings' robes. There is blue on the Virgin's gown in the lower right scene, as well as blue turnovers in the drapery. The eyeballs are painted black. A pattern of seven dots, originally gilt but now showing as bole, is seen on the background, in the hair, and on the clouds. The scenes are divided with a transverse molding picked out with red.

The hinges are of unusually heavy silver, and one is broken. There is a small chip at the upper left corner of the right-hand leaf and a break at the lower hinge.

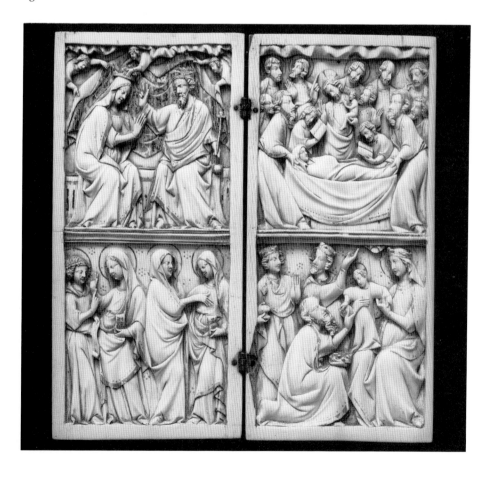

Notes: A diptych with an identical subject (in the Victoria and Albert Museum [Longhurst, vol. 2, nos. 521-1893 and A 67-1925]) is probably from the same shop but carved by another hand. While there are considerable variations in its costumes and attributes, the treatment of the figures is generally the same, and such details as the clouds in the upper register are repeated. A row of roses divides the upper and lower scenes of each.

Both wings of the Victoria and Albert diptych, acquired separately, have English histories; the work has long been called English and compared to the much-damaged sculpture of Lady Chapel at Ely (Prior and Gardner, p. 372, fig. 427). Another related piece, possibly English, is a diptych with similar wavy bands of clouds at the top of the scenes (Musée du Louvre, inv. OA-2595).

H: 7½ in. (18.2 cm); W: [open] 7 in. (17.4 cm)

The Godwin-Ternbach Museum, Queens College (CUNY), Flushing, New York (61.2 a and b), gift of Judge Irwin Untermeyer

History: Collections of Henry Walters, Baltimore; and Judge Irwin Untermeyer, New York.

Bibliography: Mrs. Henry Walters sale (Parke-Bernet, New York, 1 May 1941, lot 1048).

55

The Flagellation and the Deposition

Left wing of an ivory diptych, French (Paris), first quarter of 14th century

This panel exhibits the generous space relationships found in the Rose Group, of which it is a member, although without roses carved on the horizontal divisions. The upper scene shows the Flagellation with two tormentors; below is the Deposition with Nicodemus holding the body of Christ, while the Virgin kisses his hand, John stands aside with his Gospel, and a smaller kneeling figure pulls the nail from Christ's feet.

The ivory once had wire hinges that pierced the back of the plaque on the right side, and it is somewhat rubbed from use. There are several age cracks in the panel and in the top a hole that may not be original.

Notes: The figures relate to models in other ivories of the Rose Group, especially a diptych in the Louvre (Koechlin, no. 237) in which the left-hand tormentor, with a dis-

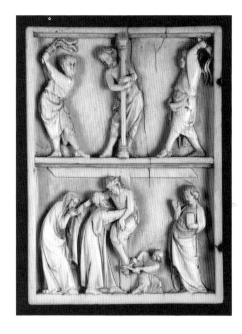

tinct sleeve pattern caused by the raised arm, is carved almost exactly in reverse of the one in this plaque. The tormentor with the upraised whip is in many Rose Group ivories on the left side, as in one (Randall, no. 288) that shares the generous spatial composition. But the figure is seen on the right in other plaques of the group (see Randall, no. 289).

In the Deposition scene is another detail repeated in many Rose Group ivories: the fold of drapery falling from the shoulder of Nicodemus (see Koechlin, nos. 237, 256, and 258). Also typical is the Cross shown with square ends in the Crucifixion scene but with diagonally cut ends in the Deposition—a feature that appears in this group and is occasionally repeated in later works (for example, Koechlin, no. 372) with the tormentor figure taken from a Rose Group model. Although the style and details of many of the Rose Group ivories vary considerably, there is a consistency that suggests a major center with many shops and a certain freedom of interpretation.

H: 4¹¹⁄₁₆ in. (12.5 cm); W: 3⅜ in. (8.5 cm)

Collection of Anthony Geber, Washington, D.C.

History: In 1924 the ivory was apparently in an Austrian collection; a note on the back states that it was shown to a Professor Hermann at the Kunsthistorisches Museum in Vienna.

56

The Deposition

Left leaf of an ivory diptych, French (Avignon?) or Italian (Venice?), first quarter of 14th century

In a complex scene with eight figures, the body of Christ is lowered by a man with a sling and received into the arms of Nicodemus and Joseph of Arimathea. The Virgin and Saint John stand together at the left side, and there are two nail pullers.

Two men stand on ladders, a straight one resting against the arm of the Cross and one constructed in stool form. The Cross is rusticated, and a skull rests at its foot, against the hill of Golgotha.

The ivory is framed in a simple rectangle, and there are hinge miters on the right edge. Traces of gilding remain in John's hair and that of the man on the ladder. Attached to the border of the ivory with eight nails is a silver frame that appears to be late medieval in date (fifteenth century?). Since its function is not to reinforce, the framing probably indicates that the ivory was turned into an icon.

Notes: While the carving of the hair and face types of the male figures is in the Paris tradition, the composition is Byzantine in origin, and the head of the Virgin relates to Italian works of the thirteenth century. Two late-Byzantine ivories show the Deposition with ladders, one with both straight and folding ladders and one with the stool type (Goldschmidt, nos. 23 and 25).

Here the artist enriched the composition with extra figures, placing Mary and John together at the left and adding the extraordinary figure on the arm of the Cross lowering Christ's body. The area of production must have been one in which Paris style or a Paris-trained carver came in contact with the Byzantine tradition, which might well have been Avignon or possibly Venice, where Byzantine conventions were still strong. That the use of a composition involving two ladders existed in Avignon is confirmed by a miniature in a Book of Hours from that center (L. Randall, *Medieval and Renaissance Manuscripts in the Walters Art Gallery* [Baltimore, 1989], vol. 1, no. 78, pl. VId), which also has the rare feature of Mary and John to the left of the Cross.

H: 4 in. (10.2 cm); W: 2⁷⁄₁₆ in. (6.3 cm)

The Godwin-Ternbach Museum, Queens College (CUNY), Flushing, New York (57.14), gift of Norbert Schimmel

History: Collection of Norbert Schimmel, New York.

Bibliography: World as Symbol, no. 56.

57

The Life of Christ

Ivory diptych, French (Paris), second quarter of 14th century

In three tiers divided by moldings carved with roses, the scenes read from left to right, beginning at the bottom: the Annunciation, the Visitation; the Nativity, the Adoration of the Kings; the Presentation, Christ Disputing with the Doctors; the Supper at Emmaus, the Last Supper; the Crucifixion, the Resurrection, the Ascension; Pentecost, and the Coronation of the Virgin.

The altar cloth in the Presentation retains most of its gilt decorative patterns; and the green paint on the lily in the Annunciation survives, as do traces of green in the landscape. Both panels were drilled at the top for hanging, the holes filled at a later time. The missing triangle of ivory from the upper inside corners results from the shape of the original slab before it was cut into two plaques. Crosshatching on the edges made it possible for each panel to be brought to a rectangle with glued ivory fills.

H: 9¹³⁄₁₆ in. (24.9 cm); W: [open] 10⅜ in. (26.4 cm)

Detroit Institute of Arts (40.165), gift of Robert H. Tannahill

History: Collection of Maurice Sulzbach (MS monogram seal on back). (Purchased from Arnold Seligmann, Rey and Co., New York.)

Bibliography: Tannahill, no. 56; *BDIA* 20, no. 8 (May 1942), pp. 74–77; D. A. Walsh, "Notes on the Iconography of a Fourteenth-Century Ivory," *Porticus* 8 (Memorial Art Gallery, Rochester, 1984), p. 5; *Medieval Treasury,* pp. 152–153; P. Barnet, "From the Middle Ages to the Victorians," *Apollo* 124, no. 298 (December 1986), p. 39.

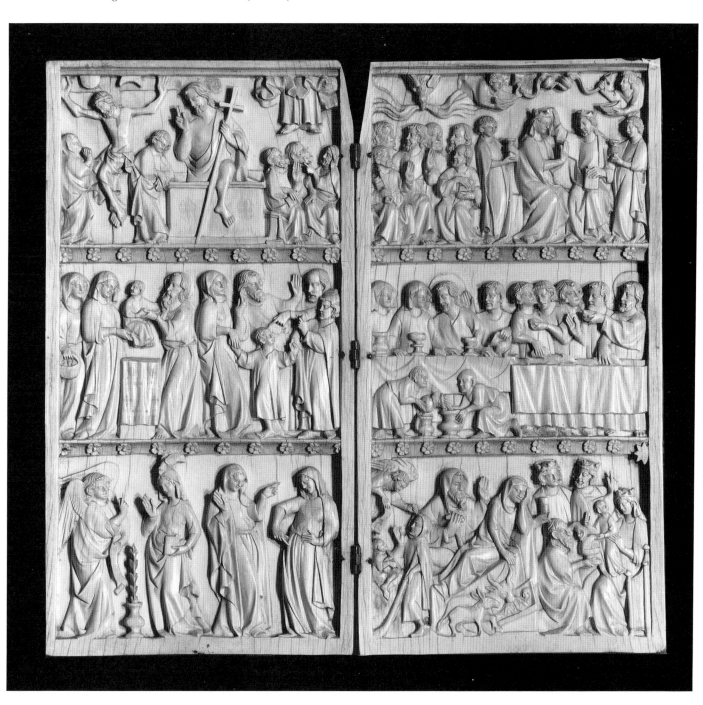

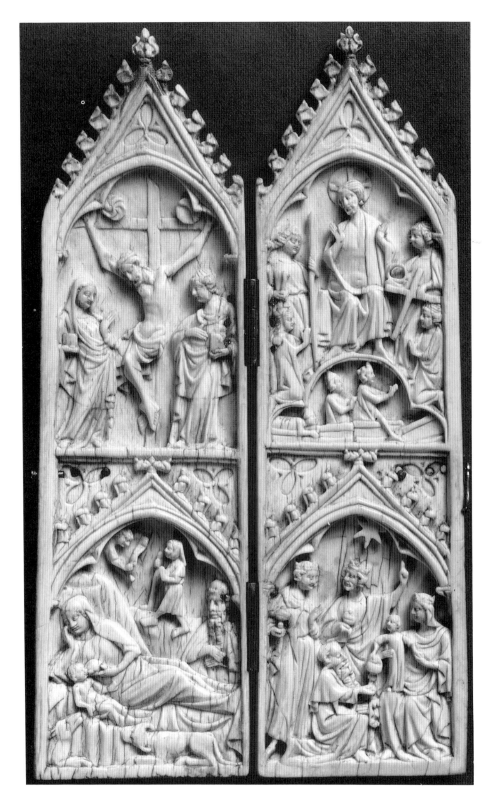

The unusually large silver hinges with shaped plates, surface mounted on the reverse, are replacements. While the catch is original (the plaque broken where a hole was drilled for it), the silver hook is modern, and there is an ivory fill where it is attached.

Notes: A second ivory of this form (Dalton, no. 268) exhibits certain differences, but the long torso of Christ in the Resurrection is notably similar. Another parallel is a terracotta model for an ivory of the Nativity (*La Nativité dans l'art* [Musée Curtius, Liège, 1959], no. 11), excavated in Liège, that shows the second king pointing at the Bethlehem star with his left hand and wearing a robe that sweeps across his chest. These unusual features are repeated exactly in the Fogg ivory.

H: 8½ in. (21.7 cm); W: 2⅜ in. (6.1 cm) each

Fogg Art Museum, Harvard University, Cambridge (1946.56)

History: Purchased from Brummer Gallery, New York, 1946.

Bibliography: G. Swarzenski, Fogg Art Museum *Bulletin* 10 (December 1947), pp. 179–184.

59

The Virgin and Child with Angels

Left leaf of an ivory diptych, French (Paris), second quarter of 14th century

The curved figure of the Virgin is seen frontally, while her head is in three-quarter view. She holds the Christ Child in her left hand and a stem of flowers in her right. The Child holds an apple. Whereas the Virgin's drapery has an apron fold in front, that of the two candlestick-bearing angels falls in a series of folds to the ground. All the angels' wings are carefully delineated, especially those that help to frame the figure of the Virgin.

58

The Life of Christ

Ivory diptych, Mosan, second quarter of 14th century

Beginning at the bottom, the scenes read from left to right and include the Nativity, the Adoration of the Kings, the Crucifixion, and the Last Judgment. The figures have unusually long torsos and straight mouths, and Joseph and the first king wear especially long, curly beards. Other anomalies are a nursing Child, with no manger, and, in the Crucifixion, a misunderstood right shoulder and neck of Saint John. The elongated leaves culminate in gabled tops with a trefoil in each tympanum, openwork crockets, and floral finials. The tympana of the lower scenes, framed by trefoils in the spandrels, are blind.

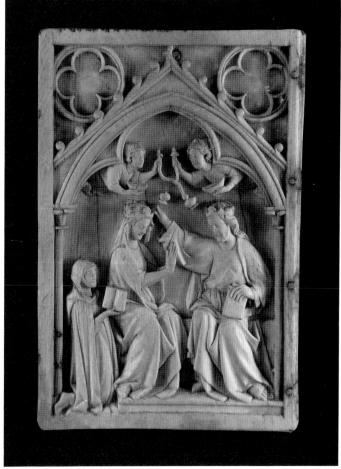

The setting is a large trefoil arch, on colonnettes with floral capitals, decorated with crockets of leaves and a poppy-head finial. Two censing angels are placed above the arch.

There is a small break at the lower hinge miter, and minor damage on the upper and lower borders.

Notes: An immensely popular type, this standing Virgin between angels was repeated in many versions. Among them are a number of plaques of similar size whose details are virtually identical in the central subjects but whose figures or ornaments above the arch vary considerably. One example (Metropolitan Museum of Art, inv. 17.190.288) has quatrefoils in the upper corners where other plaques have censing angels (the present ivory and another in the Metropolitan Museum [inv. 17.190.284]) and trefoils (cat. no. 74). This suggests that the model remained in use from the second quarter to the middle of the third quarter of the century, and perhaps longer. A panel treated with a triple arch (Koekkoek I, no. 24) appears to date from the third quarter of the century. Minor details—such as the arrangement of the angels' wings and whether they hold candlesticks or large tapers—naturally vary.

The plaques are paralleled by nearly identical figures of the Virgin and Child in the round in folding shrines of the second quarter of the century (see, for example, Longhurst, vol. 2, no. A557–1910, pl. VIII).

H: 6¾ in. (17.1 cm); W: 4³⁄₁₆ in. (10.7 cm)
The Nelson-Atkins Museum of Art, Kansas City (51.11), Nelson Fund
History: Collections of Paul Garnier, Paris (in 1906); and Emile Baboin, Lyons (after 1912). (Purchased from Raphael Stora, New York, 1951.)
Bibliography: G. Migeon, "Collection of Paul Garnier," *Les arts* 53 (May 1906), pt. 2, pp. 13–24.

60

The Crucifixion

Right leaf of an ivory diptych, French (Paris), second quarter of 14th century

Christ is crucified on a rusticated Cross between the figures of Stephaton, with a sponge, and Longinus, with his spear. The Virgin, on the left, turns away and raises her hand. The figure of John, on the right, clasping a hand to his heart, is unusual in that the mantle covers his head. Angels above the Cross hold the sun and the moon.

The scene is placed beneath a large, single trefoil arch supported by colonnettes. On either side of the gable with bud crockets are spandrels that contain large quatrefoils with protruding cones.

The plaque was once mounted with four hinges, and the left rear edge is

Figure 9 Coronation of the Virgin, ivory, Wernher Collection, Luton Hoo.

trimmed on a diagonal. The spear of Longinus is broken above his hand. There is later red paint on the reverse.

Notes: The left half of the diptych, showing the Coronation of the Virgin (the Wernher Collection at Luton Hoo, Bedfordshire; see figure 9), includes a donor—a kneeling woman wearing a wimple and holding an open prayer book.

The architectural enframement and spacious treatment of the two compositions, and the somewhat leaning postures of their figures, suggest the Paris shop of the Mege Master, who was responsible for a diptych with the Virgin and the Crucifixion (*Fastes du gothique*, no. 152) and a plaque with the Virgin and saints (*Fastes du gothique*, no. 153). The detail of two angels holding sun and moon is repeated in the Crucifixion plaque of the former. (See R. Randall, "A Parisian Ivory Carver," *JWAG* 38 [1980], pp. 60–69).

H: 5⅝ in. (17.1 cm); W: 3⅞ in. (9 cm)
The Nelson-Atkins Museum of Art, Kansas City (51.9), Nelson Fund
History: Collections of Octave Homberg, Paris; and Emile Baboin, Lyons. (Purchased from Raphael Stora, New York, 1951.)
Bibliography: Koechlin, Baboin cat., no. 2; Koechlin, no. 435.

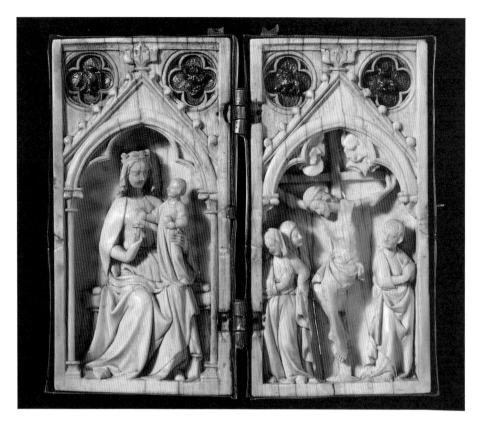

closely duplicated in an English diptych of the Rose Group with clouds (Longhurst, vol. 2, nos. 521–1893 and A67–1925, pl. XIII; see cat. no. 54 in this book).

A second ivory from the same atelier and by the same hand is the center of a triptych with the Virgin and Child (*Catalogue of the Exhibition of Ivories* [Burlington Fine Arts Club, London, 1923], no. 100; once in the collection of the Reverend L. Gilbertson). The composition, drapery, faces, enframing architecture, and bud crockets are all similar, and the columns retain their original spiral polychromy.

H: 4¼ in. (10.8 cm); W: 2⁵⁄₁₆ in. (5.9 cm) each
Royal Ontario Museum, Toronto (L960.9.24), The Lee Collection, on loan from the Massey Foundation
History: Collection of Lord Lee of Fareham, Buckinghamshire, England.

61

The Virgin and Child and the Crucifixion

Ivory diptych, English, second quarter of 14th century

The seated Virgin offers a flower to the Christ Child, who holds an apple in his left hand. In an unusual, unbalanced composition the crucified Christ is flanked, on the left, by a Holy Woman supporting the Virgin and, on the right, by John alone. The drapery descends from John's right hip in singularly flat folds. All the faces have sharp noses and chins, and the Virgin's eyes are rendered as slits.

Framing the scenes are single, nearly round arches with trefoil insets, the arch supported on columns in the Virgin plaque and on corbels in the Crucifixion. The blind tympana are surmounted by floral finials and rows of bud crockets. In the spandrels are quatrefoils set within circles, now containing copper and silver medallions with the four Evangelist symbols that were probably added in the nineteenth century.

The diptych has lost its hinges, which were small and set nearly flat, rather than diagonally. Each panel is now placed within a copper hinged frame, open in the back and with serrated edges, which are crosshatched; there are loops for hanging at the top. The Virgin plaque is crudely inscribed on the back, "1549 G [or C] Pusso," perhaps the date of the frame. Mirror damage is evident on all four face edges of the plaques, where metal tabs of the frame once existed.

Notes: A number of features suggest that these plaques are English and not French. The hinges were small and not set in the French fashion. Variations in the two frames, one with columns and one with corbels, and the asymmetry in the Crucifixion scene are likewise atypical. The rendering of the face of the Virgin is

62

The Trinity

Right leaf of an ivory diptych, English, second quarter of 14th century

God the Father, with a cruciform halo, sits enthroned, holding the crucifix between the half-length figures of Mary and John. The Dove of the Holy Ghost flies between God's mouth and the crucified Christ. At the foot of the composition, Adam in his winding sheet holds a chalice.

The figures occupy the space of a quatrefoil with intermediate projections which is set within a diamond. The areas at the top and bottom of the diamond have incised scrolls. Outside the diamond the four symbols of the Evangelists hold scrolls.

The ivory is gray in color and has apparently been buried, as there is deterioration on the Christ figure and in the center of the scene. A break has occurred at the upper hinge, and a later hole has been drilled at the top center. A slot in the back, also later, shows that the panel was reused as a pax.

Figure 10 Nativity, ivory, Fitzwilliam Museum, Cambridge.

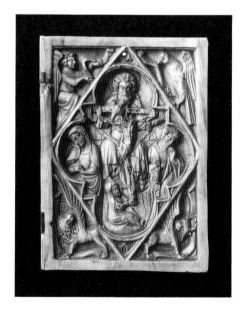

Notes: The left-hand leaf of the diptych (Fitzwilliam Museum, Cambridge; inv. M21–1917; see figure 10) shows the Nativity within the same configuration, held by two angels at the bottom and with censing angels at the top. From the same workshop but by a different carver is a diptych showing the Trinity (Gambier-Parry Collection of the Courtauld Institute in London; inv. 2) paired with the Ascension of the Virgin, surrounded by music-making angels (British Museum, London; inv. 1971–S-1, 1). This latter Trinity is accompanied by angels rather than Evangelist symbols.

There is a leaf in the same format with the Last Judgment surrounded by censing angels (Koekkoek I, no. 38); while yet another related diptych wing (cat. no. 63) includes the Trinity within an octafoil, surrounded by the symbols of the Evangelists, and a matching leaf (figure 11) shows the Adoration of the Kings.

Very popular in England, the Trinity is seen in two other ivories (*Age of Chivalry*, nos. 519 and 624), as well as in alabasters, brasses, and manuscripts. The geometric configuration is found in numerous English miniatures of the first half of the fourteenth century, such as the Trinity from the Grey-Fitzpayn Hours of 1308 (*Art of the Courts*, no. 35).

H: 3¾ in. (9.6 cm); W: 2¹³⁄₁₆ in. (7.2 cm)
National Museum of American Art, Smithsonian Institution, Washington, D.C. (1928.8.240.12), gift of John Gellatly
History: Collection of Princess Borghese, Rome (1892).
Bibliography: Borghese sale, Rome, 24 March 1892, lot 114.

63
The Trinity
Right leaf of an ivory diptych, English, second quarter of 14th century

An enthroned God the Father holds the crucifix, while the Dove of the Holy Spirit descends from his mouth to Christ. God is flanked by sun and moon and has a cruciform halo. At each end of the throne are recurved finials.

The figures are placed within a tall octafoil with four internal trefoil arches and with the symbols of the four Evangelists filling the corners. There is a band of beading at the top.

The lower hinge miter has been repaired. Visible on the outer edges of the plaque are file marks.
Notes: All the related Trinity groups are discussed in cat. no. 62. The matching leaf of the present ivory—an Adoration of the Kings (Bayerisches Nationalmuseum, Munich; figure 11)—exhibits more than

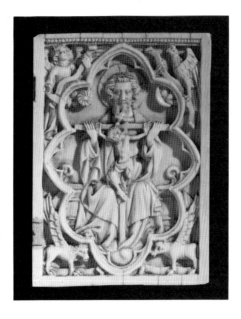

this plaque an exaggerated bulging of the eyeballs in all the figures. The distention may have been meant to provide emphasis under a coating of paint; there are remains of polychromy, including some on the eye of the second king. The edges of the left leaf are chamfered in the same way as the present example, indicating that it was the original finish.

H: 4⅛ in. (10.5 cm); W: 3 in. (7.1 cm)
Private collection, New York
History: Acquired from a Belgian noble collection through Edward R. Lubin, New York.

64
The Crucifixion
Left leaf of an ivory diptych, English (?), second quarter of 14th century

The Virgin stands at the left, clutching her breast, with Saint John at the right, his hand to his head. Above, emerging from the architecture, are clouds with the sun and moon. The figure of Christ is missing.

Over the single heavy trefoil arch set on corbels is a blind gable decorated with floral crockets and finial; the spandrels contain quatrefoils.

The hinges were very small and diagonally inset, their miters placed farther from the edge of the leaf than is customary. There are two later holes drilled at the top, a repair in the border at each side near the figures' heads, and a modern ivory fill on the lower border. The rough edges around the figures suggest that the background was not omitted originally but was cut away at a later time.
Notes: Neither the facial types nor the treatment of the hinges is French in character. The head of Mary is similar to those of an English limestone queen from Cobham, Kent, dated about 1325, and an ivory Virgin (*Age of Chivalry*, nos. 508 and 518); John's drapery is paralleled in Saint Mary's Psalter by a figure of Saint Thomas

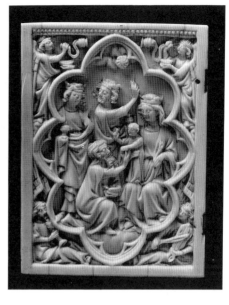

Figure 11 *The Adoration of the Kings, ivory, Bayerisches Nationalmuseum, Munich.*

(Warner, pl. 121, bottom left). No close parallels in ivory are known.
H: 3¼ in. (8.4 cm); W: 1¹³⁄₁₆ in. (5.1 cm)
Williams College Museum of Art, Williamstown, Massachusetts (78.2.5), gift of John Davis Hatch, Jr.
History: Collections of Emile Baboin, Lyons; and John Davis Hatch, Jr., Lenox, Mass. (Purchased from Raphael Stora, New York.)

65

The Virgin and Child with Angels

Left leaf on an ivory diptych, French (Paris?), second quarter of 14th century

The narrow panel accommodates a tall Virgin and Child and two tall angels. In the upper corners are two angels with censers, which fall below into the scene. The drapery is elegant and somewhat mannered, and the ivory is finely finished.

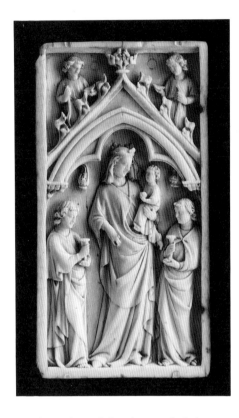

Above the trefoil arch on corbels is a blank gable with large floral crockets and a central finial.

Hinges were once inset diagonally. Both left-hand corners are chipped.

Notes: Angels above the roof line occur in French, German, and Mosan examples. The closest parallel to the wingless angels of the present ivory is a pair from Cologne (cat. no. 122).
H: 4⅞ in. (12.5 cm); W: 2⅝ in. (6.7 cm)
Edsel & Eleanor Ford House, Grosse Point Shores, Michigan

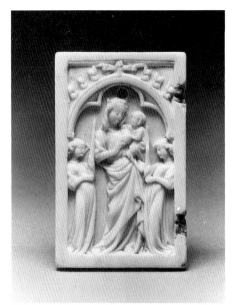

66

The Virgin and Child with Angels

Left leaf of an ivory diptych, French (Paris?), second quarter of 14th Century

The Virgin, her drapery unusually complex, stands between candle-bearing angels and offers the Child an orb.

The scene is framed beneath a single rounded trefoil arch, crowned with poorly rendered crockets and an exaggerated finial. A plain molding is incised across the top.

Where two hinges had been placed, open miters remain. The surface is considerably rubbed. There is a modern hole drilled above the Virgin's head.

Notes: The quality of the Virgin figure contrasts sharply with the coarse handling of the crockets—a disparity that suggests a small workshop in Paris or one following Paris models.
H: 2¾ in. (7 cm); W: 1¾ in. (4.4 cm)
Detroit Institute of Arts (43.463), gift of Robert H. Tannahill

67

The Crucifixion

Right leaf of an ivory dipitych, North French or Flemish, second quarter of 14th century

The figure of Christ on a tall Cross is placed between the Virgin fainting into John's arms, on the left, and two Hebrews, on the right.

A single trefoil arch set on corbels has spandrels containing rosettes; at the top is a band of studded ornament.

The hinges, now missing, were inset diagonally.

Notes: The scene of the Virgin fainting into John's arms is otherwise unknown in ivory. Tiny in scale, the plaque is superior in execution. Because of the studded border it can be associated with Flanders, Franco-Flanders, or North France.

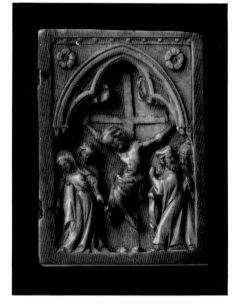

H: 2¼ in. (5.7 cm); W: 1¹¹⁄₁₆ in. (4.4 cm)
National Museum of American Art, Smithsonian Institution, Washington, D.C. (1928.8.240.20), gift of John Gellatly

68

The Passion of Christ

Ivory diptych, French, 1330–1340

The scenes read from the left, beginning at the bottom: the Flagellation, the Carrying of the Cross, the Crucifixion, and the Entombment. The format is uncommonly spacious, and there are some unusual details, such as the large cape of one flagellator, the pose of Christ in the Carrying of the Cross (turned back toward the Holy Women), and the broad, stubby figures of the Virgin and John in the Crucifixion.

Above the arcades of trefoil arches with well-articulated crockets and finials are moldings decorated with pairs of roses.

The hinges are modern, and at the top of each panel there are cuts and holes for a later arrangement. The ivory has been overcleaned.

Notes: The gesture of Christ turning toward his mother in the Way of the Cross, introduced by Jean Pucelle in the Hours of Jeanne d'Evreux (at the Cloisters, Metropolitan Museum of Art; Inv. 54.1.2),

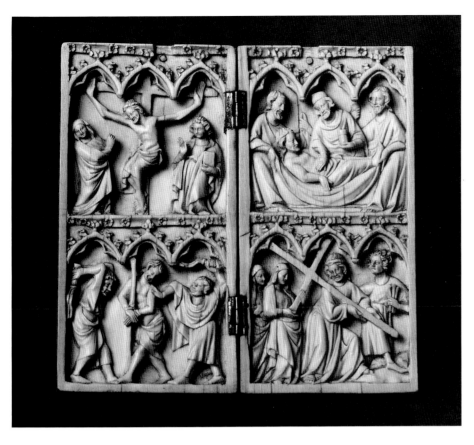

influenced such scenes as that from the marble retable of the Sainte-Chapelle (*Fastes du gothique*, no. 18). The more dramatic interpretation in the ivory has greater spatial openness, however. While the ivory is clearly influenced by Paris and Pucelle, the casual treatment of the roses and the inconsistencies in the scenes suggest that it may have been made elsewhere.
H: 4⅜ in. (11.2 cm); W: [open] 4⁹⁄₁₆ in. (11.6 cm)
Detroit Institue of Arts (42.135), gift of Robert H. Tannahill
History: Collection of Maurice Sulzbach, Paris.
Bibliography: Tannahill, no. 61.

69

Scenes of the Passion and the Afterlife of Christ

Ivory diptych, French, 1330–1350

Reading from bottom to top in the left panel and top to bottom in the right, the subjects are the Flagellation, the Crucifixion, the Resurrection, and Noli Me Tangere.

The arcade of three trefoil arches above each scene is unusual in having two narrow arches flanking a wider one. The crockets and finials are varied in scale and quality.

Notes: Arches of varying sizes appear in a number of ivories from various regions,

but they are seldom found in Paris work. A similar interpretation of the Noli Me Tangere episode can be seen, for instance, in an ivory that is also of non-Parisian character (Musée Bonnat, Bayonne; inv. 4395). In a panel with scenes under single wide

arches (Ashmolean Museum, Oxford; inv. I-203) there is a Noli Me Tangere that seems to have been taken from the same model as the present example; the John of the Crucifixion is also very similar.
H: 6⅝ in. (16.8 cm); W: [open] 6½ in. (16.5 cm)
The Cleveland Museum of Art (75.110), gift of Mrs. Chester D. Tripp in memory of Chester D. Tripp
Bibliography: CMA *Year in Review,* 1975; *BCMA* 63 (February 1976), p. 66. no. 42, ill. p. 35.

70

The Virgin and Child with Angels

Left leaf of an ivory diptych, English, 1330–1350

Standing with the Christ Child between candle-bearing angels, the Virgin is crowned by an angel above. The figures, particularly that of Mary, are tall and thin with smallish heads. Whereas the drapery of the Virgin and the right-hand angel falls in slightly curved folds, that of the left-hand angel has a pleated V-fold at the waist.

The scene is placed beneath a single trefoil arch with pinnacles at the sides of the gable, simple crockets, and a floral finial. In the spandrels are trefoils set at an angle.

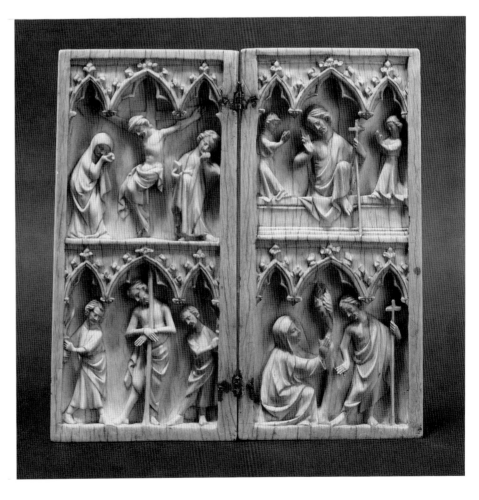

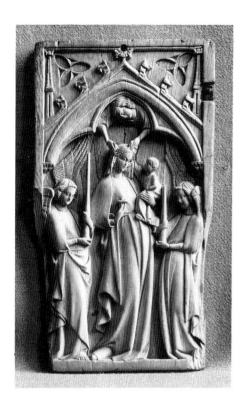

The plaque is broken on the right side below the angel's wing and on the left from the top of the angel's wing. Hinges, once inset in notches, were of iron; part of the upper one remains, and a spot of rust shows where the lower hinge was placed. An inscribed circle on the back may be original.

Notes: The figure style, which influenced sculpture in Sweden and North Germany, often appears in English Gothic works. A figure of Saint Catherine with the same proportions and treatment of the drapery can be seen in the Hours of Alice of Reyden (Cambridge University Library; Sandler, no. 67, fig. 168), dated before 1324. Similar treatment of the human form appears in North France at the same time, as in *Summa copiosa* of Henri de Suse (Bibliothèque Nationale, Paris; *Fastes du gothique,* no. 255, p. 36)—a manuscript of about 1340 attributed to Amiens, where there was considerable English influence. The style, the history of the object, and the unusual use of iron hinges set in notches suggest that this is not a French ivory but an English one.

H: 6⅝ in. (16.5 cm); W: 3³⁄₁₆ in. (10 cm)

Museum of Fine Arts, Boston (93.158), anonymous gift

History: Collections of Younger, London (label dated 1864 and inscribed "Mr.

Younge's [sic] collection"; and W. and T. Bateman, Youlgrave, Derby, England (until 1893).

Bibliography: Bateman sale, Sotheby's, London, 14 April 1893, lot 45.

71

The Crucifixion

Ivory pax, North French (?), 1320–1340

The figure of Christ is notable for an unusually complex treatment of the perizonium. He is beside the Virgin with upraised hands, standing in a curved posture, her mantle gathered in deep folds at the waist. Saint John raises his right hand and holds a book in his left hand, below which descends a series of folds. Two angels with outstretched hands surmount the Cross.

The scene is enacted beneath a wide trefoil arch set on florid corbels. There are bud crockets, a large floral finial, and a trefoil painted in the gable. The arch is flanked by two pinnacles, carefully detailed, and the spandrels contain large openwork quatrefoils. Rosettes, poorly carved, decorate the upper border.

There are a number of vertical cracks, and the left edge has been trimmed. The slot on the back for insertion of a handle is now filled with ivory. There is also the mark of a stand, and two holes are drilled at the top for hanging. Incised on the upper back is a wreath containing what appears to be a heraldic device—a reversed *4* above the initials CM—probably of the seventeenth century.

Notes: The complex perizonium of Christ occurs in Franco-Flemish manuscripts by

the Bondol workshop and from Arras (M. Meiss, *French Painting in the Time of Jean de Berry: The Late Fourteenth Century and the Patronage of the Duke* [London, 1967], nos. 519 and 534). It is a treatment found also in England—for instance, in the Syon cope of about 1300 (M. Rickert, *Painting in Britain* [Baltimore, 1954], p. 138a). A similar raised-hands gesture of the Virgin is seen in a Flemish rituale from Duine (*Vlaanse kunst op perkament* (exh. cat., Gruuthusmuseum, Bruges, 1981), pl. 72, no. 81).

Closely related is an ivory (formerly in the collection of Ruth Blumka and now in the Louvre; D. Gaborit-Chopin, *Revue du Louvre* 3 [July 1991], p. 83) that exhibits a similar posture and treatment of the drapery for the Virgin and the use of the same model for Saint John. While the powerfully carved corpus is entirely different, the architecture includes both the quatrefoils and the pinnacles—the latter with the same bands of dots near their bases (*Private Collections,* no. 78)—in a style resembling that of the first quarter of the fourteenth century. The Vanderbilt ivory is certainly from the same workshop, using the same models, but must be somewhat later, perhaps after 1320. The rosettes on the upper border and the treatment of the perizonium, along with the Arras and other North French details, suggest that the ivory was produced in North France under English influence rather than in Paris.

H: 4¾ in. (12.2 cm); W: 2⅝ in. (6.8 cm)

Fine Arts Gallery, Vanderbilt University, Nashville (1975.04)

History: Purchased from Mathias Komor, New York, 1975.

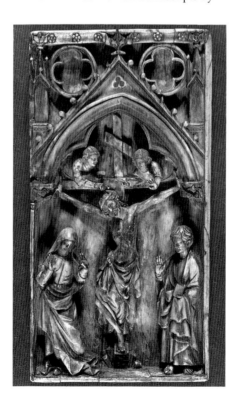

72

The Crucifixion

Right leaf of an ivory diptych, French (Paris), mid-14th century

The crucified Christ is placed between the praying Virgin and Saint John, who lowers his head and makes a gesture of despair.

Over the single trefoil arch with large sweeping crockets and a floral finial are spandrels containing large trefoils.

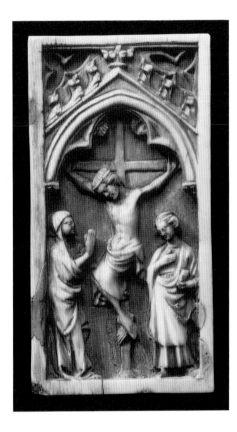

Holes for the hinges and two breaks on the right side have been filled. The lower left corner is broken off.

H: 3½ in. (8.4 cm); W: 1¹³⁄₁₆ in. (4.6 cm)
Crocker Art Museum, Sacramento (1960.3.80), gift of Ralph C. and Violette M. Lee

73

The Dormition of the Virgin

Right leaf of an ivory diptych, French (North France?), mid-14th century

The Virgin lies on a bed surrounded by twelve Apostles and Christ, who holds her soul in his left hand. Three of the Apostles are indicated by the tops of their heads, and two are seated in front of the bed.

Above are three tall, pointed trefoil arches, decorated with floral crockets and finials.

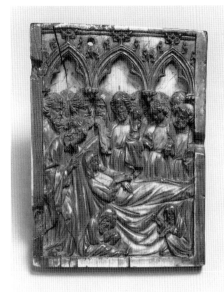

There is an original hole drilled at the top, left of center. Cracked at the upper left, the plaque has scratches at the top and beneath the arches. Where the hinges and clasp were attached semicircular gouges have been cut in the borders.

The condition of the finish is unusual, as the ivory is dark brown in color with a glossy surface that seems almost fossilized. Yet parts of the upper and lower borders, the garments of the Virgin and several central figures, and the areas beneath the arches are whitish. Although the paint has now disappeared, the white areas probably retained some polychromy that protected them during the aging process.

Notes: The placement of this scene in the right wing of the diptych is unusual, as the Dormition is traditionally on the left, opposite the Coronation. (See Koechlin, nos. 513 and 519, for French and German [or Austrian] examples.)

H: 3⅜ in. (8.6 cm); W: 2½ in. (6.4 cm)
Outside edges—H: 3⁵⁄₁₆ in. (left) and 3¼ in. (right)
Wellesley College Museum (1964.35), museum purchase in honor of Professor Agnes Abbott
History: Purchased from Mathias Komor, New York, 1964.

74

The Virgin and Child with Angels

Left leaf of an ivory diptych, French (Paris?), 1340–1360

The Virgin stands frontally in three-quarter view between winged angels bearing large tapers; she is crowned by a third angel emerging from the arch. While Mary holds the Christ Child in her left hand and a single flower in her right, the Child holds an apple or globe.

The figures occupy a single trefoil arch under a gable with large stylized crockets and finial. In the spandrels are two large incised trefoils.

The plaque is drilled with later holes for mounting: one large one in the gable, one in the Virgin's skirt, and three in the left angel's wing, possibly for a clasp. All

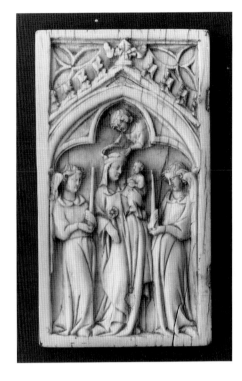

are filled with putty, as are the hinge miters. There is a large crack through the skirt of the right-hand angel, and several incised lines in semicircles appear on the back of the plaque.

Notes: Compare cat. no. 59, which is a finer example of this popular type of diptych subject, and a second plaque (Metropolitan Museum of Art, inv. 17.190.284) in which the drapery of the Virgin is nearly identical. The angels' off-side wings are omitted in this version.

H: 4⅜ in. (11.1 cm); W: 2½ in. (6.3 cm)
Royal Ontario Museum, Toronto (952.52.5)

75

The Virgin and Child with Angels and the Crucifixion

Ivory diptych, French (Paris), 1340–1360

The mantel of the Virgin continues the folds of her veil across her body. She holds a rose and the Child an orb. The angels carry tapers, and their wings are shown against the background. In the right leaf Christ is seen between the Virgin and Saint

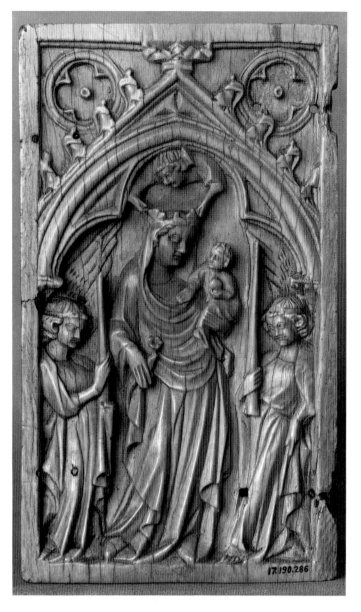

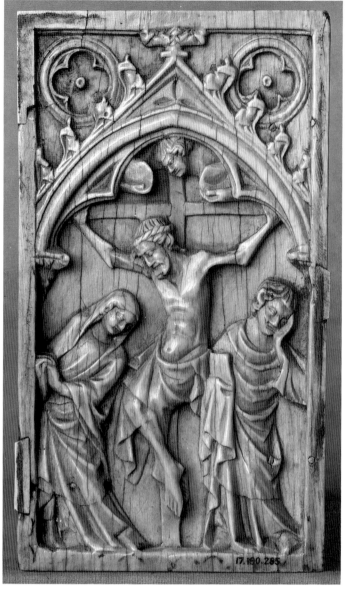

John, both in curved postures, she wringing her hands and he turning away with his hand to his face.

The scenes are placed beneath single trefoil arches on corbels. There are floral crockets and finials and an incised trefoil in each gable. The spandrels are filled with large quatrefoils.

Both plaques are damaged where the hinges were removed, and that with the Crucifixion has an ivory fill at the lower miter. Numerous abrasions, chips, and cracks are visible, and a square hole penetrates the drapery of the right-hand angel. Several holes are drilled above the left-hand angel's head where the clasp would have been attached, and the space in the right wing where a catch was once inset has been filled.

Notes: The architectural format with quatrefoils in the spandrels would place the diptych in the second quarter of the century,

but the postures of the Virgin and John in the Crucifixion are related to a slightly later group of North French ivories (see cat. no. 79) and are mirrored in a plaque (cat. no. 83) that may also be Parisian.
H: 5½ in. (14.1 cm); W: 3 in. (7.7 cm) each
Krannert Art Museum, University of Illinois, Champaign (82-6-1 and 2), Harlan E. Moore Charitable Trust
History: Collections of J. Pierpont Morgan (before 1913); and Metropolitan Museum of Art, New York (1917–1981; inv. 17.190.285 and 286).

76

The Life of Christ

Ivory diptych, French (Paris), 1340–1360

The scenes read downward, starting on the left leaf with the Nativity and the Adoration, and ending in the right leaf with the Crucifixion and the Entombment. In the Nativity there are two annunciate angels and two shepherds, one of whom

holds his chin in wonder. Joseph, with an elaborately curled beard and holding a cane, appears to be watching the angels. In the Crucifixion the Virgin has a twisted skirt and is accompanied by three Holy Women, one looking up at the Cross. The Entombment shows the anointing of Christ's body, with Mary and John flanking Nicodemus. The sarcophagus is decorated with undercut quatrefoils.

Each scene has a scored molding at the top and is set beneath three trefoil arches with floral crockets and finial.

The top hinge has been broken away, carrying a fragment of the border of the right leaf. Once shattered into several pieces at the lower right, the right panel is glued together (lacking a large flake between the two right-hand arches).

Notes: The right panel of this diptych provides an instance in Paris work of a composition that became popular in the Rhine

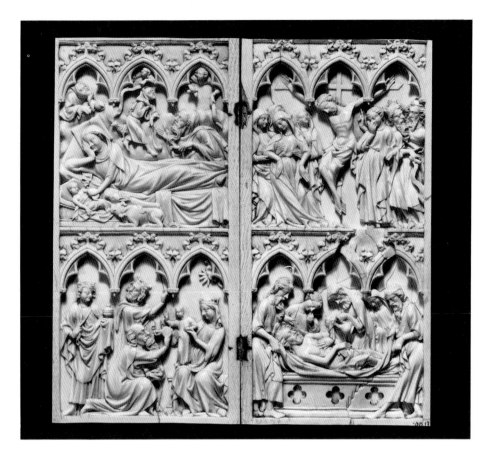

and Meuse regions (see cat. nos. 126–129): a group of women at the Crucifixion, including the Virgin with a twisted skirt and the woman who looks up at the Cross. (For a second French example of the period, see R. Calkins, *Monuments of Medieval Art* [Ithaca, New York, 1985], fig. 161.)

H: 8⅜ in. (21.4 cm); W: [open] 8½ in. (21.6 cm)

The Art Institute of Chicago (1970.115), Kate S. Buckingham Fund

History: Collections of Jesuit Church, Bury St. Edmunds; and Stonyhurst College, Lancashire, England (until 1969). (Purchased from Ronald A. Lee, London, 1970.)

Bibliography: Fine Medieval, Renaissance and Later Works of Art, Stonyhurst sale, Sotheby's, London, 2 December 1969, lot no. 13.

77

The Adoration of the Kings

Left leaf of an ivory diptych, French (Paris?), 1340–1360

The Christ Child touches both the gold of the first king and a globe held by the Virgin. Mary has an unusually pointed nose.

Above the three trefoil arches with blind gables are large leaf crockets and floral finials; a pearled molding runs along the top.

Since the ivory is framed, its back has not been examined nor is it known whether there are hinge miters. Traces of gilding remain on the crowns and crockets.

H: 3¼ in. (8.3 cm); W: 2¼ in. (5.7 cm)

J. B. Speed Art Museum, Louisville (66.44), members' purchase

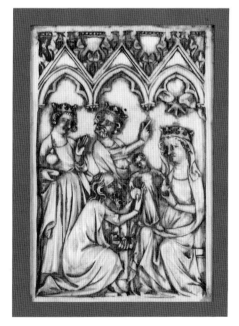

78

The Crucifixion

Ivory panel, French (Paris), 1340–1360

Christ is flanked by a carefully balanced Mary and John. Both have cloaks ending in a curve at the knees, and each fold and fall of drapery is balanced in the other figure, as are their gestures of hands and heads. The hands of Christ follow the curved line of an arch that suspends the sun and the moon over the Cross.

Above this five-cusped arch is a single wide, flattened arch and a blank gable with large floral crockets and finial. At the sides are two colonnettes. Two weeping angels, hiding their faces with their hands, occupy the upper corners, and a notched molding runs along the top.

The plaque has no signs of ever having been hinged or mounted. Saint John's nose is broken.

Notes: The unusual treatment of the arch can be seen in another example of the same period from La Ferté-Bernard (Koechlin, no. 546), which is probably not Parisian. Lacking hinges, the present plaque could be an unused diptych wing or pax, or it may have been intended as an inlay in a box or book cover.

H: 5⅛ in. (13 cm); W: 3¼ in. (8.2 cm)

The Art Museum, Princeton University (39-33), Carl Otto von Kienbusch, Jr., Memorial Collection

History: Collection of Joseph Brummer, New York (until 1949).

Bibliography: Brummer sale, Parke-Bernet, New York, 14 May 1949, lot 672 [?]; *The Carl Otto von Kienbusch, Jr., Memorial Collection* (The Art Museum, Princeton University, Princeton, 1956), no. 65; *Carver's Art*, no. 6.

The Crucifixion

Right wing of an ivory diptych, North French, 1340–1360

The torso of Christ is displayed in an S-shaped posture, and the ample drapery falls in ribbon folds. His feet are large and his elbow joints slightly exaggerated. At the left Mary stands with gesturing hands, her body and drapery in a curve. John, on the right, looks away, placing his left hand against his cheek and holding a book in his right. His hair is treated with alternating wide and narrow locks.

The scene is placed beneath a single large trefoil arch, which springs from corbels. Above is a blind gable, and the roof line is punctuated with large floral crockets. There are two pinnacles rising at the sides and two trefoil piercings with outlined edges.

Christ's head was damaged, as can be seen in early photographs, and the present head is a restoration, carefully placed on the remains of the original. One of the Virgin's fingers is partially broken, and the forehead area of her veil is restored. There is an inset of ivory in the right edge, where the catch would have been attached, and a section of the upper left border has been replaced above the hinge miter. The diagonal hole at the top appears to be original.

Notes: The ivory is part of a group from a single workshop. Two panels—cat. no. 80 and a second at the Schnütgen Museum in Cologne [B-125]—seem to be by the same carver, judging by the treatment of details, especially the hands of the Virgin. There are changes in the drapery folds and the positions of the figures in each example. From the same workshop, but by different carvers, are cat. nos. 81 and 82, where the major features of the curved posture of the Virgin and the treatment of the drapery are closely related. Another ivory from the workshop (Metropolitan Museum of Art, inv. 11.12) is a left wing of a diptych, showing the Virgin between candle-bearing angels. In all of the examples the single-arch format with similar details is used, with minor variations in the inclusion or omission of trefoils above the arch.

H: 5¹¹⁄₁₆ in. (14.6 cm); W: 3⁵⁄₁₆ in. (4.4 cm); D: ⁷⁄₁₆ in. (2.3 cm)
Indiana University Art Museum, Bloomington (72.100.3)
History: Collections of Mortimer Schiff, Paris (until 1905); and Claudius Cote, Lyons. (Purchased from Leopold Blumka, New York, 1972.)
Bibliography: Schiff sale, Georges Petit, Paris, 11 March 1905, lot 270; E. Molinier, "La collection de Monsieur Claudius Cote," *Les arts,* November 1906, p. 31.

80

The Crucifixion

Right wing of an ivory diptych, North French, 1340–1360

The crucified Christ is shown between Saint John and the Virgin. Her figure creating an arc, emphasized by the lines of the drapery, Mary lowers her head and places her hands palm outward; her fingers are exceptionally long. Saint John puts one hand to his cheek and holds a book in the other. His drapery falls in unusually straight folds, and his right hand and right foot, as well as the feet of Christ, are somewhat oversize.

The scene is placed beneath a single trefoil arch with a blind gable above and large floral crockets on the roof line. There are pinnacles on each side and outlined trefoils in the spandrels.

The frame, once gilded, retains much of the gilt. Both hinge miters have been filled, and there is a modern transverse metal pin inserted in the center of the base.

Notes: The ivory is part of a group by the same hand (including cat. no. 79 and a plaque in the Schnütgen Museum in Cologne [B-125]). The posture and position of the Virgin's hands here are similar to cat. no. 79, and the drapery of Christ is virtually identical.
H: 6⁹⁄₁₆ in. (16.6 cm); W: 3⅞ in. (9.8 cm)
The Montreal Museum of Fine Arts (37.DV.3), gift of J. W. McConnell
History: Collections of Henry Daguerre, Paris; Julius Campe, Hamburg; and Paul, no. 557. (Purchased from Arnold Seligmann, Rey and Co., New York 1937.)
Bibliography: The Montreal Museum of Fine Arts (Montreal, 1977), p. 52, fig. 32.

81

The Crucifixion

Right leaf of an ivory diptych, North French, 1340–1360

The Crucifixion takes place between Mary and John; the Virgin, whose figure forms an arc, raises her hands and turns away, while John looks down, gesturing with his right hand and holding a book with his left. Sheltering the figures is a single large trefoil arch, supported on corbels, under a blind gable whose roof line has large floral crockets. Trefoils are pierced in the upper corners.

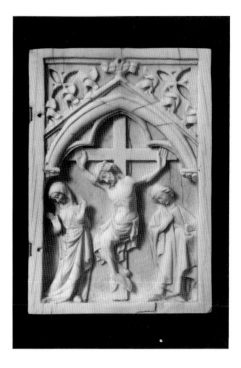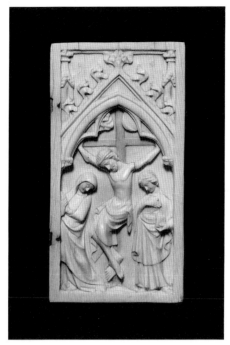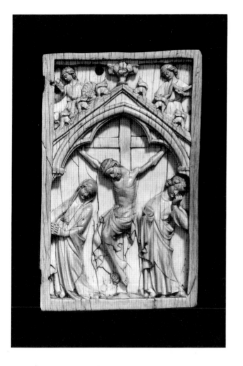

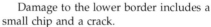

Damage to the lower border includes a small chip and a crack.

Notes: The ivory comes from the same workshop as cat. nos. 79 and 80 but is probably by another hand. While the Virgin figure is clearly taken from the same model, there are small differences in the depth of the carving and the treatment of the hands and feet. See cat. no. 82 for another ivory from the workshop.

H: 4³⁄₁₆ in. (10.7 cm); W: 2⅞ in. (7.4 cm)

Worcester Art Museum, Worcester, Massachusetts (1919.230)

History: Purchased from Philip J. Gentner, Florence, 1919.

Bibliography: Worcester Art Museum *News Bulletin and Calendar,* October 1953, p. l.

82

The Crucifixion

Right leaf of an ivory diptych, North French, 1340–1360

Christ is placed between the Virgin and Saint John. Mary's figure forms an arc, and her hands are clasped. John's drapery is of the "apron" type but with folds running through both layers of cloth.

The single trefoil arch, supported by corbels, has a blind gable above and a roof line treated with large floral crockets and two pinnacles.

There are traces of gilded diamond shapes above the arch on each side. A fragment of one silver hinge remains in the lower hinge miter.

Notes: The ivory probably comes from the same workshop as cat. nos. 79, 80, and 81, although it is by a different hand. Smaller in dimension and less deeply carved, it is the only example with painted ornament above the arch. The posture of the Virgin and other details are very close to those of cat. no. 79.

H: 5¹³⁄₁₆ in. (14.8 cm); W: 3¹⁄₁₆ in. (7.9 cm)

Lyman Allyn Art Museum, New London, Connecticut (1952.122), gift of Stanley Marcus, 1952

History: Collection of Stanley Marcus, Dallas.

83

The Crucifixion

Right leaf of an ivory diptych, French (North France [?] or Paris [?]), 1340–1360

The deeply carved, heavy plaque portrays the crucified Christ in an S-posture. His lavish drapery contrasts with the simpler folds used for the Virgin and Saint John. Both attendant figures are shown in curved postures, Mary clasping her hands and leaning toward the Cross, while John leans away with his hand to his face.

The single wide trefoil arch, set on corbels, is capped by a blind gable, large floral crockets, and a central finial. In the spandrels are two angels holding the sun and the moon, above them a plain molding.

The ivory is broken along several vertical cracks and is now set in a silver frame. There is a large, later hole drilled at the top. The Virgin's forehead shows unusual wear.

Notes: While the panel resembles cat. no. 79 and other related works, it differs in several respects. It is the only plaque with angels in the spandrels and with the hands clasped rather than open. The gesture of Saint John is somewhat similar to the John of cat. no. 79, but the body is turned away more in the manner of Parisian work (for example, cat. nos. 75 and 104) and of other diptychs attributed to the Meuse Valley (see cat. no. 84). The quality suggests that the ivory could be a Parisian prototype of the North French group.

H: 6¹⁵⁄₁₆ in. (17.3 cm); W: 3⅞ in. (10.7 cm); D: ⅝ in. (1.3 cm)

Museum of Fine Arts, Boston (1973.690), gift of John Goelet in honor of Hanns Swarzenski

History: Collections of Mary Onsen, Washington, D.C.; and Henry Ickelheimer, New York (until 1950). (Purchased from Germain Seligman, New York, 1973.)

Bibliography: Ickelheimer sale, Parke-Bernet, New York, 10 May 1950, lot 134.

84

The Life of Christ

Ivory diptych, Mosan (?), 1340–1360

The two lower scenes are devoted to the Adoration of the Magi, the kings appearing in the left panel and the Virgin and Child between candle-bearing angels in the right. The Virgin faces away from the kings, and the angels hold candlesticks that apparently had no candles. Above are the Crucifixion and the Entombment. One of only three male mourners, Nicodemus anoints the body of Christ before burial.

Overhanging each of the scenes is an arcade of three trefoil arches with floral crockets and finials. There are incised trefoils in the spandrels.

Considerable traces of polychromy remain: a brownish black color on the Cross and gilt on the hair and borders of the robes, on the sun and moon, and on details of the architecture, including patterns on the sarcophagus. The lower iron hinge has rusted and split the ivory on both panels, and a section of border is missing from the right panel. A silver clasp and a pin are attached to the outer edges.

Notes: The diptych is related in most details to a panel with the Three Kings and the Crucifixion (collection of Martin Le Roy, Paris; Koechlin, no. 780). In both cases the sturdy figures are Mosan in type, particularly the Saint John with busy drapery.

The pattern of pleats on the shoulder of the second king can be seen in cat. no. 158.
H: 6⅝ in. (17 cm); W: [open] 6¾ in. (17.3 cm)
Private collection, Scarsdale, New York
History: Collection of Baron Robert von Hirsch, Basel (until 1978). (Purchased through Edward R. Lubin, New York, 1978.)
Bibliography: Von Hirsch sale, Sotheby's, London, 22 June 1978, lot 289.

85

The Virgin and Child with Angels and the Crucifixion

Ivory diptych, Mosan (?), 1340–1360

Standing between candle-bearing angels, the Virgin holds the Child on her left arm, while he pulls her veil and displays a globe or fruit. She has apron drapery with complex folds and holds the stem of a flower in her right hand. Above the Virgin are two winged angels, emerging from clouds, holding a crown above her head; the pair at her sides have candlesticks that appear not to have held candles. The sturdy figure of Christ in the Crucifixion has carefully modeled anatomy. Mary raises her hands, and John holds his head.

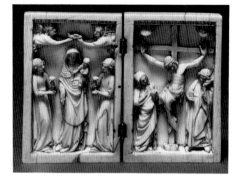

The sun and moon hang below a studded cornice.

The hinges are of silver. A crack at the lower hinge of the left panel has damaged the lower border and the angel's drapery, which is now repaired with glue; the upper hinge miter is damaged as well.
Notes: There is no known instance of two flying angels crowning the Virgin other than in this original composition. Nor is there a close parallel for the studded border, although studs used in a different way do appear in Flanders and the Meuse in the third quarter of the fourteenth century. The Christ Child pulling his mother's veil is seen in other Mosan diptychs of the period (Koechlin, nos. 539 and 541).
H: 2¹⁵⁄₁₆ in. (7.5 cm); W: 2 in. (5 cm) each
The Saint Louis Art Museum (493:1955)
History: Collection of Emile Baboin, Lyons. (Purchased from Raphael Stora, New York, 1955.)
Bibliography: Koechlin, Baboin cat., no. 6; *Collector's Choice Exhibition* (exh. cat., City Art Museum, Saint Louis, 1955), no. 289.

86

The Crucifixion

Right leaf of an ivory diptych, Mosan, 1340–1360

Christ is shown between the Virgin and three Holy Women, on the left, and Saint John, two Hebrews, and the centurion at the right. The figures have long, serious faces with large noses, and Christ's elongated torso has unusual drapery folds above the right hip. At either side of the rusticated Cross, under the canopy, two angels hold the sun and the moon.

Above the four trefoil arches are tympana filled with trefoils, the roof line ornamented with bud crockets and floral finials. There are large incised trefoils in the spandrels, and a hatched band runs across the upper border.

One silver hinge is broken, and a modern hole is drilled at the top.
Notes: The facial type is seen frequently in Mosan sculpture of the fourteenth century

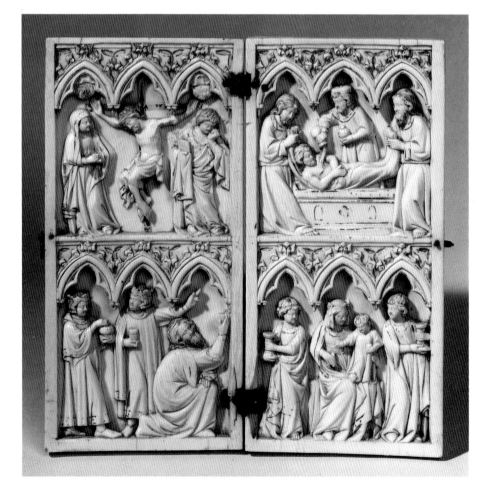

in both wood and stone. A notable example is the head of the second king in the Adoration portal of the church of Notre Dame at Huy (figure 3). A second ivory from the same atelier (Destrée, no. 25) shows the Virgin and Child, on a large throne, between the Magdalen and Saint John.

H: 4⅛ in. (10.5 cm); W: 3⅛ in. (8 cm)
The Nelson-Atkins Museum of Art, Kansas City (51–10), Nelson Fund

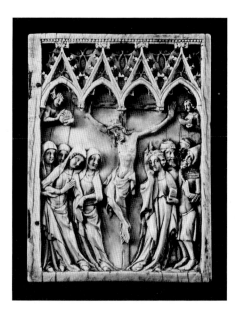

History: Collections of Mortimer Schiff, Paris (until 1905); and Emile Baboin, Lyons. (Purchased from Raphael Stora, New York, 1951.)
Bibliography: Schiff sale (Georges Petit), Paris, 11 March 1905, lot 271; Koechlin, Baboin cat., no. 7.
See also cat. nos. 153 and 154.

87

The Crucifixion

Right leaf of an ivory diptych, Lower Rhenish (Cologne?), 1340–1360

The thin Christ is shown with little torsion and with his head in pure profile. There is a chalice at the foot of the Cross. On the left is the kneeling centurion, his hands folded in prayer, and behind him the Virgin and two companions. On the right the sponge bearer offering vinegar is accompanied by the bareheaded Saint John and two Hebrews, distinguished by their hats. There are four angels, two in corbellike positions at the ends of the Cross arms and two above, hiding their eyes. The sun and moon are in the central arch of the arcade crowning the scene.

The three trefoil arches (the center one slightly larger) are tall and pointed, the gables are pierced with trefoils, and the elements of arch and gable are distinguished

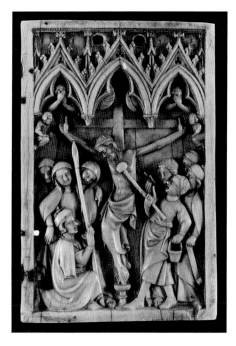

with extra moldings. Along the roof line are floral crockets and finials and pierced pinnacles with floral caps between the gables. There is a band of pearling at the top.

Two holes for string hinges are later, as are nine others drilled in the panel; two large ones at the top are presumably for mounting. A small break has occurred at the lower hinge miter, and a piece is chipped out of the lower border.

Notes: While the composition shares many elements in common with cat. no. 129, it is handled in a completely different manner. The work is sculpturally stronger, with deep relief and great attention to detail. For instance, the hair of the sponge bearer and John has carefully incised strands, and the sponge bearer has an open mouth. The profile head of Christ is unusual, as are the three Marys staring at the viewer and the chalice beneath the Cross. The detailing of the arches is notably meticulous.

No immediate comparisons are known, but the use of pinnacles between the gables occurs almost always in German

works, such as a Crucifixion from Sigmaringen (A. Legner, *Kleinplastik der Gotik und Renaissance* [Frankfurt, 1967], no. 6), wherein the arches are similar but the figure style different. The use of pinnacles is seen also in Cologne illuminations (see von Hirsch sale, Sotheby's, London, 20 June 1978, lot 6; and C. Gaspar, *Les principaux manuscrits à peinture de la Bibliothèque Royale de Belgique* [Paris, 1937], pl. LXVII).

H: 4¹³⁄₁₆ in. (11.3 cm); W: 3³⁄₁₆ in. (7.8 cm)
Spencer Museum of Art, University of Kansas, Lawrence (54.122)
History: Purchased from Leopold Blumka, New York, 1954.
Bibliography: R. Branner, "A Medieval Ivory Crucifixion," *Register of the Museum of Art of the University of Kansas,* February 1955, no. 5, pp. 17–20.

88

The Life of Saint Martin of Tours

Ivory diptych, German (Cologne), 1340–1360

The left leaf shows the consecration of Saint Martin. A donor figure kneeling in the background is painted in gilt above the saint's head. In the right leaf Martin divides his cloak with a beggar.

The scenes are placed beneath single trefoil arches with floral crockets and finials on the gables. There are pierced pinnacles and floral finials at each side, and the spandrels are patterned as tile.

Well-preserved polychromy includes gilt details of the bishops' robes, miters, and croziers; the hair of the figures; the harness of the horse; and architectural features such as a trefoil pattern in the gables. The background of each scene is lapis blue (with the donor figure in gilt), and the tile is red.

The upper silver hinge is broken. Part of Saint Martin's foot is lacking in the right leaf.

Notes: The combination of pinnacles and a tiled roof, German in usage, appears in Cologne works (see, for instance, Koechlin, no. 564) and works of the Kremsmunster Master of Mainz (Koechlin, nos. 824 and 825). The delicate scale and finish of the Cleveland ivory can be seen in a Cologne diptych with the Three Kings and the Crucifixion (Koekkoek II, no. 1). Comparable with a seated statue of Saint Nicholas in Cologne (Erzbischöfliche Diözesan-Museum, Cologne; W. Schulten, *Kostbarkeiten in Köln* [Cologne, 1978], fig. 24), the figures on the left resemble also three standing bishops in a Cologne manuscript (MS. 148 [ff. 21v, 24v, and 38] at the Walters Art Gallery in Baltimore, which has always been called Rhenish, has been reattributed to Cologne (D. Miner, "Preparatory Sketches by the Master of Bodleian Douce MS 185," *Kunsthistorische Forschungen Otto Pacht zu Ehren* [Salzburg, 1972], pp. 118–128).

H: 3⁹⁄₁₆ in. (9.1 cm); W: 2 in. (5.1 cm) each
The Cleveland Museum of Art (71.103), J. H. Wade Fund
History: Collections of Ozenfant, Lille; and anonymous owner, North France. (Purchased from Julius Bohler, Munich, 1971.)
Bibliography: Wixom 1972, fig. 23 and back cover.
See also colorplate 10.

89

The Virgin and Child with Angels and the Crucifixion

Ivory diptych, German (Cologne), 1340–1360

The Virgin, holding the Christ Child in her left hand and a flower in her right, wears a veil that is shown as part of a long robe. Her straight-falling drapery contrasts with that of the flanking angels, who hold candlesticks, their off-side wings spread against the background. The figures of Mary and John in the Crucifixion are broadly handled, while the haloed Christ has elegant, bent, thin arms.

Both the wide central trefoil arch and the smaller side arches have blank gables with floral crockets and finials. The spandrels are carved with deep, undercut trefoils, emphasized with incised triangles.

An original hole is drilled at the top of each plaque. The right-hand leaf has a semicircular cut in the lower border. The hinges are of silver-plated bronze. There is a trace of red paint on Saint John's book.
Notes: The large central arch in the arcade is a feature shared in common with a number of other German works (see cat. nos.

90 and 96), as are the deeply carved trefoils in the spandrels (for example, in a diptych at the Courtauld Institute [T. Gardner, "The Ivories in the Gambier-Parry Collection," *Burlington Magazine* 109 (1967), p. 143, fig. 42] and the British Museum [Dalton, no. 303] and at the Metropolitan Museum of Art [inv. 17.190.198]). The shallow carving of the drapery and the broad, Lorraine-type figures occur in other works attributed to Cologne.

H: 4⅞ in. (12.5 cm); W: 3⅞ in. (9.9 cm) each
Beaverbrook Art Gallery, Fredericton, New Brunswick, Hosmer-Pillow-Vaughan Collection
History: Collections of François van Waegeningh, The Hague; Raphael Stora, New York; and Elwood B. Hosmer, Montreal. (Purchased from Watson Art Galleries, Montreal, 20 August 1940.)
Bibliography: R. Didier, "Contribution à l'étude d'un type de Vierge française du XIVᵉ siècle," *Revue d'architecture et histoire d'art de Louvain* 3 (1970), fig. 10; I. Lumsden, "Le récent agrandissement du Musée Beaverbrook," *Vie des arts* 29 (September–November 1984), no. 116, p. 31.

90

The Adoration and the Crucifixion

Ivory diptych, German (Cologne), 1340–1360

Following a standard iconographical format, the Adoration includes a Virgin of broad Lorraine proportions. The second king wears a cape and points with his right hand, while the third king stands out for a markedly receding chin. Like those on the left, the figures in the Crucifixion are broadly and flatly carved, and the arms of Christ have an elegant double bow.

Blank gables with floral crockets and finials surmount the large central trefoil arch and two smaller side arches. The spandrels are decorated with narrow trefoils, all given incised triangles for emphasis.

Replacing the original hinges are iron ones set in mastic. The lower exterior corner of each plaque is chipped, and both have holes drilled near the upper hinge. The outer edges are chamfered.

On the upper right border of the Adoration plaque is an incised leaf, probably an atelier mark.

Notes: This is the only ivory known to date with such an incised mark designating a workshop or carver. The attribution to Cologne is based on the broad Lorraine-type figures; the receding chin of the third king, which occurs in other German works; and the use of a larger central arch between two smaller ones, as in cat. nos. 89 and 96. An Adoration plaque with a similar arrangement of arches and incised trefoils (Metropolitan Museum of Art, inv. 17.190.283), has details that are comparable, but the figure style varies.

H: 3¹⁵⁄₁₆ in. (10 cm); W: 2¹¹⁄₁₆ in. (6.8 cm) each

Detroit Institute of Arts (24.69), gift of A. S. Drey

Bibliography: Songs of Glory, no. 85, p. 242.

91

The Crucifixion

Ivory writing-tablet cover, French (North France?), 1340–1360

Carved in low relief are a thin figure of Christ and broad figures of the Virgin and Saint John. Mary raises one hand and holds a book; John wipes his tears with his robe.

The scene is placed beneath a single round trefoil arch, set on corbels, with vestigial crockets above.

The ivory is rubbed and has an original large hole in the upper left corner for attaching other leaves. It is now mounted in a brass pax frame.

Notes: The gesture of John and the rendering of the fingers can be seen in a plaque (cat. no. 135) that is North German or Danish and another (cat no. 80), probably North French, that is similar also in the raised hand of the Virgin. The single round arch, which appears almost Romanesque, is extremely conservative and in stark contrast to the developed drapery and gesture of Saint John. The reuse of a writing tablet as a pax is unusual.

H: 3⁷⁄₁₆ in. (8.8 cm); W: 2¹⁄₁₆ in. (5.3 cm) in frame

The Art Museum, Princeton University (29-36), gift of Frank Jewett Mather, Jr.

92

The Virgin and Child with Angels

Left leaf of an ivory diptych, German (?), 1340–1360

The Virgin, holding the Child, is placed between two candle-bearing angels. Certain details, such as the head and neck of the left-hand angel, appear almost unfinished.

Above the three trefoil arches are blind gables that are unusual in having a triangular molding within a triangle.

Once inset diagonally at the right edge were unusually small hinges (now missing). The panel is badly warped and broken along the right side. There is an Austrian export stamp on the back.

Notes: The panel appears to have been carved in great haste, judging by the treatment of the gables and the neck of the left-hand angel. There is also a carving error in the central fold of the Virgin's skirt on the proper right side, where the cutting is so deep as to have removed the space for Mary's hip.

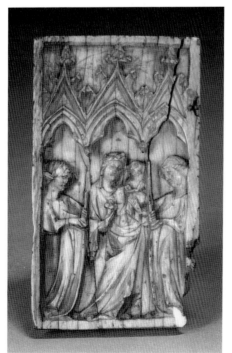

H: 3⅝ in. (9.3 cm); W: 1¹⁵⁄₁₆ in. (4.9 cm)

Indianapolis Museum of Art (57.98), gift of Mrs. Booth Tarkington in memory of Booth Tarkington

History: Collections of Graf Wilzek, Burg Kreutzenstein, Austria; and Mr. and Mrs. Booth Tarkington, Indianapolis. (Purchased from Silberman Galleries, New York, 1934.)

93

The Adoration and the Crucifixion

Ivory diptych, Swedish or North German, 1340–1360

The left wing shows a tall Virgin holding the Child and facing away from the Three Kings, the first of whom doffs his crown. In the Crucifixion, with figures shorter than the unusually tall ones of the Adoration, Stephaton and Longinus are posed in front of Mary and John.

The scenes are placed beneath arcades of three trefoil arches with blind gables whose molded cornices are ornamented with crockets and finials. Above are deeply incised trefoils and a band of roses on the upper border.

The heavy, surface-mounted iron hinges, clasp, and catch are old but not original. Considerable traces of polychromy—blue and dark red—appear to be repainting of the Baroque period. The left leaf has suffered abrasion at the base, and two later holes are drilled through two of the trefoils.

Notes: The Virgin with her back to the kings undoubtedly derives from a triptych or polyptych (like cat. no. 32, for example), where it is customary to have the kings in a left wing, while the central Virgin faces to the right. Another diptych (Fitzwilliam Museum, Cambridge [Koechlin, no. 276]) illustrates both similar drapery for the Virgin and roses on the upper moldings. The rather conservative Crucifixion group with Stephaton and Longinus can be seen in some French but many more German ivories (see cat. no. 156; and Koechlin, no. 288). Several features, including the combination of incised trefoils and roses on the molding, suggest a date in the middle of the century.

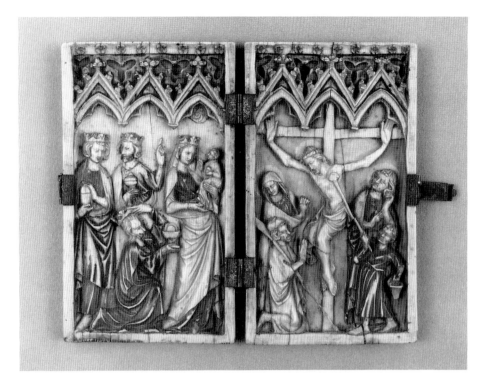

While the models for the figures are clearly Parisian, the elongation of those in the left leaf and the carver's approach to the drapery folds, which decorate the surface rather than modeling the figure, are related to North German and Swedish sculpture; see, for instance, a Virgin from Hedesunda (A. Anderson, *Wood Sculpture in Sweden* [Stockholm, 1966], fig. 24) whose drapery has a similar effect on her extraordinarily tall figure. The doffing of the crown by the first king occurs in various German works, as well as in other northern European ivories (for instance, cat. no. 158; Metropolitan Museum of Art, inv. 30.25.115; and G. Schmidt, "Das kleine Bargello Diptychon," *Etudes d'art français offertes à Charles Sterling* [Paris, 1975], pp. 47–56 and fig. 42—the last two dating from 1340–1360), but seldom in French examples. A Master of Kremsmunster diptych (Koechlin, no. 824) has both the crown doffing and the Three Kings standing behind the Virgin.

H: 4⅜ in. (11.1 cm); W: 2⅝ in. (6.6 cm) each

Virginia Museum of Fine Arts, Richmond (69.18), the Arthur and Margaret Glasgow Fund

History: Purchased from Blumka Gallery, New York, 1969.

94

The Passion of Christ; the Virgin and Child; and Three Saints

Ivory diptych, Flemish, 1340–1360

Reading from the top left, the diptych shows the Carrying of the Cross with an indication of the hill of Golgotha; the Crucifixion with nine figures, including the centurion; the Virgin and Child enthroned between censing angels; and Saints John the Baptist, James Major, and Lawrence.

Each scene is placed beneath three flattened trefoil arches with atrophied

crockets and floral finials. There are trefoils in the spandrels. The hinges are replacements.

Notes: The tall, thin figures are characteristic of Flemish ivories, as is the inclusion of rows of saints. While the drapery of most of the figures could be dated in the second quarter of the fourteenth century, the unusual folds and richness of the mantle of John the Baptist suggest a slightly later decade.

H: 3³⁄₁₆ in. (8.1 cm); W: [open] 4⁷⁄₁₆ in. (11.3 cm)

Detroit Institute of Arts (43.457), gift of Robert H. Tannahill

95

Saint George and the Dragon; and the Virgin and Child with Saints

Ivory diptych, Flemish, 1340–1360

Sitting on a caparisoned horse, Saint George holds his lance aloft after conquering the dragon. He is dressed in chain mail and surcoat, and his arms appear on his shield, the ailette on his right shoulder, and the pennant on his lance. An angel lifts his helm from his head, and the princess leads the dragon away with her girdle. Behind Saint George a bird perches on a pollarded tree. In the right leaf the Virgin stands with the Christ Child between Saints John the Baptist and Catherine.

Crowning each scene is an arcade of three trefoil arches, their tall gables ornamented with crockets and finials. There are trefoils incised in the gables and the spandrels.

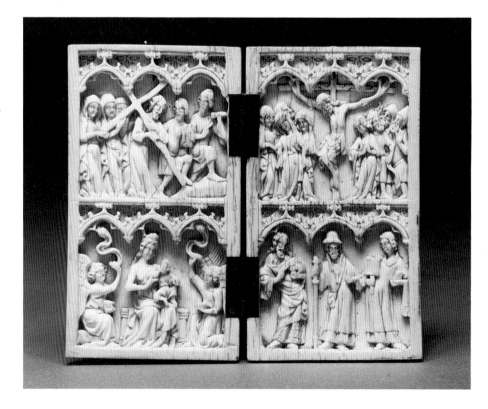

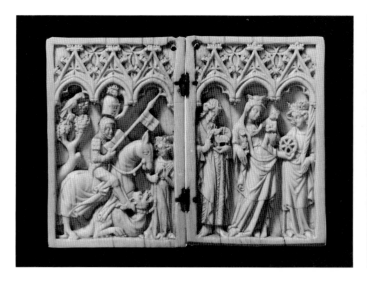

The hinges are of silver, and later holes are drilled in the inside corners at the top.

Notes: Another diptych wing representing the Saint George legend, with minor changes (W. Wells, *Scottish Art Review* 11, no. 1 [1967]), comes from the same Flemish workshop; that ivory and its matching leaf (Koechlin, no. 379) also have paired seated saints. The drapery of the saints and the ailette worn by Saint George are features of the first half of the century, but the architectural treatment, which is comparable in the two diptychs, suggests a date in the third quarter. (See R. Randall, "Van Eyck and the St. George Ivories," *JWAG* 39, [1981], pp. 34–48 and fn. 5.)

H: 3⁹⁄₁₆ in. (9 cm); W: 2⅜ in. (6 cm) each
Walters Art Gallery, Baltimore (71.1181), gift of Max Falk in honor of Richard H. Randall, Jr.

History: Collections of R. Forrer, Strasbourg; and E. and M. Kofler-Truniger, Lucerne. (Purchased from Edward R. Lubin, New York.)

Bibliography: Schnitzler, Kofler cat., no. S-92.

See also colorplate 11.

96

The Adoration and the Crucifixion

Ivory diptych, German (Cologne), 1340–1370

The figure of the Virgin in the Adoration is the broad Lorraine type. As the first king offers a large gold coin, the second points with his gloved left hand. In the Crucifixion an issue of blood from Christ's wound strikes the Virgin, who faints and is helped by two Holy Women. John is seen at the right with two Hebrews, and a sun and moon flank the Cross.

Each of the scenes is placed beneath a large central trefoil arch and two smaller side arches with blank gables and floral crockets and finials. The hinges and clasp are of silver, and there is a break in the right-hand leaf beside the lower hinge.

Notes: Closely related is a diptych (Longhurst, vol. 2, no. 235-1867; and Koechlin, no. 481) that repeats the general details of the Crucifixion, the issue of blood, and the glove on the second king, as well as the form of the arcade. A second diptych leaf (Koechlin, no. 292) includes a similar Crucifixion scene.

H: 5 in. (12.5 cm); W: 3⅜ in. (8.6 cm) each
Collection of Neil F. Phillips, New York

History: Collection of J. J. Klejman, New York (until 1974).

Bibliography: Klejman sale, Sotheby's, New York, 1 November 1974, lot 19; *Court Style,* no. 17.

97

The Life of Christ

Ivory diptych, English (?) or French (Guyenne?), 1345–1365

The scenes read from left to right, beginning in the lower level with the Annunciation, the Nativity, and the Adoration of the Kings. In the upper tier are the Crucifixion, the Coronation of the Virgin, and the Last Judgment. There are many unusual details, such as the inclusion of the stable and three horses in the Adoration, the first king with his crown on his arm, grape leaves against the background, and a glove on the hand of the second king. In the Crucifixion John makes a gesture of despair, the Virgin has a twisted skirt, and Adam holds a chalice at the foot of the Cross. The Coronation is set on a pedestal, and the Last Judgment is treated like a tympanum with a lower scene of the dead rising from their coffins.

Each half-section of the two plaques has three trefoil arches (the central one slightly larger) with very small crockets and finials. Above the spandrels, containing incised trefoils, are floral bands, each carved in a different pattern. Traces of gilt halos remain around the heads of Christ and two attendant angels.

Borders are trimmed on all sides but the top, where leaves continue around the edge of the plaque. The hinges are missing, and the edges of the panels have later cross-hatching. The Cross in the Last Judgment has been repaired, the wreath in the angel's hand is new, and the angel in the Coronation has a new hand and a modern incorrect Cross.

Notes: The Christ figure in the Crucifixion has parallels in two other English diptych leaves (see cat. no. 98; and Dalton, no. 271). Beneath the Cross is the figure of Adam catching Christ's blood in a chalice—a subject made popular by the Franciscans and Dominicans—which appears as early as 1250–1255 in the Amesbury Psalter (N. Morgan, *Early Gothic Manuscripts* [Oxford, 1982], vol. 1, no. 101, fig. 29) and is frequently represented in English fourteenth-century work, such as the Holkham Bible Picture Book (W. O. Hassall, *The Holkham Bible Picture Book* [London, 1954], f. 32v and notes). Adam is present in two other diptych leaves (Dalton, nos. 273 and 274)—works that are probably English—and in a diptych (Dalton, no. 260) that may be either English or Mosan. The usage has not been found in France, but it appears in three

German examples (Koechlin, nos. 202 and 832; and Schnitzler, Kofler cat., no. S-93—the latter two by the Master of Kremsmunster). While the chalice beneath the Cross continues in England well into the fifteenth century in alabaster, it is seen most often with angels holding the vessel.

The placing of the Coronation of the Virgin on a base is a device used also in French diptychs (see Koechlin, no. 250), but in the Providence ivory it has a unique purpose: serving as a transition to the final scene. This is the most elaborate rendering of the Last Judgment in ivory, and while the subject exists in other examples, none so closely imitates the central portal of a French Gothic cathedral. Although the Christ reflects the pervasive influence of the tympanum of Notre Dame in Paris, the entire composition—especially the treatment of the souls arising from their tombs—is closer to Saint-Seurin in Bordeaux (Mâle, fig. 176).

A diptych with many similar features, but with six scenes (once in the M. Manzi collection in Paris; sale, Manzi et Joyant, Paris, 15–16 December 1919), has an upper tier with the same three episodes, including the Coronation on a raised pedestal. Its Last Judgment is treated like that in a diptych in Lyons Cathedral (Koechlin, no. 524), with the rising souls centrally placed beneath a trefoil on which Christ sits, showing his wounds, between the kneeling Virgin and Saint John and two standing angels. In the Crucifixion the influence of the friars is apparent in both the chalice beneath the Cross and the issue of blood

from Christ's side. The second tier of the Manzi diptych shows the Adoration similarly composed and including a groom with the kings' horses and the roof of the stable.

The figure of Christ in the Last Judgment of the Providence diptych descends from a model like that of a much earlier ivory triptych (Koechlin, no. 172) wherein Christ raises both hands to show his wounds—a posture repeated in a diptych of the Rose Group (Koechlin, no. 234).

A feature unknown elsewhere in ivory is the occurrence of large grape leaves on the background behind the Adoration of the Kings (for leaves adorning the front of Christ's sarcophagus, compare a diptych in the Metropolitan Museum of Art, inv. 17.190.200). The glove on the hand of the pointing king is often found in German work (see, for instance, a diptych in the Louvre [Gaborit-Chopin, fig. 243]).

While the present ivory has generally been placed in the first half of the fourteenth century, the twisted skirt of the Virgin in the Crucifixion scene indicates a date at mid-century or the beginning of the third quarter—a date that would be appropriate also for the diptychs from Lyons and the Manzi collection.

The non-Parisian treatment of the architecture in both the Manzi and Providence diptychs, as well as the inclusion of unusual features—Adam with the chalice, the stable and horses, and the leaves on the background—strongly suggest that the carving is English in origin. Alternatively, it may have come from Bordeaux when it was part of the English province of

Guyenne, where the composition of the Last Judgment is most closely paralleled in stone sculpture.

H: 9½ in. (24.3 cm); W: 5¼ in. (13.4 cm) each

Museum of Art, Rhode Island School of Design, Providence (22.201)

History: Collection of Alrid Maudsley, England. (Purchased from Durlacher Brothers, London, 1922.)

Bibliography: Koechlin, no. 348 bis; *Bulletin* of the Museum of Art, Rhode Island School of Design 11, no. 1 (1923) and 25, no. 2 (1937); *Museum Treasures* (Rhode Island School of Design, Providence, 1956).

98

The Crucifixion

Right leaf of an ivory diptych, English, 1345–1365

The body of Christ is carefully rendered, and his head is seen in almost pure profile. Above a cruciform halo on the Cross are the sun and moon. On the left is the Virgin with hands raised and on the right Saint John makes a similar balancing gesture.

The two trefoil arches are capped by molded cornices with small crockets and finials, and three incised trefoils occupy the spandrels.

The plaque has been altered, perhaps to fit into a frame or pax, by carving an arc of ivory from the sides and top. There are three later holes drilled in the spandrels, and several vertical cracks in the panel. A piece of the background is missing behind the Cross, and the area is filled with mastic. The ivory is mounted in a silver base decorated with leaves signed "M. Bucellati, Milano, Roma, Firenze" (made after 1919).

Notes: The figure of Christ with the head in profile is related to a Providence diptych (cat. no. 97) and to a leaf of a diptych in the British Museum (Dalton, no. 271), which is probably English. Also similar to Dalton 271 is the drapery of the Saint John in the Cleveland leaf, which is nearly identical to that of the Virgin in that example. The doll-like Mary and John in the Cleveland ivory are comparable with the figures in a second British Museum diptych (Dalton, no. 269), where the head of Christ is almost in profile. The left leaf of Dalton 269 shows a Virgin between angels; her pointed-nose face is related to yet another English ivory, cat. no. 61.

H: 4¼ in. (10.8 cm); W: 2⁹⁄₁₆ in. (6.6 cm)

The Cleveland Museum of Art (47.65), J. H. Wade Fund

History: Purchased from Adolph Loewi, Los Angeles, 1947.

99

The Life of the Virgin

Ivory box lid with brass studs, French (Paris), 1360–1380

The box lid is coarsely carved with the Annunciation, the Visitation, and (in two panels) the Adoration of the Kings. The scenes are placed under wide trefoil arches with blind gables and floral crockets.

In its original form the lid had five metal cross straps and a central ring handle, now missing, which have been replaced by eleven brass floral studs of the sixteenth or seventeenth century.

Notes: The lid is related to one on a box with scenes of the life of Saint Margaret on its sides (Randall, no. 338). While the drapery and configuration of the Annunciation and Visitation scenes are similar, as though from the same model, they are by different hands. Attribution to a Paris shop is based on the similar treatment found in book covers in the Treasury of Saint-Denis (*Fastes du gothique*, no. 210).

L: 3¹³⁄₁₆ in. (9.7 cm); W: 2⅛ in. (5.4 cm)

Detroit Institute of Arts (70.455), bequest of Robert H. Tannahill

Bibliography: Randall, no. 338.

100

The Crucifixion

Fragments of an ivory box, French (Paris), 1360–1380

On one fragment appears the Virgin wringing her hands, and on the other are Christ crucified and the figure of Saint John holding a book.

The pieces are from the back of an ivory box, which must have had five compartments. First in the sequence, the scene with the Virgin includes reserved areas for the attachment of silver straps. A second compartment, now missing, may have shown Longinus. Christ would have occupied the third compartment, Saint John the fourth. As the John panel does not include reserved areas for straps, there must have been a fifth compartment with a Hebrew holding a scroll.

The carving is shallow and coarse, the separate sections were cut somewhat unevenly, and the upper edge has been

trimmed. There is a later hole in each piece, probably for mounting.

Notes: The box relates to several others attributed to Paris, with lives of Saints Margaret and Catherine (Randall, no. 338; see also cat. no. 99).

H: 1⁵⁄₁₆ in. (3.4 cm); L: [together] 2⁹⁄₁₆ in. (6.5 cm)

National Museum of American Art, Smithsonian Institution, Washington, D.C. (1928.8.240.3), gift of John Gellatly

101

Dormition of the Virgin and The Crucifixion

Ivory writing tablets, German, 1360–1380

With only eight Apostles around the Virgin's bed, the Dormition includes a central Christ carrying his mother's soul in his left arm. In the Crucifixion the Virgin is attended by two Holy Women, and Saint John wipes away tears with the edge of his cape.

The scenes are placed beneath three trefoil arches with stylized crockets and finials. There are trefoils in the gables and the spandrels.

The carving is shallow and simplified, especially the rendering of the hair and details like toes and fingers. The plaques are recessed on the back for wax and have no drilled holes for attachment.

Notes: By 1912 Koechlin had noted that the Dormition was rare in ivory and that most of the comparative material was German (see, for instance, Koechlin, Baboin cat., no. 519). Similar in style is a diptych depicting twelve Apostles at the Dormition (Stafski, no. 216). Exhibiting shallow carving and a stylized rendering of the hair, it comes from the West German church of Wollersheim i Eifel in the Rhineland (see also cat. no. 157).

The unusual gesture of Saint John raising his cape to his face is found in panels believed to be North French (cat. nos. 80 and 91).

H: 4 in. (10.2 cm); W: 2⁷/₁₆ in. (6.3 cm) each

Royal Ontario Museum, Toronto (952.52.1 and 2)

History: Collection of Emile Baboin, Lyons. (Purchased from Raphael Stora, New York, 1952.)

Bibliography: Koechlin, Baboin cat., no. 8.

102

Scenes of the Passion

Ivory diptych, French (Paris or North France), 1365–1380

The four scenes read from left to right, beginning at the bottom: the Arrest of Christ, the Death of Judas and the Flagellation, the Carrying of the Cross, and the Crucifixion.

Embellishing the arcades of the three trefoil arches are floral crockets and finials. There are incised trefoils in the spandrels and a plain stepped molding above.

The figures are deeply carved on plaques that are heavier than usual.

Notes: The scenes of the Arrest and the Crucifixion are based on Passion diptychs, while the Flagellation and the Carrying of the Cross are found in other contemporary or slightly earlier works such as a diptych from Vich (Randall, no. 299) and a late Rose Group diptych (once in the Grandjean collection; Koechlin, no. 807). Although the style is Parisian, the heavy panels suggest that the diptych may have been made elsewhere.

H: 9½ in. (21 cm); W: [open] 9⅞ in. (24.5 cm)

Martin D'Arcy Gallery of Art, Loyola University, Chicago (6.84), gift of Dr. and Mrs. Edward J. Ryan

History: Collection of Stonyhurst College, Lancashire, England (acquired in 1800).

Bibliography: D. Rowe, *The Martin D'Arcy Gallery of Art: The First Ten Years* (Chicago, 1979), no. 33.

103

Scenes of the Passion

Ivory diptych, French (Paris?), 1365–1390

The Passion of Christ is shown starting at the upper left with the Raising of Lazarus and the Entry into Jerusalem, the Washing of the Feet, the Last Supper, Gethsemane, the Arrest of Christ and Judas Hanged, and the Crucifixion.

The scenes are placed beneath arcades of five trefoil arches with floral crockets and finials. Above the arches are incised trefoils, and the upper molding is decorated with roses.

There is a small, discolored crack at the top of the right leaf.

Notes: Iconographically this diptych forms part of the series attributed to the atelier of the Passion Master in Paris (for characteristic examples see Koechlin, nos. 788 and 795). Broader in the handling of the figures, however, and tighter in composition than the usual Passion diptych, it is probably by the same hand as an example that shares similarities especially in the drapery of Christ in the Washing of the

Feet, in Gethsemane, and in the Arrest; the gesture of the first Apostle in the Washing of the Feet; and the unusual hat of the soldier in the Arrest (Longhurst, vol. 2, no. 291–1867).

The treatment of the enframement—with five arches, trefoils, and rose-decorated molding—is rarely found in France, but it appears frequently in the works of the Master of Kremsmunster of Mainz (for instance, Koechlin, nos. 833 and 836). The carver could have been a German who was working in Paris in the Passion atelier or who had been trained in Paris.

H: 10⅜ in. (26.4 cm); W: [open] 9¾ in. (24.8 cm)

The Toledo Museum of Art (50.300), gift of Edward Drummond Libbey

History: Collections of Frédéric Spitzer, Paris; Julius Campe, Hamburg; and Emile Baboin, Lyons. (Purchased from Raphael Stora, New York, 1950.)

Bibliography: Molinier, Spitzer cat., vol. 1, p. 50; R. Koechlin, "Quelques ateliers d'ivoires français," *GBA* 37, no. 3 (1906), p. 49; Koechlin, Baboin cat., no. 19; Koechlin, no. 792; R. Riefstahl, "Medieval Art," *Toledo Museum News,* n.s. 7, no. 1 (Spring 1964), p. 155; *Treasures from Medieval France,* no. V 24; "Medieval Art at Toledo: A Selection," *Apollo* 86, no. 70 (December 1967), p. 440, fig. 7.

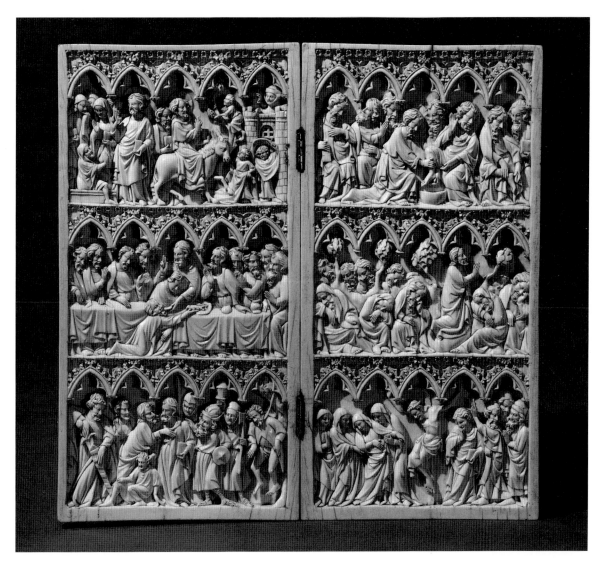

104

The Crucifixion

Ivory pax, French (Paris?), 1370–1380

The figure of Christ is flanked by the Virgin and Saint John, all with powerfully conceived drapery. Mary gestures with her hands, and John turns away with his hand pressed against his cheek.

The back is slotted for the insertion of a handle, which is missing. What appears to be the trimming of the sides and top, above the trefoil arch, were probably later modifications made to adapt the plaque for framing.

Notes: The ivory is related to a group of diptychs with the scenes under single arches. The gestures of both attendant figures are duplicated in cat. no. 79 and that of John in cat. no. 83. All the members of the group have architectural details suggesting the third quarter of the fourteenth century or slightly later. Of the few paxes of the fourteenth century that have survived, some are mounted in fifteenth-century frames (see Koechlin, nos. 588 and 613). This example, made as a flat rectangular pax with an inserted handle, was probably altered in the fifteenth century.

H: 4¼ in. (10.8 cm); W: 2⅛ in. (5.4 cm); D: ⅜ in. (1 cm)

Seattle Art Museum (50.106), gift of Dorothy Chatterton Malone in memory of her father, Reverend Herbert I. Chatterton

History: Purchased from Blumka Gallery, New York, 1950.

Bibliography: Medieval Art, no. 105; Joice Knight McCluskey, *Ivories in the Collection of the Seattle Art Museum* (Seattle, 1987), p. 17.

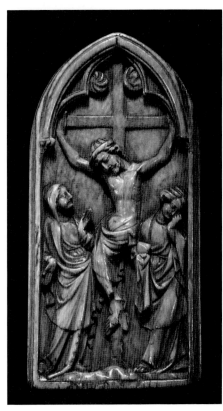

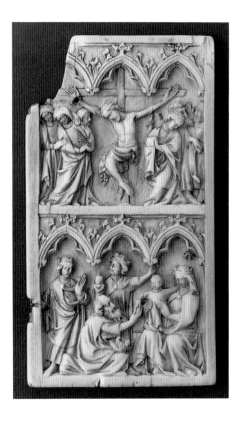

105

The Crucifixion and the Adoration

Right leaf of an ivory diptych, French (Lorraine), third quarter of 14th century

Carved in two tiers, with the Crucifixion above the Adoration of the Kings, the plaque is notable especially for the massive quality of the kneeling king and the Virgin in the Adoration. The broad figures are given a strong sense of movement by their postures and the treatment of the heavy drapery. While John turns his head aside in the Crucifixion, the Virgin is supported by two companions.

The figures are placed beneath arcades of three trefoil arches with floral crockets.

The upper left corner of the ivory is broken away at the miter, and the lower hinge is missing. Both the upper and lower edges of the plaque are chipped, and there is considerable rubbing of the figures. The vessel in the hand of the third king has been broken, probably by the rivet of the hinges. Unusual silver strap hinges with rounded ends, once attached with two rivets to the ivory, have left silhouettes on the reverse.

Notes: The drapery of the Virgin in the Crucifixion scene is closely related to the Ryaux Virgin in the Louvre, which is attributed to Lorraine (*Fastes du gothique*, no. 5), and the seated Virgin in the Adoration can be compared with Lorraine examples.

H: 5 in. (12.7 cm); W: 2½ in. (6.3 cm)

Royal Ontario Museum, Toronto (952.52.4)
History: Collections of Mortimer Schiff, Paris (until 1905); and Emile Baboin, Lyons. (Purchased from Raphael Stora, New York, 1952.)
Bibliography: Schiff sale, Georges Petit, Paris, 11 March 1905, lot 272; Koechlin, Baboin cat., no. 14.

106

The Virgin and Child with Angels and Saint George

Left leaf of an ivory diptych, English, third quarter of 14th century

The Virgin stands, nursing the Christ Child, between candle-bearing angels and with the kneeling figure of Saint George at her feet. Her veil falls in a sweep from her crown, and her robe falls over her right arm, giving an apron effect with two large folds emphasized at the top. Saint George wears chain mail, a long cotte, and a helmet with the visor raised; the shield on his left shoulder and an ailette above it are both emblazoned with his coat of arms. The angels' wings are shown against the background.

Above the figures are three trefoil arches, with incised trefoils in spandrels flanking the central arch. Trimmed on three sides, the plaque still has hinge marks on the right edge.

The bottom, which has lost its left corner, was cut for a mount. There is an old but not original hole drilled at the lower right.

Notes: The posture and drapery of the Virgin are repeated in two ivories in the British Museum that are also thought to be English. One is a panel portraying the Virgin with Saints Eanswyth and Peter

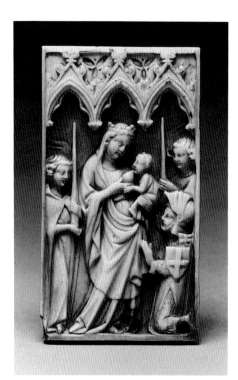

(Koechlin, no. 586 bis, as "English"), while the second is a small diptych plaque with the Virgin between censing angels (Dalton, no. 288). Yet another related example—found at Cannock Wood, Staffordshire, before 1784—is the center of a triptych, carved on both sides, showing the Virgin and a donor on one side and a Nativity on the other (Dalton, no. 258; and Koechlin, no. 449). The broad face of the Virgin and the rendering of the eyes are similar to corresponding features in the Detroit ivory. A plaque that shows Saint George (on horseback) with a similar helmet and ailettes (W. Welles, "An Ivory Panel in the Burrell Collection," *Scottish Art Review* 11, no. 1, [1967], pp. 7–8) is now believed to be Flemish.
H: 2⅞ in. (7.3 cm); W: 1⅝ in. (4.1 cm); D: ⅜ in. (1.5 cm)
Detroit Institute of Arts (43.461), gift of Robert H. Tannahill

107

The Life of the Virgin

Ivory diptych, Flemish, third quarter of 14th century

The scenes read from the left, beginning at the bottom: the Nativity, the Adoration of the Kings, the Crucifixion, and the Coronation of the Virgin. The treatment of the figures' slightly bulging eyes with emphasized lower lids is a distinguishing feature, as is the way the fourth Holy Woman looks upward at the Cross. Christ's contorted body has long, sinuous arms, and the censer chain of the right-hand angel in the Coronation is completely undercut.

Above the figures are three wide, slightly pointed trefoil arches with abstractly rendered crockets and floral finials. Trefoils are incised between the arches.

The hinges are of brass. There are original pairs of holes for hanging at the top of each panel. It is unusual that the left plaque is one-sixteenth inch thicker than the right.

Notes: Two diptychs from the same workshop are at the Metropolitan Museum of Art (inv. 32.100.199a,b) and a private collection in Holland (Koekkoek I, no. 35). The Metropolitan ivory, by a finer hand, has rounded arches and a studded upper border. Both repeat the long arms of Christ and the face of the fourth Holy Woman turned upward, as well as the three angels in the sky in the Coronation, the gesture of Saint John in the Crucifixion, and the long, curly beard of Joseph in the Nativity. (See also cat. no. 125.)
H: 5⅞ in. (15.1 cm); W: [open] 7⅝ in. (19.5 cm)
The Toledo Museum of Art (50.299), gift of Edward Drummond Libbey

H: 4¹³⁄₁₆ in. (12.4 cm); W: 3¾ in. (9.6 cm)
Worcester Art Museum, Worcester,
Massachusetts (1919.231)
History: Purchased from Philip J. Gentner,
Florence, 1919.
Bibliography: Worcester Art Museum *News
Bulletin and Calendar,* October 1951, p. 1.

109

The Life of the Virgin and the Decollation of John the Baptist

Ivory diptych, Flemish, third quarter of 14th century

Reading from the top left are the Annunciation, the Visitation, the Crucifixion, the Death of the Virgin, and the Decollation of John the Baptist. Among the details of the Annunciation are Gabriel with his left wing raised against the background, a scroll, a vase of lilies, and a dove directly above the Virgin's head. The figure of Elizabeth in the Visitation wears a turban retained by a band that falls down the back. In the Dormition are eleven Apostles and Christ holding the Virgin's soul. The rare episode of the beheading of John the Baptist shows Salome waiting with a large bowl.

Above the scenes are arcades of three trefoil arches, resting on colonnettes, with crockets and finials. There is a serrated molding at the top.

The hinges and catch are modern brass replacements, and there are breaks and fills where the original hinges were pulled out. Various initials—AN and an X—are scratched on the back of the right wing.

History: Collections of Edouard Chappey, Paris (until 1907); and Emile Baboin, Lyons. (Purchased from Raphael Stora, New York, 1950.)
Bibliography: Chappey sale, Georges Petit, Paris, 5–7 June 1907, lot 1685; Koechlin, Baboin cat., no. 13; Koechlin, no. 332.

Above the arcade of three trefoil arches with blank gables are floral crockets and finials that are large and well executed. Pierced trefoils occupy the spandrels, and a studded molding appears at the top.

Hinges that were inset diagonally are missing. There are several later holes for mounting—three at the bottom, two between the arches, and two through the center trefoils.

Notes: The studded borders, which are characteristic of certain Flemish ivories (see cat. nos. 110 and 111), are found occasionally in both Mosan and German work (see cat. no. 85).

108

The Adoration of the Kings

Left leaf of an ivory diptych, Flemish or Mosan, third quarter of 14th century

The drapery of the heavy-set figures is characterized by groups of transverse folds. Heads and hands are large and emphasized in relief.

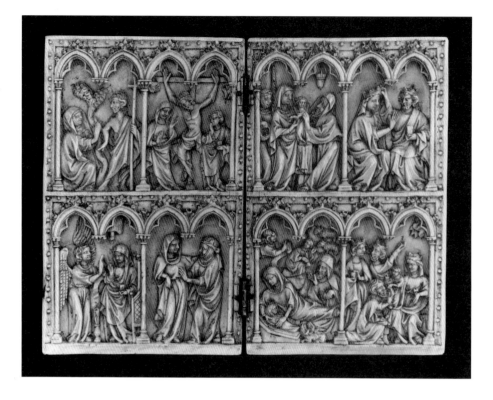

Notes: The figure style and composition, particularly those of the Annunciation and the Visitation, can be compared with Flemish ivories having studded borders (see cat. nos. 110 and 111). While rows of saints often appear in Flemish work, a martyrdom is unusual.

H: 4¾ in. (11.8 cm); W: 2¾ in. (6.8 cm) each

Royal Ontario Museum, Toronto (952.52.3)

History: Collection of Emile Baboin, Lyons (not in Koechlin, Baboin cat.). (Purchased through Raphael Stora, New York.)

110

The Life of Christ

Left leaf of an ivory diptych, Flemish, third quarter of 14th century

Beginning at the bottom left are the Annunciation, the Nativity, the Crucifixion, and the Three Marys at the Tomb. Defined with simple carving, the figures are given summary treatment of details such as the hands, which are used for expressive accents.

The scenes are set beneath pairs of trefoil arches festooned with crockets and finials. They are separated by colonnettes and framed with studded borders, except at the base. A raised area representing a carved hinge was provided for diagonally set hinges.

There are two later holes for mounting drilled in the upper border of each tier.

Notes: Ivories with studded borders exhibit consistency in the treatment of scenes, especially those of the Annunciation and the Visitation. (For other members of the group, see cat. no. 111; Koechlin, no. 384; and Longhurst, vol. 2, no. 665-1853.)

H: 6⁵⁄₁₆ in. (15.9 cm); W: 4¹⁵⁄₁₆ in. (10.9 cm)

Smith College Museum of Art, Northampton, Massachusetts (1961:62)

History: Purchased from the Paul Drey Gallery, New York, 1961.

111

The Life of Christ

Ivory diptych, Flemish, third quarter of 14th century

The narrative reads from left to right, the lower tier including the Annunciation, the Visitation, the Nativity, and the Adoration. In the sequence of the upper tier— Noli Me Tangere, the Crucifixion, the Presentation, and the Coronation of the Virgin—the placement of Noli Me Tangere and the Presentation are reversed. The scenes are filled with lively movement, with emphasis on drapery folds and gestures of the hands, some of which have elongated fingers.

Colonnettes divide the eight episodes, which are canopied by pairs of trefoil arches. The borders are studded, except at the base, and the hinge areas are carved to simulate surface hinges.

Silver butt hinges, attached flat to the sides of the plaques, replace the usual type inset diagonally. There is a small flaw at the lower left side of the left leaf. Three holes are drilled at the top of each plaque, two unexplained and one diagonal for hanging. All six holes are plugged.

Notes: There were no absolute rules of order for the arrangement of scenes on Gothic ivories. In the workshop of the Passion Master, some works read from the top, others from the bottom. The tiers can proceed in either direction and often change in alternate levels. The present arrangement seems to have been caused by

carving the plaques separately without reference to each other. Both read

C D

A B,

which is a logical and often-found pattern, but the sequence is

G F E H

A B C D

when the two are combined. A similar error occurs in a related diptych (Koechlin, no. 370) with the Ascension and the Pentecost preceding the Crucifixion.

The headdress of Elizabeth in the Visitation has often been taken to designate a late date, since it survives into the fifteenth century, but it can be found as early as 1255 in the Isabella Psalter (R. Branner, *Manuscript Painting in Paris during the Reign of Saint Louis* [Berkeley, 1977], fig. 402). It is usually reserved for serving women and elderly figures. (See also cat. no. 109.)

H: 5⅛ in. (13.1 cm); W: [open] 6¾ in. (17.1 cm)

Museum of Fine Arts, Saint Petersburg, Florida (68.30), Rexford Stead Purchase Fund

History: Collections of Paul R. G. Horst, an English collector in Paris; and Robert Horst, Paris. (Purchased through Jacques Seligmann, Paris, 1968.)

112

The Virgin and Child with Angels

Left leaf of an ivory diptych, North French, third quarter of 14th century

The Virgin holds the Christ Child in the curve of her left arm and a stem of flowers in her right hand. Her apron drapery has

deep folds in the skirt, and she has an unusually long veil falling on her right side. Clad in contrasting drapery, the candle-bearing angels disappear slightly behind the frame. Their eyes are rendered with bulging lids.

The figures are placed beneath a single trefoil arch under a gabled roof with large crockets and a floral finial. There are pinnacles at each side and incised trefoils in the spandrels.

The composition is placed somewhat unevenly in the frame. Hinges are lacking, and the bottom miter is cracked. Slight deterioration has occurred on the lower edge and left corner, and there are traces of polychromy.

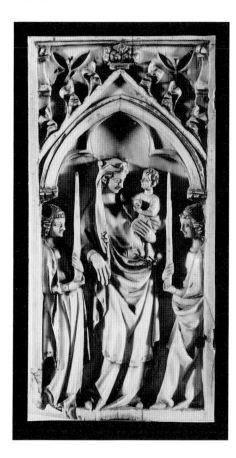

Notes: The uneven frame and the unusual overlapping of the angels by the frame suggest that the plaque is not Parisian in origin. The bulging eyes can be seen in cat. no. 73, which is also probably North French.

H: 5½ in. (14 cm); W: 2¹¹⁄₁₆ in. (6.9 cm)

The Malcove Collection, University of Toronto (M82.201)

History: Collection of Dr. Lillian Malcove, New York. (Purchased from Mathias Komor, New York, 1960.)

Bibliography: S. Campbell, *The Malcove Collection, University of Toronto* (Toronto, 1985), no. 418.

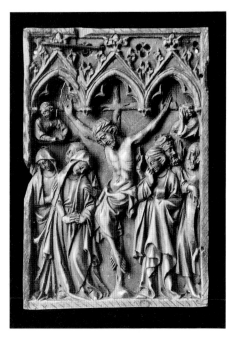

113

The Crucifixion

Left leaf of an ivory diptych, French (?), third quarter of 14th century

Christ is seen on a rusticated Cross between the Three Marys, on the left, and Saint John with two Hebrews, on the right. The Virgin is wringing her hands, and the other women turn their heads away from the Cross. One Hebrew is depicted as bald. An angel above clenches his hands and another hides his face.

The three trefoil arches have blank gables capped by large floral crockets and finials. In the spandrels are trefoils of drilled holes.

The ivory, gray in color, is broken diagonally at the top left and riveted. There is a break in the left side and at the upper hinge miter on the right. The border is crosshatched.

Notes: No close parallels have been found for these unusually fine figures. The careful treatment of the drapery and gestures, the variety in facial expression, and the differentiation of the two angels are exceptionally sensitive in this Crucifixion with the fainting Virgin—a subject that is commonplace in the third quarter of the fourteenth century.

H: 4½ in. (11.6 cm); W: 3⅛ in. (8 cm)

National Museum of American Art, Smithsonian Institution, Washington, D.C. (1928.8.240.18), gift of John Gellatly

114

The Crucifixion and the Nativity

Left leaf of an ivory diptych, North French, third quarter of 14th century

The Crucifixion emphasizes the three main figures, that of Christ being large in scale with careful detailing. Mary, wearing no head covering, spreads her arms as she swoons into the arms of three women. Saint John stands in an S-posture with hand to cheek; his drapery is broad and richly interpreted. The Virgin of the Nativity is likewise larger than the attendant figures and her drapery is finely handled with imaginative touches, such as the scarf over her shoulder and right arm. Joseph is shown asleep, his hands crossed on his staff. By contrast, lesser details such as the ox and ass are summarily handled. In the background are two shepherds, one with bagpipe, observing the angel with his scroll.

The scenes are placed beneath three trefoil arches with floral crockets and finials, and incised trefoils decorate the spandrels.

Above the lower of the two diagonal hinge miters, the ivory has been broken and repaired. Other damage includes a flaw at the upper right, a broken lower left corner, and a coarse line that was incised along the top at a later time. Leather straps, once bound around the outside, have left darkened silhouettes, and there are three holes for their attachment. The right arm of the bagpiper is missing.

Notes: The figure of Saint John relates this ivory to a diptych leaf attributed to North France (Randall, no. 309) and to a missal from Châlons-sur-Marne (see *International Style*, no. 44). The bareheaded Virgin appears in a number of ivories of French, German, and Mosan origin (for instance, Schnitzler, Kofler cat., nos. s.85, s.87, and

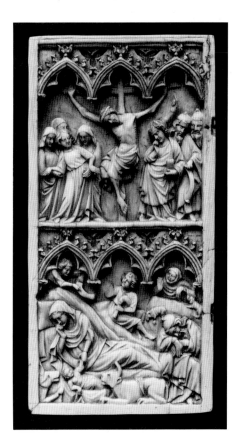

S.99; and Randall, no. 318), all of the third quarter of the century or later. A Flemish ivory of the same era (British Museum, inv. 78.11–1.36) includes the rare sleeping Joseph; and a plaque with studded borders, also believed to be Flemish (von Hirsch sale, Sotheby's, London, 22 June 1978, lot 284), repeats many details of the Rochester ivory.

H: 6⅜ in. (16.3 cm); W: 3¼ in. (8.4 cm)
Memorial Art Gallery, University of Rochester (49.19), R. T. Miller Fund

History: Collections of Richard von Passavant-Gontard, Frankfurt; and Joseph Brummer, New York (until 1949).

Bibliography: G. Swarzenski, *Sammlung R. von Passavant-Gontard* (Frankfurt, 1929), no. 71; Brummer sale, Parke-Bernet, New York, 23 April 1949, lot 650; *Memorial Art Gallery Handbook* (Rochester, 1961), p. 51; D. Sutton, *Treasures from Rochester* (Rochester, 1977), p. 11; S. P. Dodge, *Memorial Art Gallery, University of Rochester* (New York, 1988), p. 52.

115

The Crucifixion

Right leaf of an ivory diptych, Mosan (Liège?), third quarter of 14th century

Christ is depicted on a rusticated Cross between the fainting Virgin with two Holy Women and the mourning Saint John with two Hebrews. The Virgin wears a simplified twisted skirt, while John's complex drapery includes a scarf on the back of his head. The eyes are represented as long ovals between raised lids, and details such as hands and feet are summarily carried out, particularly in the rendering of thumbs. An angel above the Cross holds in his hands the sun and moon.

The large trefoil arch, set on floral corbels, has a blank gable with large crockets and a floral finial. In the spandrels are two quatrefoils with raised conical centers.

Removal of unusually large hinges, set diagonally, and a catch plate has left disfigurement; there are chips on three corners and a crack at the top center. The hole drilled in the upper border appears to be original.

The back of the plaque is engraved with a Nativity by a folk artist probably of the eighteenth century. Within a double incised border the scene includes the ox and ass, a second bovine, a pigeon, an oval star, and a wattle fence.

Notes: The falling drapery on John's head appears in two similar ivories of the same period (*Trésors du Musée d'Art Religieux et d'Art Mosan de Liège*, p. 41, no. 49; and Koechlin, no. 539). The same figure of an angel holding the sun and moon occurs in

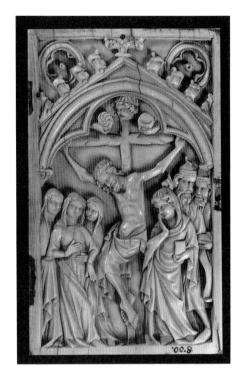

the latter ivory, as does the architectural format with quatrefoils above the arches. A third comparable plaque (Dalton, no. 301) has a similar composition and a related figure of Saint John.

John's scarf is apparently taken from a classical prototype of a priest or emperor wearing the toga on the back of the head. One such figure—a Roman bronze of the first century A.D.—is a statuette of a "genius" (see E. Richardson, "The Etruscan Origins of Early Roman Sculpture," *Memoirs of the American Academy in Rome* 21 [1953], p. 110, fig. 20). The fashion is adapted also in a late illustration by the Limbourgs (M. Meiss, *The Late XIV Century and the Patronage of the Duke* [London and New York, 1967], fig. 781).

The figure of an angel holding the sun and moon can be seen, compositionally, as balancing the crowning angel when the Coronation of the Virgin is the adjoining plaque (see Koechlin, no. 539). It appears in Paris ivories (see cat. no. 75) as well as in English examples (Dalton, no. 273) and one that is possibly North French or English (British Museum, inv. 1920, 4–15,7).

H: 5⅜ in. (13.7 cm); W: 3⁵⁄₁₆ in. (8.4 cm)
Herbert F. Johnson Museum of Art, Cornell University, Ithaca (79.62), University Purchase Fund

History: Collection of Stonyhurst College, Lancashire, England (accessioned in 1800);

"Art Treasures" exhibition, Manchester, England, 1862; collections of Edward R. Lubin, New York; Mr. and Mrs. John R. Blum (1972); and Martin d'Arcy Gallery of Art, Loyola University, Chicago. (Purchased from Edward R. Lubin, New York, 1979.)

Bibliography: D. Rowe, *Martin d'Arcy Gallery: The First Ten Years* (Chicago, 1979), no. 30; *Gesta* 19, no. 2 (1980), p. 140, fig. 14.

116

The Nativity

Ivory writing tablet, Flemish or North French, third quarter of 14th century

Lying on a bed with a large pillow, the Virgin tends the Christ Child in a crib woven like a wattle fence. An ox and an ass flank the crib, and at the foot of the bed sits Joseph, holding his cane in his hand. In the background are two sheep and a shepherd who waves at the annunciate angel.

The three trefoil arches have trefoils both in and above the gables. The crockets and floral finials are simplified and geometric. A single hole is visible at the top.

Notes: The object is presumed to be a writing-tablet cover; it was not examined from the back. The artist showed a great interest in patterns—the scarf of the Virgin, the pillow, the bed sheet, the wattle crib, and the sheepswool.

H: 3⁵⁄₁₆ in. (8.2 cm); W: 2⅛ in. (5.5 cm)
Crocker Art Museum, Sacramento (1960.3.101), gift of Ralph C. and Violette M. Lee

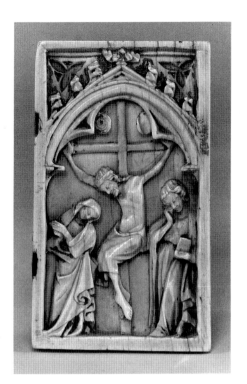

117

The Crucifixion

Right leaf of an ivory diptych, French, third quarter of 14th century

The figure of the crucified Christ is seen between Saint John and the Virgin, who bows her head and clasps her hands.

On either side of a single trefoil arch sprouting crockets and finial are spandrels with incised trefoils.

The panel has two diagonal hinge miters and traces of a catch on the right. Remains of polychromy include gilt on the crockets and blue on the figures.

Notes: While provincial, the panel shows an inventiveness in the Virgin's gesture and the large spiral fold of her drapery.

H: 3¼ in. (8.4 cm); W: 1⅞ in. (4.8 cm)

The Denver Art Museum (1971.237), Marion G. Hendrie Fund

History: Purchased from Loewi-Robertson, Los Angeles, 1971.

118

The Life of Christ

Left leaf of an ivory diptych, Flemish or Mosan, third quarter of 14th century

The Annunciation and the Adoration of the Kings, placed within quatrefoils, are carved with heavy and squat figures, so that details like the angel's scroll and the crown of the first king are difficult to read.

Drilled trefoils occupy each corner, and the plaque has a studded border within a recessed band, except on the bottom edge. Hinge plates are carved on the ivory surface.

Staining has left the panel brown-black in color, and there are small chips on the upper edge.

The matching leaf of the diptych (figure 12; collection of Ruth Blumka, New York) depicts the Nativity and the Crucifixion. On the back of the two plaques is a Flemish inscription, deeply carved in Gothic letters: DIT GAF DONAE[S] / DIE MOER M̅[ER] VRAUE / TAN̅[N]E TVOS INT JAER MCCCCLXXVIII (*Donaes de Moer gave this to Milady Tanne, the daughter of De Vos, in 1478*).

Notes: That the ivory was presented a century after it had been made suggests that it was still in use; the inscription and date are a measure of the gift's significance to the donor.

A closely related work showing the Arrest of Christ and the Nativity (Koekkoek I, no. 39) has similar quatrefoils and a studded border. The Providence ivory must come from the same workshop.

H: 6⁵⁄₁₆ in. (16.2 cm); W: 3 in. (7.7 cm)

Museum of Art, Rhode Island School of Design, Providence (27.185), gift of John Marshall

History: Collection of John Marshall, Providence (before 1927). The matching leaf was purchased by Leopold Blumka from Oscar Bondy in Vienna in 1933. The two must have been separated at some time before 1927, when this plaque entered the collection of the Rhode Island School of Design. A copy of the complete diptych, made before that time (Schnitzler, Kofler cat., S-69), is unlocated.

Figure 12 Nativity and Crucifixion, ivory, collection of Mrs. Ruth Blumka, New York.

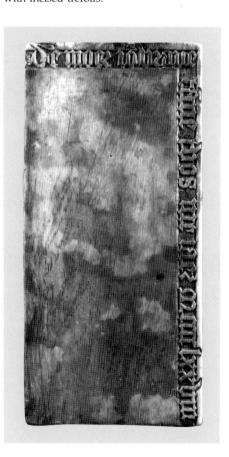

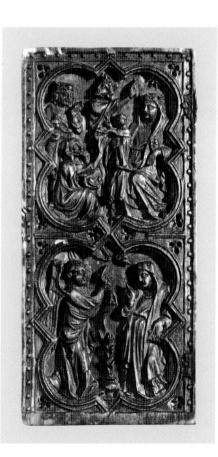

119

The Nativity and the Crucifixion

Ivory diptych, Rhenish (?), third quarter of 14th century

The figures are carved in a somewhat simplified manner with an emphasis on gesture. In the Nativity Joseph gestures behind the Virgin, who rests her head in one hand and stretches the other toward the swaddled Child in a wicker basket. The ass is overly large and the ox unusually small. Robes of the annunciate angel and the single shepherd in the background are characterized by deeply cut, simple folds, and the coats of the sheep are striated. In the Crucifixion the Virgin's body is contorted as she faints into the arms of two Holy Women, and Saint John is shown in contrapposto, looking away from the Cross, his hand to his face.

The three trefoil arches have large blank gables surmounted by floral crockets. There are traces of red-brown paint on the Cross.

Notes: The calm Nativity scene contrasts with the emotional postures of John and the Virgin in the Crucifixion. A similar treatment is found in a Thomas Becket plaque with the Crucifixion (Koechlin, no. 346 bis), which is called Rhenish. Although the architecture is quite different, the same or a similar model must have been used in both instances.

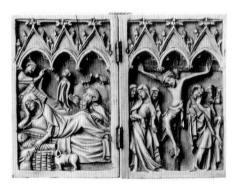

For discussion of the various workshops that produced Becket plaques, see cat. nos. 120 and 121.
H: 3¼ in. (8.4 cm); W: 2³⁄₁₆ in. (6.3 cm) each
National Museum of American Art, Smithsonian Institution, Washington, D.C. (1928.8.240.8), gift of John Gellatly

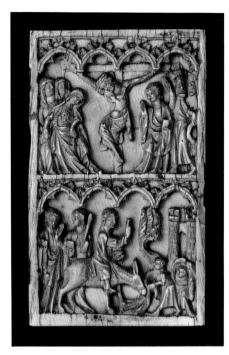

120

The Crucifixion and the Entry into Jerusalem

Right leaf of an ivory diptych, French (Paris), third quarter of 14th century

Christ is placed between two groups of three: Mary fainting into the arms of two Holy Women and Saint John with two Hebrews. As the Virgin and John curve away from the Cross, their opposing postures emphasize the central figure. In the Entry scene Christ is again accentuated in the center, with two Apostles behind him and a gateway and a tree looming ahead; two boys spread garments on the ground in front of the donkey.

The scenes are placed beneath four slightly flattened trefoil arches with crockets and finials.

Whereas the ivory is whitish in the background, the figures are grayish. It is chipped in the center on the right side. The hinges are lacking.

Notes: The format under four flattened arches, the small size, and the type of carving relate this ivory to a group of plaques depicting the murder of Thomas Becket (see cat. no. 121). By tradition the group has been considered German, and probably Rhenish. The similar rendering of the Entry in an ivory from Saint-Denis (Koechlin, no. 823) suggests, however, that this is lesser-quality Parisian work. Another related example is a plaque with the Arrest of Christ and the Entry into Jerusalem (Musée de Cluny, Paris; inv. Cl. 15322).
H: 5¹⁄₁₆ in. (13.1 cm); W. 3¹⁄₁₆ in. (8 cm)
Yale University Art Gallery, New Haven (1966.90), Enoch Vine Stoddard Fund

History: Collection of George Eumorfopoulos. (Purchased from K. J. Hewett, London, 1966.)
Bibliography: Catalogue of the Exhibition of Ivories (Burlington Fine Arts Club, London, 1923), pl. 37, no. 115.

121

The Crucifixion and the Murder of Thomas Becket

Leaf of an ivory writing tablet, French (Paris), third quarter of 14th century

In the Crucifixion John raises his hand and stands at the right with two Hebrews. The Virgin and attendants (as in cat. nos. 119

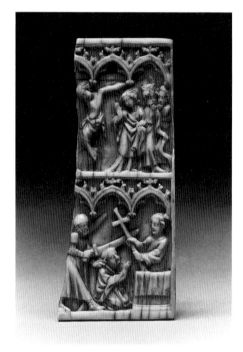

and 120) are missing. Thomas Becket is shown below, kneeling at the altar, defended by his crucifier, Grim, and struck with the falchion of the first soldier, who wears mail, a steel cap, and an ailette. The sword of a second soldier is seen in the background.

Consisting originally of four trefoil arches, the arcade above the figures is decorated with floral crockets and finials.

A portion of the ivory is missing at the left, where a vertical crack occurred. It is trimmed on the right edge, and there is a large hole above the Cross for a cord to attach other writing tablets.

Notes: The plaque is closely related to cat. no. 120, and the summary treatment of Saint John and the Hebrews suggests the same workshop. Another Becket plaque of

the same small scale (Randall, no. 307) shows the first soldier similarly armed and using a falchion. The latter example includes a sword piercing the Virgin's side—iconography that originates in the Rhineland. In a third example (Longhurst, vol. 2, no. A380–1923) the composition of the Becket scene is again comparable, but the plaque has bands of studded ornament and might be either Flemish or North French. The ailette on the shoulder of the soldier suggests a date not later than the third quarter of the century.

H: 3¹¹⁄₁₆ in. (9.4 cm); W: 1⁹⁄₁₆ in. (4 cm)

Detroit Institute of Arts (43.460), gift of Robert H. Tannahill

122

The Virgin and Child with Angels

Left leaf of an ivory diptych, German (Cologne), third quarter of 14th century

The Virgin holds a flower, which the Child touches with his right hand while holding a globe in his left. Standing in an arched posture on the left is an angel wearing a cape with a series of V-folds; the one on the right wears a simple gown and a cape.

The single trefoil arch has crockets and a floral finial. Angels are shown in the spandrels, their censers falling beneath the arch above the Virgin's head.

Notes: The delicately carved ivory can be attributed to the Berlin Master and compared to his other works. (See Koechlin,

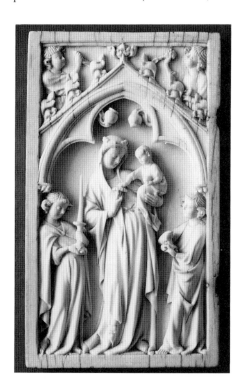

nos. 120 and 533; Randall, no. 301; and cat. no. 43 in this book. Probably by this artist as well is Schnitzler, Kofler cat., no. S-66.)

H: 5½ in. (14 cm); W: 3¼ in. (8.3 cm)

The Museum of Fine Arts, Houston (71.7), Laurence H. Favrot Bequest

History: Collections of Octave Homberg, Paris; Mme Homberg, Paris (until 1931); and E. and M. Kofler-Truniger, Lucerne (until 1965).

Bibliography: Koechlin, no. 411 (incorrectly as Niort Museum); Schnitzler, Kofler cat., no. S-67; J. H. Schroder, "An Ivory Plaque with the Virgin and Child in Glory," *Bulletin,* Museum of Fine Arts, Houston (May 1972), pp. 35–37.

See also colorplate 12.

123

The Virgin and Child with Angels

Ivory writing tablet, German, third quarter of 14th century

The Virgin stands with the Child between wingless angels, who hold incense boats in their left hands and whose censers meet above Mary's head. The figures are simply draped and somewhat sketchy.

A wide arch with five cusps of rounded form frames the scene at the top. The crockets are simplified, the floral finial squeezed into the composition, and there are trefoils in the spandrels. Two holes are drilled below the upper border.

Notes: The detail of censers meeting above the Virgin's head, while treated in various ways, is frequent in German work (see, for instance, cat. no. 122, a diptych leaf by the Berlin Master).

H: 3 in. (7.7 cm); W: 1¾ in. (4.6 cm)

Crocker Art Museum, Sacramento (1960.3.59), gift of Ralph C. and Violette M. Lee

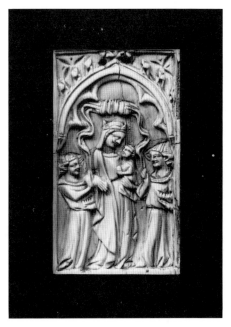

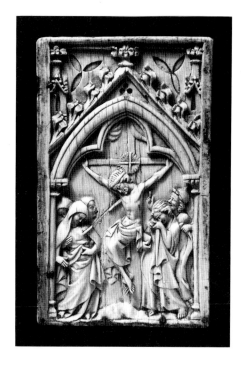

124

The Crucifixion

Right leaf of an ivory diptych, German, third quarter of 14th century

The figure of Christ with a cruciform halo is flanked by the Virgin supported by two women, on the left, and Saint John, wiping his eyes with his robe, accompanied by a Hebrew with a scroll, at the right. As one of Mary's attendants brushes away tears, the second looks at the Cross, which is set in a mound of Golgotha that is larger than usual. An issue of blood or spear pierces the Virgin's breast. Emphasis on the swaying postures of the figures is conveyed by the treatment of the drapery.

The scene is placed beneath a single trefoil arch on colonnettes, with a crocketed gable and floral finial above. There are pierced pinnacles at each side and trefoils in both the gable and the spandrels.

The silver hinges are missing, but the nails that secured them remain. Many vertical cracks are present, and the issue of blood is damaged. The base, trimmed slightly, has four later nail holes.

Notes: No close parallels have been found, but the inclusion of the issue of blood, the cruciform halo, and the emotion expressed in the figures suggest that this small ivory is German, perhaps Rhenish.

H: 3³⁄₁₆ in. (8.3 cm); W: 2 in. (5.2 cm); D: ³⁄₁₆ in. (1.1 cm)

The Fine Arts Museums of San Francisco (59.8), M. H. de Young Endowment Fund

History: Purchased from Walter Laemmle, Los Angeles, 1959.

125

The Crucifixion and the Adoration

Ivory writing-tablet cover, Flemish (?), third quarter of 14th century

Christ is portrayed in the Crucifixion between the Three Marys and Saint John with two Hebrews. The Adoration shows the first king offering a huge gold coin. Shallow carving of the figures is done with the use of certain shorthand tricks that effectively catch the light; the left arm of the third king is poorly handled.

The arcades of three trefoil arches have floral crockets and finials, and there are incised trefoils in the spandrels.

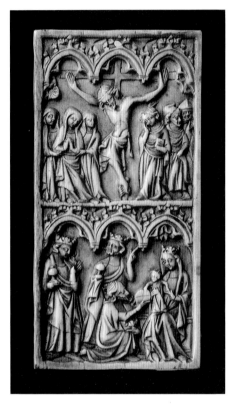

Notes: The exaggeration of Christ's arms, the somewhat modified twisted skirt of the Virgin, and the outsize gold coin of the first king are all paralleled in a diptych attributed to Flanders (cat. no. 107).
H: 3⅞ in. (10 cm); W: 1¹⁵⁄₁₆ in. (5.1 cm)
National Museum of American Art, Smithsonian Institution, Washington, D.C. (1928.8.240.13), gift of John Gellatly

126

The Crucifixion

Left leaf of an ivory diptych, Mosan or Rhenish, third quarter of 14th century

The figure of Christ is flanked by two angels carrying the sun and moon. A *titulus*

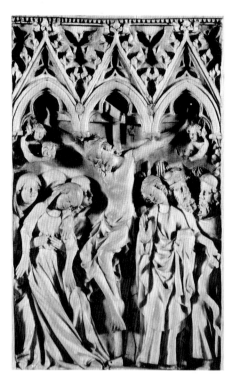

is posted on the Cross, and at its foot is a wedge. Three Holy Women support the fainting Virgin, on the left, and at the right Saint John appears with two Hebrews. The scene is placed beneath an arcade of three trefoil arches in gables that have floral crockets and finials. Trefoils fill the gables as well as their spandrels, and the top edge is accented by a band of pearling.

The panel had three hinges (now missing) on the right, and the miters are filled, as are several later holes in the canopy that were drilled for mounting. At some time after the plaque was broken in half, the upper part of the damaged area was filled with mastic, while in the lower part there is an ivory inset. The moon is missing from the hands of the right-hand angel.

Notes: While the carving is much finer, this panel probably comes from the same workshop as cat. nos. 127, 128, and 129. Far larger than the others, it has extra figures and features, such as angels with sun and moon, a third Holy Woman, and a *titulus* on the Cross. But the treatment of the woman looking at the Cross and the gestures of the Hebrews are handled so similarly as to point to use of the same model.
H: 5¹⁄₁₆ in. (12.9 cm); W: 3¼ in. (8.2 cm)
The Malcove Collection, University of Toronto (M.82.202)

History: Collection of Dr. Lillian Malcove, New York. (Purchased from George Seligmann, New York, 1958.)

Bibliography: S. Campbell, *The Malcove Collection, University of Toronto* (Toronto, 1985), no. 419.

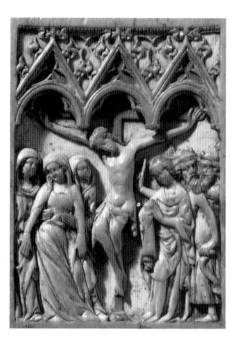

127

The Crucifixion

Ivory pax, Mosan or Rhenish, third quarter of 14th century

The Christ figure, depicted with long, thin arms, is placed between two Holy Women who support the Virgin, on the left, and Saint John and two Hebrews, on the right.

The arcade of three rounded trefoil arches in gables has floral crockets and finials. Trefoils are pierced in the gables and in the spandrels, and a band of pearling runs across the top.

The ivory is somewhat rubbed and brownish in color. There is a slot in the back for a handle, which is lacking. The back is chamfered from the center toward the edges.

Notes: From the same workshop as cat. nos. 126, 128, and 129, the scene has minor variations. Both this example and one other (Koechlin, no. 600) are paxes, while the other members of the group are the wings of diptychs. See cat. no. 129.
H: 4½ in. (8.4 cm); W: 3¼ in. (5.4 cm)
Collection of Neil F. Phillips, New York
History: Acquired through Ronald Lee, London.

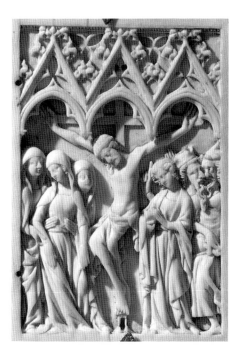

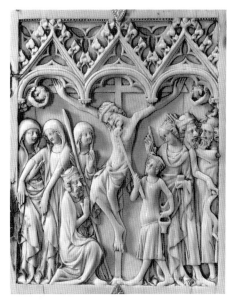

128

The Crucifixion

Right leaf of an ivory diptych, Mosan or Rhenish, third quarter of 14th century

The thin Christ, carved with long, attenuated arms, is flanked by the Virgin and two Holy Women, on the left, and Saint John and two Hebrews, on the right.

Forming an arcade over the figures are three rounded trefoil arches in gables ornamented with floral crockets and finials. Both the gables and the spandrels are filled with trefoils, and the upper border has a band of pearling.

The hinges are no longer in place, and there are later holes for mounting: two drilled in the central arch and one at the foot of the Cross.

Notes: The Christ figure is nearly identical to that in cat. no. *127*, and the other details vary only slightly. The two ivories are certainly from the same workshop and probably by the same carver (see cat. no. 129).

H: 3⁷⁄₁₆ in. (8.2 cm); W: 2⁵⁄₁₆ in. (6 cm)

Wadsworth Atheneum, Hartford (1949.169), Hartford Foundation for Public Giving

History: Collection of Joseph Brummer, New York (until 1949).

Bibliography: Brummer sale, Parke-Bernet, New York, 12 May 1949, lot 682.

129

The Crucifixion

Right leaf of an ivory diptych, Mosan or Rhenish, third quarter of 14th century

The figure of Christ has long, attenuated arms. On the left, in front of the Virgin and two Holy Women, Longinus kneels

with his lance; on the right, wearing a winged hat and offering the sponge, is Stephaton, behind him Saint John and two Hebrews. Two angels flanking the Cross hide their eyes.

The scene is placed beneath three flattened and rounded trefoil arches in gables with floral crockets and finials. Pierced trefoils fill the gables and the spandrels, and at the top is a band of pearling.

Removal of the hinges has damaged the miters, breaking away the lower one with a section of the border. There is a silver button catch on the right side.

Notes: This is one of several ivories apparently from the same workshop (see cat. nos. 126, 127, and 128; and Koechlin, no. 600). While the composition is based on a Parisian model (such as that of cat. no. 134), there are differences that suggest another center. The same unusually flattened and rounded arches are seen in Mosan works (like cat. nos. 153 and 154), and the attenuation of Christ's arms is also a feature found in ivories attributed to the Meuse Valley (for example, cat. no. 153).

In the related works, none of which includes Longinus and Stephaton, the Virgin's arms are usually carved unconvincingly, and one of her supporters wears a veil curving against the frame, while the second looks at the Cross. The hats of the two Hebrews are the same in all examples, one crownlike and one pointed. Similarities extend to architectural details, the arches being almost always rounded, although to different degrees.

H: 4⅜ in. (11.2 cm); W: 3⁹⁄₁₆ in. (9.2 cm)

Wadsworth Atheneum, Hartford (1949.170), Hartford Foundation for Public Giving

History: Collection of Mrs. Rodier Rampson; "Art Treasures" exhibition, Manchester, England, 1857 (label); collection of R. W. M. Walker, London (1945); H. Blairman and Son, London; and Joseph Brummer, New York (until 1949).

Bibliography: Brummer sale, Parke Bernet, New York, 12 May 1949, lot 673; *Religious Art: The Middle Ages and the Renaissance* (Wadsworth Atheneum, Hartford, 1950), p. 19 and pl. VI.

130

The Crucifixion

Ivory writing-tablet cover (?), French, third quarter of 14th century

Christ is placed between the fainting Virgin supported by two Holy Women, on the left, and a mourning Saint John and two Hebrews, on the right. His crucified body is thin and elongated, and all the figures' hands are summarily carved.

The arcade of three trefoil arches has trefoils in the gables, which are ornamented with floral crockets and finials. There is a band of pearling at the top.

Framed because of its condition, the ivory could not be examined from the back. As no hinge miters are evident, it is probably a writing-tablet cover. The plaque was broken in half vertically through the center as well as in several places in the upper right corner.

Notes: The ivory is based on a Parisian model (for example, cat. no. 134) and could have been made in Paris or elsewhere in France. Its inclusion of trefoils in the gables relates it to a large group of Mosan or Rhenish ivories (including cat.

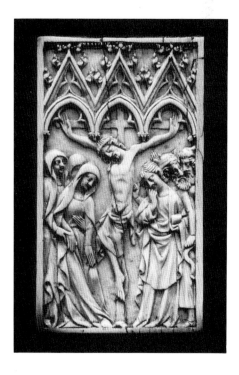

nos. 128 and 129), although all of those have trefoils in the spandrels, and the heads of the trefoils within the arches there are rounded rather than pointed.

H. (8.7 cm); W: 2 in. (5.1 cm)
Kresge Art Center, Michigan State University, East Lansing (65.37), University Fund

History: Purchased from Mathias Komor, New York, 1965.

Bibliography: R. Rough, "A Gothic Ivory in the MSU Art Collection," Kresge Art Center *Bulletin* 1, no. 7 (April 1968), pp. 69–72.

131

The Crucifixion

Ivory plaque (pax?), German (Cologne?), third quarter of 14th century

The thin figure of Christ has unusually long arms. He is flanked by the fainting Virgin, accompanied by two women, on the left, and Saint John and two Hebrews, on the right. The fainting Virgin, her head falling sideways and down, follows a common model (as in cat. no. 134) quite widespread in the third quarter of the fourteenth century.

Above the three trefoil arches are tall, leafy crockets and floral finials punctuating the roof line. Both the gables and the spandrels contain trefoils, and a serrated band borders the top edge.

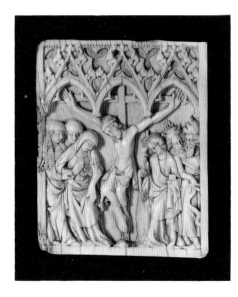

Lacking hinges, the plaque has a single off-center hole at the top. The back is plain. On the left edge are two areas of damage that appear to be from burial.

Notes: The panel belongs to a group of ivories of the same subject apparently from the same workshop. One (Berliner, no. 53)

is a poorly carved plaque that repeats the postures and drapery of the Virgin and John. Several are the right leaves of diptychs, while others (like the present example), having no signs of hinging, are not. Neither are they writing-tablet covers; however, it is possible that they were the centers of paxes.

H: 4¼ in. (10.9 cm); W: 3⅜ in. (8.6 cm)
Milwaukee Art Museum (M1967.72), Acquisition Fund

132

The Life and the Passion of Christ

Ivory diptych, French (Paris), third quarter of 14th century

Reading from the left, beginning at the bottom, are the Annunciation, the Visitation (with part of the Annunciation to the Shepherds under the right arch), the Nativity, the Adoration of the Kings, the Flagellation, the Carrying of the Cross, the Crucifixion, and the Resurrection. There is a certain attention to pattern in the manger, the Virgin's pillow, and the sarcophagus of Christ. In the Flagellation one torturer wears a jupon buttoned down the front and a belt purse.

Divided by colonnettes, the scenes are placed beneath an arcade of three trefoil arches. The gables, incised with trefoils, have floral crockets and finials.

Notes: The Crucifixion, the Resurrection, and the Adoration are related to those of cat. nos. 133 and 134. The three subjects are interrelated with the ivories of the Paris Passion atelier—for instance, a diptych now dated in the last third of the fourteenth century (*Fastes du gothique,* no. 162).

The Philadelphia example is highly refined and drier than cat. nos. 133 and 134, but it probably comes from the same workshop.

H: 6⁹⁄₁₆ in. (16.7 cm); W: [open] 8⁷⁄₁₆ in. (21.7 cm)
Philadelphia Museum of Art (21-20-1), gift of Mrs. Charles Wolcott Henry

133

The Infancy and the Passion of Christ

Right leaf of an ivory diptych, French (Paris), third quarter of 14th century

Carved with the Infancy cycle below that of the Passion are the Crucifixion, the Resurrection, the Adoration, and the Presentation. To the left of the crucified Christ the Virgin faints, a twisted skirt giving motion to her body, while John, at the right, stands calmly erect. The figure of Christ in the Resurrection is unusually massive, and the sarcophagus is crosshatched. The Adoration follows the customary design; and in the Presentation the woman with the doves wears a turban, and Simeon is conspicuous for his large head.

The scenes, divided by colonnettes, are in two tiers under three trefoil arches each. There are crocketed gables with finials above the arches, and a row of pearling runs across the top of each section.

The ivory is brown-gray in color and very hard, retaining a high polish. Trimmed on all sides and beveled, possibly for framing, the plaque has hinge miters remaining at the left. A number of surface chips follow the diagonal grain of the

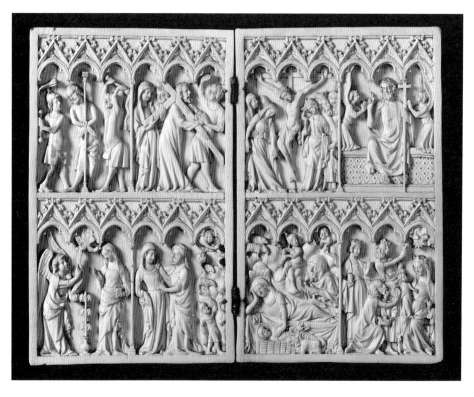

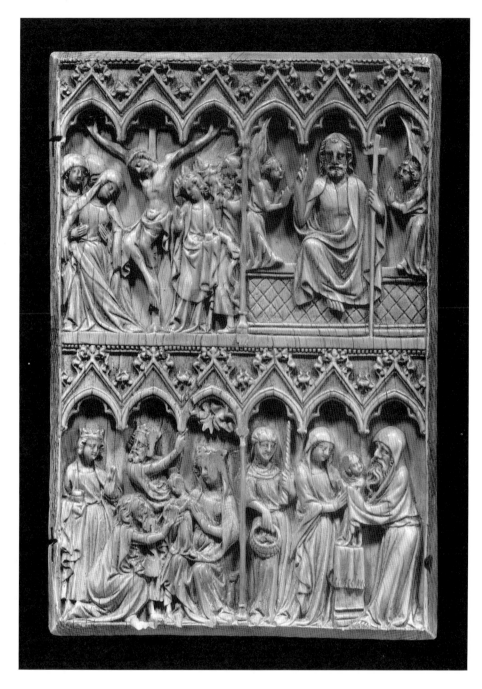

The Crucifixion

*Ivory writing tablet, French (Paris), third
quarter of 14th century*

Christ is placed between the fainting
Virgin supported by two Holy Women, on
the left, and Saint John with two Hebrews,
on the right. Mary has a twisted skirt, and
John's mantle falls in a series of folds to
the knee.

The scene is set beneath three trefoil
arches with blind gables, decorated with
floral crockets and finials. There is a band
of pearling at the top, under which is a
large hole for a cord to attach other tablet
leaves. Four modern holes for mounting
are drilled in the corners, and a chip is
missing from the lower right.

Notes: This tablet cover comes from the
same workshop as cat. no. 133 and is
clearly taken from the same model. Here
the figures are more compressed, and
Christ's body is not as pronounced an
S-shape. Certain details, such as the top
of the second Holy Woman's head, are
identical, as is the architectural format.

H: 3¹¹⁄₁₆ in. (9.5 cm); W: 2¼ in. (5.7 cm)

Mount Holyoke College Art Museum,
South Hadley, Massachusetts (M.M.1.1959),
gift of Mr. and Mrs. Charles R. Snow in
memory of their daughter, Annie E. Snow
(Class of 1938)

History: Purchased from Mathias Komor,
New York, 1959.

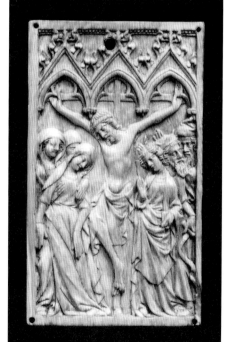

ivory in the Adoration scene—the head of
the second king, that of the Christ Child,
and that of the Virgin, as well as the crown
of the first king. Below are small breaks in
the border.

Notes: From the same workshop is an ivory
(Schnitzler, Kofler cat., no. S-98) in which
the Entombment takes the place of the
Crucifixion. The architecture is the same,
with colonnettes, blind gables, and pearl-
ing at the top. While the other scenes are
virtually identical, there are interesting
minor differences implying that two carv-
ers worked from the same model. The
Christ in the Resurrection is less grandiose
and turns slightly to the left, as was more

usual in Paris ivories (for example,
Koechlin, no. 819). Moreover, the woman
with the doves does not wear a turban in
the Kofler example, and the position of the
Virgin's left hand is changed.

Another ivory from the workshop (cat.
no. 134) shows minor changes in the drap-
ery and in John's hand holding the book,
but certain unusual features, such as the
half-hidden head of the second woman
with the fainting Virgin, are the same.

H: 5⁵⁄₁₆ in. (15.1 cm); W: 4 in. (10.1 cm);
D: ⁵⁄₁₆ in. (0.8 cm)

Seattle Art Museum (51.125), Eugene Fuller
Memorial Collection

History: Collection of Emile Baboin, Lyons
(after 1912). (Purchased from Raphael
Stora, New York, 1951.)

Bibliography: Waning Middle Ages, no. 77,
p. 66.

135

The Crucifixion

Ivory writing tablet, Danish or North German, third quarter of 14th century

Protruding from the side of the crucified Christ is a sword that penetrates the breast of the Virgin, as she stands with two Holy Women. Saint John touches his chin and holds a book, while a Hebrew in a cap points at the Cross. The workmanship is crude, with hands and faces simplified and with the garments of the Virgin and John carved broadly in simple, mostly vertical folds.

The triple trefoil arcade has trefoils in the gables and spandrels and vestigial floral crockets and finials on the roof line. In the central gable is a hole (probably enlarged) for a cord to attach other leaves of the writing tablet.

Among a number of unusual details are the guard of the sword from Christ's side, which resembles that of a kidney dagger; Christ's hands, which have only four digits; and the presence of one Hebrew, rather than two, with Saint John.

Notes: The ivory is related to cat. no. 136 and to a diptych found in the sand at Stege, Denmark (Liebgott, no. 58). The architectural frame is similar, though not identical, and details such as the rendering of the hands are generalized in the same manner.

H: 3¼ in. (8.4 cm); W: 1⅞ in. (4.8 cm)
The Snite Museum of Art, University of Notre Dame, Indiana (72.36.1), gift of J. W. Alsdorf

136

The Crucifixion

Bottom of an ivory box, North German or Danish, third quarter of 14th century

The jet of blood from Christ's body is shown striking the Virgin's heart. She turns away, supported by two Holy Women, and Saint John stands with two Hebrews in pointed caps. All the figures are elongated and the drapery summarily carved.

The scene is placed beneath three trefoil arches, its gables and spandrels pierced with drilled trefoils; the crockets are highly stylized. Below the figures is a row of three carved quatrefoils within squares.

Inside the box are three slots, each beside two holes for retainers, and two larger recessed areas of different dimensions. There are diagonal slots for the missing hinges.

Notes: The plaque is closely related to a diptych recovered from the beach at Stege, Denmark, with the Crucifixion and the Harrowing of Hell (Liebgott, no. 58).

Construction details on the reverse of the ivory panel, similar to those of cat. no. 162, suggest that this was a painter's box. The slots were probably for pigments, which were retained here with swiveling straps of ivory, as is indicated by the circular marks around the drilled holes. The two palettes of differing sizes are exactly like those of cat. no. 162.

H: 3¹³⁄₁₆ in. (9.7 cm); W: 2³⁄₁₆ in. (5.6 cm); D: ⁵⁄₁₆ in. (0.8 cm)
Detroit Institute of Arts (43.459), gift of Robert H. Tannahill

137

The Lives of Christ and the Virgin

Ivory diptych, North French, third quarter of 14th century

At the top of the left leaf Longinus and Stephaton are included in the Crucifixion between the fainting Virgin and two Holy Women, on the left, and Saint John and three Hebrews, on the right. Pilate is present in the scene of the Flagellation. In the right leaf the Coronation of the Virgin, at the top, is shown between kneeling angels with tapers and flying angels with censers. The Dormition includes four Apostles, along with John, who carries a palm, and Christ, who holds the Virgin's soul.

Ornamenting the arcades of three trefoil arches are floral crockets and finials; the spandrels contain incised trefoils.

Silver straps running along the edges of the plaques have replaced the original hinges.

Notes: While Pilate is not often seen in the Flagellation, he is present in the Granjean diptych (Koechlin, no. 807) that also includes Longinus and Stephaton in the Crucifixion. More closely related in format and treatment of the figures, and apparently taken from the same model as the present ivory, is a Flagellation scene on a diptych (Musée du Louvre, Paris; inv. OA 2597) in which Pilate is shown seated.

The carving is shallow and the rendering of the arches unsure, suggesting that these panels are from a provincial workshop.

H: 4⅛ in. (10.5 cm); W: 2⅜ in. (6.2 cm) each
Collection of Neil F. Phillips, New York
History: European Works of Art, sale, Sotheby's, London, 4 December 1988, lot 28. (Purchased from Ronald Lee, London, 1988.)

The three trefoil arches have blank gables with floral crockets and finials. In the spandrels are incised trefoils.

The hinges were cut away, leaving large indentations in the right side, and there is an old hole drilled at the upper left.

H: 2¹¹⁄₁₆ in. (6.9 cm); W: 1¹³⁄₁₆ in. (4.7 cm)

Detroit Institute of Arts (43.462), gift of Robert H. Tannahill

140

The Nativity

Left leaf of an ivory diptych, North French, third quarter of 14th century

The Nativity is rendered in the usual manner but with several variant details. The shepherd with a bagpipe is standing in the background rather than seated on a hillock, as is customary, and the two sheep are on a diagonal instead of being parallel to the picture plane. The Virgin's pillow is crosshatched.

Decorated with floral crockets and finials, the three trefoil arches are rather coarsely cut. There is a band of beading at the top.

Hinges are lacking, the bottom edge is roughly faceted, and a number of small cracks are evident.

Notes: The rough workmanship and large hinge miters suggest a provincial atelier.

H: 3⅛ in. (8.1 cm); W: 2¼ in. (5.3 cm)

Williams College Museum of Art, Williamstown, Massachusetts (57.25), bequest of Frank Jewett Mather, Jr.

Notes: The curved posture of the Virgin and the treatment of the drapery relate the panel to larger examples of the North French group (see cat. nos. 79 and 82).

H: 3½ in. (8.9 cm); W: 2 in. (5.1 cm)

Detroit Institute of Arts (70.456), gift of Robert H. Tannahill

139

The Nativity

Left leaf of an ivory diptych, French (?), third quarter of 14th century

The Nativity reflects the early format of the Virgin and Child in bed, with the manger omitted. Joseph is notable for a large head and a long, divided beard, and the ass is summarily carved.

138

The Crucifixion

Ivory writing tablet, French, third quarter of 14th century

Its figures rendered in a lively way, the scene is placed beneath three trefoil arches with blank gables and floral crockets and finials. Two holes are drilled at the top and one at the bottom for a cord to attach other leaves of the writing tablet.

The holes are plugged, and there is a chip in the left edge. Severe wear from usage precludes a thorough analysis.

141

The Crucifixion

Right leaf of an ivory diptych, French, third quarter of 14th century

The squarish panel shows the crucified Christ on a Cross that is crooked and does not appear behind his legs. He is flanked by the Three Marys and John with two Hebrews. While the Virgin swoons, supported by a companion, John holds his hand to his face.

The scene is placed beneath one wide and two narrow trefoil arches with large leaf crockets and finials. The carving is extremely coarse.

Removal of the large, diagonally inset hinges damaged the ivory around the miters. At the top center is a break and a later drilled hole. The figures are severely rubbed.

Notes: The composition is typical of the third quarter of the century, and the broad figures suggest Lorraine or Burgundy.

H: 3⅞ in. (9.9 cm); W: 2⅞ in. (7.4 cm)

Isabella Stewart Gardner Museum, Boston (S27 W29)

History: Purchased from Gaetano Pepe, Naples.

142

The Crucifixion

Right leaf of an ivory diptych, French, third quarter of 14th century (?)

The nearly square plaque shows Christ between a gesturing Mary and John. Their setting is a wide, almost round trefoil arch with tall crockets and a floral finial. The carving is rough and the borders uneven.

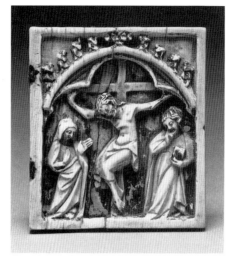

Considerable modern polychromy has been added: gilding on the crockets, blue in the background, and brown on John's hair and book. Unevenly spaced iron hinges that penetrate to the back are inset diagonally. There is a later hole above John's shoulder. An old break at the base has an ivory inset.

Notes: A simple, provincial work of unusual format, the ivory is difficult to date.

H: 2½ in. (6.4 cm); W: 2¼ in. (5.7 cm)

Detroit Institute of Arts (23.143), Founders Society purchase

143

The Coronation of the Virgin

Part of the right leaf of an ivory diptych, French (?), third quarter of 14th century

The Coronation, the topmost scene of a diptych wing, is shown between two candle-bearing angels. The carving is summary, with inconsistent handling of the faces. In the upper left corner of the unornamented compartment is a modern hole; the right border has been trimmed.

Notes: While diptychs portraying the life of the Virgin are rare, they did occur in Rose Group ivories at the beginning of the four-

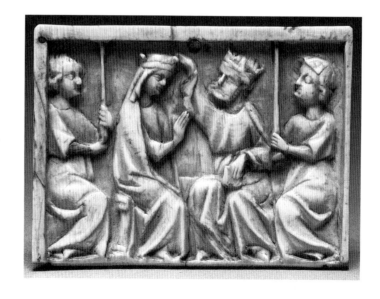

teenth century (see, for instance, Koechlin, nos. 250 and 265—the latter an Italian version). The late survival of the type and the indifferent quality of the present example suggest a provincial atelier.

H: 1⅞ in. (4.8 cm); W: 2 9/16 in. (6.5 cm)

Detroit Institute of Arts (23.138), Founders Society purchase

144

The Nativity and the Crucifixion

Right leaf of an ivory diptych, Franco-Flemish, third quarter of 14th century

The Crucifixion episode includes Stephaton and Longinus, accompanied by eight other figures. A woman attendant is present at the Nativity, along with Joseph and the ox and the ass. Beside the Nativity is the Annunciation to the Shepherds against a grassy hill with a tree and grazing sheep.

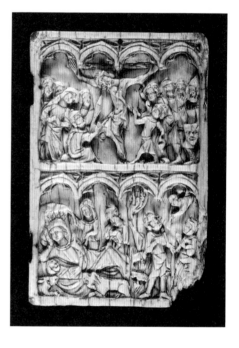

The scenes are placed under coarsely carved arcades of four flattened trefoil arches with flattened trefoils above them.

One silver hinge remains, and there is an original hole for hanging at the center of the top. Many age cracks are visible in the ivory, which has been gnawed at three corners by mice.

Notes: Despite rubbing that obscures the features, it is apparent that the ivory had little surface detail in its original state. The carver used shortcut techniques such as the triangular shape outlining the Virgin's knees. There is considerable sprightliness in the figures, however—a sign that for all its coarseness, the panel must have been based on a good model.

A second ivory of comparable quality (Zastrow, no. 39, fig. 74) shows the Nativity and the Coronation of the Virgin.
H: 4½ in. (11.5 cm); W: 3 in. (7.7 cm)
Collection of Dr. and Mrs. Giraud Foster, Baltimore
History: Acquired in London, 1965.

145

The Virgin and Child with Saints

Left leaf of an ivory diptych, Flemish, third quarter of 14th century

The Virgin stands holding the Christ Child between Saint James (with staff, book, and pilgrim's hat) and Saint Christopher (with the Christ Child). All the figures are elongated.

The three small trefoil arches in the upper part of the panel have crocketed gables, and trefoils are incised in both the gables and the spandrels.

Replacing the missing hinges in the miters on the right side are ivory insets. There are cracks in the borders at the top and at the lower right corner.

On the reverse are an Austrian export stamp and an illegible inscription.

Notes: The same saints (reversed) under a similar arcade flank the Virgin on a writing tablet (Koekkoek I, no. 49; II, no. 13), and a comparable group of saints appears on a diptych wing paired with a scene showing Saint George and the dragon (cat. no. 169).
H: 3⁷⁄₁₆ in. (8.8 cm); W: 2⅛ in. (5.5 cm)
Indianapolis Museum of Art (57.99), gift of Mrs. Booth Tarkington in memory of Booth Tarkington
History: Collections of Graf Wilzek, Burg Kreutzenstein, Austria; and Mr. and Mrs. Booth Tarkington, Indianapolis. (Purchased from Silberman Galleries, New York, 1934.)

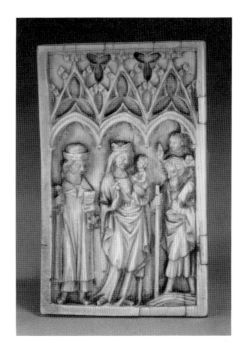

146

The Life of Christ

Ivory diptych, German (Thuringia or Saxony?), third quarter of 14th century

Reading from the top left are the Raising of Lazarus, the Entry into Jerusalem, the Crucifixion, and the Entombment. The figures, crisply and deeply carved, are posed in theatrical attitudes, the Virgin in the Entombment thrusting forward and the Holy Women in the Crucifixion staring at the viewer.

Arcades of five trefoil arches with floral crockets and finials are suspended over the scenes.

Ivory is inset in the borders where hinges were attached. Lazarus lacks his left hand, the sword piercing the Virgin's breast is broken away, and the iron nail from Christ's right hand is missing. Marks on the edges indicate that the diptych was once framed.

Notes: The Byzantine iconography of the Entombment, with the body of Christ being thrust into a cave tomb, was well known in Germany, and in the thirteenth century a sarcophagus was substituted for the cave. Two Byzantine ivories of the subject are known to have been in Germany—one set into a book cover now in Berlin and the other in Petershausen Cloister, now in Constance (Goldschmidt and Weitzmann, nos. 207 and 208). The Entombment was often shown in German manuscripts of the period, such as the Evangelary of Saint Martin in Cologne (H. Swarzenski, *Die Lateinische illustrierte Handschriften Rhein, Main und Donau* [Berlin, 1936], fig. 14).

The ivory is part of a group that exhibits Byzantine iconography as well as the theatricality of the Lazarus and Entombment scenes. Based on identical models are a diptych in Cracow (Koechlin, no. 787) and another that seems also to be from the same workshop (Hever Castle sale, Sotheby's, London, 6 May 1983, lot 242). Two ivories that repeat only the

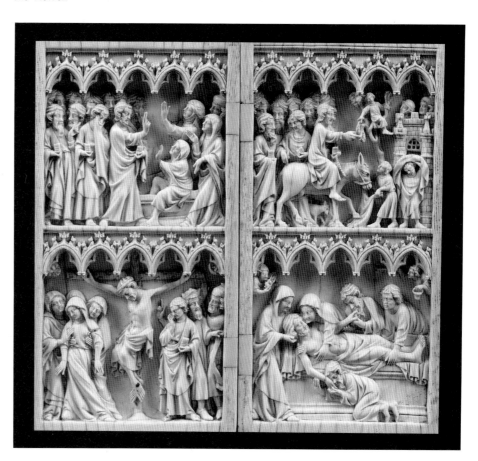

Lazarus scene (Schnitzler, Kofler cat., S-99; and Koechlin, no. 799) appear to be from different shops. The Crucifixion of the Cracow diptych is related in turn to a plaque (Koechlin, no. 784) that, like the Hever Castle diptych, has scenes set beneath a severely plain series of trefoil arches, recalling the similar treatment of wall arcades in the choir of Meissen Cathedral (H. Kuas, *Der Dom zu Meissen* [Leipzig, 1939], fig. 15).

The strong influence of Byzantine art in Thuringia and Saxony, the location of two of the pieces of the group in eastern Europe, and the theatrical approach to the scenes, found in no other works of the Rhine Valley and western Germany, suggest a center in the east.

H: 8⅛ in. (20.6 cm); W: 4⅜ in. (11.1 cm) each

The Cleveland Museum of Art (84.158), Andrew R. and Martha Holden Jennings Fund

History: Collection of de Vinck de Winnezeele, Antwerp (paper sticker with family arms). (Purchased through Marie-Elaine d'Udekem d'Acoz, 1984.)

Bibliography: Middeleeuwse Beeldhoukunst (exh. cat., Château de Laarne, Belgium, 1969), no. 48.

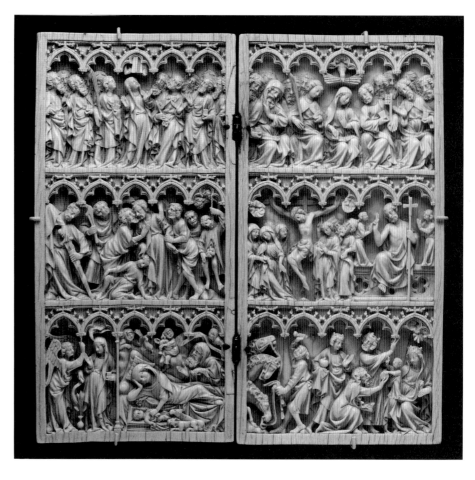

147

The Life and the Passion of Christ

Ivory diptych, French (Paris), 1375–1390

Reading from the bottom left are the Annunciation, the Nativity; the Adoration of the Kings; the Arrest of Christ; the Crucifixion, the Resurrection; the Ascension, and the Pentecost. Some inconsistency of scale is apparent in the figures, which are deeply carved for chiaroscuro effect.

The scenes are set beneath arcades of five pointed trefoil arches with crockets and finials.

There are new hinges and repairs to the left leaf, where the original hinges were broken away.

Notes: The Minneapolis diptych is related to several ivories from the Paris atelier of the Passion Master (for the closest parallel and for a reduced version showing the Ascension and the Pentecost, see *Fastes du gothique,* nos. 162 and 161, respectively). A comparable example (Randall, no. 312) has the scenes in reverse order, reading from the top.

Probably later productions of the Passion workshop, these diptychs include scenes based on the stone sculpture of the tympana at Mantes Cathedral and the Portail de la Calende at Rouen, dating about 1330–1335 (see Randall, Bib.). All the works from this atelier represent the most fashionable ivory products of Paris in the reigns of Charles V and VI; they can be documented in royal inventories and church treasuries of the last decades of the fourteenth century.

H: 8³⁄₁₆ in. (21.4 cm); W: [open] 8¾ in. (22.3 cm)

The Minneapolis Institute of Arts (83.72), gift of Mr. and Mrs. John E. Andrus III, Atherton and Winifred Bean, and The Centennial Fund

History: Collections of Félix Ravaisson-Mollien, Paris (until 1903); Paul Garnier, Paris (until 1917); Jacques Seligmann, Paris; Cranbrook Academy of Art, Bloomfield Hills, Mich. (until 1972). (Purchased from Ruth Blumka, New York, 1983.)

Bibliography: Exposition rétrospective de l'art français de 1900 (Paris, 1900), no. 133, p. 19; G. Migeon, "L'exposition rétrospective de l'art français," *Revue de l'Art Ancien et Moderne* 1 (1900), p. 460; G. Migeon, "La collection de M. Paul Garnier," *Les arts* 53 (May 1906), p. 13; *Medieval, Renaissance and Later Tapestries, Works of Art, and Furniture,* Cranbrook sale, Sotheby's, New York, 25 March 1972, lot 97); R. Randall, "An Ivory Diptych," *Minneapolis Institute of Arts Bulletin* 5, no. 66 (1983–1986), pp. 2–17.

See also colorplate 13.

148

The Ascension of Christ

Left wing of an ivory diptych, French (Paris), last third of 14th century

The Virgin stands, hands raised, between Saint John and Saint Peter (?), who points to the ascending Christ. The heads of six other Apostles, partially visible in the background, are distinguished by curly beards and hair. Saint John holds a palm leaf, and the head of Peter (?) is covered by his cape. The feet of Christ and the bottom of his gown are seen disappearing in a cloud at the center.

Ornamenting the three trefoil arches within blank gables are well-developed crockets and floral finials. At the top is a blank molding.

Broken ends of the silver hinges remain, and there are a number of abrasions on the border.

Notes: The figure of the Virgin is close in detail to three other diptychs (Koechlin, no. 808; *Fastes du gothique,* no. 161; and Randall, no. 312); Saint John carries a palm leaf in the last two of these examples. In the present ivory the treatment of the figures in the background is handled quite differently, and the architecture is distinct from the other works, which include arcades of trefoil arches without gables. All

must date from the last third of the fourteenth century, when the Ascension was introduced in the later works of the Passion atelier.

H: 4 1/16 in. (10.3 cm); W: 2 11/16 in. (6.7 cm)

National Museum of American Art, Smithsonian Institution, Washington, D.C. (1929.8.240.19), gift of John Gellatly

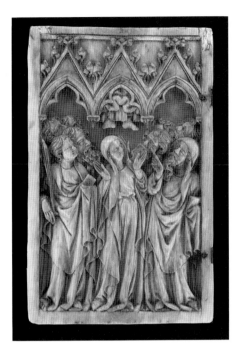

149

The Dormition of the Virgin

Scene from the left leaf of an ivory diptych, German (Mainz), fourth quarter of 14th century

The Virgin lies on a bed surrounded by the twelve sorrowing Apostles, while at the center Christ holds her soul in his arms. Peter can be distinguished at the head of the bed, as can Paul at the foot and John beside Christ with a martyr's palm leaf.

The lowest register of a left wing that had three scenes divided by bands of rosettes, the ivory has a hinge miter at the right side. It is brownish in color, as if it had been varnished.

Notes: The strong surface movement of the figures and drapery is typical of the work of the Master of Kremsmunster, as are the boyish face and curly hair of Saint John. The style of this master is known from over sixteen works (see Koechlin, nos. 824–840). His busy, crowded compositions give a chiaroscuro effect, enhanced in most cases with rich enframements combining arches, roses, bosses, and other elements. The simple format of the present ivory is an exception.

The same model or drawing was used for a Dormition of the Virgin (Koechlin, no. 839); notwithstanding various differences—such as omitting the seated figure at the left—the folds of the bed sheets, the

Apostles sitting on the floor, and Paul in a chair at the right are analogous. The figure of John with a covered head is a purposeful departure from the usual John of the atelier, as shown in the adjoining scene of the Funeral of the Virgin (Koechlin, no. 840).

H: 2 3/4 in. (7.1 cm); W: 3 5/8 in. (9.3 cm)

The Art Institute of Chicago (1943.60), Kate S. Buckingham Fund

History: Collections of Salamon, Berlin (until 1912); and Mayer-Fuld, New York (until 1943).

Bibliography: Salamon sale, Berlin, 1912; Mayer-Fuld sale, New York, 1943, lot 141; M. Rogers and O. Goetz, *The Buckingham Medieval Collection* (Art Institute of Chicago, 1945), no. 51.

150

The Entombment

Scene from the left leaf of an ivory diptych, German (Mainz), fourth quarter of 14th century

As Christ is anointed in the tomb, several figures, including Mary and John, stand in attendance.

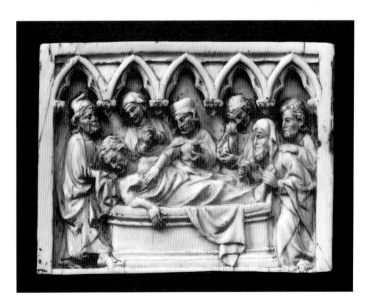

There are five plain trefoil arches with a blank molding above. The location of the hinge miter indicates that the plaque was cut from the top of the left wing of a diptych.

Notes: This work by the Master of Kremsmunster follows the same model as the Entombment in a diptych in Berlin that also includes a winding sheet (Koechlin, no. 833). It is interesting to compare the richness of the latter example with the simple enframement of the Sacramento ivory.

H: 2 3/4 in. (7.1 cm); W: 3 11/16 in. (9.4 cm)

Crocker Art Museum, Sacramento (1960.3.77), gift of Ralph C. and Violette M. Lee

151

The Coronation of the Virgin and the Crucifixion

Ivory writing tablets, Lower Rhenish or Mosan, fourth quarter of 14th century

Christ holds an orb and blesses the Virgin, who is crowned by a descending angel. Two angels swinging censers stand on the corners of the large bench. To the left of

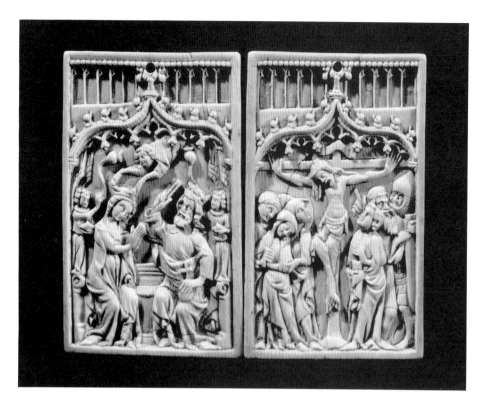

the crucified Christ are the Virgin and three Holy Women, one wearing a turban and one with her hood blown out to frame her face. Saint John, at the right, looks upward, while a Hebrew addresses a soldier.

The single ogee arches have five foliate subdivisions and floral crockets and finials. Above is an arcade of twelve tall trefoil arches, surmounted by a band of beading.

There are holes at the center of the top to hold cords for attachment, and the backs are recessed to receive wax.

Notes: Another plaque with an arcade above the central arch is from the church of Wollersheim i Eifel in the Rhineland (Stafski, p. 83, no. 6). The closest parallel to the Falk ivory, however, is a Virgin with music-making angels (attributed to Cologne by Vöge [no. 136]; called German in Koechlin [no. 622 bis]); while the figure style is flatter, the architecture is nearly identical. A Mosan plaque showing the same woman with a turban and one with a blown hood (cat. no. 153) has a Christ figure with the elongated arms typical of the Meuse group (cat. nos. 126–129 and 131) and with drapery that is clearly also from the same model as the Falk example. It is possible that the present ivory is a Cologne copy of a Mosan work or a Mosan borrowing of the architectural format.

H: 3¼ in. (8.2 cm); W: 2 in. (5.1 cm) each
Collection of Max Falk, New York
History: European Works of Art, sale, Sotheby's, London, 9 December 1988, lot 26.

152

The Virgin Nursing the Christ Child

Ivory writing-tablet cover, Rhenish or Mosan, fourth quarter of 14th century

Nursing the Child in her lap, the Virgin sits on a buttressed throne replete with pinnacles and a pierced crest rail. Two angels playing stringed instruments flank the throne.

The scene is placed beneath three flattened trefoil arches in gables decorated with vestigial crockets and floral finials. There are trefoils in the gables and spandrels.

Two original holes at the top once held cords to attach other tablet leaves, and in the center of the recessed back is a circular depression. The ivory is rubbed from use.

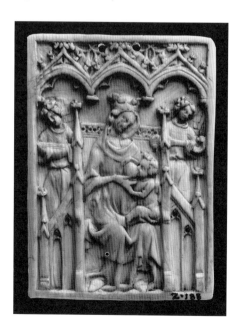

Notes: An ivory of the same subject (called German in Koechlin [no. 622 bis]; attributed to Cologne in Vöge [no. 136]) has a Virgin figure taken from the same model, as is clear from the drapery and the profile against the blown veil. While the thrones differ, the angels, reduced from four to two here, are treated similarly. Architectural elements are completely different, those of the related plaque paralleled in cat. no. 151—ivories that are likewise called Rhenish or Mosan.

The subject of the enthroned Virgin with music-making angels (see Koechlin, nos. 570 and 621, which are Flemish and French, respectively; and Destrée, no. 25, which is Mosan) appears only by the third quarter of the century. Without angels the enthroned Virgin is used for paxes (see, for example, cat. no. 172; and Grodecki, fig. XLIII).

H: 2¾ in. (7 cm); W: 2¹⁄₁₆ in. (5.2 cm)
Royal Ontario Museum, Toronto (953.62.4)

153

The Crucifixion and the Entombment

Ivory writing tablet, Mosan, fourth quarter of 14th century

Both scenes are crowded, the Crucifixion with nine figures and sun and moon, the Entombment with eight slightly larger figures. There is considerable exaggeration in Christ's arms, in the stylized beards of the figures, and in the blowing hoods of two women at the Crucifixion. On the Cross is a *titulus.*

The three flattened trefoil arches have stylized pendants, simplified crockets, and squat finials.

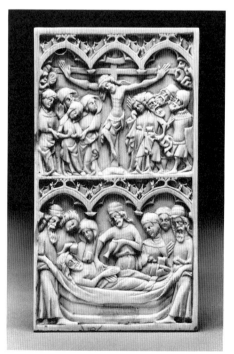

The back is hollowed out for wax, and the left edge has been trimmed.

Notes: Compare cat. nos. 151 and 154.

H: 4⅛ in. (10.5 cm); W: 2⁵⁄₁₆ in. (5.9 cm)

Detroit Institute of Arts (43.458), gift of Robert H. Tannahill

154

The Adoration and the Entombment

Right leaf of an ivory diptych, Mosan, fourth quarter of 14th century

The Entombment of Christ, with nine figures, is presented above the Adoration of the Kings, which includes a groom and three horses. The faces of the figures are notably long and the noses prominent.

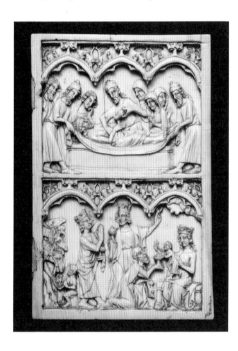

Each scene is placed beneath three flattened trefoil arches with coarsely carved crockets and large floral finials. There are trefoils in the spandrels.

Both miters were broken during removal of the hinges and are filled with putty.

Notes: For the figure type, see cat. no. 86 (compare cat. no. 153).

H: 4⁵⁄₁₆ in. (11.1 cm); W: 2¾ in. (7.1 cm)

Allen Memorial Art Museum, Oberlin College, Oberlin, Ohio (47.47), R. T. Miller, Jr., Fund

155

The Life of Christ

Ivory diptych, Mosan, fourth quarter of 14th century

Reading from the lower left are the Annunciation, the Nativity, the Adoration, and the Presentation in the lower tier; and the Flagellation, the Crucifixion, the

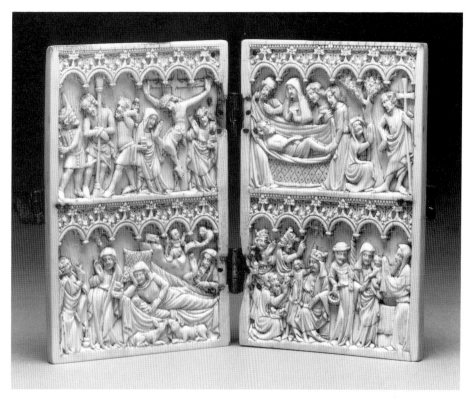

Entombment, and Noli Me Tangere in the upper tier. Depicted with various overlapping figures, the scenes are crowded and active. The top of Christ's Cross in Noli Me Tangere flares into a Latin shape, the sarcophagus is crosshatched, and the flagellators wear the buttoned jupons of the end of the century.

Above the six rounded trefoil arches is a double-beaded molding; linear, incised trefoils occupy the spandrels.

The hinges are broken away, leaving losses of ivory at each miter. Two extra holes at two of the miters show that the hinges had been replaced at an early time.

Notes: A wing that has the same scenes as the right half of the Detroit ivory (British Museum, London; inv. 1919.7.10.2) is probably from the same workshop. Details such as Christ's Cross and the sarcophagus are handled identically. Another comparable work indicative of a date at the end of the fourteenth century is an Adoration plaque (*L'art ancien au pays de Liège* [Exposition Universelle, Liège, 1905], no. 1453) with architecture that differs only in having gables above the arches incised with trefoils.

H: 6⅛ in. (15.4 cm); W: 3¹⁵⁄₁₆ in. (10 cm) each

Detroit Institute of Arts (26.284), gift of Lewis and Simmons, Inc.

156

The Crucifixion

Left leaf of an ivory diptych, Rhenish (?), fourth quarter of 14th century

Christ is seen between Mary and John, with Longinus (at the left, holding a lance) and Stephaton (offering a sponge, on the right). The figures have squarish faces,

generalized hands, and simple drapery. Christ's rib cage is carefully delineated. The sun and moon flank the Cross.

Two trefoil arches join in an unusual arrangement just above Christ's head. Sprouting from the arches are pinnacles, tall and stylized crockets, and wide floral finials.

Hinges (now missing) were inset diagonally. The entire ivory is badly rubbed, and the large hole through the center shows wear from a secondary use.

Notes: The pinnacles suggest a Rhenish origin. Simplification of the figures and of the crockets and other details point to a late provincial workshop.

The feature of the arches descending on the head of the crucified Christ can be seen in cat. nos. 97 and 98.

H: 3¼ in. (8.3 cm); W: 2¹⁄₁₆ in. (5.3 cm)

The Glencairn Museum, The Academy of the New Church, Bryn Athyn, Pennsylvania (04.CR.41)

History: Probably acquired by Raymond Pitcairn in 1927.

157

The Dormition of the Virgin

Left leaf of an ivory diptych, German, fourth quarter of 14th century

Christ carries the Virgin's soul and blesses her body in its winding sheet, which is held by two of the twelve Apostles. One Apostle holds a palm and one a book; two are seated on the floor. At the base of the bier are casually placed trefoils, some of which pierce the ivory.

The four trefoil arches have carved trefoils in the gables and spandrels.

There are a number of later holes, a large one at the top appearing quite old. Four above Christ's haloed head and one at the base are filled with wax. Hinge miters are present on the right edge. On the back are three later compass doodles with stars.

Notes: The casual treatment and shallow carving have been noted in other examples of this subject, which was popular in Germany (see cat. no. 73).

H: 3⁹⁄₁₆ in. (9 cm); W: 2⁹⁄₁₆ in. (6.4 cm)

World Heritage Museum, University of Illinois, Urbana (26.3.4)

History: Purchased from A. Semail, Paris, June 1926.

158

The Life of Christ

Ivory diptych, Flemish (?), 1380–1400

Reading from the top left downward, across to the right and up, are the Nativity, the Adoration of the Kings, the Presentation, and the Crucifixion. The figures are carefully carved with considerable attention to patterns such as the crosshatched pillow, the rustication of the Cross, studded decoration on the base of the manger and the altar, and the detail of sewn ribs on the cape of the second king. Rather theatrically the first king doffs his crown, and Joseph, in heavy drapery, leans on his cane.

An incised line reinforces the shape of the enframing quatrefoils, which have intermediate diamond projections at the center of each side. The hinges are of silver, and there are two later holes drilled at the upper inside corners of the plaques.

Notes: The studded ornament on three other plaques in quatrefoil format (Schnitzler, Kofler cat., no. S-70; Koekkoek, vol. 1, no. 39; and *De Madonna in de Kunst* [Antwerp, 1954], no. 582) suggests its use in Flanders. The Kofler ivory shares with the Detroit example the same theatrical figure style and similar details in the Nativity. Another related Nativity (Stafski, no. 225) also repeats the interest in surface patterns. (For other examples of a cloak with ribbed patterns on the shoulder, compare Morey, no. A99—probably a Mosan work—and cat. no. 84 in this book.) See cat. no. 93 for discussion of the doffing of the crown by the first king.

H: 4⅞ in. (12.4 cm); W: 2⅜ in. (6 cm) each

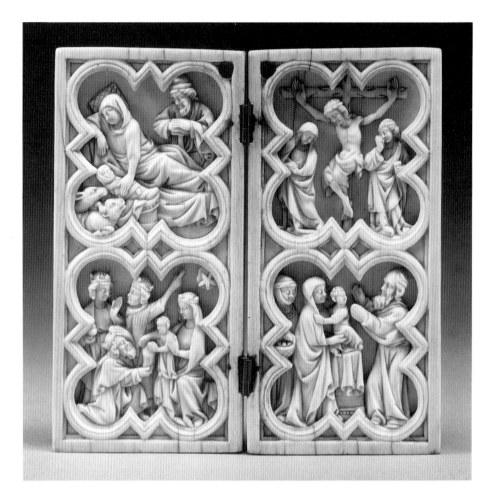

Detroit Institute of Arts (43.455), gift of Robert H. Tannahill

History: Collection of Professor A. Gilbert, Paris (until 1927).

Bibliography: Gilbert sale, Hôtel Drouot, Paris, 29 March 1927, lot 67.

159

The Crucifixion

Right leaf of an ivory diptych, Dutch (?), 1390–1400

Christ appears between two groups of four figures: the fainting Virgin supported by Holy Women, on the left, and the mourning Saint John with Hebrews, on the right. The drapery is simplified, the fingers crudely carved, and the eyes rendered as small slits between bulbous lids.

Overhanging the scene are four low arches with vestigial crockets and leaf finials; trefoils occupy the spandrels above them.

There are traces of paint in the hair, beards, and headdresses. Large silver hinges retain their original pins, and at the top, near the left side, is a silver ring for hanging. A hole is visible on the right edge, where the clasp was fitted. The plaque is nearly square.

Notes: The unusual treatment of the eyes, found in Dutch art, is particularly notable in the paintings of Geertgen tot Sint Jans

in the mid-fifteenth century. Eyes carved in the same manner can be seen in many fifteenth-century sculptures, the earliest being two Virgin statues of about 1400 (W. Vogelsang, *Die Holz Skulptur* [Utrecht, 1911], vol. 1, no. 1, pl. II; and vol. 2, no. 5, pl. II).

The initials *D v P* on the back imply a Dutch ownership.

H: 3¾ in. (9.5 cm); W: 3⅜ in. (8.5 cm)

Honolulu Academy of Arts (2887.1), gift of Mr. and Mrs. Livingston Jenks

History: Purchased from Adolph Loewi, Los Angeles, 1961.

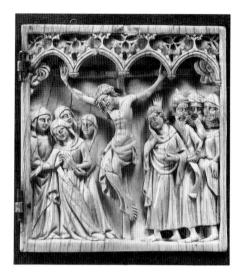

160

The Life of Saint Margaret of Antioch

Lid of an ivory casket, Flemish, 1380–1410

The scenes show Margaret being instructed in the virtues by her nurse; Margaret spinning and watching sheep; and a figure in hunting costume, possibly the Roman governor Olybrius or one of his huntsmen, bidding Margaret to come with him.

The nine low trefoil arches have tall gables and spandrels incised with trefoils. Separated into thirds by decorated pilasters with elaborately crocketed finials, the entire composition is set within a double-molded frame. The background is diapered with quatrefoils.

Two sections of ivory are inset in the upper border, where the hinges were placed, and one fills a space at the bottom, where the hasp was attached. There are two holes near the sites of the hinges and two others, for a bail handle, in the pilasters.

Notes: Among a small group of ivories of Flemish character—all with diapered grounds comparable to that seen here—are a plaque with a Virgin and saints (Tardy, vol. 1, p. 39), a rectangular pax showing the Crucifixion with a decorated border (Berliner, no. 59), a Nativity tablet (Burrell Collection, Glasgow; inv. 21/14), and a

round-headed pax with a Crucifixion under an ogee arch (Musée d'Unterlinden, Colmar; unpublished). The high, pointed gables above small arches can be found in a Flemish enthroned Virgin with music-making angels (from the Passavant-Gontard collection in Frankfurt; von Hirsch sale, Sotheby's, London, 22 June 1978, lot 288).

Exhibiting the same architectural details is the front of a casket (Dalton, no. 372) that depicts the beheading of Saint Margaret, her soul taken to heaven, and horsemen. (Its background is crosshatched rather than diapered, and the carving is poor.) A side panel from the same box (Tardy, vol. 1, p. 220) shows Margaret led before the idolatrous Olybrius for judgment. Since both the front and the present plaque (a lid) were mentioned in 1836 (in *Gentleman's Magazine* [see Bib.]) as being from the Douce/Meyrick collection, and the front was a gift to the British Museum by the grandson of S. R. Meyrick, it is reasonable to assume that they belong together. Their authenticity is not in question (as Tardy [vol. 1, p. 220] alleged), and the measurement given by Meyrick (four inches) is correct for a box assembled in the Flemish manner, with the sides slotted into the corner posts. Another series of caskets with the lives of saints (see Randall, no. 338) have lids of a quality superior to the sides, as seems to be the case here (see also cat. no. 164).

L: 4³⁄₁₆ in. (10.3 cm); W: 3⁵⁄₁₆ in. (8.5 cm)

Williams College Museum of Art, Williamstown, Massachusetts (78.2.6), gift of John Davis Hatch, Jr.

History: Collections of Sir Samuel Rush Meyrick, Goodrich Court, Hertfordshire (by 1838); Henry Walters, New York (before 1931); and John Davis Hatch, Jr., Lenox, Mass.

Bibliography: S. R. Meyrick, "The Douce Museum," *Gentleman's Magazine*, April 1836, p. 384, no. 16; Mrs. Henry Walters sale, Parke-Bernet, New York, 1 May 1941, lot 1047.

See also colorplate 14.

161

The Coronation of the Virgin

Painted ivory pendant in a silver-and-niello mount, Flemish, 1410–1440

An angel crowns the Virgin, who sits with God the Father on a long bench with an arcaded back. He holds an orb and makes the gesture of blessing, while she raises her hands in astonishment.

The plaque is set under rock crystal within a late Gothic silver frame of leafage with sunflowers at the corners. The back is nielloed with a series of plants, including sunflowers. Traces of gilding remain on the frame.

The polychromy—including blue for the Virgin's robe, red for God, and gilt for the hair—is well preserved. There is a large crack through the center of the panel, and minor losses are visible in the bench and sky sections.

Notes: Attributed by Wilhelm Volbach (see Bib.) and Hanns Swarzenski to Northeast France, the ivory seems rather to be completely Flemish in character. It is related to a Saint George locket in the Metropolitan Museum of Art (R. Randall, "Jan van Eyck and the St. George Ivories," WAG *Journal* 39 [1981], p. 46, fig. 6) wherein the Virgin's drapery is the exact reverse of that of God the Father in the Boston plaque.

The ivory must have been cracked and chipped before being put into the frame, which is datable stylistically to the late fifteenth or early sixteenth century.

H: 3³⁄₁₆ in. (8 cm); W: 2¼ in. (5.7 cm)
Museum of Fine Arts, Boston (54.932), Helen and Alice Colburn Fund
History: Collections of Heckscher, Vienna; Kaiser Friedrich Museum, Berlin (after 1898); and Hinrichsen, Berlin.
Bibliography: Volbach, p. 41, no. 98.220; *Secular Spirit,* no. 100a.

162

The Crucifixion

Bottom of an ivory box, Flemish or German, first half of 15th century

A corpulent body of Christ hangs on a Cross with slash marks to indicate wood grain. The Virgin and one Holy Woman stand at the left, while Saint John and a Hebrew in a tall hat are at the right.

Above the scene, rendered in low relief on a crosshatched ground, is an arcade of three rounded trefoil arches with tall, pointed gables sprouting stylized crockets and finials. Trefoils are incised within the gables and spandrels.

Inside the box are two depressions of different size and three slots with ends shaped like trefoils. Inscribed on the lower edge is: XIULLIE [RI?]. There are two large and somewhat worn holes that held cords for tying the box closed.

Notes: The interior of the box is similar to that of cat. no. 136. It is in all likelihood a painter's box with three slots to hold pigments, the open spaces being palettes.

A nearly identical plaque (Koekkoek I, no. 51), certainly by the same hand, is the right wing of a diptych; while a second example (Koekkoek I, no. 50), slightly broader and allowing more room for the

figures, is a pax inset in a metal frame. The three are undoubtedly from the same workshop and are based on a print as yet unidentified.

L: 4¼ in. (10.9 cm); W: 2⅜ in. (6.1 cm)
National Museum of American Art, Smithsonian Institution, Washington, D.C. (1928.8.240.10), gift of John Gellatly

163

The Life and the Passion of Christ

Bone casket on a wood core, Flemish, 1430–1460

The coffer-shaped casket is decorated with thirty scenes beneath triple rounded arches. On the top are the Annunciation, the Visitation, the Nativity, the Adoration of the Kings, the Flight into Egypt, the Presentation, the Baptism, the Temptation of Christ, and the Entry into Jerusalem; on the front, Christ before Caiaphas, the Flagellation, and the Crowning with Thorns; on the right end, Christ before Pilate and the Carrying of the Cross; on the back, the Crucifixion, the Deposition, the Entombment, the Resurrection, and the Harrowing of Hell; and on the left end, Noli Me Tangere, Christ Appearing to Peter, and the Doubting Thomas. At each end is a prophet with a scroll between panels of leaves, and beneath the lock is a torturer who is part of the adjoining Flagellation. The figures are carved against crosshatched grounds, and battens carved with vines divide the scenes.

The bottom of the box is a chessboard formed of alternate squares of intarsia and bone. The borders of the lid, the top edge of the box, and the base are molded, and the base is cut with a series of bracket feet. Hinges, lock, and bail handle are of silver.

Much of the polychromy remains, including gilding of hair, halos, beards, and

other details; green for the trees and grass; and black for the mouth of Hell and Peter's cave.

Half of the basal molding on the back has been replaced in wood. The chess-board on the bottom is missing two intarsia squares and five of bone. In the areas at the end of the board, forty squares and triangles of bone and wood are lacking.

Notes: A number of similar Flemish caskets survive, mostly with flat lids and carved either with the Life of the Virgin (see Longhurst, vol. 2, no. 176–1866, pl. XXXVIII) or with the Life and Passion of Christ (see cat. no. 164). They are related also to Flemish folding Virgin shrines (for instance, cat. no. 35; and Koechlin, no. 946). There are many such caskets in Italian and Spanish collections, as natural results of trade with Flanders.

L: 12¾ in. (32.4 cm); D: 7¾ in. (19.7 cm); H: 7¾ in. (19.7 cm)

Martin D'Arcy Gallery of Art, Loyola University, Chicago (3-84)

History: Said to have been brought to the Convent of Carmel in Chartres at the request of the daughter of the marquis de Denonville, governor for Philip V of Spain, in 1701, and to have contained relics of Saint Theresa; collection of Thomas F. Flannery (until 1983).

Bibliography: Flannery sale, Sotheby's, London, 1 December 1983, lot 62.

164

The Passion of Christ

Bone casket on a wood core, Flemish, 1430–1460

This large casket with a flat lid is decorated with twenty scenes of the Passion, its figures shown on a crosshatched ground. On the top are the Presentation in the Temple, Christ Debating with the Doctors, the Baptism, the Supper at Emmaus, the Entry into Jerusalem, the Last Supper, the Washing of the Feet, and Gethsemane; on the front, the Arrest of Christ, the Flagellation, the Carrying of the Cross, and the Crucifixion; on the right side, the Deposition and the Entombment; on the back, the Resurrection, the Harrowing of Hell, Noli Me Tangere, and Christ's Appearance to His Mother; and on the left side, Christ's Appearances to Thomas and to Peter.

Battens carved with vines divide the scenes, and the borders of the lid, the

upper lip, and the base are molded. The base is cut with a series of bracket feet. A chessboard of black wood and bone is inlaid on the bottom. The hinges are of iron, the lock plate of brass. A later twisted-brass bail handle is attached to the top.

Much polychromy survives: gilt on beards and garments, blue on the arches, green on trees and grass in the landscape, and brown and gilt on the battens. The lid and many battens are warped. There are four later copper nails in the back battens.

Notes: While some of the designs on this casket are known to be after the *Biblia Pauperum,* others have no identified print source. Compare a Flemish box of the same form, containing the same sequence of scenes (Randall, no. 359).

L: 12¼ in. (31 cm); D: 8 in. (20.4 cm); H: 6¼ in. (15.9 cm)

Wadsworth Atheneum, Hartford (1949.393), gift of Mrs. Charles C. Cunningham

History: Purchased from Ars Antiqua, New York, 1949.

Bibliography: European Art, 1450–1500 (exh. cat., Brooklyn Museum, New York, 1939), no. 173 (lent by French and Co.).

165

The Incredulity of Thomas

Panel from a bone casket, Flemish, 1430–1460

Thomas is shown placing his finger in Christ's wound, and Christ carries the banner of the Resurrection. Set beneath an ogee arch, supported by two columns, the figural scene has a crosshatched background. There are pinnacles, crockets, and a floral finial above, seen against an ashlar wall.

Considerable remains of polychromy include gilt halos and architectural details, black hair, and green grass. Traces of gold

at the cuffs, hems, and Cross indicate that the garments were not fully painted but were given gilt outlines.

Notes: The scene, taken from a print source, formed part of a Passion series decorating a large box (like, for example, cat. no. 164 and Randall, no. 359). Some of the scenes follow the woodcuts of the *Biblia Pauperum,* but no surviving print of the Doubting Thomas is known.

H: 3¾ in. (9.5 cm); W: 2⅜ in. (6 cm)

Detroit Institute of Arts (37.48), gift of Lillian Henkel Haass

History: Purchased in Florence, 7 November 1913 (Customs seal).

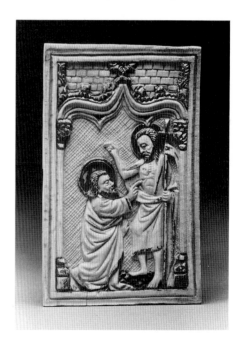

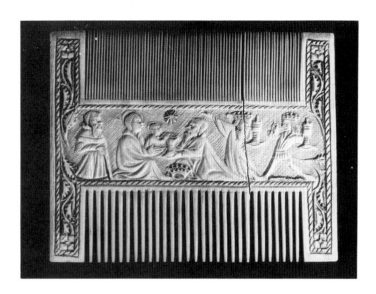

166

The Annunciation and the Adoration

Ivory comb, French (Alsace) or German (Black Forest), 1400–1470

One side is carved on a hatched ground with the Adoration of the Kings, including the figure of Joseph at the left. The reverse shows a broadly carved Annunciation, the angel with spreading wings and a decorative looping scroll. The Virgin kneels at a prayer desk with a pendant curtain above.

There are considerable traces of polychromy in green and gold on the ground planes and figures, and the star of the Annunciation was apparently yellow. A crack in the comb bisects the middle king on one side and the angel's head on the other; the damage was once repaired with pins.

Notes: Combs from the same workshop, many with secular subjects, include one with morris dancers and a hunting scene (Longhurst, vol. 2, no. 230-1867) and one with jousting and bathing scenes (*Waning Middle Ages,* no. 85).

L: 5¼ in. (13.4 cm); W: 4⅛ in. (10.6 cm)

World Heritage Museum, University of Illinois, Urbana (29.6.3)

History: Purchased from B. Hein, Paris, 1929.

167

The Virgin and Child with Saints

Ivory pax, Dutch (Utrecht), 1440–1470

Both hooded and crowned, the Virgin offers the Christ Child a flower. She is flanked by Saint John the Baptist, gesturing at his sheep, and Saint Catherine with her wheel, martyr's palm, and crown. John has a halo and Catherine does not.

The scene is placed beneath an ogee arch with stylized crockets and a floral finial. Above the arch are two trefoils of rayonnant tracery. The ground throughout is crosshatched, and there is a molded frame.

Notes: Another pax with this subject (Randall, no. 363), more broadly carved, is perhaps slightly later. In that example the Virgin is also hooded and crowned, and both saints have halos. A panel with the Crucifixion (Dalton, no. 318) shows the Virgin and Saints John and Peter with halos and Saint Catherine without, as in the Detroit pax. The Virgin figure here is nearly identical with the Virgin of cat. no. 169. Similar in many features to the Virgins of the two paxes is a carved wood Virgin and Child in an aureole of light (Koch [Bib.], fig. 7).

H: 4¾ in. (12.1 cm); W: 3⅜ in. (8.6 cm)

Detroit Institute of Arts (25.91), gift of Mrs. Lillian Henkel Haass

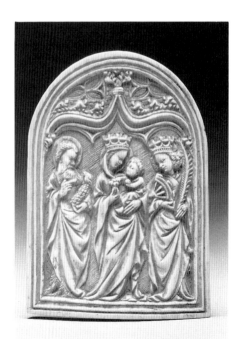

Bibliography: R. Koch, "An Ivory Diptych from the Waning Middle Ages," *Record of The Art Museum,* Princeton University, 17, no. 2 (1958), pp. 55–64; Randall, no. 363. *See also colorplate 15.*

168

The Crucifixion

Left leaf of an ivory diptych, Dutch (Utrecht), 1440–1470

The body of Christ on the Cross is somewhat distorted, with a huge chest, large feet, and thin but muscular legs and arms; his head hangs down, emphasized by the loose, falling locks of hair. Rays of light surround his figure and form halos for the heads of the Virgin and Saint John. As

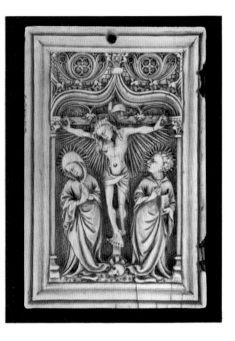

Mary turns away and clasps her hands, John stares into space, clutching his robe and his book. The Cross, rendered with wood grain, has a curving scroll *titulus,* and a skull with bones sits at its base.

Set against a crosshatched ground, the scene is placed beneath an ogee arch on colonnettes. Crockets and finials are rendered abstractly, and the stone wall above the arch is inset with rayonnant tracery with central quatrefoils. The plaque has a double-molded frame.

There were once large hinges, retained by two pins. A vertical crack descends through the center of the plaque, and a later hole for hanging is drilled at the top.

The back of the plaque is inscribed IHS within a circle.

Notes: One of the finest and richest ivories of the Utrecht group, this Crucifixion can be compared with two other panels (Dalton, nos. 318 and 319) and a pax (Longhurst, vol. 1, no. 150-1879). Similar in all four examples are the details of the head of Christ—the hanging hair and the crown of thorns—the treatment of the loin-cloth, and the exaggerated feet. There are close comparisons also in the architectural detail, and all but the pax are set within a series of molded borders.

The group includes cat. nos. 167 and 169 of this book as well (see R. Koch, "An Ivory Diptych from the Waning Middle Ages," *Record of the Art Museum,* Princeton University, 17, no. 2 [1958], pp. 55–64).

H: 3¹³⁄₁₆ in. (9.8 cm); W: 2¹³⁄₁₆ in. (7.2 cm)

National Museum of American Art, Smithsonian Institution, Washington, D.C. (1928.8.240.11), gift of John Gellatly

169

Saint George and the Dragon; and the Virgin and Child with Saints

Ivory diptych, Dutch (Utrecht), 1440–1470

Saint George is seen on horseback, in full armor, spearing the winged dragon in the mouth. In the landscape background kneels the princess, under a hovering angel. The right leaf shows the Virgin standing with the Child, her head in profile between Saints John the Evangelist and Christopher.

Above the ogee arches with stylized crockets and finial are ashlar walls with panels of rayonnant tracery trefoils. There is a molded inner frame, and the grounds are crosshatched.

The original hinges are lacking, as are replacements that were once attached to the surface. Both panels are drilled with five later holes in the outside border.

Notes: The Saint George image is based on a lost painting of the subject by Jan van Eyck, of which there are several copies (one attributed to Rogier van der Weyden at the National Gallery of Art in Washington, D.C.). The Virgin between saints is a typical subject of the Utrecht ivory group. (See, for examples, two paxes: Randall, no. 363; and cat. no. 167 in this book. Compare also cat. no. 168.)

H: 3¹⁄₁₆ in. (7.7 cm); W: 1¹³⁄₁₆ in. (4.8 cm) each

The Art Museum, Princeton University (56-136), Carl Otto von Kienbusch, Jr., Memorial Collection

History: Collection of John Hunt, Dublin. Purchased from Mathias Komor, New York, 1956. (When in the Hunt collection, the panels were bound with leather, as a book, and contained two Spanish manuscript leaves.)

Bibliography: R. Koch, "An Ivory Diptych from the Waning Middle Ages," *Record of The Art Museum,* Princeton University, 17, no. 2 (1958), pp. 55–64; R. Randall, "Jan van Eyck and the St. George Ivories," WAG *Journal* 39 (1981), pp. 39–48; *Carver's Art,* no. 13.

170

The Annunciation

Ivory roundel, Upper Rhenish, third quarter of 15th century

The kneeling Virgin turns from her reading desk as the winged Gabriel approaches, carrying a scepter and a scroll. Above are the dove of the Holy Ghost and a tiny Christ Child with a cross. The drapery is treated with a series of complex, squarish folds.

The edge of the roundel is incised for attachment, and a later hole is drilled at the top center for suspension. Two vertical cracks are visible, and there is a chip on the left edge. A hole in the center is plugged with ivory.

Notes: The subject is taken, with minor changes, from a print by the Master E. S. (see figure 6). Here the book and dove are repositioned, the background omitted, and the angel's wings greatly enlarged. The full, round faces of Master E. S. are now long, thin ones characteristic of Upper Rhenish sculpture.

Diameter: 2¾ in. (7.1 cm)

The Cleveland Museum of Art (17.7), Andrew R. and Martha Holden Jennings Fund

History: Collection of E. and M. Kofler-Truniger, Lucerne. (Purchased from Leopold Blumka, New York, 1971.)

Bibliography: Schnitzler, Kofler cat., no. S-133; *CMA Year in Review,* 1971; *BCMA* 59 (January 1972), p. 41, no. 28, p. 8; Wixom 1972, fig. 46; *CMA Handbook* (Cleveland, 1978), p. 78.

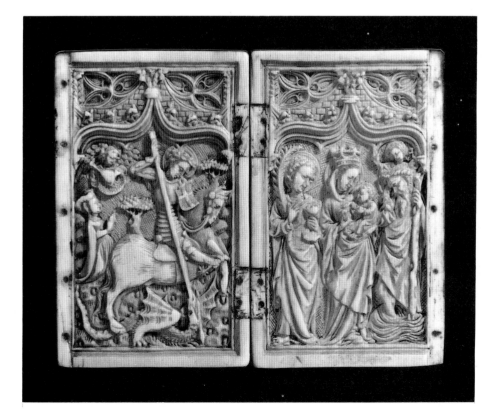

171

The Adoration of the Kings

Ivory roundel, Middle Rhenish, third quarter of 15th century

The seated Virgin, with heavy locks of curly hair, looks at the viewer, while Joseph (in the doorway of the stable) clasps the box of gold of the first king, who kneels and kisses the Christ Child. The second king lifts his hat, and the third, a turbaned Moor, stands in an elegant posture. An angel's head appears in the sky, and plants decorate the right side and foreground. The box of gold and the ostensory of the third king have Gothic decoration.

That the plaque was originally inset into an object is clear from the evidence of four pinholes in the border. There are seven cuts in the outer edge for a subsequent mounting and a later hole for hanging at the center top. Broken along a curved line above the bottom, the plaque has been repaired.

A complex commercial symbol incised on the reverse of the roundel, resembling watermarks on paper of the late fifteenth century, may be the mark of an ivory atelier.

Notes: An ivory of the same subject at the Victoria and Albert Museum in London, slightly smaller in scale, comes from the same shop. Both are based on a lost print by the Master E. S., who died in 1467 (H. Huth, "Ein verlorener Stich des

Meisters E. S.," in *Festschrift Adolph Goldschmidt, zu seinen Siebenzigsten Geburtstag* [Berlin, 1935], pp. 74–79). The subject was repeated in mother-of-pearl, stone, wood, terra-cotta, and plaster in various parts of Germany and France.

Diam.: 2⅝ in. (6.5 cm); Depth: ⅝ in. (1.7 cm)
Honolulu Academy of Arts (1167.1)
History: Purchased from Adolph Loewi, Los Angeles, 1951.

172

The Virgin Nursing the Christ Child

Ivory pax, Flemish, fourth quarter of 15th century

Dressed in a cape and a voluminous skirt, the Virgin nurses the Child. She is crowned, and both figures have halos. The large throne is decorated with rounded arches, a Gothic fret, and arms with crozier-like volutes for terminals.

At the top are three rounded arches with floral pendants, set on corbels. The ground is crosshatched, and the frame is molded. An ivory handle is slotted into the back.

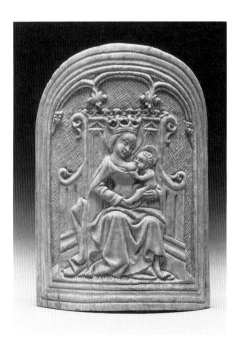

Notes: The architecture of the throne suggests the end of the fifteenth century. (See Berliner, no. 64, for another ivory pax with the subject of the nursing Madonna.)
H: 4¹³⁄₁₆ in. (12.2 cm); W: 3⅜ in. (8.6 cm)
Detroit Institute of Arts (43.454), gift of Robert H. Tannahill
History: Collection of Michel Boy, Paris (until 1905).
Bibliography: Boy sale, Georges Petit, Paris, 15–24 May 1905, lot 303; Tannahill, no. 73.

173

The Crucifixion

Ivory pax, Flemish, fourth quarter of 15th century

Against a crosshatched background Christ is flanked by Mary and John, on a Cross with a *titulus* at the top and the mound of Golgotha at the base. The drapery postdates Rogier von der Weyden, and details such as halos and the interstices of the arches are decorated with floral designs and striations. The molded frame has three abstract floral projections at the top, where a trefoil arch with rounded sections is set on geometric corbels. There are ivory nails in Christ's hands.

On the reverse is a slot for an ivory handle, which has been replaced with an iron loop riveted to the plaque. The rivets of the handle penetrate the ivory and appear on the chest of Christ and at the base of the Cross. The back is inscribed with the name of the donor: HEER P/ ORTHEN/ TEN BOS.

Notes: Paxes of the late fifteenth century usually have rounded arches, and several have ornamental projections at the top (Koechlin, no. 919, for instance). Inscription of the donor's name on a pax—a common practice—occurs on other examples of Flemish origin (see Koechlin, no. 932, which is inscribed on the front).
H: 5¼ in. (13.5 cm); W: 3⅞ in. (10 cm)
Fine Arts Gallery, Vanderbilt University, Nashville (1979.676P)
History: Purchased from Mathias Komor, New York, 1979.

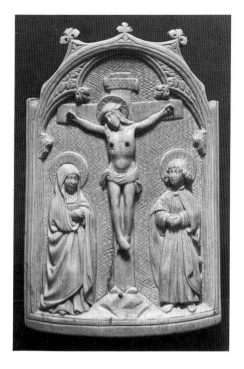

has flowing hair, large and bulging eyes, and a heavy robe with wide sleeves.

The scene is set against a plain ground beneath four arches with leaf finials. Two faceted columns frame the sides, the upper edge is decorated with five leaves, and the bottom is diapered. A triangular handle is slotted into the back.

Notes: A popular subject in the late fifteenth century, the Virgin in Glory is repeated in numerous woodcuts and early prints. While the exact model has not been identified, many details of the subject are included in a print pasted into the lid of a fifteenth-century leather casket (A. J. J. Delon, *Histoire de la gravure: Des origines à 1500* [Brussels, 1924], vol. 1, pl. 1, fig. 1).

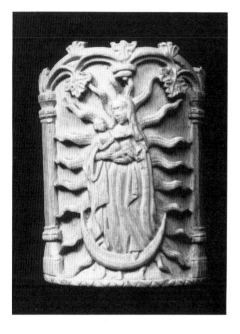

174

Christ Carrying the Cross

Ivory plaque with a silver frame, Lower Rhenish or Flemish (Antwerp?), 1480–1500

Christ carries the Cross, helped by Simon of Cyrene and surrounded by a group of soldiers and ruffians. One man in boots pulls Christ with a rope, another sticks out his tongue and threatens with a club, while still another strikes with a rope. Below a crenellated castle set on a hill, four armored soldiers carry a banner, spears, and a halberd. Simon wears a large belt purse, large shoes, and a cowl that covers his shoulders.

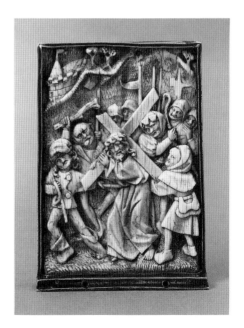

There are traces of color and gilding. The plaque is mounted in a contemporary silver frame, engraved on the back with the Crown of Thorns and the Nails under the arms of the owner (argent, a sable cross with five scallops argent), below a helm and oak leaves. A later hole is drilled through the frame and ivory at the top, left of center.

Notes: The subject is based on an engraving of Christ Carrying the Cross by the Master E. S. or a variant of it (Lehrs 42, pl. 58, no. 147). An artist whose prints were widely distributed and copied in many media, the Master E. S. worked in the Upper Rhine from about 1450 to 1467. Comparable are an ivory with similar features, showing Christ before Pilate (sale, Sotheby's, London, 7 April 1977, lot 210), which appears to be Flemish, and a wood relief of the Carrying of the Cross with a related treatment of the landscape and a similar grimacing soldier, which bears the paw mark of Antwerp (sale, Sotheby's, London, 10 April 1967, lot 111).

H: 4¹⁵⁄₁₆ in. (12.6 cm); W: 3½ in. (8.9 cm)

The Cleveland Museum of Art (71.6), J. H. Wade Fund

History: Purchased from Leopold Blumka, New York, 1971.

Bibliography: Sale, Sotheby's, London, 17 April 1969, lot 4; Wixom 1972, p. 108a, figs. 48 and 59.

175

The Virgin in Glory

Ivory pax, Flemish, 1490–1500

Surrounded by the flames of an aureole of light, the crownless Virgin stands with the naked Christ Child on a sickle moon. She

There also Mary lacks a crown, and the flowing hair and the nude Child on the right arm are portrayed as in the ivory.

Two ivory paxes from the same Flemish workshop (Koechlin, no. 909; and Volbach, no. 704) show an Annunciation taken from a Troyes incunabulum of 1492 (A. Hind, *An Introduction to the History of the Woodcut* [London, 1935], vol. 2, p. 621, fig. 368). Varying only slightly from one another in detail, the ivories are framed by two columns under a series of arches, their bases and upper edges diapered in the same manner.

H: 4⅞ in. (12.5 cm); W: 3½ in. (9 cm)

Crocker Art Museum, Sacramento (1960.3.58), gift of Ralph C. and Violette M. Lee

SECULAR IVORIES

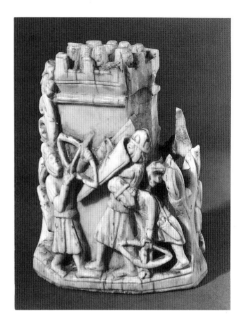

176

Battle before a Castle

Ivory chessman (king?), English (?), 1140–1210

The carving shows a crenellated square tower filled with helmeted knights and attacked by soldiers on two sides. Opposite men armored in gambesons and helmets, with bow, sword and shield, and crossbows, are soldiers wearing chain mail, one a bowman and one with sword and shield. The kite-shaped shields are squared at the top, and the tall, domed helmets have crossbands. At the center of the group of knights in the castle is a larger figure in mail, possibly the king. His head is damaged, as is the stylized openwork foliage on opposite sides of the piece.

Notes: The dating is based primarily on the armor and on the lack of a surcoat over the mail, which usually indicates a date before the year 1200. Kite-shaped shields with the tops cut straight appeared about 1140 and were used to the end of the century. The helmets, or kettle hats, with crossbands are of Scandinavian type, found mostly in Norway. They are seen, for instance, in a thirteenth-century Scandinavian chessman (a knight wearing a surcoat) (*Collection Carrand au Bargello* [Rome, 1895], pl. 15) and in the Maciejowski Bible of about 1250 (S. Cockerell and J. Plummer, *Old Testament Miniatures* [New York, n.d.], f. 10r, p. 62).

An English ivory castle dated, on other grounds, to 1220–1240 (*Age of Chivalry*, no. 145) also has soldiers who carry triangular shields with straight tops. The foliage of the present example is related to that on two English chessmen (*Age of Chivalry*, nos. 146 and 147) dated even later, to 1240–1250.

H: 3⅝ in. (9.2 cm)

Private collection, New York
History: Purchased from Edward R. Lubin, New York, 1989.
Bibliography: Sale, Hôtel Drouot, Paris, 10 June 1988, lot 76.

177

Inhabited Scrolls

Ivory relief fragment, French (?) or English (?), mid-13th century

Within a crisply carved grapevine scroll are a lion seizing a deer and a hound with a goat. The leaves are displayed flat, and clusters of grapes are scattered along the vine, one bunch being pecked at by a bird.

The fragment, which retains its original edges, was made to fit an unusual space. On the uncarved, canted upper edge are four evenly spaced holes and a fifth smaller hole piercing the ivory. The back is crosshatched to receive glue for attachment, and there is a deep recess. The stag's left rear hoof and horns are lacking.

Notes: The object has been called both a fragment of a musical instrument and part of a saddle bow, the latter being more likely. Related to no other known ivory, the

crisp carving is similar to that of the Warwick gittern (G. Remnant and R. Marks, "A Medieval Gittern," British Museum *Yearbook* 4 [1980], pp. 83–134) in the treatment of the leaves, the undercutting, and the overall effect. Similar emphasis on realistic leafage can be found on the pier capitals at Rheims Cathedral (with animals), at Southwell Cathedral, and in the west choir of Naumberg Cathedral, all dating from 1240 to 1250 (A. Martindale, *Gothic Art* [New York, 1986], figs. 32, 44, and 86).

L: 6¾ in. (17.2 cm); W: 1¾ in. (4.5 cm)
The Saint Louis Art Museum (34:1927)
History: Collection of Conde De Las Almenas (until 1927). (Purchased from Joseph Brummer, New York, 1934.)
Bibliography: Las Almenas sale, American Art Association, New York, 13 January 1927, lot 314; *Spanish Medieval Art* (exh. cat., The Cloisters, Metropolitan Museum of Art, New York, 1955), no. 29.

178

Pair of Figures

Ivory stylus or hair parter, French, first half of 14th century

Forming the handle of a five-sided shaft, capped with a simple faceted molding, are two figures—the man standing with one hand on the head and one on the shoulder of a kneeling woman whose hands are raised in prayer. She wears a hat or crown of pillbox form.

The figures are severely worn from use, and there is a small break in the man's left arm. The tapered end of the shaft is broken off.

Notes: Whether this is a stylus or a hair parter (*gravoir*) cannot be determined, because of its broken end. The five-sided shaft is unusual, as most French examples have straight shafts that are round in section.

Gravoirs often have subjects from Romance literature, such as Phyllis and Aristotle, and the present subject may be of that genre.

L: 7¹⁵⁄₁₆ in. (20.2 cm)

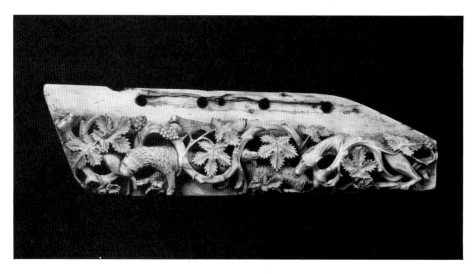

Williams College Museum of Art, Williamstown, Massachusetts (78.2.1), gift of John Davis Hatch, Jr.

History: Collection of John Davis Hatch Jr., Lenox, Mass. (Purchased from Leopold Blumka, New York.)

179

Dragon

Ivory hair parter, French, early 14th century

The tapering hair parter is slightly curved in the lower third; it changes in section from oval at the tip to an octagon with uneven facets. On its molded plinth perches a convoluted dragon with batlike wings.

Notes: The dragon is in the tradition of French gargoyles and architectural decoration of the thirteenth century, although no hair parters of that period are known; the majority seem to be French or Italian of the first half of the fourteenth century.

L: 7⅜ in. (18.3 cm)

Private collection

180

The Legend of Saint Eustace

Ivory casket with gold, silver-gilt, and enamel mounts, French (Paris), 1325–1350

The box is carved with seventeen scenes of the life of Saint Eustace. Beginning on the front, the saint is shown hunting, then kneeling before the vision of Christ's head

between the antlers of a stag, and recounting the event to his wife. On the right end he distributes alms to the crippled, and his family is baptized by the bishop of Rome. On the rear panel Eustace is seen fleeing with his family and being thrown from a boat while his wife is kidnapped, followed by a man killing a lion that has seized one of Eustace's children. On the left end a wolf attacks the other child, and Eustace is shown caring for the village crops. On the top of the box, reading from the lower right, is a view of the family reunited, followed by a battle in which, according to legend, Eustace was victorious and regained his military honors; he is then seen dining with the emperor Hadrian. In the top row the emperor prays before an idol, Eustace and his family are condemned to death in the brazen bull, and the soul of Eustace is taken to Heaven.

The casket has fittings of silver gilt and enamel, probably from the seventeenth century. Against a translucent blue enamel are straps and hinges engraved with lions passant, fleurs-de-lis, and plants. The straps

are attached with elaborate domical rivets, those on the lid inset with tiny rubies. The bail handle is silver gilt, and the lock plate is gold, enameled with the arms of England: quarterly, first and fourth, azure semée of fleur-de-lis, second and third, gules three lions passant or.

The gold hasp of the lock is bent. Red velvet covers the interior.

On the bottom of the box are stickers from the Manchester exhibition of 1857 inscribed "Ho. Magniac Esq." (see History); a blue-and-white sticker with "H. Magniac Esq./ Colworth [sic]/ no. 17"; a black-and-white sticker with "Magniac Collection"; and a round yellow sticker with "Astor of Hever."

Notes: Seldom represented, the story of Saint Eustace follows the Golden Legend closely on this box. Shown on the lid of another French casket (E. Gersbach, "La collection Carrand au Musée National de Florence, II," *Les arts* 3, no. 32 [August 1904], p. 23, fig. 84) is the Saint Eustace story in a different sequence, including the

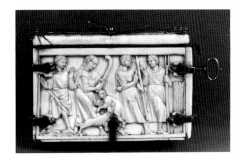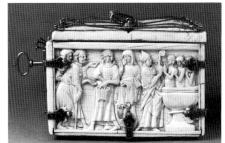

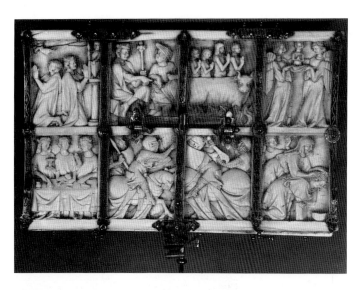

family reunion, the battle, the emperor praying, and the martyrdom of Eustace. While most large-scale Parisian caskets related to the present example depict romances and Arthurian legends, there is a small group of lesser quality with the lives of saints, including Catherine and Margaret (for example, Randall, no. 338; and cat. no. 99 [a lid] in this book).

L: 7⅛ in. (18.1 cm); D: 4¼ in. (10.8 cm); H: 3 in. (7.6 cm)

Private collection, New York

History: Collections of British royal family; Henry Stuart, cardinal of York before 1807; and dowager duchess of Cleveland (1807); "Art Treasures" exhibition (Manchester, England, 1857 [according to label]) collections of Hollingworth Magniac, Coleworth House, Bedfordshire (before 1857–1892); and Lord Astor of Hever (until 1983).

Bibliography: J. Skelton and W. H. St. John Hope, *The Royal House of Stuart* (London, 1890), no. 40; Hollingworth Magniac sale, Christie, Manson, and Woods, London, 2 and 4 July 1892, lot 258; Koechlin, no. 255. Hever Castle sale, Sotheby's, London, 5 May 1983, lot 230.

181

La Chatelaine de Vergy

Back of an ivory box, French (Paris), 1330–1350

Carved on the rear panel of the large box are four scenes from the beginning of the romance of "La Chastelaine de Vergi." Reading from left to right, the duke of Burgundy speaks with the chevalier and sees the chevalier greet the chatelaine; next are shown the duke telling the duchess the secret mentioned in the story and a messenger bringing the chatelaine an invitation to the dance. The scenes are divided by blank strips for metal mounts, which are drilled for rivets.

The figures are slightly rubbed, and there is some abrasion at the right end. Through the base of the two scenes at the right is a diagonal break and an old repair.

Notes: Among a number of similar Parisian caskets showing the story of "La Chastelaine de Vergi" are two that follow the same model as the present example (compare boxes in the Metropolitan Museum of Art [inv. 17.190.177] and the Musée du Louvre [Koechlin, no. 1301]). That the scenes are handled identically and yet appear to be by three different carvers suggests an atelier of considerable size. There exist other caskets (Dalton, no. 367 and Gross, p. 21, fig. r), following a different model, that show the equivalent figures of the four scenes reversed and the landscape elements altered. A second box in the

Metropolitan Museum (inv. 17.190.180) presents a completely different artistic interpretation of the story.

L: 9⁷⁄₁₆ in. (23.9 cm); W: 3⁷⁄₁₆ in. (8.7 cm)

Spencer Museum of Art, The University of Kansas, Lawrence (66.5)

Bibliography: Waning Middle Ages, no. 81; L. Gross, "'La Chastelaine de Vergi' Carved in Ivory," *Viator* 10 (1979), pp. 311–321; *Songs of Glory,* no. 87.

182

Scenes of Lovers

Ivory box, French (Paris), 1330–1350

The small box is carved with pairs of lovers courting. On the lid four couples exchange wreaths and caresses; on the front a man and a woman hold up the lock

plate, under which crouches an old man, flanked by a hawker and a lady with a wreath; on the left end a couple play chess; on the right end lovers exchange a caress on horseback, followed by a huntsman; and on the back, two others on horse-

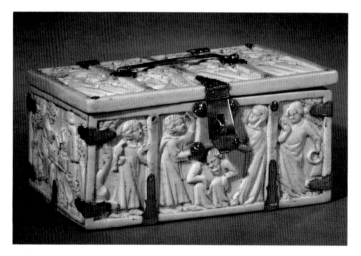

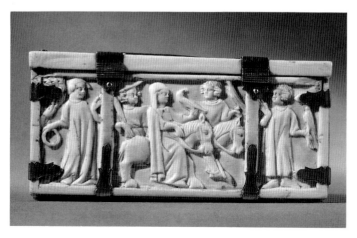

back are seen hawking, accompanied by a huntsman and flanked by a lady with a wreath and a hawker on foot.

The box is complete, including the bottom, but all the silver mounts are replaced.

Notes: While the style is Parisian, the work is coarse. Other boxes with lovers (Koechlin, nos. 1261 and 1266) share the common feature of figures holding the lock plate, with a figure or animal placed beneath it.

L: 5½ in. (13.9 cm); D: 3⅜ in. (8 cm); H: 2½ in. (6.3 cm)

The Toledo Museum of Art (50.303), gift of Edward Drummond Libbey

History: Collections of Bourgeois Frères, Cologne; and Emile Baboin, Lyons. (Purchased from Raphael Stora, New York, 1950.)

Bibliography: Bourgeois Frères sale, Lempertz, Cologne, 19–24 October 1904, lot 1056; Koechlin, Baboin cat., no. 28.

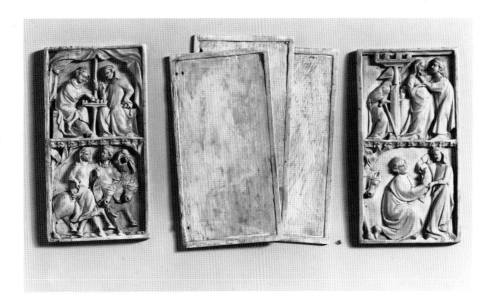

183

Four Scenes of Lovers

Pair of ivory writing-tablet covers and three blank leaves, French (?) or English (?), second quarter of 14th century

Four scenes of lovers are carved on the ivory plaques. At the top of the front cover a couple play chess, while below a man and a woman ride to the hunt with a falcon. On the rear cover, above a suitor kneeling before his lady, is another couple—the man chucking the woman's chin, watched by a hooded elder through a door. The scenes are divided by a molding decorated with rosettes.

The covers are recessed on their backs to receive wax, and the three blank leaves are recessed on both faces. Joining the tablets were fine cords that passed through holes at top and bottom of the covers on one edge.

The set retains its original leather case, incised with three vertical bands of decoration, the central one with scrolls of large quatrefoil flowers. On one end of the case are five loops for a stylus, and on the other end is space for a stylus and a pocket for a wax smoother.

Notes: The treatment of the architecture in the upper scene of the back cover, where the figure's head passes through the door frame, is most unusual. The house wall is cut away, and the door frame is represented as supporting the crenellations of the castle roof, as it might be envisioned in a stage set. While figures behind columns are well known in the fourteenth century—for instance, the angel of the Annunciation in the Hours of Jeanne d'Evreux (The Cloisters, inv. 54.2), the reduction of a building as here has few paral-

lels. The treatment can be found, however, in the Holkham Bible Picture Book (W. O. Hassall, *The Holkham Bible Picture Book,* London, 1954), where (on f. 39v) a figure passes through the doorway of a tower that supports a few crenellations representing an entire building. Elsewhere in the manuscript (on f. 29) a pier and crenellations again represent a building, and (on f. 15) a stable is shown as two columns supporting a cut-off building, through which a baby ass passes.

Both the unusual architecture and the character of the figures' faces suggest that the tablets may be English rather than French.

Leaves—H: 3¾ in. (9.6 cm); W: 2⅛ in. (5.5. cm) each

Case—H: 3¹⁵⁄₁₆ in. (10.1 cm); W: 2½ in. (6.4 cm)

Private collection

184

Chess Game

Ivory mirror case, French (Paris), second quarter of 14th century

Seated on crosshatched benches, a couple play chess under a tent. The man, holding the tent pole and removing a piece from the board, has his legs crossed in the position of judgment. His partner has taken a chessman in one hand and points to the board with the other.

The ivory has lost its corner projections and has a later hole for hanging drilled at the top. A slot or bayonet fitting is cut on the reverse for insertion of the mirror.

Notes: Two other high-style Parisian ivories depicting a chess game—in the Victoria and Albert Museum and the Musée du Louvre (Koechlin, nos. 1046 and 1053, respectively)—are probably from the same atelier. Both pieces repeat details of the Cleveland case, such as the man's drapery and foot position, the placement of the benches, and the emphasized fold in the center of the woman's skirt. In particular, the squaring of the skirt hem along the lower border is duplicated in the Louvre

ivory. There is a closely related copy, perhaps German or Austrian, at the Kunsthistorisches Museum in Vienna (Koechlin, no. 1049).

Diameter: 3⅞ in. (9.8 cm)

The Cleveland Museum of Art (40.1200), J. H. Wade Fund

History: Collection of George Eumorfopoulos. (Purchased from Richard N. Zinser, 1940.)

Bibliography: Catalogue of the Exhibition of Ivories (Burlington Fine Arts Club, London, 1923), no. 1936; *BCMA*, October 1941; *Treasures of Medieval France*, no. V-18.

185

Royal Couple Hunting

Ivory mirror case, French (?) or English (?), second quarter of 14th century

Accompanied by three attendants, a king and his queen ride to the hunt. The two men on horseback hold lures for falcons in their hands, and a groom on foot holds a pair of gloves. The king chucks the queen beneath her chin. All five figures are

dressed in cottes with hoods. With a roughened ground plane below and two trees overhanging at the top, the plaque is framed by four monster corner terminals.

An original section of the background has been replaced next to the queen's head, and a large restoration of diamond shape is inset next to her shoulder, running over to the first horseman. His lure is restored as a mace or baton. The face of the groom has flaked off.

While the front has been cleaned and bleached, the back is still stained dark brown, as though it had been buried in a peat bog. A double molding encircles the mirror cavity; there are no slots for lugs.

Notes: The carving is unusually fine in quality and somewhat different from all other mirror cases. Special attention is paid to details such as the retaining strap on the king's saddle, the cross-hatching of the girth, and the depiction of the tall-backed

saddles. The large, round faces of the figures are also noteworthy, resembling no other French sculpture of the period.

One other mirror case showing a seated king and queen with attendants is known (Koechlin, no. 1057). Although it has long been thought to be of royal origin, the depiction could well be King Mark and Iseult. Whether the Fogg mirror represents a Romantic subject or was a gift to a king is difficult to surmise.

Diam.: 5 in. (12.8 cm)

Fogg Art Museum, Harvard University, Cambridge (1952.95), purchase with gift for special uses

History: Collections of John Watkins Brett, Burleigh House, London (until 1864); Whitehead, London (?) (until 1906); Henry Oppenheimer, London (until 1936); William Randolph Hearst, New York. (Purchased from Blumka Gallery, New York, 1952.)

Bibliography: Brett sale, Christie, Manson, and Woods, London, 18 April 1864, lot 2007; Whitehead sale, London (?), 14 March 1906, lot 10; *Catalogue of the Exhibition of Ivories* (Burlington Fine Arts Club, London, 1923), no. 146; *Exhibition of French Art* (London Academy of Arts, 1932), no. 380r; Oppenheimer sale, Christie's, London, 15 July 1936, lot 174; H. Bober, "A French Gothic Mirror Case," Fogg Art Museum *Annual Report*, 1952–1953, p. 5; *Court Style*, no. 10.

186

Hawking on Horseback

Ivory mirror case, French (Paris), second quarter of 14th century

Depicted on the mirror case are a man and woman on horseback, each with a falcon. The woman wears a long-brimmed riding hat with ear lappets and the man a buttoned hooded riding cape. They are preceded by a huntsman on foot with three dogs on leashes.

The scene is set in a frame of six lobes within a circle. At the corners are crouching monster bipeds with human heads.

Those at the top right and lower left have bearded and balding heads, while that at the upper left has a female head, as did presumably the damaged fourth monster.

Both lower corner ornaments are damaged, that at the lower right so as to be unreadable. An original hole is drilled through the top left ornament.

Notes: The simple framing of the scene can be found on a smaller French mirror cover (Randall, no. 321). The subject was a popular one for mirror cases, and in several examples (see Longhurst, vol. 2, no. 222-1867, pl. XLII; and Randall, no. 329) the woman wears a similar riding hat.

Diam.: 3⁵⁄₁₆ in. (8.2 cm)

The Art Institute of Chicago (1949.211), Kate S. Buckingham Fund

History: Purchased from Brummer Gallery, New York, 1949.

187

Hawking

Ivory mirror case, French (Paris), 1330–1350

A hawking party is depicted on horseback, the three chief figures riding abreast. The first woman feeds her hawk, watched by a man with a bird on his wrist, while the second woman swings a lure to attract her falcon. Seen at the rear is a huntsman on horseback, blowing his horn. The group is set within enframing trees, in one of which a bird perches. At the bottom a hound chases a rabbit into its hole.

The mirror is framed by six lobes, with grotesque masks in between, and is brought to a square with leaf projections at the corners. The circular frame is slightly

flattened on each side. There is an original diagonal hole for hanging at the top.

The back of the mirror has been planed, leaving it nearly flat. It was cut at the top with an arc so that it could be mounted on a stand, for which there are four rivet holes for attachment.

Inscribed in ink on the reverse in a seventeenth-century hand is an illegible name, the date 1608, and the price of 77 guineas.

Notes: The mirror case is the product of a Parisian shop from which several works survive. Most similar is an example (*Secular Spirit,* no. 104) that repeats, with variations, the actions of the three central figures, one of whom (the man) wears a tall hunting hat. The huntsman is seen somewhat differently, there is a bird in a tree, and a hound chases a rabbit at the bottom. While it is similarly enframed with masks, the corner ornaments are lions. A second mirror case (Koechlin, no. 1035) has the same format with three mounted hunters (plus one on foot), but it differs in having the scene set before a castle wall from which four figures observe the hunt. The corner projections are leaves, and the number of lobes framing the scene varies. There is a dog chasing a rabbit at the bottom.

The front of a casket that repeats many of the features (in Maihingen; Koechlin, no. 1290) includes the bird in the tree and the hound and rabbit. A mirror case with lion corner terminals and a subject of lovers (formerly in the Dormeuil collection; Koechlin, no. 1014) may be from the same atelier.

H: 3¹⁵⁄₁₆ in. (10 cm); W: 3¹⁵⁄₁₆ in. (10 cm)
Private collection, New York
History: Collections of anonymous English owner (1608); John Hunt, Dublin; and Howard Ricketts, London. (Purchased from Edward R. Lubin, 1988.)

188

Jousting

Ivory mirror case, French (Paris),
1330–1350

Two pairs of knights are shown jousting in front of a castle, where two levels of attendees view the proceedings. There are trumpeters at each side, sitting in trees, and the two-towered castle is depicted with barred windows and a raised portcullis. The right-hand knights wear chain mail, surcoats,

and helms with crests. They carry triangular shields, one covered with roses. The left-hand knights have cloth streamers, rather than crests, attached to their helms, and the knight with roses on his shield knocks the helm from his opponent's head. The scene has a simple, round frame with four crouching monsters at the corners. There is no socket on the back, where rosettes encircle the mirror opening.

Only the lower right monster is original, the other three being restorations. A long vertical crack in the ivory has been repaired with an inset at the base.

Notes: Another mirror case (Burrell Collection, Glasgow; inv. 21/10) shows a lance striking a helmet in an attack on the Castle of Love; only rarely is the helmet knocked off, as in the present scene. The mirror case is one of a very few without a socket for inserting the mirror, and the rosette decoration on the reverse is unknown elsewhere.

H: 4¾ in. (12 cm); W: 4¾ in. (12 cm)
Virginia Museum of Fine Arts (69.45), Adolph D. and Wilkins C. Williams Fund
History: Purchased from John Hunt, Dublin, April 1969.
Bibliography: "La Chronique des Arts," *GBA,* February 1970, no. 1213, fig. 244.
See also colorplate 16.

189

Attack on the Castle of Love

Ivory mirror case, French (Paris),
1330–1350

A central castle with crenellated battlements and a gate flanked by two towers is defended by five ladies, three of whom throw roses down onto the attackers. In combat in front of the castle, horsemen with chain mail, helms, and shields attack each other with sword and falchion. The rider on the left carries a basket of roses, and the helmeted figure on the right carries a spear and a shield. Two knights have scaled the battlements, the one on the right being helped over the ramparts by a lady, while the one on the left hands up his sword in surrender.

Framed in a plain molding, the circular scene is brought to a square by the four monsters carved at the corners. The back has one key slot and an undercut groove to receive a round mirror. There are several vertical age cracks in the ivory, and the back has been sealed with varnish.

Notes: A mirror case from the same shop, and probably by the same carver (once in the Maurice Sulzbach collection, Paris; Koechlin, no. 1088), has virtually identical architecture and figures in the castle. The knights in the foreground wield tree branches instead of swords, and the third

horseman wears a helmet and carries another branch. Trees at the sides replace the helmeted soldier on the right and the surrendering figure on the left.

Also from the same workshop is a mirror case (Koechlin, no. 1086) that shows the architecture slightly rearranged and the knights on horseback fighting within the gateway. The ladies throwing roses are repeated, however, as is the third horseman riding in from the left.

H: 4½ in. (11.5 cm); W: 4¼ in. (10.8 cm)
Seattle Art Museum (49.37), Donald E. Frederick Memorial Collection
History: Collections of Baroness Lambert, Brussels; and Baron Gustave de Rothschild, Paris. (Purchased from Rosenberg and Stiebel, New York, 1949.)
Bibliography: Art Quarterly 12, no. 2 (Spring 1949), pp. 191ff., ill. p. 188; *Handbook* (Seattle Art Museum, 1951), p. 116; *Treasures of Medieval France,* no. V-19, p. 206; *Medieval Treasury,* no. 81; *Waning Middle Ages,* no. 78; *Images of Love and Death,* no. 67; *Songs of Glory,* no. 84; Joice Knight McCluskey, *Ivories in the Collection of the Seattle Art Museum* (Seattle, 1987), no. 12, p. 16.

190

Scenes of Lovers

Ivory box with silver mounts, English,
1340–1360

Coarse but lively carving defines this ivory box decorated with scenes of lovers in various settings under pointed and flattened trefoil arches. Somewhat irregular in shape, the arches are surmounted by squarish crockets and finials. On the right end of the box are Tristan and Iseult beneath a tree with King Mark in its branches, and next to it is the familiar subject of lovers playing chess. The center section of the front has a man and a woman holding up the escutcheon plate, under which is carved a heraldic rose. Courtship scenes depicted on the other panels show lovers

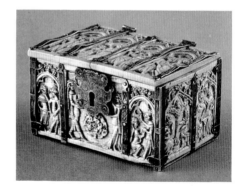

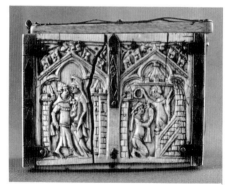

man's costume seen here—a fringed cape, arm and shoulder pendants, and a long, belted cotte—was introduced only in the 1340s. It can be found on French ivories by the "Atelier of the Boxes" (R. Randall, *Gesta*, figs. 3 and 4) as well as in a manuscript of 1330–1340 (Smithfield Decretals; Sandler, vol. 2, p. 111, no. 101).

L: 4⁹⁄₁₆ in. (11.3 cm); D: 3⁵⁄₁₆ in. (8.2 cm); H: 2½ in. (6.1 cm)

Museum of Fine Arts, Boston (64.147), Theodora Wilbour Fund in memory of Charlotte Beebe Wilbour

History: Said to have belonged to Lord Talbot; collections of his son John, earl of Shrewsbury, and descendants (to the twentieth century). (Purchased from Premsela and Hamburger, Amsterdam, 1964.)

Bibliography: Medieval Treasury, pp. 155–157, no. 79; *Waning Middle Ages,* no. 64; *Songs of Glory,* no. 80.

191

Scenes of Lovers

Ivory mirror case, English, 1340–1360

Two pairs of lovers are separated by the corner of a crenellated wall. On the left is a lady wearing a low-cut dress with elbow pendants and with a ribbon in her hair; she gives a wreath to a kneeling lover, who is dressed in a belted cotte with sleeve pendants. The couple on the right are similar, except that he wears a hat with a pendant and presents her with flowers. She is standing on a staircase and points suggestively upward into the building. A tree within the castle walls and a stream in the foreground complete the landscape.

The mirror has lost its corner projections and has been somewhat roughly trimmed with a knife. Part of the stream is repaired with an ivory inset, and a vertical crack is visible on the right side. A small missing piece in the kneeling lover has been filled with plastic wood.

Notes: The same model was used for the man on the right and one on cat. no. 190 (the third scene from the left on the box lid); they are clearly from the same workshop. A mirror case roughly carved with tall figures (*Avori gotici francese*, no. 34) may be from that atelier as well. While the costumes are a few years earlier in style, the treatment of sleeve pendants and other details is similar, as is the stylization of the foliage.

chin chucking, giving wreaths and flowers, helping to arm a lover, and in two cases suggesting an ascent into a building.

The box retains many of its original silver mounts, which contain traces of niello and are engraved with monsters under pointed arches. The hinges and all four corner mounts have been replaced, and the strap for the hasp is repaired and partly replaced. A silver escutcheon of the seventeenth century is engraved with four roses and floral motifs, including a thistle.

Notes: The Lord Talbot mentioned in the family history of the object was a judge at the trial of Joan of Arc in 1460. It is presumably the Talbot heraldic rose that is carved under the lock, and the seventeenth-century silver lock plate with roses and a thistle is also typically English.

The figure style is found in an English mirror cover (cat. no. 191), and the unusual hat and shoulder pendant of the right-hand lover on the mirror case follow the same model as the lover in the third panel of the box lid. While the ailette worn on the shoulder of the kneeling knight was a fashion that disappeared in England by the middle of the fourteenth century, the

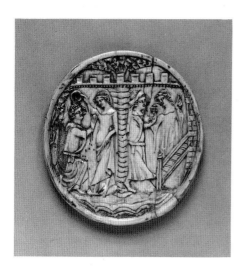

Diam.: 3⁷⁄₁₆ in. (8.7 cm)
The Art Museum, Princeton University
(54-61), gift of Mrs. Albert E. McVitty
Bibliography: Songs of Glory, no. 83; *Carver's
Art*, no. 68.

192

Yvain at the Fountain

*Side of an ivory box, French (Paris),
1330–1350*

According to the Romance legend by
Chrétien de Troyes, Yvain takes water from
a fountain to pour on a magic rock. Beside

the fountain sits a giant cowherd, shown
as a wild man; he is described in the story
as dressed in skins and covered with tufts
of hair. Yvain's horse is at the left and a
tower, perhaps representing the chapel in
the narrative, is at the right. There are trees
in the background.

The plaque, which formed the end of a
casket, is drilled with five holes for strap
rivets. A later hole is drilled in the base,
and some modern transverse scratches are
visible on the back.

Notes: As the story of Enyas and the wode-
house often appeared as a scene on the
ends of Parisian ivory boxes, this subject
has been interpreted as a variant of the
theme (compare Koechlin, no. 1285; and
Dalton, no. 369). Some years ago, however,
it was correctly identified by Laila Gross
(in personal communication) as Yvain at

the fountain, and it appears to be the only
known image of the scene. The cowherd is
described in the tale as armed with a club
and covered with hair, customary attri-
butes of a wild man, as the ivory carver
depicted him.

L: 3¾ in. (9.7 cm); W: 2¼ in. (5.8 cm)
Private collection, Washington, D.C.
History: Collection of Baron Robert von
Hirsch, Basel (until 1978).
Bibliography: Von Hirsch sale, Sotheby's,
London, 22 June 1978, lot 281.

193

Picking Flowers

*Ivory plaque, French (North France or
Paris), 1340–1360*

A man picks flowers from a tree to present
to two young women, one of whom holds
a wreath. Dressed in a short cotte, a cape,
and a hood, he wears a kidney dagger. The
women wear wide-necked dresses, and
one has hair plaited over her ears, while
that of the second is short and flowing.
The tree is rendered with long serrated
leaves and flowers. Three trefoil arches
above the figures have floral crockets and
finials, and trefoils are incised in the gables
and spandrels.

Lacking both hinges and holes, the
plaque could have served as an inlay or
the lid of a box.

Notes: Although it is unusual in having a
flat ground plane, the ivory has been attrib-
uted to the "Atelier of the Boxes." Its top
is identical to other works of the atelier, as
is its Romantic subject (Randall, *Gesta,*
p. 32, fig. 6).

H: 3¼ in. (8.4 cm); W: 1¹³⁄₁₆ in. (4.7 cm)

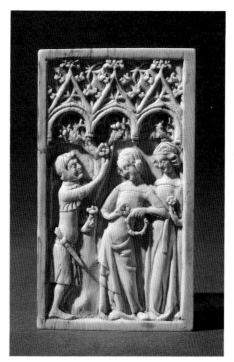

The Toledo Museum of Art (57.20), gift of
Edward Drummond Libbey
History: Collection of Count Gregorii
Stroganoff, Rome.

194

Scenes from Floire et
Blanchefleur

*Ivory box with copper-gilt mounts, North
French or Flemish, third quarter of 14th
century*

Carved on the box are thirty-two scenes of
paired lovers holding hands, exchanging
gifts, pleading, and being spied on by vil-
lagers. The settings are outside castle
walls, in gardens, or in landscape shown
as undulations, with grass indicated in a se-
ries of incisions. Costume for the men con-
sists of buttoned jupons and capes, while
the women wear wide-necked dresses and
hair arranged in plaits over the ears.

Each scene is set beneath a double tre-
foil arch with floral crockets and finials.
Above the arches are incised trefoils. The
edges of the box are stepped ivory mold-
ings, and the bottom is cut with a series of
bracket feet.

The original strap mounts of the box
are of gilt copper. Dividing the scenes are
ribs with fleur-de-lis terminals and a cen-
tral flower; the central rib supports a bail
handle of oval shape, decorated with
punching. The four corners are reinforced
by bracket strips with scalloped edges of
thin sheet copper, probably added when
the interior was gessoed. The lock has
floral corners, and the hasp is replaced.

There are numerous breaks and cracks
where the ivory has shrunk away from the
rivets on the lid, front, and back of the
box. The inside is lined with paper that is
covered with gesso and painted silver with
red scrolls and the letters IHS—alterations
probably of the seventeenth century.

Notes: While the steeply pitched landscape
and the rendering of hillocks and grass are
characteristic of the "Atelier of the Boxes"
(Randall, *Gesta*, pp. 30–40), the figure style
is different. This factor, considered along
with the unusual construction of the box
and the copper-gilt mounts, suggests
North France or Flanders. The foot is re-
lated to those on fifteenth-century boxes of
Flanders, such as cat. nos. 163 and 164.

The subject has been identified only re-
cently (see Theresa Lynn Weller, "The
Illustration of the Medieval Romance *Floire
et Blanchefleur* on an Ivory Box in the
Toledo Museum of Art," Ph.D. thesis,
Michigan State University, 1990).

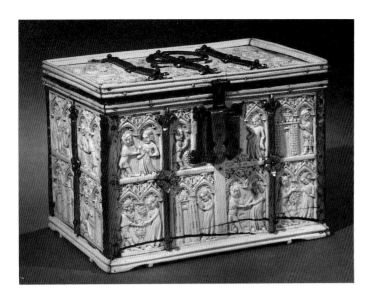

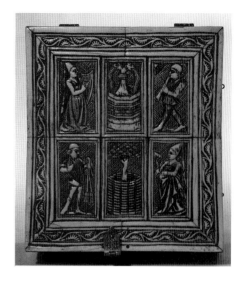

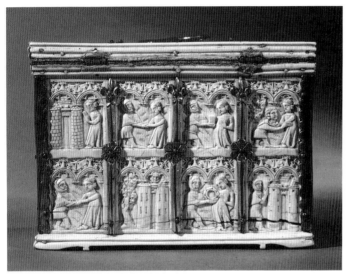

L: 6½ in. (16.7 cm); D: 4½ in. (11.6 cm);
H: 4½ in. (11.6 cm)

The Toledo Museum of Art (50.302), gift of
Edward Drummond Libbey

History: Collections of Hollingworth
Magniac, Coleworth House, Bedfordshire;
Frédéric Spitzer, Paris; and Emile Baboin,
Lyons. (Purchased from Raphael Stora,
New York, 1950.)

Bibliography: Molinier, Spitzer cat., vol. 1,
p. 59, no. 104; Koechlin, Baboin cat.,
no. 29; Koechlin, no. 1313; Randall, *Gesta*,
p. 38.

195

Secular Scenes

*Bone game box on a wood core, French
(Alsace) or German (Black Forest),
1440–1470*

The bone plaques on the lid show two cou-
ples: on either side of a fountain are a lady
playing a harp and a gentleman a horn;
below them are two hawkers flanking a
tree within a woven fence, the man with a
hawk and the woman with a lure. The
women wear voluminous gowns with
V-necks and *henins* with streamers, while
the men are dressed in short doublets,
hose, and skullcaps. There is a border of
vine ornament within a double molding
like those that surround the scenes.

On the right side an archer shoots a
stag pursued by two hounds and a hunts-
man blowing his horn. The back shows
two musicians with harp and horn, a tree
between them; and the subject of the left
side is a morris dance, including a drum-
mer, two men in elaborate costumes and a
woman (Maid Marian) dancing, and a fool
with his baton. On the front, flanking the

lock, are two plaques of wild men with
clubs. The scenes are framed in plain bone,
contrasting with the carved vine border of
the lid and the slightly enlarged vine bor-
der of the base.

The lid is hinged at the back, and there
is a drawer below the lock on the front.
The bottom is a checkerboard of bone and
tortoiseshell squares.

Much of the polychromy is preserved,
including the gilded, crosshatched back-
grounds of the scenes; gilding of the vine
scrolls; red, blue, and brown on the cos-
tumes of the figures; and dark green on
the trees.

Both lock and hinges are seventeenth-
century brass replacements of Dutch or
English origin.

Notes: This box is one of a large group in
bone that can be placed along the upper
Rhine by a box with coats of arms of
German families from the region of
Baden-Baden and Strasbourg (C. Beard,
"Heraldry," *Connoisseur* 96 [1935], pp. 238–
239). The heraldry of that object suggests
an origin in the Black Forest (see
Longhurst, vol. 2, p. 55 for Koechlin's view
in support of northeast France as the
source). The group includes many boxes
with a morris dance on the lid (Randall,
no. 358; and Longhurst, vol. 2, no. 4660-
1859), as well as garden scenes and wild
men; the sides combine hunting, garden
scenes, tilting, and children's games.

The Princeton box is the only example
known with a drawer. It is significant also
for establishing a link with a series of
ivory combs that have long been un-
attributed. One such comb (Longhurst,
vol. 2, no. 230-1867) is carved with scenes
identical to those on the sides of the
Princeton box: the stag hunt and the mor-

ris dance. The quality of the combs is somewhat higher, perhaps because of their material. Produced by the same workshop, and carved even more roughly than the boxes, is a set of folding game boards with carved bone borders (see cat. no. 198).

L: 6³⁄₁₆ in. (15.7 cm); D: 5½ in. (14 cm); H: 3¹³⁄₁₆ in. (9.7 cm)

The Art Museum, Princeton University (59-11), museum purchase, a gift of the National Forge Foundation

Bibliography: Record of The Art Museum, Princeton University, 20, no. 1 (1961), p. 27; *Waning Middle Ages*, p. 72, no. 86; *Carver's Art*, no. 25.

See also colorplate 17.

196
Secular Scenes

Bone game box on a wood core, French (Alsace) or German (Black Forest), 1440–1470

The plaques on the lid are carved with a falconer and his lady, posed on either side of a tree within a woven fence, above a couple flanking a fountain—the woman playing a harp and the man a horn.

Plaques of a hound and a hunter surround the lock. On the right side are a hunter blowing his horn, a central tree, and a bear; on the back are two hounds and a tree; and on the left side a hound pursues a fox who is disappearing into his burrow. A game board of wood and bone squares occupies the bottom. The borders are running leaf scrolls.

There is considerable surviving polychromy: green for the trees and leaves, gilding in the hair, and touches of brown and black. Lacking its lock and hasp, the box is supplied with four small rings, two on each side, for a carrying strap.

Notes: This box is from the same atelier as cat. no. 195. Constructed without a drawer, it is the more usual product of the shop. The subject of the lid is the same, but the plaques are arranged differently. Other objects from the workshop include a comb and a folding chessboard (cat. nos. 166 and 198; see discussion in cat. no. 195).

L: 6¾ in. (17.2 cm); D: 5⅞ in. (15.1 cm); H: 2½ in. (6.9 cm)

The Fine Arts Museums of San Francisco (1979. 50.5a and b), gift of Ruth L. Koch from the Alfred B. Koch Collection

197
Scenes of Wild Men and Hunters

Bone and wood casket, French (Alsace) or German (Black Forest), 1440–1470

The lid of the box is divided into six panels showing wild men with shields and clubs flanking dragons. (The beast in the top tier, with wings, may be a wyvern.)

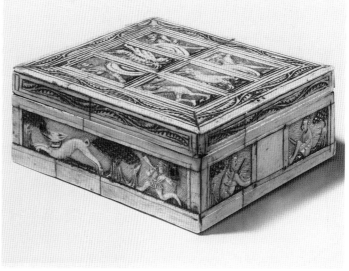

Incised borders frame the panels, while a band of running leaf design frames the lid and decorates its sides.

Two seated men, perhaps holding a snare, flank the lock on the front of the box. On the left side are a hunter with a horn, a hound, and two trees; on the back are two hounds; and on the right are a boar, a tree, and a hunter with a spear. The bottom of the casket has a chessboard formed of bone and wood squares.

There are many remains of paint: dark green on the trees, landscape, and borders; gilt on the hair; red in the borders; and brown on the wild men and dragons. The lock is missing, and the box is fitted with six rings in the sides for a carrying cord. Minor abrasions are visible on the lid.

Notes: This is the only box of its group with scenes of wild men on the lid, although wild men occur flanking the locks on several others (see cat. no. 195). The scenes on the sides correspond to others of the series, while that of the men snaring is otherwise unknown.

H: 2¹³⁄₁₆ in. (7 cm); W: 6 in. (15.3 cm); L: 7¼ in. (18.5 cm)

Collection of Mr. and Mrs. Richard B. Flagg, Milwaukee

198

Hunting Scenes

Folding bone game board on a wood core, French (Alsace) or German (Black Forest), 1440–1470

The borders of the board are carved with hunting scenes. At the top of the exterior— the checkerboard side—a hound faces a dragon (wyvern?) in a landscape with two tree stumps and stylized trees at the corners. On the left side a hound pursues a boar, and a rabbit runs into its burrow. The same rabbit is pursued at the bottom by a hunter with a boar spear and a hound. On the right two hunters blow their horns, and two foxes go to ground in a landscape with trees and stumps. The checkerboard is composed of squares of bone and brown wood, and it has a roped border at top and bottom.

A backgammon board on the inside, made of bone and dark and light brown wood, has scenes identical to those on the exterior at the right side and top. At the bottom is a horn-blowing hunter with a greyhound, while on the left a hunter with horn and spear chases a rabbit into its burrow and a hound races after another rabbit.

There are traces of polychromy, particularly the dark green of the trees and touches of brown and white.

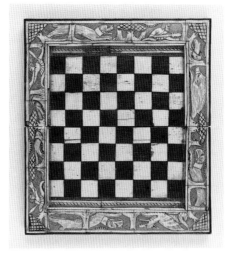

Notes: The game board comes from the same atelier as cat. nos. 195 and 196 (boxes) and cat. no. 166 (a comb).

L: [open] 10⅞ in. (27.6 cm); W: 9¾ in. (24.8 cm); D: ⁹⁄₁₆ in. (1.3 cm)

Detroit Institute of Arts (41.2), gift of Mrs. William Clay

History: On the back is the tag of Silberman, Seilenstätte 5, Vienna, no. 832. Purchased in 1941.

199

Secular Figures

Bone saddle on a wood core, Tyrolean, second quarter of 15th century

The saddle is carved in low relief over its entire surface with figures of gentlemen and ladies in elaborate costumes amid scrolls, trees, and banderoles with mottoes and letters. On the left side of the saddle is Saint George killing the dragon; he appears in armor with a wide skirt, like one of 1440 shown in a painting by Konrad Witz (C. Blair, *European Armour* [London, 1958], fig. 33). A man on the tail of the saddle, below the cantle, wears a Burgundian-type costume resembling those in Arras tapestries of the third and fourth decades of the century (for instance, the "Rose

Tapestries" at the Metropolitan Museum of Art). Three banderoles with the motto "GEDENKCH UND HALT" (*think and stop*) are carved on the saddle. There are also scattered letters such as G and S throughout the composition.

Constructed of wood covered with bone in large sections, the saddle is lined on the underside with birch bark. The scale suggests that the bone must be from the hip bones of deer or cattle. Several small sections of bone have been inset to replace losses. There are ten circular holes for attaching harness, as well as two large slots for the girth and two for the stirrup leathers.

Notes: Twenty-one such saddles are known, four of them at the Metropolitan Museum of Art. All are constructed in the same way, and the form is referred to as a "Hungarian" saddle. Two examples bear Italian coats of arms—Este and Gonzaga— one the arms of Wenzel I, king of the Romans, and one initials and mottoes associating it with Savoy. Since each has a depiction of Saint George and the dragon, it is assumed that these are ceremonial saddles related to an unidentified knightly

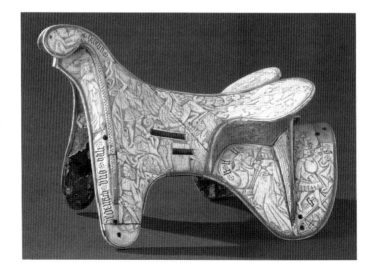

order. At least two others, like the present example, are associated with Hungarian families.

The origin of the saddles in the Tyrol, more specifically the "Alte Adige," is confirmed by the use of German mottoes and by the low-relief carving style, which appears on furniture from the region (such as an armchair now at the Cloisters of the Metropolitan Museum of Art [57.144.2]).

H: 16 in. (41 cm); L: 23 in. (58.6 cm)

Museum of Fine Arts, Boston (69.944), Centennial Acquisition Fund

History: Collections of Princes Batthyani-Strattman, castles of Rohancz and Kormend, Hungary, 1520–1966.

Bibliography: J. Schlosser, "Elfenbeinsättel des ausgehenden Mittelalters," *Jahrbuch der kunsthistorisches Sammlungen des allerhöchsten Kaiserhauses* 15 (1894), pp. 260–294; *Archaeologiai Ertesito* (Budapest) 14, no. 1 (1894); sale, Sotheby's, London, 17 April 1959, lot 6; "Hungarian Art Treasurers," *Catalogue* (Victoria and Albert Museum, London, 1967), no. 64.

See colorplate 18.

200
Falcon-Hood Stand

Ivory, Flemish, 1440–1460

The bulbous top of the hood stand emerges from a rounded base carved with fleurs-de-lis on a crosshatched ground between two borders of leaf scroll. The flat front of the base has a shield-shaped recess framed by pilasters with scale decoration and surmounted by a coronet. Carved on the underside of the base is a second shield-shaped recess.

A large chip of ivory is missing from the right lobe of the top of the stand, a break has occurred between the two shield cutouts, and there is a chip in the base at the back.

Notes: The evidence of a falcon-hood stand with a carved coat of arms on the front (formerly in the Figdor collection; Koechlin, no. 1251) suggests that the shield recess here was for an inset coat of arms in metal or enamel. The treatment of the

fleurs-de-lis on a crosshatched ground resembles the backgrounds of two Flemish Virgin shrines (Zastrow, nos. 44 and 45), and the leaf-scroll borders are found on Flemish paxes (Koechlin, nos. 921, 927, and 932). The shield cutout on the underside of the base appears to be for a later use, perhaps for a seal.

H: 4 in. (10.2 cm); W: 2¼ in. (5.7 cm)

Detroit Institute of Arts (66.128), Founders Society purchase, Hill Memorial Fund

History: Collection of Chalandon, Paris. (Purchased from Adolph Loewi, Los Angeles, 1966.)

Bibliography: Exposition de Lyon (Lyons, 1877), no. 808; *Exposition du moyen-age* (Paris, 1913), no. 124; Koechlin, no. 1250; Beigbeder, fig. 71; *Waning Middle Ages,* no. 88.

201
Knight

Ivory chessman, German, 1490–1510

The knight wears a full suit of late Gothic armor with an open-faced sallet and *bevor.* Black dots decorate the tail of the sallet and the reins of the horse. The rotund animal, with a full mane, an overlarge chest, and incorrect front knees, stands on a simple plinth with fluted edges.

Details of the armor are difficult to read because of wear, but protective cops are visible on elbows and knees.

Notes: Although the armor is of a type worn in the last decade of the fifteenth century, it remained in use and can be noted in Albrecht Dürer's *Knight, Death, and Devil* of 1513 (E. Panofsky, *The Life and Art of Albrecht Dürer* [Princeton, 1955], fig. 207).

H: 1¹³⁄₁₆ in. (4.6 cm); L: 1½ in. (3.8 cm)

Detroit Institute of Arts (41.107), gift of Arnold Seligmann, Rey, and Co.

ITALIAN IVORIES

202

The Annunciation

Volute of an ivory crozier, Italian, 13th century

Within the faceted volute stands the angel of the Annunciation, portrayed with a long face and with wings striated to represent feathers. His drapery falling in overlapping folds over his left arm, he grasps a staff topped with a volute and what appear to be feathers. The Virgin's throne has ball feet and ball finials, and the sides have keyhole perforations. The volute, decorated with clusters of leaves at the base and at three points on the outer curve, terminates in a dragon's head.

There are traces of yellow and black polychromy on the angel's wings and black in his hair. Small portions of the Virgin's feet and the ends of her drapery are all that remain of Mary, who once stood before the small throne. The angel's saluting hand is also missing. The edges of all four leaf clusters are damaged.

Notes: Among a group of croziers with the same faceted form and small leaf-clump decoration are one with a central eagle (Randall, no. 260), one with a cockatrice (Dalton, no. 75), one with an Entombment (*Trésors des églises de France*, no. 631), and one with an Adoration of the Kings (Musée de Cluny, Paris; inv. Cl.14085). Close in concept to the Detroit ivory, the last of this group shows the Virgin seated on a small throne with ball finials. The style evolved from twelfth-century Islamic croziers made for export to Europe, which contained animal combats in profile within the volute (*Trésors des églises de France*, no. 337, for instance).
H: 5⅜ in. (13.8 cm); W: 4⅞ in. (12.5 cm)
Detroit Institute of Arts (41.125), gift of Robert H. Tannahill

203

Crozier

Ivory and gilt bronze, Italian, 14th century; and German, late 15th century

The volute of the crozier is made of nineteen faceted blocks threaded on a rod. They are supported on the outer side by a later gilt-bronze strap with leaf crockets. A late-Gothic leaf in gilt bronze has replaced the ivory connector that originally extended from the first block to support the volute. Gilded with flowers and patterns, the volute is inscribed (on one face) AVE MARIA [G]RA[T]A PLE[NA] and (on the other) SALUTE SANCTA LUC[I]A [MISE]RICORD[I]A.

The terminal of the volute is a restoration. A cut in the fourth-from-last block suggests that there was originally a figure or ornament in the center.

The round shaft terminates in a dragon's head with open jaws just below the volute. There are traces of gilt decoration, best preserved on the lowest segment. The gilt-bronze mounts of the shaft, which terminates at the bottom in a spiked ferrule, date from the sixteenth or seventeenth century.

Notes: The unusual construction of the volute suggests a fourteenth-century date, as does the style of the lettering of the inscriptions. The dragon's head at the top of the shaft, however, is a thirteenth-century type found on both ivory and enamel croziers.

To judge by the style of the metalwork, the crozier was in use in Germany or Austria in the fifteenth century and later.

A large number of related croziers are found throughout Europe—one from Bredelar Abbey at the Westfalisches Landesmuseum in Münster, for instance, with leaves on its outer perimeter, figures in the volute, and a faceted knop below the dragon (*Monastiches Westfalen, Kloster und Stifte, 800–1800* [Münster, 1982], fig. 94). Other examples are at the Bishop's Palace in Czestochowa (Poland), the Nonnberg in Salzburg, Siena Cathedral, Galeria Nazionale in Perugia, and the Bargello in Florence (see Barbara Wolff-toznisko, "Grupa Wtoskich Pastorow z Kosci Stoniowej Iegzemplarz Zachowang W Polace" [A Group of Italian Ivory Croziers Preserved in Poland], *Ars Auroprior, Festschrift for Jan Bialostocki* [Warsaw, 1981], figs. 1–6).
H: 60⅞ in. (164.3 cm)
The Art Institute of Chicago (1974.84), gift of Leopold Blumka through Mrs. Ruth Blumka

204

The Coronation of the Virgin

Ivory crozier, Tuscan or Lombard (?), third quarter of 14th century

Placed within the volute, which is carved with foliage and has nine applied projecting leaves, is the Coronation of the Virgin. The stem is a separate piece carved on the back with the Annunciation, under a complex baldachin with trefoils in the spandrels, and on the front with the Virgin and Child flanked by angels, each figure in a separate trefoil niche with a blank tympanum. On the base of the stem are large leaves.

The outermost basal leaf and the top of the second leaf are broken off.

Notes: The application of leaves to the volute indicates the Italian origin of the crozier, which is carefully modeled on a French example (such as a Coronation crozier in Munich; Koechlin, no. 771). Particularly notable among the similarities is the elongated crowning angel in both works. The date is inferred from the niches with blind tympana and the use of trefoils in the spandrels above the Annunciation, both features of the third quarter of the fourteenth century. (The model for the Coronation motif was probably slightly earlier.)
H: [of volute] 12¼ in. (31 cm)
Private collection, New York

History: Collections of Mortimer Schiff, Paris (until 1905); and Lord Astor, Hever Castle, Kent, England (until 1983).

Bibliography: Schiff sale, Hôtel Drouot, Paris, 13 March 1905, lot 278; Hever Castle sale, Sotheby's, London, 6 May 1983, lot 234.

See also colorplate 19.

205

The Baptism of Christ

Ivory crozier, Tuscan, second or third quarter of 14th century

The Baptism scene in the circular volute of the crozier includes John the Baptist on the left and an angel on the right. Outside the volute are the figure of God the Father emerging from leaves at the top and eight prophets within leaf scrolls. Banderoles identify the prophets as Isaac, Isaiah, Solomon, Ezekiel (?), and Zephaniah (?) (three banderoles are blank).

Decorated with leaves, the volute issues from a dragon's mouth above the head of the shaft, which is hexagonal and is carved with six Apostles or saints beneath trefoil arches crowned by a separate section of leaves between pinnacles. The figures are Paul, Peter, Andrew, John, one with a sword and shield, and one with a beard and a book. Three hexagonal sections carved with a scale pattern step down to receive the shaft.

There is much polychromy remaining, mostly gilt with touches of brown in the hair and beards, blue in the backgrounds of the Apostles, and gilt and red highlights. The best-preserved decoration—in the uppermost and lowest sections of the shaft—shows gilt rabbits, dragons, and plants.

Notes: The style of the Apostle figures and the central scene relates to the works of Giovanni del Biondo (d. 1399) and other followers of Giotto. A comparable crozier from Volterra (Longhurst, vol. 2, no. A547-1910) has a central Adoration of the Magi, and a bone example with similar figures of prophets in scrolls (Randall, no. 344) depicts the Dormition of the Virgin.

While the above-mentioned pieces have been assigned dates late in the fourteenth century, a Tuscan crozier with an Adoration of the Kings that has many points in common with the present example (D. Gaborit-Chopin, *Avori Medievali* [Florence, 1988], no. 20) is documented to a date prior to 1343, suggesting that the entire group is precocious and may stem from the second quarter of the century.

H: 75 in. (190 cm)

Private collection, New York

History: From Volterra (?); collections of Bardini, Florence (until 1899); Lord Astor, Hever Castle, Kent, England (until 1983).

Bibliography: J. Sambon, *Les ivoires de la ville de Volterra* (1880); Bardini sale, Florence (Christie's), 5 June 1899, lot 299, pl. LVIII; Hever Castle sale, Sotheby's, London, 6 May 1983, lot 233.

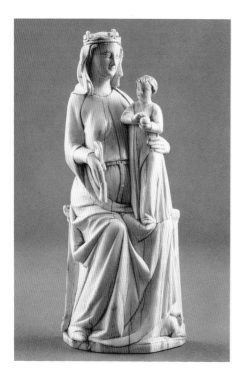

206

The Virgin and Child

Ivory statuette, North Italian, second quarter of 14th century

The seated Virgin is shown with a low crown, integral with her head, and with strong V-folds of drapery both between her knees and on the proper right side. Her veil falls in wavy folds, rather than straight. The Child stands holding a globe in his mother's lap, and there is a monster biped beneath her left foot. The figures' eyes bulge slightly, their lower lids accentuated.

Only the stem remains of the flower in the Virgin's hand.

Notes: The formality of the pose suggests that this is an Italian version of a French model, such as the Virgin of a folding shrine (Tardy, vol. 1, p. 33). While the monster beneath the foot is unusual, the present work recalls the type of a Norman ivory (cat. no. 4) in this detail. Following (but reversing) the latter model is an Italian Virgin and Child (Berliner, no. 34) wherein the monster beneath the foot is interpreted as a rock and the Child is treated in the manner of the Houston statue. (See Molinier, Spitzer cat., no. 54, p. 45, for another similar ivory.)

H: 8%6 in. (21.7 cm)

The Museum of Fine Arts, Houston (44.602), Edith A. and Percy S. Straus Collection

207

The Virgin and Child

Ivory statuette, Italian, second quarter of 14th century

Standing in a frontal pose, the Virgin holds the Christ Child in her left arm. A veil covers her wavy hair; a mantle falls from her right shoulder in soft, transverse folds to her knees; and the robe beneath descends in straight folds to the ground. Both the Virgin and the Child have unusually pointed noses and pouches beneath the eyes. His hair is represented as thick and curly, and there is a noticeable fold at the neck of his shift.

Traces of polychromy include ivy leaves on Mary's veil and right breast. Remaining in silhouette along the border of her mantle is a row of large diamonds with leaf tops that were either painted or gilt. Her hair is gilt, and the Child's is dark brown with gilt highlights. Both figures lack their right hands, which were repaired at one time with pinned pieces, as was the Virgin's right foot. Her head has a hole and discoloration on the top, perhaps from a later halo, as well as a bronze pin at the rear. A recess for a jewel on her chest is filled with ivory.

Notes: The present statue appears to depend in form on a French Virgin from a polyptych (for example, Koechlin, no. 156). Details such as the unusual twist in the neck of the Child's shift can be seen in a French seated Virgin and Child (cat. no. 11) as well as in the Virgin of the Sainte-Chapelle in Paris (Gaborit-Chopin, fig. 199). Other features, however—for instance, the soft treatment of the transverse drapery folds—are found in a number of works by the Pisani (who are known to have used French high Gothic sculptural models [see Seidel, pp. 28 and 35]). Examples include a marble Virgin

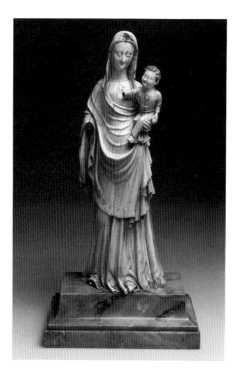

and Child attributed to Nino Pisano (A. Moskowitz, "A Madonna and Child Statue: Reversing a Reattribution," *BDIA* 61, no. 4 [1984], pp. 34–35) and a statue of Saint Paul by Tommaso Pisano (A. Moskowitz, *The Sculpture of Andrea and Nino Pisano* [Cambridge, 1986], fig. 287).

H: 14½ in. (36.9 cm); W: 5¼ in. (13.4 cm)
Cincinnati Art Museum (1971.553), J. J. Emery Fund
History: Purchased from Piero Tozzi, New York, 1971. (The old red number [35.77.136] on the back may indicate that the statue was once in the J. P. Morgan collection.)

208

The Ox of Saint Luke

Ivory appliqué, North Italian, late 13th–early 14th century

The winged ox lies on a roughened ground plane with his front feet resting on a scroll inscribed S ∗ LV for Saint Luke. Carved details include incised feathers, drilled eyes, and a fringe of fur in relief on the forehead.

The tail is missing, and one horn has been damaged.

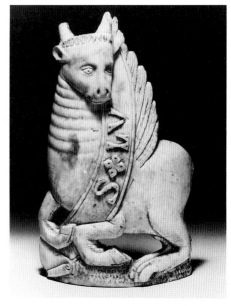

Notes: A lion from the same group of four Evangelist symbols (*Smalti-Avori*, pp. 286–287, fig. 137) has a stylized mane ending in tight curls. While the treatment of the mane is typical of the many Italian Romanesque lions used as architectural supports, it survives into the Gothic period in such examples as an Italian ivory dagger grip (Beigbeder, fig. 79) of the second half of the fourteenth century. The strong stylization of both the lion's mane and the ox's neck suggests a date in the early fourteenth century.

The symbols must have framed a Crucifixion or Christ in Majesty of large scale, which might have been a sculpture in ivory or another material, or possibly a painting.

H: 6½ in. (16.2 cm)

Museum of Fine Arts, Boston (1989.969), gift of Max Falk

History: Purchased from Edward R. Lubin, New York, 1989.

209

The Passion of Christ

Ivory diptych, North Italian, first quarter of 14th century

In the upper tier are the Temptation of Judas, the Tribute Money, the Arrest of Christ, Judas Hanged, and Pilate Washing His Hands. The second tier includes the Flagellation, the Carrying of the Cross, the Crucifixion, and the Deposition. At the lowest level are the Entombment, the Three Marys at the Tomb, Noli Me Tangere, and the Harrowing of Hell. The scenes are divided horizontally by molded bands, one of which has serrations at the top.

The panels are not quite rectangular, and the dividing bands are somewhat uneven and discontinuous in the two leaves. Mice have gnawed away part of the left edge and lower border of the diptych, as well as one spot on the lower right edge. Other damage indicates that the ivory was buried at one time. The large hinges are deeply inset diagonally and have canted edges.

There are traces of polychromy, including blue on the Cross and on the nail puller in the Deposition; red on the first soldier's legs and the Virgin's robe in the Crucifixion; and green on various trees.

Notes: The bold, rough carving relates the ivory to several other pieces (see Koechlin, no. 265—a French diptych). While its format derives from French Rose Group panels (for example, Koechlin, no. 258), the iconography comes from the late-thirteenth-century Soissons Group and its derivatives (see cat. no. 36). The scenes follow closely two Soissons diptychs (Koechlin, nos. 34 and 36). An Italian version of the Soissons Group (Egbert, no. 33) is closer to the Detroit diptych in both carving and figure style.

Unusual features such as the emphasis on the Temptation of Judas appear also in another Italian example that combines Noli Me Tangere with the Harrowing of Hell (Egbert, no. 38; formerly in the Antocolsky collection). The bent shape of the Cross in the Road to Calvary occurs in both of those ivories and on an Italian box (Koechlin, no. 272).

H: 6¾ in. (17.2 cm); W: 4 in. (10.2 cm) each

Detroit Institute of Arts (42.138-139), gift of Robert H. Tannahill

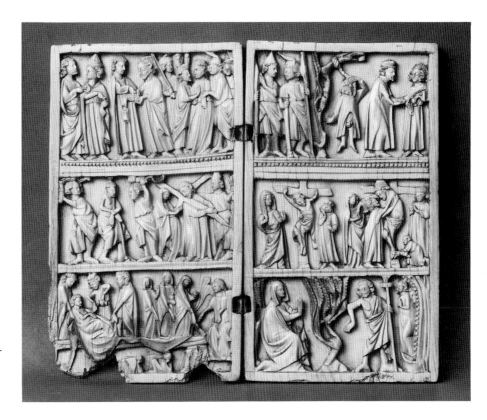

History: Said to have come from the cathedral treasury of Laon; collections of M. Manzi, Paris (until 1919); and Maurice Sulzbach, Paris. (Purchased from Arnold Seligmann, Rey, and Co., New York, after 1928.)

Bibliography: A. Alexandre, "La Collection Manzi," *Les arts,* no. 177 (1919), p. 21; sale, Manzi-Joyant, Paris, 15–16 December 1919, lot 45; Tannahill, no. 54; Egbert, p. 189, fig. 40; *Trésor de Saint-Denis,* p. 242, fig. 1.

210

The Life of the Virgin

Pair of ivory writing-tablet covers, North Italian, second quarter of 14th century

Reading from the bottom left and up, then across and down, are the Annunciation, the Visitation, the Adoration of the Kings, the Presentation in the Temple, and the Flight into Egypt, including the Miracle of the Wheat Field. The squat figures have large heads and hands, and the drapery is carved in broad strokes with many angular folds.

Above the arcades of five arches are somewhat misunderstood crockets and large, spreading floral finials with irregular quatrefoils in between.

Each panel is drilled on one side with five holes and on the other with two. Since all are filled, it is difficult to know the original arrangement. There is a crack with a chip at the base of the left panel and a candle burn on the Virgin of the Annunciation.

Notes: The slight misunderstanding of the architecture and exaggeration of the gestures and postures of the figures are typical of a group of Italian ivories (including

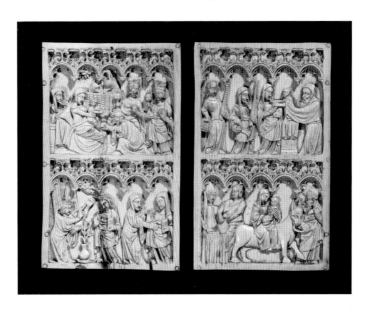

Egbert, nos. 313 and 314—two openwork plaques). There (as in Egbert, no. 618) the large heads and brisk carving of the drapery are repeated. While the wormlike clouds are characteristically Italian, the inclusion of the rare scene of the Miracle of the Wheat Field suggests a Flemish model (see, for example, Dalton, no. 306).

H: 4½ in. (11.5 cm); W: 2⅞ in. (7.4 cm) each
Virginia Museum of Fine Arts, Richmond (57-44-1 and 2), Adolph D. and Wilkins C. Williams Fund

History: Collection of Count Gregorii Stronganoff, Rome.

211

Annunciations to the Virgin and to Zacharias

Pair of ivory writing tablets, Tuscan, third quarter of 14th century (?)

In the Annunciation to the Virgin, the angel raises his right hand, while the left holds the scroll down below the waist. The Virgin stands in a modest S-posture with a book in her left hand. Between them is a vase of flowers, slightly tilted. Zacharias, with long beard and twisted hair, leans on his cane before the half-stooping angel, who holds the annunciate scroll in both hands.

The scenes are placed in niches framed by columns supporting two trefoil arches, each within an ogee arch decorated with floral crockets and finial. Floral crosses occupy the spandrels. There are large flowers and incised trefoils above the arches on each panel, and a band of beading runs across the top.

The panel of the Annunciation to the Virgin has a circular depression in the

back; the other is recessed to receive wax. The Zacharias panel was broken in half and repaired.

Notes: The inclusion of large flowers in architectural decoration occurs in a number of Italian examples of the second half of the fourteenth century: a Presentation (collection of Elizabeth Drey, New York [unpublished]), a Nativity (Nationalmuseum, Stockholm; inv. D46.549), and an Adoration of the Kings (sale, Sotheby's, London, 9 December 1988, lot 27).

The Annunciation to the Virgin follows the design of a Flemish diptych with colonnettes in Brussels (Koechlin, no. 370), which is comparable also in the postures and other details; the Zacharias scene is unknown elsewhere. The unusual stooping pose of the angel is related to the seated figure of Hope on the bronze Baptistry doors in Florence by Andrea Pisano (J. Pope-Hennessy, *Italian Gothic Sculpture* [London, 1955], pl. 46). A close parallel in the treatment of the necks, particularly that of the Virgin, whose head thrusts forward in the line of the left shoulder, is to be found in the figure of Temperance on the facade of Santa Maria Maddalena in Genoa, which is thought to be a copy of a figure of about 1313 from the tomb of Margaret of Brabant by Giovanni Pisano (Seidel, fig. 37). Both the posture and the drapery of the Virgin are related to a figure of Saint Paul by Pisano from the pulpit of San Andrea in Pistoia (Seidel, fig. 35), itself dependent on a French model.

H: 3⅛ in. (8.1 cm); W: 1⅞ in. (4.8 cm) each
Private collection, New York

History: Collections of Richard von Passavant-Gontard, Frankfurt; and Baron Robert von Hirsch, Basel (until 1978).

Bibliography: G. Swarzenski, *Sammlung R. von Passavant-Gontard* (Frankfurt, 1929), p. 18, nos. 74 and 75, pl. 15; von Hirsch sale, Sotheby's, London, 22 June 1978, vol. 2, lot 292.

212

The Coronation of the Virgin

Ivory writing tablet, North Italian, last quarter of 14th century

The exaggerated, semiabstract presentation of this scene of the Coronation of the Virgin is shown under an arch and two half arches with simplified crockets and finials. There are trefoils in the central tympanum and in the spandrels. The figures, whose garments are carved with simple, angular lines, sit on a plain bench, while two censing angels hover above them at the sides. Two folds, perhaps clouds or the top of a misunderstood curtain, appear below the angels.

The plaque, which shows no sign of hinges, is inset in a nineteenth-century binding. While the ivory has not been examined from the back, the central hole at the top identifies it as a writing tablet.

Notes: The plaque is related to two other ivories, both of North Italian origin. One is a Coronation in an openwork plaque (Dalton, no. 313), whose figures are so close in detail that they would have to come from the same model and probably from the same workshop. The hanging fold at the right wrist of God the Father, for instance, and the repeat of folds across

the body are precisely the same. The second Coronation is part of a series of pierced scenes from a box (Museo Cristiano, Vatican; Egbert, fig. 58b) in which the abstract and generalized lines are of the same nature, and the clouds or curtains beneath the angels are repeated.

On the basis of the related ivories, the present piece can be dated to the late fourteenth century or later (see Egbert, pp. 198–206). The geometrical feeling and architectural emphasis given the box plaques suggest an attribution to Milan. H: 1¹¹⁄₁₆ in. (4.4 cm); W: 1¾ in. (4.5 cm) Walters Art Gallery, Baltimore (10.39)

History: Purchased from Léon Gruel in Paris by Henry Walters before 1931. The ivory was inset in the book cover when rebound by Gruel, a typical antiquarian habit of his workshop.

Bibliography: L. M. C. Randall, *Medieval and Renaissance Manuscripts in the Walters Art Gallery* (Baltimore, 1989), p. 90, no. 39.

213

Lovers

Ivory mirror case, North Italian (Lombardy or Milan), 1390–1400

In a landscape with castles at the sides and a central tree, a gentleman offers a lady his heart. Wearing a dress with pendants (liripipes) on the sleeves, she has her hair arranged in plaits over the ears; he wears a

houppelande with a hood. The ground is shown as a series of hummocks with incised grass.

The quadrilobed frame is brought to a circle with interstices containing incised trefoils. Missing from the edges are corner ornaments in the form of leaves, and there is a chip at the lower edge. The hole at the top is modern.

Notes: Among other examples in a large group apparently from the same shop are four Italian mirror covers (Dalton, no. 384; Longhurst, vol. 2, no. A108-1920; Randall, no. 345; and Metropolitan Museum of Art, inv. 17.190.257). They all share the same landscape elements and similar costumes and hairstyles.

Diam.: 3⅜ in. (8.7 cm)
National Museum of American Art, Smithsonian Institution, Washington, D.C. (1929.8.240.4), gift of John Gellatly

214

Scenes of Lovers

Painted ivory box on a wood core, North Italian (Savoy?), 1390–1410

The sarcophagus-shaped box is painted over its entire surface in four horizontal bands. At the top are the words POUR CE QUIL ME/PLEST (inscribed twice), with the word PLEST on each end. The second tier depicts on the front two lovers flanked by Amor with wings in male costume and a woman with a bow (Frau Minne?); at the sides are a dog and a lion. On the right end are three figures in a landscape. On the back are a winged female (Frau Minne?) and a male figure with a bow (Amor?), flanked by a man and a woman with a dog and a lion. On the left end are two lovers and a youth.

The largest band of painting around the body of the box contains, on the front, two lovers in a landscape and three figures of a procession of stylishly dressed young men and women. The procession continues on the right end with three more figures. On the back are a girl of the procession and two pairs of lovers with trees and flowers. Again on the left end are three figures of the procession. The lowest band of decoration is a repeated pattern of arabesque ornament.

The top is painted with the letter M repeated on either side of a flower and a banderole with the motto POUR CE QUIL ME PLEST, much obliterated, and with another M. The paint is nearly all red and brown,

with pale brown instead of gilt used for the lettering. There is green in the flowers and trees.

The box is made of a series of ivory plaques attached to a wood core with ivory pins. Along its corners and lower edges, the top has reinforcing bands painted with running plant ornament. The clasp is carved of ivory, as are two studs on the lid to retain a bail handle. An iron lock and a keyhole are found at the front of the box. The bottom is formed of a series of ivory squares set on the diagonal and attached with ivory pins.

The panels are cracked in many places, and there is a small loss at the bottom right front corner. The ivory hasp is broken off short, as is one of the studs for the handle. Several squares are missing from the bottom. The paint is unevenly rubbed throughout.

Notes: Despite the European structure and method of attaching the plaques, the shape of the box and the painted ornament, particularly the band of arabesques, indicate that a Sicilian model was being imitated. The Italian figure style and the French motto suggest that the box comes from Savoy, where French was the court language. A related series of carved combs with youths and lovers in landscapes (see cat. no. 215) have had tentative attributions to Lombardy, but may instead be from Savoy.

Another painted Italian box with gilt flowers and figures (*Secular Spirit,* no. 11) shows a similar practice of reinforcing corners with ivory strips, as well as the use of turned ivory fittings to retain a bail handle. A painted comb with birds among flowers (*Secular Spirit,* no. 107a) probably comes from the same region.

L: 7⅞ in. (20 cm); D: 5⅛ in. (13 cm); H: 6¼ in. (15.8 cm)
The Glencairn Museum, The Academy of the New Church, Bryn Athyn, Pennsylvania (04.CR.45)

History: Acquired by Raymond Pitcairn in 1927.

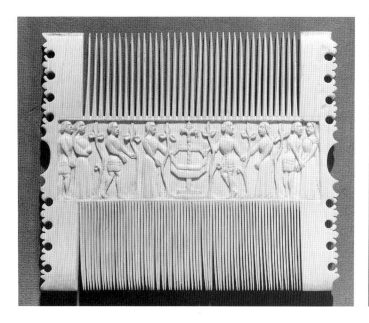

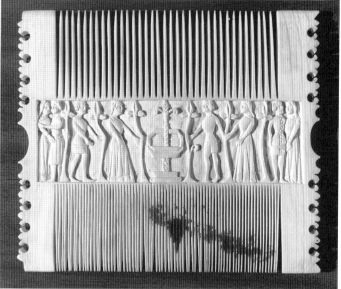

215

Lovers in a Garden

Ivory comb, North Italian (Savoy), 1390–1410

The comb is decorated on both sides with scenes of lovers approaching a fountain. Wearing high-necked dresses, the women are accompanied by men in buttoned jupons. The trees are shown as stems with three leaves at the top.

Drilled and carved at each end with stylized plants and a large depression in the center, the comb has teeth in two sizes, the small ones discolored on one side. There are traces of gesso, and some green polychromy remains on a few of the plants.

Notes: This is one of a group of stiffly carved combs that depict lovers, the attack on the Castle of Love, Frau Minne, religious scenes, and hunts (see Longhurst, vol. 2, pls. LVI and LVII; and Schnitzler, Kofler cat., nos. S-126 and S-127). A completely painted comb (Randall, no. 349) shows lovers in a garden with similarly stylized trees. The ends of the Kofler comb with religious scenes (S-126) are treated in the same way.

For the attribution to Savoy, see cat. no. 214.

L: 5½ in. (13.8 cm); W: 4⅜ in. (11.2 cm)

The Snite Museum of Art, University of Notre Dame, Indiana (67.48.2–3), gift of Jack Linsky

History: Collection of Jack Linsky, New York.

216

Lovers in a Landscape

Ivory mirror case, Tuscan, 1420–1440

The case is carved in deep relief with a young gentleman about to kneel before his seated lady, who holds out a wreath. Below a stylized tree separating the figures, a dog, symbol of Faith, buries a bone. The reverse has turned moldings with straight, rather than undercut, sides to receive the mirror.

There is a large crack on the right side behind the woman, and the lower edge from the man's left foot to the landscape beyond the dog is a restoration. A modern hole is drilled at the top.

Notes: Costumes with high belts and wide sleeves are found in Florence from 1420 onward (for instance, in a garden painting from the Figdor collection; sale, Glueckselig, Vienna, 11 June 1930, vol. 5,

pl. III, no. 5). The stylized tree with rows of overlapping leaves, which was the norm for Embriachi and other fifteenth-century Italian ivories, can be found in major sculpture such as Lorenzo Ghiberti's Gates of Paradise on the Baptistry doors (R. Krautheimer, *Ghiberti's Bronze Doors* [Princeton, 1971], fig. 88), datable between 1425 and 1452, and in Michele da Firenze's Adoration of the Magi relief in the Pellegrini Chapel of 1435 (C. Seymour, *Sculpture in Italy, 1400–1500* [Harmondsworth, 1966], pl. 40).

Diam.: 4⁵⁄₁₆ in. (10.8 cm); Depth: ⁹⁄₁₆ in. (1.2 cm)

Museum of Fine Arts, Boston (51.2471), Samuel Putnam Avery Fund

History: Collection of Prince Liechtenstein, Vienna. (Purchased from Leopold Blumka, New York, 1951.)

Bibliography: Images of Love and Death p. 111, no. 73.

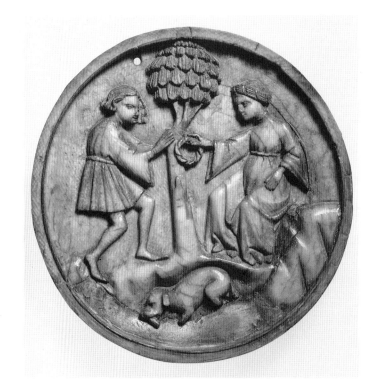

The Life and Passion of Christ

Bone, horn, and wood casket, Venetian (Embriachi workshop), early 15th century

The casket is decorated on two levels with large panels containing bone plaques. The lower panels, composed of four sections of bone, depict the Annunciation, the Adoration of the Shepherds, the Adoration of the Kings, the Baptism, the Entry into Jerusalem, and the Last Supper. On the lid, in two- or three-bone sections, are Gethsemane, the Arrest of Christ, Christ before Pilate, Christ Carrying the Cross, the Crucifixion, and Noli Me Tangere. The subjects are framed beneath long, rounded arches with smaller, curved arches under them. Quatrefoils and trefoils pierce the spandrels, and spiral colonnettes flank each scene.

The bottom plaques are inscribed in gilt on their bases as follows: Annunciation—ANNUCIA/TA : VERGINE MARI/PLENA TIG(?)S; Adoration of the Shepherds—COME SILPA(?)C. O/EIASM : NO/STPA; Adoration of the Kings—COME IMAGI/OFERA A SIGNO / V(?)T S; Baptism—COME SAN GIOVANI BAP ESA GLEXV CRISTO; Entry into Jerusalem—COME GIESV: VA: IGERUSIEME SVLAS; Last Supper—COME IANO A CENA DOMINE DL NOS. While the plaques of the lid have identical bases, they seem not to have been inscribed.

Much of the original polychrome decoration has survived. The figures have gilt hair and gilt details on shields and costumes. At the tops of various plaques are buildings picked out in red, blue, and green, while certain details, such as the aureole of the Christ Child, are emphasized with gilding. The wood bottom of the casket is painted brown with stylized floral ornament.

The intarsia borders are composed of wood, horn, and bone, except for the basal molding of the lid, which has alternating blocks of hoof and bone. There are two gilt-bronze bail handles on the lid. A central metal ornament, once placed in the center of the lid, is missing, and minor restorations have been made to the intarsia and borders. The interior is lined with later red silk.

Notes: The Embriachi workshop was founded in Florence in 1389 by Baldassare degli Embriachi, who later opened a second workshop in Venice. Documents show the terminal date of the Venice operation to have been 1433, presumably marking the end of production. There has been little or no attempt to separate the work done in Florence from that of Venice. (For the original study of the workshop with the relevant documents, see Schlosser, pp. 220–282. The author illustrated and discussed representative examples of the shop in ivory and bone.)

The Embriachi workshop made altarpieces (two, for instance, for the Certosa di

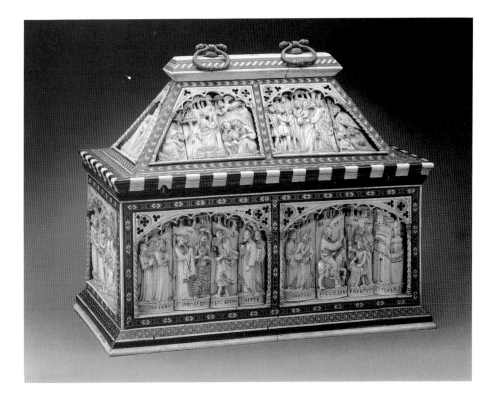

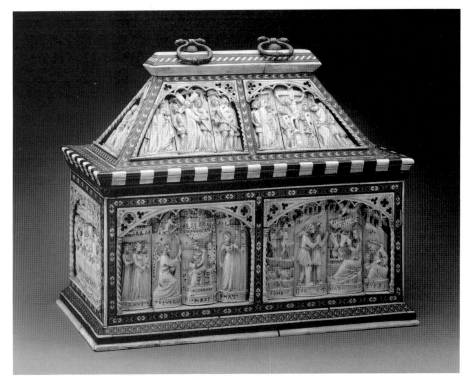

Pavia and the Chartreuse de Champmol [see Schlosser]; see also Metropolitan Museum of Art, inv. 17.190.489 and 490), caskets with secular scenes of romances and paired lovers, wall mirrors, and religious triptychs. Examples of all these types of work exist in American collections (see cat. nos. 218–225, 231–237, and 239–245; and Randall, pp. 236–237).

With the exception of the ivory altarpieces, religious subject matter was confined in the Embriachi workshop chiefly to a large number of triptychs. In

the case of the present casket, while a special ecclesiastical use is implied by the two handles on the lid, there are no interior fittings to suggest what that use might have been. Similar arched panels, spandrels with pierced quatrefoils, and spiral colonnettes occur on a box with secular scenes housed in the Cathedral Treasury at Pistoia (L. Venturi, *Storia dell'Arte* [Milan, 1906], vol. 4, fig. 745).

L: 13 in. (33.1 cm); D: 7½ in. (19.1 cm); H: 11⅛ in. (28.4 cm)

Los Angeles County Museum of Art (47.8.25), The William Randolph Hearst Collection

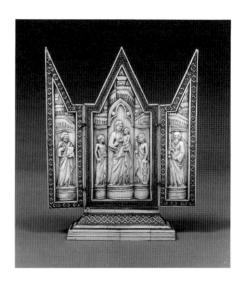

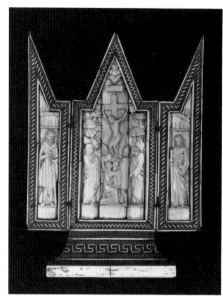

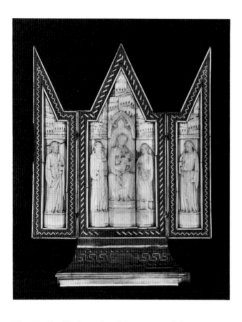

218

The Virgin and Child with Saints

Bone, intarsia, and wood triptych, Venetian (Embriachi workshop), about 1390

The Virgin stands with the Christ Child between two female martyrs, Apollonia (?) on the left and Catherine on the right. Above them is a trefoil arch in a city wall, with buildings in the background. The subject of the left wing is Saint Bartholomew with knife and book; in the right wing Saint Paul holds his sword. All the figures stand on semicircular plinths with a decorative molding at the top.

The frame is inlaid with intarsia of lozenges and zigzags in bone, cow horn, and cow hoof. On the spreading base are molded strips of bone and an inlay of interlaced intarsia.

H: 11⅞ in. (30.1 cm); W: [open] 9½ in. (24.3 cm)

The Snite Museum of Art, University of Notre Dame, Indiana (84.34.3), gift of Mr. and Mrs. James W. Alsdorf

Bibliography: D. Porter, *Selected Works from The Snite Museum of Art* (Notre Dame, Ind., 1987), p. 60.

219

The Crucifixion and Saints

Bone, wood, and intarsia triptych, Venetian (Embriachi workshop), about 1390

On the central plaque of the Crucifixion panel, the Magdalen is shown embracing the Cross between two soldiers. At the left is the Virgin with three soldiers, and at the right Saint John stands alone. There are trees on a hill behind the figures, and the Cross has a *titulus* and symbolic flowers growing above it. In the left wing is Saint Paul and in the right Saint James Major, shown in front of city walls. All five bone plaques have faceted bases for inscriptions.

The frame is inlaid with intarsia of bone and cow horn in a ribbon pattern. On the base is a meander, and the exterior faces of the wings are painted with a leonine sunburst.

There are a numerous losses of bone edging and intarsia.

Notes: A sunburst on a red ground is painted on the outside of the wings of an Embriachi triptych with the Virgin and Child (Zastrow, no. 49, ill. p. 122).

H: 13⅛ in. (33.5 cm); W: [open] 9⅝ in. (24.5 cm)

The Duke University Museum of Art, Durham, North Carolina (1966.30)

History: Purchased from Mrs. Ernest Brummer, New York, 1966.

220

The Virgin and Child with Saints

Bone, intarsia, and wood triptych, Venetian (Embriachi workshop), about 1390

The seated Virgin, nursing the Christ Child, is flanked by Saint Anthony and a togate saint with a sword. The wings show Saint James Major on the left and Saint Francis on the right. All the figures stand on faceted plinths, beneath a city wall with buildings beyond.

A ribbon pattern in bone and cow horn is inlaid in the wood frame. The spreading base, faced with bone strips, is inlaid with a meander pattern in intarsia. On the exterior are two angels painted on a red ground.

There are considerable losses of bone and intarsia from the base and from the edge of the left wing. The painted angels are much rubbed and flaked.

Notes: Similar angels on a red ground can be seen on the wings of another Embriachi triptych (Randall, no. 356).

H: 13⁹⁄₁₆ in. (34.6 cm); W: [open] 10¼ in. (26.2 cm)

The Duke University Museum of Art, Durham, North Carolina (1966.29)

History: Purchased from Mrs. Ernest Brummer, New York, 1966.

221

The Adoration of the Kings

Bone plaque, Venetian (Embriachi workshop), about 1425

The seated Virgin holds the Christ Child, who receives the gift of the second king. Above the group is a stylized shed roof and trees.

Notes: The quality is very high. See cat. no. 222.

H: 3¹⁵⁄₁₆ in. (10 cm); W: 1⅝ in. (4.1 cm)

The Art Museum, Princeton University (29-18)

History: Purchased in Rome by Frank Jewett Mather, Jr., 1929.

222

The Nativity; and the Annunciation to the Shepherds

Ivory plaques, Venetian (Embriachi workshop), about 1425

One panel shows the Virgin holding the swaddled Christ Child in front of the manger with the ox and ass. Over a thatched shed roof, the angel of the Annunciation flies. The second plaque includes four shepherds—two in the foreground with the seated Joseph and two in the background landscape with a flock of sheep.

Notes: Whether these plaques formed part of a casket or a larger work, or were

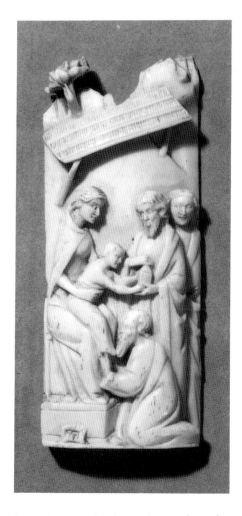

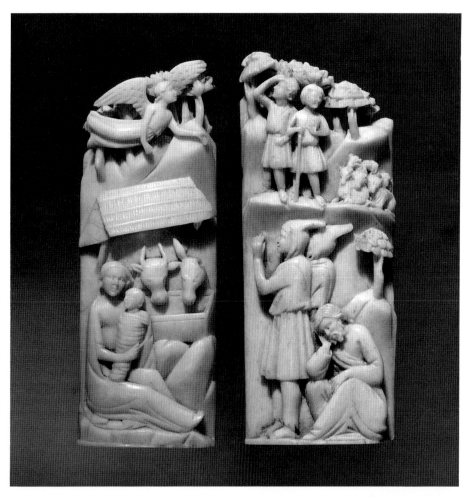

framed as a single picture, has not been determined. Of the same size and quality as an Adoration of the Kings (cat. no. 221), they are carved in ivory rather than bone. Common elements are facial type, treatment of the eyes, and similar landscape details, notably the shed roofs, The three are apparently by the same carver.

Left—H: 4⁵⁄₁₆ in. (11 cm); W: 1⅝ in. (4.2 cm)

Right—H: 4⁷⁄₁₆ in. (11.2 cm); W: 1¹¹⁄₁₆ in. (4.3 cm)

The Art Museum, Princeton University (59-41 and 42), Caroline Mather Fund

History: Purchased from Mathias Komor, New York, 1959.

223

Saints

Panels from the wings of a bone triptych, Venetian (Embriachi workshop), about 1390

Standing on a simple plinth, beneath a city wall with buildings beyond, are a bishop saint and Saint Bartholomew on the left-hand panel, and John the Baptist and a deacon saint, probably Stephen, on the right wing. There are two modern holes for hanging.

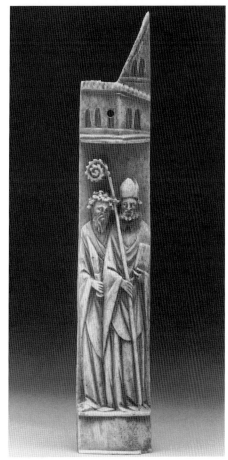

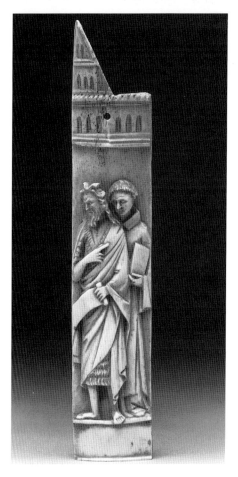

Notes: The shape is typical of the panels in the wings of Embriachi triptychs (see cat. nos. 218–220). While the two plaques are clearly a pair, their size, dictated by the bone, varies slightly.

Left—H: 7⅜ in. (18.7 cm); W: 1½ in. (3.8 cm)

Right—H: 7½ in. (19.1 cm); W: 1⅜ in. (3.5 cm)

The Detroit Institute of Arts (26.166 and 167), City of Detroit purchase

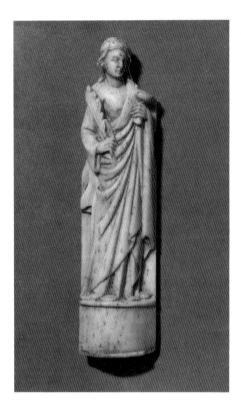

224

Saint Lucy

Plaque from a bone casket, Venetian (Embriachi workshop), about 1390

Saint Lucy is shown holding a chalice and a palm of martyrdom. She stands on a simple semicircular plinth.

H: 4¹³⁄₁₆ in. (12.2 cm); W: 1³⁄₁₆ in. (3 cm)

The Art Museum, Princeton University (37-284), gift of Frank Jewett Mather, Jr.

History: Purchased in Rome by Dr. Mather in 1929.

Bibliography: Carver's Art, no. 41.

225

Saint James Major

Plaque from a bone triptych or casket, Venetian (Embriachi workshop), about 1390

The plaque, showing Saint James Major with his staff and book, is carved with a castellated head and a simple, faceted plinth.

H: 4⁷⁄₁₆ in. (12.8 cm); W: 1¹⁄₁₆ in. (2.7 cm)

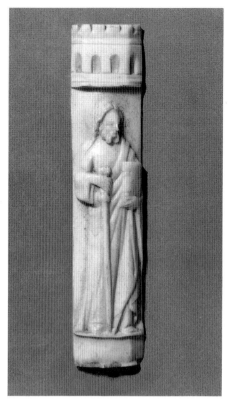

The Art Museum, Princeton University (29-35), gift of Frank Jewett Mather, Jr.

History: Purchased in Rome by Dr. Mather in 1929.

226

Figure of a Man

Bone plaque, Venetian (?), about 1400

The unidentifiable man in robe and cap faces to the right. The plaque is indented at the base for attachment and has a decorative molding at the top.

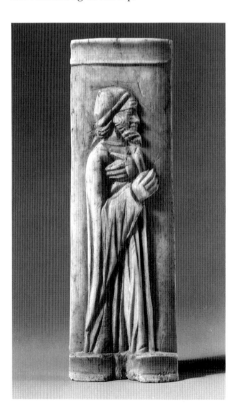

Notes: The size and indentation at the base suggest that this is from the same shop as a pair of plaques portraying Adam and Eve (see cat. no. 230). It is, however, by a different carver and from a different object.

H: 4⅜ in. (11.3 cm); W: 1½ in. (3.8 cm)

The Brooklyn Museum (61.80.3), gift of Harry Friedman

227

Adam

Bone plaque, Venetian (?), about 1400

An awkward figure of Adam is placed against a background of acanthuslike leaves. The plaque is indented at the base for attachment.

Notes: Identical in style and height to an Eve produced by a rival of the Embriachi

atelier (cat. no. 228), this plaque is certainly from the same object.

H: 4½ in. (11.1 cm); W: 1½ in. (3.8 cm)

The Brooklyn Museum (61.80.2), gift of Harry Friedman

228

Eve

Bone plaque, Venetian (?), about 1400

The tall, ungainly figure of Eve is placed against a background of large acanthuslike leaves. Indented in the center at the bottom, the plaque is rather flat and wide.

Notes: It is now clear that work in bone was carried out in several countries in the late fourteenth and fifteenth centuries, when ivory carving virtually ceased (see Schlosser for his opinion that bone work was an exclusive production of the Embriachi). In Italy there were imitators of the Embriachi shop who worked in different manners and had basically different approaches to style and physical structure. This plaque certainly comes from a workshop, perhaps in Venice, that was using the basic ideas of the Embriachi carvers but with quite different results. The placement of Eve against a decorative leafage background is an approach never used in the Embriachi shop. Like cat. nos. 227, 229, and 230, the plaque is indented in the center of the base, rather than projecting, implying a system of attachment different from the Embriachi examples.

H: 4½ in. (11.1 cm); W: 1⁹⁄₁₆ in. (4 cm)
The Art Museum, Princeton University (37-282), gift of Frank Jewett Mather, Jr.
Bibliography: Carver's Art, no. 40.

229

Adam and Eve

Bone plaques, Venetian (?), about 1400

Four plaques of the story of Eden show Eve, Adam, the tree with the serpent, and the angel of the Lord. Each figure projects in the round beneath a tree with flattish leaves. The striated ground on which the figures stand has indentations for mounting. The plaque with the serpent is cracked at the bottom.

Notes: While different in carving and in many stylistic details, the four panels appear to come from the same shop as four other Adam-and-Eve plaques (cat. nos. 227, 228, and 230). Their size is similar and their bases are shaped in the same manner for attachment. Comparable also is the approach to the subjects and the trees, which is quite unlike that of the Embriachi workshop.
H: 4⁹⁄₁₆ in. (11.7 cm); W: [together] 7⅜ in. (18.8 cm)
Crocker Art Museum, Sacramento (1960.3.57a–d), gift of Ralph C. and Violette M. Lee

230

Adam and Eve

Pair of bone plaques, Venetian (?), about 1400

Wearing either a ribbon in his hair or a hat, Adam stands beneath a fruit tree. Eve is posed similarly, facing toward Adam. The plaques are indented at their bases for attachment.

Notes: Having been acquired together and being of the same height, the two are likely to have come from the same object.

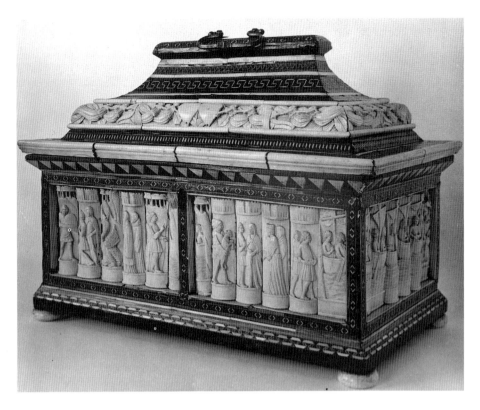

Notes: The Jason story was popular with the Embriachi atelier, whose artisans worked in both Florence and Venice between 1389 and 1433. Written by Benoît de Sainte-Maure, the medieval *Roman de Troie* inspired numerous caskets with scenes from the story.

L: 14 in. (35.5 cm); H: 12 in. (30.5 cm)
The Minneapolis Institute of Arts (61.27), John R. Van Derlip Fund
See also colorplate 20.

232

Scenes of Lovers

Bone, wood, and intarsia marriage casket, Venetian (Embriachi workshop), about 1390

Twenty-two bone plaques show paired lovers and, at the corners, guardian female figures, each armed with spear and shield. On the lid are carved putti holding blank shields for the arms of the recipients.

The intarsia has been completely replaced, perhaps imitating the original designs. There is a bronze bail handle on the lid.

Notes: See also cat. nos. 233 and 235 with similar subjects.

L: 12¼ in. (31.1 cm); D: 7 in. (17.9 cm); H: 9 in. (23 cm)
Detroit Institute of Arts (41.86), Founders Society purchase, Elliott T. Slocum Fund

Their dimensions and structure, with an indented base, suggest that the plaques are from the same shop as another Adam and Eve (cat. nos. 227 and 228), although by a different carver. They can be attributed to a shop competing with the Embriachi.
Adam—H: 4½ in. (11.1 cm); W: 1⅛ in. (2.8 cm)
Eve—H: 4½ in. (11.1 cm); W: 1¼ in. (3.3 cm)
The Brooklyn Museum (61.80.4 and 60.80.1), gifts of Harry Friedman

231

The Story of Jason

Bone, intarsia, and wood marriage casket, Venetian (Embriachi workshop), about 1390

The large casket tells the story of Jason and the Golden Fleece. Depicted on thirty-six bone plaques of equal size are Medea, killing the dragon, holding the Golden

Fleece (in the form of a live ram), and the fleet of the Argonauts. On the lid is a series of bone plaques carved with putti holding scrolls and a double shield for the coats of arms of the betrothed couple.

The wood frame of the box is inlaid in wood and cow horn with intarsia patterns including the Greek key, lozenges, and diamonds. Its lid edged with a bone molding and fitted with a bronze bail handle at the top, the casket is mounted on bone feet.

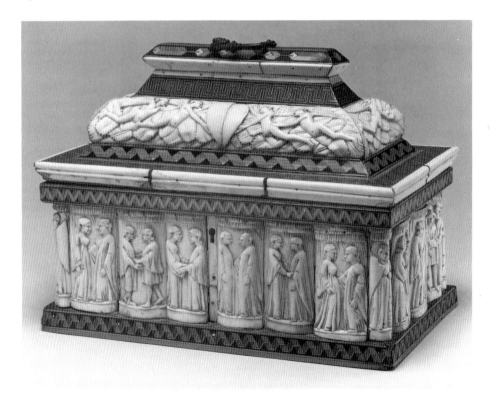

233

Scenes of Lovers

Bone, cow horn, intarsia, and wood marriage casket, Venetian (Embriachi workshop), about 1390

Pairs of lovers in fourteen plaques are separated at the corners by guardian female figures with wands and shields. On the lid are putti holding blank shields for the arms of the betrothed. There is intarsia in wood, bone, and cow horn on the lid, and the base is revetted with plain strips of cow horn, from which the feet are formed. The lid has a wide bone molding around its edge and a brass bail handle on the top.

Notes: Compare cat. nos. 232 and 235 for varying levels of quality within the same ivory atelier.

L: 8⁵⁄₁₆ in. (21 cm); D: 4⁷⁄₈ in. (12.5 cm); H: 6⅛ in. (15.5 cm)

The Art Museum, Princeton University (55-3261), gift of Edith Bloodgood

Bibliography: Carver's Art, no. 26.

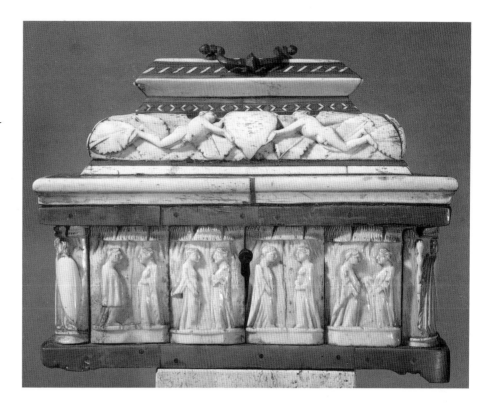

234

Unidentified Story

Bone, intarsia, and wood casket, Venetian (Embriachi workshop), about 1390

The box is revetted with bone plaques carved with figures and architecture. On one side are a man in Roman armor, two prisoners, and a helmeted soldier; on the other side are two women and two men gesticulating. Both end panels contain figures who appear to be part of a stoning episode. The scenes are interspersed with garden gates, fountains, and trees and with addorsed, stop-fluted pilasters at the corners.

Fitted with heavy bone moldings on the flat lid and on the base, the box has intarsia of bone, horn, and hoof in zigzag and interlace patterns.

Notes: A similar Embriachi box (Zastrow, p. 138) has a depiction of a stoning.

L: 12½ in. (31.7 cm); D: 7 in. (17.8 cm); H: 7¾ in. (19.7 cm)

The Godwin-Ternbach Museum, Queens College (CUNY), Flushing, New York (81.13), gift of Mr. and Mrs. Joseph Ternbach in memory of Dr. Frances G. Godwin

235

Scenes of Lovers

Bone, intarsia, and wood marriage casket, Venetian (Embriachi workshop), about 1390

This six-sided box is revetted with eighteen bone plaques, two on each side showing paired lovers and those at the corners carved with civic guards holding spears and shields and wearing short, buttoned jupons of the late fourteenth century. On a wide band at the top, winged putti hold blank shields that were to be painted with the arms of the betrothed couple.

Complete with its original silk lining, the wood box is veneered with cow hoof, horn, and bone in various patterns of intarsia. There are wide bone moldings on the edge of the lid and around the base. The lock is missing, and the finial—carved with emperor portraits—is a replacement of the seventeenth century.

Notes: Decorated with the traditional subject of lovers (see cat. nos. 232 and 233), this marriage casket is of outstanding qual-

Mattabruna (see cat. no. 237), from *The Golden Eagle (Il Pecorone)* by Fiorentina, and from the Judgment of Paris. In a carved band on the lid, set against striated leaves, are putti and animals surrounding shields for the arms of the betrothed. Borders with various patterns of intarsia in bone, horn, and hoof are inlaid on the wood core. The six-sided terminal on the lid retains its original iron ring.

Notes: Replacing the more usual armed guardians at the corners are fluted columns. H: 13¹⁵⁄₁₆ in. (33 cm); W: [of base] 11½ in. (28.6 cm)

The Art Institute of Chicago (1985.112), bequest of Mrs. Gordon Palmer

237

The Story of Mattabruna

Bone, cow horn, and wood casket, Venetian (Embriachi workshop), about 1390

Eight scenes of three plaques each, inset into arched spaces, relate the medieval tale of Mattabruna, the evil mother-in-law who stole seven princes and substituted seven puppies. In the final scene Mattabruna is burned.

An unusual feature of the casket is its simple decoration: white bone moldings and a base of dark cow horn with bone triangles. The turned feet are of ebonized wood. Somewhat misshapen from warping, the box is otherwise intact.

Notes: The story of Mattabruna was popular with the Embriachi atelier, and a number of caskets with the subject survive (see Schlosser, no. 77, fig. 26).

ity. The warders at the corners vary from the usual robed female figures with spears and shields.

H: 12½ in. (31.5 cm); W: [of base] 9 in. (22.9 cm)

Museum of Art, Rhode Island School of Design, Providence (85.075.8), gift of the estate of W. Phelps Warren

236

Various Stories

Bone, cow horn and hoof, and wood marriage casket, Venetian (Embriachi workshop), 1390–1400

The decoration consists of groups of three bone plaques between projecting columns. There are scenes from the story of

H: 13 in. (32.9 cm); W: [of base] 15¾ in. (39.6 cm)

Martin D'Arcy Gallery of Art, Loyola University, Chicago (6-80)

238

The Story of Ameto and the Nymphs

Bone, horn, and wood casket, North Italian, about 1400

The story is identified as that of Ameto from Boccaccio's *Commedia delle Ninfe Fiorentine*. Thirty plaques carved with one, two, or three figures, standing on high molded bases for inscriptions, are divided by spiral columns. On the lid are six Virtues in trefoils and a band of putti with symbolic objects and animals. The realistically rendered creatures include a grasshopper beneath Charity, as a symbol of patience, and a rabbit beneath Prudence, as a symbol of vigilance. Below Justice is the *bocca della verità*, Fortitude has a miter, Faith a font, and Temperance a stag.

The lid of the hexagonal casket is decorated with intarsia borders of cow horn and bone and with triangular configurations of bone circles framing the Virtues. Both the base and the cornice are of ebonized wood. There is a gilt-bronze bail handle on the lid.

Notes: This casket and a group of related works seem clearly not to be the work of the Embriachi atelier but of a competing shop; there are distinct differences of approach in the use of intarsia, in corner elements, and in the types of feet on the various examples. Here is evident a decided interest in representing animals and creatures such as snails and grasshoppers. Also from this shop is a casket, with stepped bone feet and sharply ridged moldings (Longhurst, vol. 2, no. 2563-1856), that depicts battles between putti and animals. Another box similar to the Virginia example (Zastrow, nos. 182–184), with couples surrounding an enthroned Venus, portrays figures of the trades on the reverse and includes inlaid-enamel coats of arms at each end of the lid. A comparable hexagonal casket (see F. Santi, *Dipinti, scultore, e ogetti d'arte di età romanica e gotica* [Galleria Nazionale dell'Umbria, Perugia, 1969], no. 134), although carved with a different story, repeats the Virtues and their animal symbols; original inscriptions in gilt survive on the bases of the figures.

H: 11 in. (28 cm); W: [of base] 14¾ in. (37.5 cm)

Virginia Museum of Fine Arts, Richmond (83.111), gift of John D. Archbold

Bibliography: J. Bliss, "A *Cuir Bouilli* Case and Other Decorative Arts from the Italian Renaissance," *Arts in Virginia* 29, no. 1 (1989), pp. 16–39.

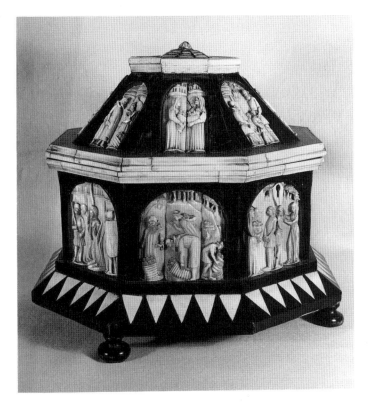

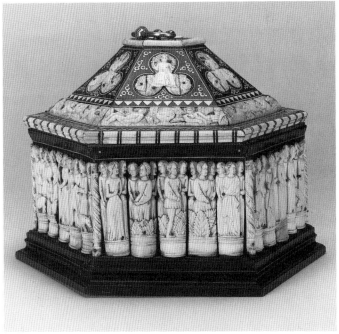

H: 3⁷⁄₁₆ in. (8.7 cm); W: 1½ in. (3.7 cm)
The Art Museum, Princeton University
(29-16)
History: Purchased in Rome by Frank
Jewett Mather, Jr., in 1929.
Bibliography: Carver's Art, no. 39.

241
Two Women

*Plaque from a bone casket, Venetian
(Embriachi workshop), about 1390*

The plaque with two women facing each
other probably comes from a casket that
represents figures in a garden setting.
There is a fringe of trees at the top and a
molded base at the bottom.

Notes: Similar figures are found on caskets
depicting paired lovers (see cat. no. 242).
The scene was once interpreted as the
Visitation.

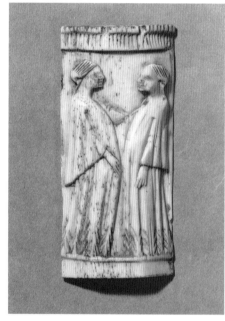

239
Two Argonauts

*Plaques from a bone casket, Venetian
(Embriachi workshop), about 1390*

The two plaques represent Argonauts from
a casket with the story of Jason and the
Golden Fleece. Placed beneath groves of
trees, the soldiers are dressed in helmets
and plate armor with decorated skirts.
They carry swords and shields.

The figures stand on protruding bases,
which were often used for inscriptions.

Notes: Similar figures appear in various ver-
sions of the Jason story from the Embriachi
workshop (see cat. no. 231).

Left—H: 4⁷⁄₁₆ in. (11.2 cm); W: 1³⁄₁₆ in.
(3 cm)
Right—H: 4 in. (10.1 cm); W: 1⅛ in.
(2.8 cm)
Worcester Art Museum, Worcester,
Massachusetts (1919.241 and 242)

240
Leander

*Plaque from a bone box, Venetian
(Embriachi workshop), about 1390*

The plaque shows Leander swimming the
Hellespont, according to the Greek legend
of Hero and Leander. Typical features of

the atelier are mushroom trees, rocks as
landscape, and water indicated by wavy
lines.

The bone is slightly convex, and at the
base is a small ridge instead of the usual
raised plinth.

Notes: In two panels of a chest by the
Embriachi shop (Schlosser, fig. 1), the same
story is depicted; the central plaque of the
first scene shows Leander swimming, as in
the Princeton example.

H: 3⁵⁄₁₆ in. (8.4 cm); W: 1⁹⁄₁₆ in. (4 cm)
The Art Museum, Princeton University
(29-15)
History: Purchased in Rome by Frank
Jewett Mather, Jr., in 1929.

242
Pair of Lovers

*Plaque from a bone casket, Venetian
(Embriachi workshop), about 1390*

From a casket with paired lovers, the
plaque shows hills and trees in the back-
ground and has a narrow molding at the
base.

H: 3 in. (7.6 cm); W: 1¹¹⁄₁₆ in. (4.2 cm)
The Art Museum, Princeton University
(37-286), gift of Frank Jewett Mather, Jr.
Bibliography: Carver's Art, no. 42.

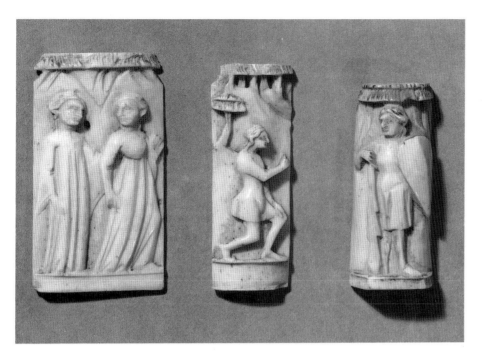

243

Kneeling Youth

Plaque from a bone casket, Venetian (Embriachi workshop), about 1390

The plaque is carved with a kneeling youth before a landscape of hills and trees. Its molded base is typical of works from the Embriachi atelier.

H: 2¾ in. (7 cm); W: 1 in. (2.6 cm)

The Art Museum, Princeton University (29-17)

History: Purchased in Rome by Frank Jewett Mather, Jr., in 1929.

244

Amazon

Plaque from a bone casket, Venetian (Embriachi workshop), about 1390

The woman warrior with club and shield could have functioned as a guardian figure on a box with paired lovers. The shaped, molded base indicates that it was a corner element on a casket.

H: 2⁹⁄₁₆ in. (6.5 cm); W: 1¹⁄₁₆ in. (2.8 cm)

The Art Museum, Princeton University (37-285), gift of Frank Jewett Mather, Jr.

245

Figures from a Romance

Plaques from a bone casket, Venetian (Embriachi workshop), about 1390

The two scenes, each composed of three panels, include figures dressed in "ancient" costume, as used for characters in the Jason and Troy romances. In one an elder talks to a group of five men, and the second shows a dozen men saluting a youth.

Pairs of windows at the top of the plaques have shutters open, closed, and ajar. There are no bases. Remains of black polychromy are visible on one youth's hair and on the ground plane.

Notes: The scenes resemble some of the episodes from the story of Jason and the Golden Fleece. The window detail appears in early Embriachi works (see Schlosser, pl. XXXIII). It is unusual for an Embriachi panel not to have a raised base (an anomaly recorded also on a casket [cat. no. 237] and in the Nativity plaques [cat. no. 222]).

H: 4⅛ in. (10.5 cm); W: 3⁹⁄₁₆ in. (9.2 cm) each

The Barnes Foundation, Merion, Pennsylvania

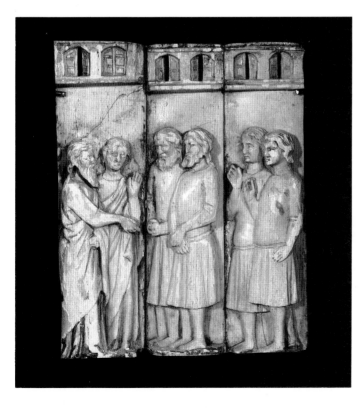

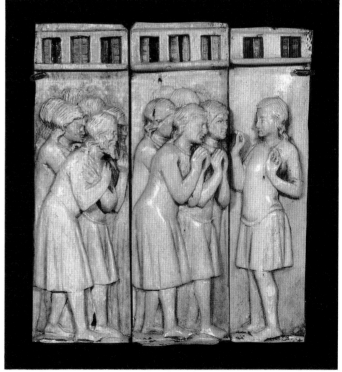

Bibliography

Abbreviated titles used in the text and notes

Age of Chivalry	*The Age of Chivalry: Art in Plantagenet England, 1200–1400* (exh. cat., Royal Academy). London, 1988.
Art Mosan	*Art Mosan et arts anciens au pays de Liège* (exh. cat., Exposition internationale). Liège, 1951.
Art of the Courts	*Art of the Courts of France and England from 1259–1328* (exh. cat., National Gallery of Canada). Ottawa, 1972.
Avori gotici francesi	*Avori gotici francesi* (exh. cat., Museo Poldi-Pezzoli). Milan, 1976.
Beigbeder	Beigbeder, O. *Ivory*. New York, 1965.
Berliner	Berliner, Rudolf. *Die Bildwerke des Bayerisches Nationalmuseums*. Vol. 4. Munich, 1926.
Carver's Art	St. Clair, Archer; and McLachlan, Elizabeth Parker. *The Carver's Art: Medieval Sculpture in Ivory, Bone, and Horn* (exh. cat., Zimmerli Art Museum, Rutgers University). New Brunswick, N.J., 1989.
Court Style	Gillerman, Dorothy. *Transformations of the Court Style: Gothic Art in Europe, 1270 to 1330* (exh. cat., Museum of Art, Rhode Island School of Design). Providence, 1977.
Dalton	Dalton, O. M. *Catalogue of the Ivory Carvings of the Christian Era . . . in the British Museum*. Oxford-London, 1909.
Destrée	Destrée, Joseph. *Catalogue des Ivoires* (Musées Royaux des Arts Décoratifs et Industriels). Brussels, 1902.
Devigne	Devigne, Marguerite. *La sculpture Mosane du XIIe au XVIe siècle*. Brussels, 1932.
Egbert	Egbert, Donald Drew. "North Italian Gothic Ivories in the Museo Cristiano of the Vatican Library," *Art Studies* 7 (1929), pp. 168–207.
Fastes du gothique	*Les fastes du gothique: Le siècle de Charles V*. Ed. Françoise Baron (exh. cat., Grand Palais). Paris, 1981.
Gaborit-Chopin	Gaborit-Chopin, Danielle. *Ivoires du moyen age*. Fribourg, 1978.
Giusti and de Castris	Giusti, Paola; and de Castris, Pierluigi Leone. *Smalti di Limoges e avori gotica in Campania* (exh. cat., Museo Duca di Martina). Naples, 1981.
Goldschmidt and Weitzmann	Goldschmidt, Adolf; and Weitzmann, Kurt. *Die byzantinischen Elfenbein-skulpturen*. 2 vols. Berlin, 1931–1934.
Grodecki	Grodecki, Louis. *Ivoires français*. Paris, 1947.
Hegemann	Hegemann, Hans Werner. *Elfenbein in Plastik, Schmuck, und Gerät*. Hanau, 1967.
Images of Love and Death	*Images of Love and Death in Late Medieval and Renaissance Art*. Ed. W. Levin. (University of Michigan Museum of Art). Ann Arbor, 1975.
International Style	*The International Style: The Arts in Europe around 1400*. Ed. Philippe Verdier (exh. cat., Walters Art Gallery). Baltimore, 1962.
Jászai	Jászai, Géza. "Nordfranzösisch oder mittelrhenish," *Westfalen* 57 (1979), nos. 1–4, pp. 16–23.
Koechlin	Koechlin, Raymond. *Les ivoires gothiques français*. 3 vols. Paris, 1924.
Koechlin, Baboin cat.	Koechlin, Raymond. *Ivoires gothiques: Collection Emile Baboin*. Lyons, 1912.
Koekkoek I	Koekkoek, Roland. *Gotische Ivoren* (exh. cat., Rijksmuseum, Het Catharijne-convent). Utrecht, 1987.

Koekkoek II	Koekkoek, Roland. *Gotische Ivoren in Het Catharijneconvent*. Utrecht, 1987.
Lehrs	Lehrs, Max. *Geschichte und Kritischer Katalog des deutschen, niederländischen, und französischen Kupferstichs im 15. Jahrhunderts*. 9 vols. Vienna, 1908–1934.
L'Europe gothique	*L'Europe gothique, XIIᵉ–XIVᵉ siècles* (exh. cat., Musée du Louvre). Paris, 1968.
Liebgott	Liebgott, Neils-Knud. *Elfenben—fra Danmarks Middelalder* (Nationalmuseet). Copenhagen, 1985.
Longhurst	Longhurst, Margaret. *Catalogue of Carvings in Ivory*. 2 vols. (Victoria and Albert Museum). London, 1927 and 1929.
Mâle	Mâle, Emile. *L'art religieux du XIIIᵉ siècle en France*. Paris, 1923.
Maskell	Maskell, Alfred. *Ivories*. London, 1905.
Medieval Art	*Medieval Art* (exh. cat., Philbrook Art Center). Tulsa, 1965.
Medieval Treasury	Calkins, Robert G. *A Medieval Treasury* (exh. cat., Cornell University). Ithaca, N.Y., 1968.
Molinier, Spitzer cat.	Molinier, Emile. *La Collection Spitzer*. 6 vols. Paris, 1890.
Morey	Morey, Charles Rufus. *Gli oggetti di avorio e di osso del Museo Sacro Vaticano*. Vatican City, 1936.
Philippovitch	Philippovitch, Eugen von. *Elfenbein*. Brunswick, 1961.
Prior and Gardner	Prior, Edward; and Gardner, Arthur. *Medieval Figure-Sculpture in England*. Cambridge, 1912.
Private Collections	Gomez-Moreno, Carmen. *Medieval Art from Private Collections* (exh. cat., The Cloisters, Metropolitan Museum of Art). New York, 1968.
Randall	Randall, Richard H., Jr. (with co-authors Diana Buitron, Jeanny Vorys Canby, William R. Johnston, Andrew Oliver, Jr., and Christian Theuerkauff). *Masterpieces of Ivory from the Walters Art Gallery*. New York, 1985.
Randall, *Gesta*	Randall, Richard H., Jr. "Medieval Ivories in the Romance Tradition," *Gesta* 28, no. 1 (1989), pp. 30–40.
Randall, "Monumental Ivory"	Randall, Richard H., Jr. "A Monumental Ivory," *Gatherings in Honor of Dorothy E. Miner*. Baltimore, 1974.
Sandler	Sandler, Lucy Freeman. *Gothic Manuscripts, 1285–1385*. 2 vols. Oxford, 1986.
Schlosser	Schlosser, Julius von. "Die Werkstadter Embriachi in Venedig," *Jahrbuch der Kunsthistorisches Sammlungen des allerhöchsten Kaiserhauses* 20 (1899), pp. 220–282.
Schnitzler, Kofler cat.	Schnitzler, Hermann; Volbach, Fritz; and Bloch, Peter. *Skulpturen—Elfenbein, Perlmutter, Stein, Holz—Europäisches Mittelalter, Sammlung E. und M. Kofler-Truniger*. Lucerne, 1964.
Secular Spirit	*The Secular Spirit: Life and Art at the End of the Middle Ages* (exh. cat., The Cloisters, Metropolitan Museum of Art). New York, 1975.
Seidel	Seidel, Max. "Die Elfenbeinmadonna im Domschatz zu Pisa," *Mitteilungen des Kunsthistorisches Institut in Florenz* 16, no. 1 (1972), pp. 1–50.
Smalti-Avori	Mallé, Luigi. *Smalti-Avori del Museo d'Arte Antica Turin* (Museo Civico). Turin, 1969.
Songs of Glory	*Songs of Glory* (exh. cat., Oklahoma Museum of Art). Oklahoma City, 1985.
Stafski	Stafski, Heinz. *Die Mittelalterlichen Bildwerke in Stein, Holz, Ton, und Elfenbein bis um 1450* (Germanisches Nationalmuseum). Nuremberg, 1965.
Sterling	Sterling, Charles. *The Hours of Etienne Chevalier—Jean Fouquet*. New York, 1971.
Tannahill	Tannahill, Robert H. *French Gothic Art of the 13th to 15th Century* (exh. cat., Detroit Institute of Arts). Detroit, 1928.
Tardy	Tardy. *Les ivoires*. 2 vols. Paris, 1966.
Treasures from Medieval France	Wixom, William D. *Treasures from Medieval France* (exh. cat., Cleveland Museum of Art). Cleveland, 1967.
Trésor de Saint-Denis	*Le Trésor de Saint-Denis* (exh. cat., Musée du Louvre). Paris, 1991.
Trésors des eglises de France	*Les Trésors des eglises de France* (exh. cat., Musée des Arts Décoratifs). Paris, 1965.
Vöge	Vöge, Wilhelm. *Die Königlichen Museen zu Berlin, Elfenbeinwerke*. Berlin, 1900.

Volbach	Volbach, Wilhelm F. *Die Bildwerke des Deutschen Museums: Die Elfenbeinbildwerke.* Berlin, 1923.
Waning Middle Ages	*The Waning Middle Ages: An Exhibition of French and Netherlandish Art from 1350–1500.* Ed. J. L. Schrader (exh. cat., University of Kansas Museum of Art). Lawrence, 1969.
Warner	Warner, George. *Queen Mary's Psalter, Royal Manuscript 2 B VII, in the British Museum.* London, 1912.
Williamson, Thyssen cat.	Williamson, Paul. *Medieval Sculpture and Works of Art (The Thyssen-Bornemisza Collection).* London, 1987.
Witte	Witte, Fritz. *Die Skulpturen der Sammlung Schnütgen in Cöln.* Berlin, 1912.
Wixom 1972	Wixom, William D. "Twelve Additions to the Medieval Treasury," CMA *Bulletin* 59 (April 1972), p. 95.
Wixom 1979	Wixom, William D. "Eleven Additions to the Medieval Collection," CMA *Bulletin* 66 (March 1979), pp. 86–151.
Wixom 1987	Wixom, William D. "A Late Thirteenth-Century English Ivory Virgin," *Zeitschrift für Kunstgeschichte* 50, no. 3 (1987).
World as Symbol	*The World as Symbol: An Exhibition of Medieval Art* (exh. cat., Queens College). New York 1959.
Zastrow	Zastrow, Oleg. *Museo d'arti applicate: Gli avori.* Milan, 1978.

PERIODICALS

Bull mon.	*Bulletin monumental*
BCMA	Cleveland Museum of Art *Bulletin*
BDIA	Detroit Institute of Arts *Bulletin*
BMMA	Metropolitan Museum of Art *Bulletin*
GBA	*Gazette des Beaux-Arts*
JMMA	Metropolitan Museum of Art *Journal*
JWAG	*Journal* of the Walters Art Gallery

General Index

Page numbers in *italics* refer to illustrations.

Index of Collectors and Former Owners

The references are to catalogue numbers.

Photograph Credits

Photographs are supplied by the museums and private owners cited, with the following exceptions:

Cat. no. 12, C. T. Little; 31, E. Irving Blomstrann; 45 (a,b,c), Daniel Babior; 55, Marolin de Velagin; 72, Daniel Babior; 115, Jon Reis; 123, Daniel Babior; 130, E. Irving Blomstrann; 137, Courtesy of Sotheby's; 150, Daniel Babior; 151, Courtesy of Sotheby's; 157, Courtesy of Ronald Lee, London; 175, Daniel Babior; 197, P. Richard Eells; 208, Courtesy of Edward R. Lubin, New York; 211, Courtesy of Sotheby's; 229, Daniel Babior.

Figure 1, Lefèvre-Pontalis, Arch. Phot. Paris, S.P.A.D.E.M.; 3, A.C.L., Brussels; 4, A.C.L., Brussels; 7, Courtesy of Musées de Niort; 8, Courtesy of Musées Nationaux: Louvre, Paris; 9, Courtesy of The Wernher Collection, Luton Hoo, Bedfordshire; 10, Courtesy of the Fitzwilliam Museum, Cambridge; 11, Courtesy of the Bayerisches Nationalmuseum, Munich; 12, Courtesy of Blumka Gallery, New York.

Colorplate 1, Robert Hashimoto.